AMERICAN
IMPRESSIONISM

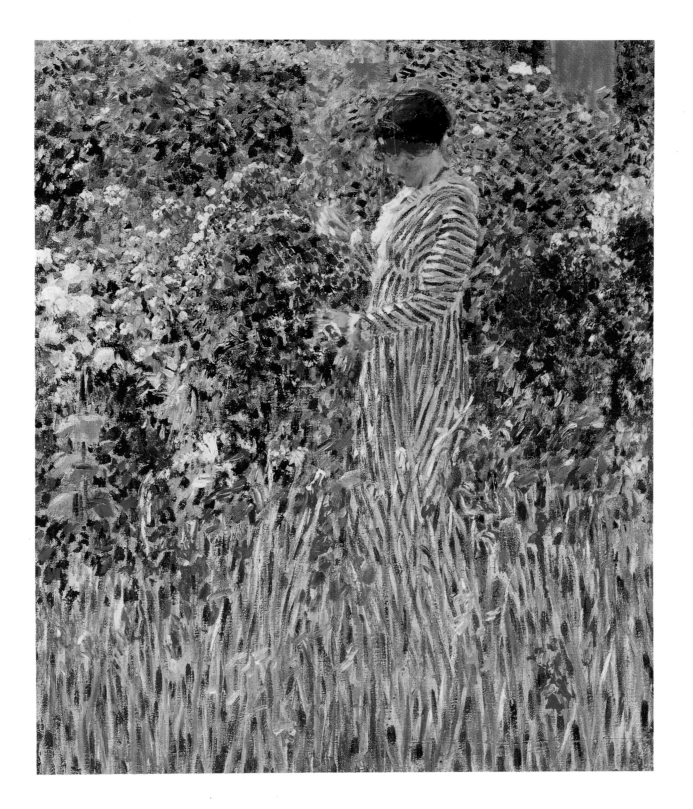

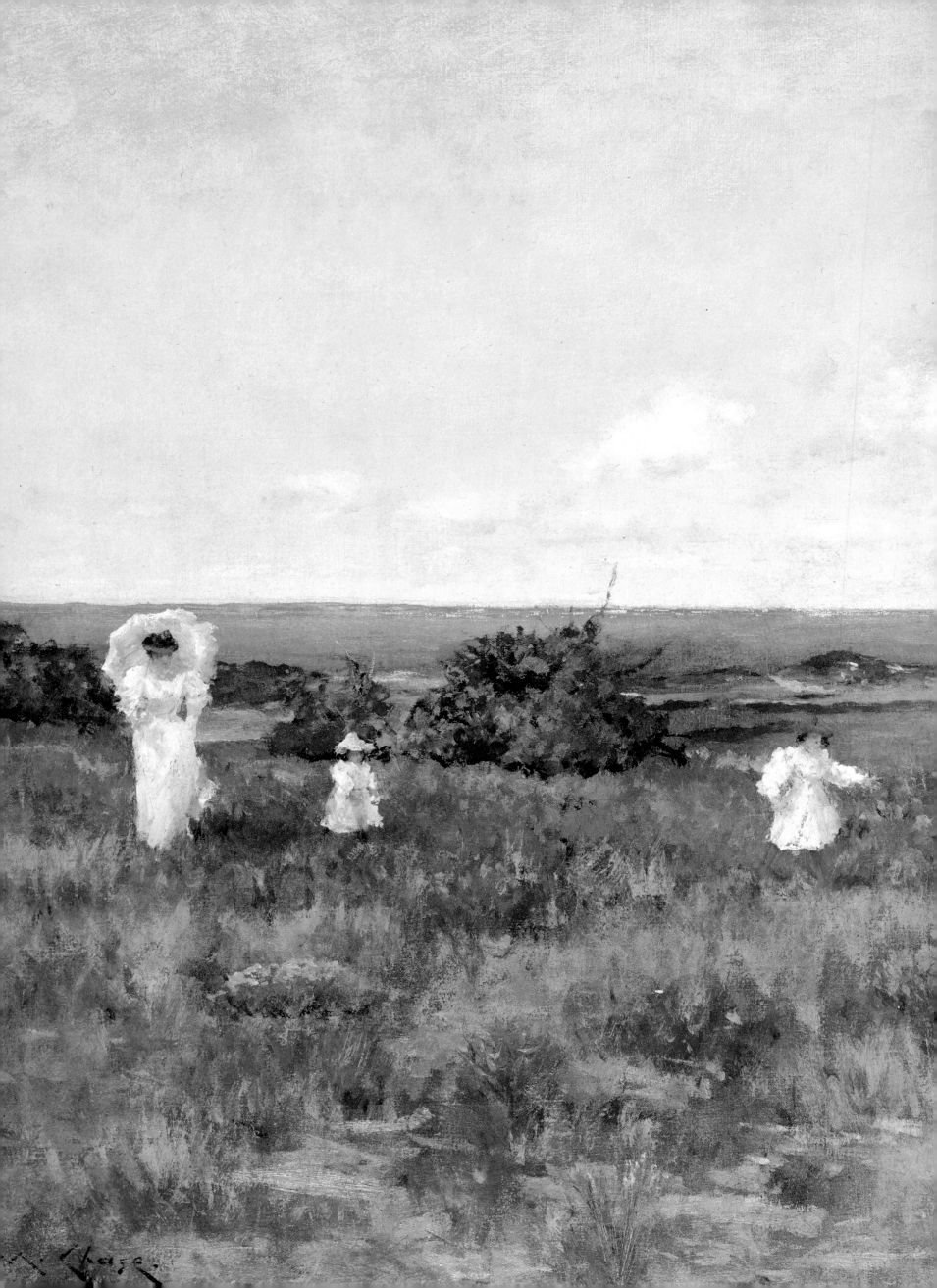

AMERICAN IMPRESSIONISM

AMY FINE COLLINS

GALLERY BOOKS
An imprint of W.H. Smith Publishers Inc.
112 Madison Avenue
New York, New York 10016

For Bradley Isham Collins, Jr., who spent summers in Childe Hassam's house on Egypt Lane, and whose great-uncle Samuel Isham wrote one of the first studies on these American artists.

Published by Gallery Books
A Division of W H Smith Publishers Inc.
112 Madison Avenue
New York, New York 10016

Produced by
Brompton Books Corp.
15 Sherwood Place
Greenwich, CT 06830

ISBN 0-8317-0291-5
Reprinted 1990
Printed in Spain

10 9 8 7 6 5 4 3 2

My thanks to Kenneth E. Silver for proposing I write this book, and Bradley Collins, Jr., for reading the manuscript. Doris Honig Guenter very helpfully took me to New England museums to look at many of these paintings. My parents taught me by example that it is possible to write a book.

The publisher would like to thank Janet Wu York, the editor and picture researcher; and Sue Rose, the designer.

Page 1:
Frederick Frieseke
Lady in a Garden, c. 1912
Oil on canvas, 31⅞ × 25¾ in.
Terra Museum of American Art, Chicago

Pages 2-3:
William Merritt Chase
Near the Beach, Shinnecock, c. 1895
Oil on canvas, 30 × 48⅛ in.
The Toledo Museum of Art

Contents and List of Plates

INTRODUCTION

Art plays such a conspicuous part in American culture today, it is hard to imagine that this is a fairly recent development. Americans clung for generations to Puritan notions that art was a decadent frivolity. Even our second president John Adams declared in 1778, "It is not indeed the fine arts which our country requires: the useful, mechanic arts are those which we have occasion for." As late as 1835, the French social observer Alexis de Tocqueville lamented in his study *Democracy in America* "that few of the civilized nations of our time have . . . so few great artists." He concluded that in a democracy the practical would always take precedent over the beautiful.

Given these inauspicious circumstances, it is a wonder that an American school of painting developed at all. From the beginning, portraiture was most in demand, as it served a useful, geneological function. Thus it comes as no surprise that America's first great artist, John Singleton Copley, was a portraitist. The Boston-based painter received ample commissions, but, eager to leave a country where, in his words, artists were ranked with "shew makers," he eventually migrated to England – an expatriate pattern followed by future generations of American painters.

Right: Frederic Church, *Niagara,* 1857. The Corcoran Gallery of Art, Washington, D.C. Man's presence is nowhere visible in this pristine, overpowering panorama. We are not even given a secure, dry foothold. The delicate rainbow arcing from upper left toward lower center creates a reassuring, hopeful mood, very common in American art.

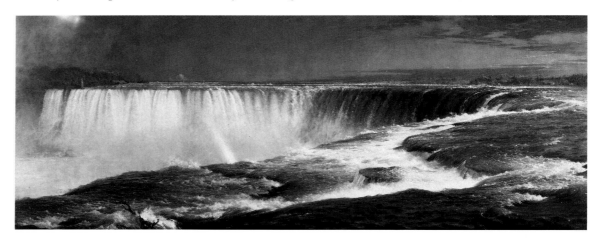

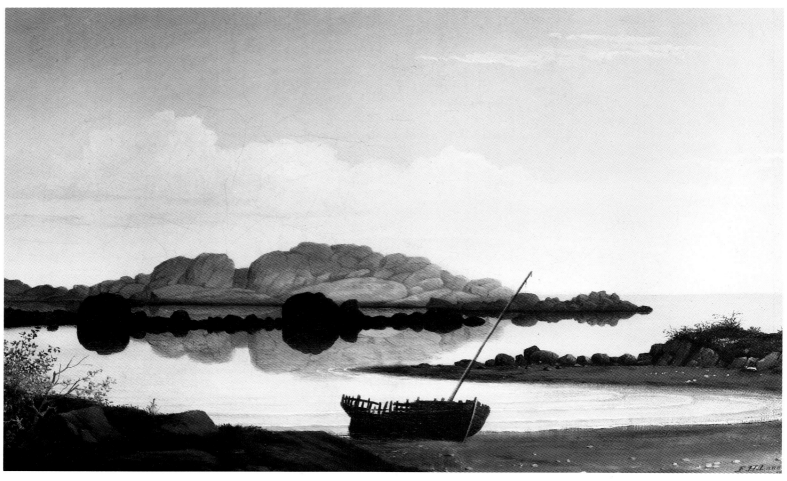

With complete independence from the mother country (following the War of 1812), American artists soon found the theme that would give their work a distinct national identity – the American landscape. Even as forests were felled, a pride in native wild scenery emerged. "What comparison is there between the garden landscapes of England or France," declared an American magazine in 1847, "and the noble scenery of the Hudson, or the wild witchery of some of our unpolluted lakes and streams? One is man's nature, the other – God's."

Among the first to celebrate the country's natural treasures, Thomas Cole is generally considered the founder of the Hudson River School. From about 1830 to 1860, Cole produced grand, pantheistic views of the American countryside. Cole habitually saw landscapes in terms of spiritual symbols, while his student Frederic Church's sublime spectacles suggest the presence of a powerful yet benevolent God. Slightly later, a group of painters, including Fitz Hugh Lane and Martin Johnson Heade, made more restrained, meditative pictures of nature's humbler side. Their hushed, crisp style is now known as Luminism because of the becalmed atmosphere and almost spiritual light that emanates from their lonely landscapes.

The next generation of American artists branched off in various new directions. In Philadelphia, the Paris-educated Thomas Eakins brought European-style rigor to both his realist painting and comprehensive teaching techniques. His meticulously calibrated space and crystal-clear forms are close to his Luminist predecessors, but his interest in depicting people pursuing modern leisure activities in familiar, open-air settings was extremely up-to-date. George Inness worked in the Hudson River School style until he discovered in the French painters of the Barbizon School (such as Corot and Millet), another, more subjective and poetic approach to landscape. But his fascination with creating a palpable, softening atmosphere also approximates Impressionism. Inness's moody scenes bear affinities as well with the visionary, symbolic pictures of eccentric American painter, Albert Pinkham Ryder, whose eerie moonlit landscapes are, however, totally imaginary.

Winslow Homer began as a magazine illustrator of scenes from everyday life, but in the early 1860s turned to paintings more devoted to lively effects of design, color and pattern than to human-interest anecdotes. During a trip to France in 1867, when his works (along with Inness's) were exhibited in the American section

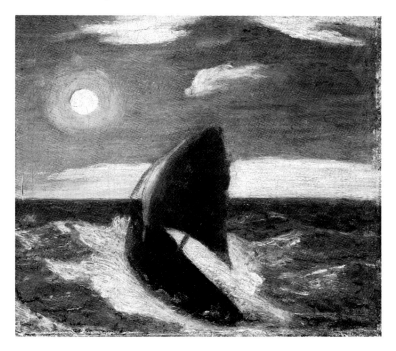

Opposite below: Fitz Hugh Lane, *Brace's Rock, Brace's Cove*, 1864. The serene composition, carefully described space, and mirror-smooth finish of this Luminist picture give a sense of the permanent and eternal, in contrast to the fugitive effects of Impressionism.

Right: Jean-François Millet, *Autumn Landscape with a Flock of Turkeys*, 1870-74. The Barbizon artists, who painted unpretentious scenery and peasant laborers, were both popular with American collectors and important to the development of Impressionism.

Above: Albert Pinkham Ryder, *Toilers of the Sea*, before 1884. An eccentric, visionary painter, Ryder was befriended by American Impressionists.

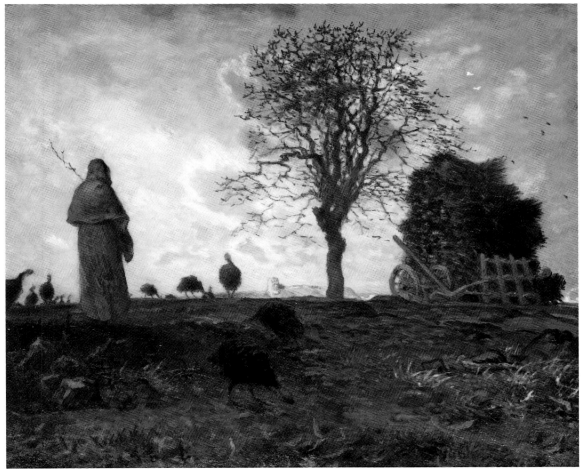

of the Paris Universal Exposition, Homer evidently studied early examples of the newest school of French painting, Impressionism. There is really no other way to account for the pictures painted after his return, such as *Long Branch, New Jersey* (1869), which exhibit a blonder palette, more preoccupation with dazzling sunshine, and a more buoyant lightness to the figures.

Winslow Homer.

By the time Homer traveled to France, the Civil War had ended, and a new era had begun for American culture. America started to emerge as a world power, contributing significantly to advances in finance, technology and communications. The nation prospered and great fortunes were made. Naturally, Americans also wanted to compete in the cultural arena, but opportunities for artists in this country were limited by a dearth of exhibiting and training institutions and a lack of a patronage system. Americans responded in two ways: by establishing more art-promoting organizations and taking greater advantage of opportunities abroad.

Despite America's new art-consciousness, which inspired the founding of museums, societies, and schools across the country, Europe still beckoned. Munich was a popular choice, but Paris was by far the favorite city for Americans. Among other attractions, Paris offered free instruction at the prestigious government-sponsored École des Beaux-Arts, training at independent academies (Julian's or Colorassi's) and private classes at important masters' studios. At mid-century, American artists in France could be counted in the dozens; from the 1880s onward, they numbered well over a thousand.

Ironically, just as American artists were beginning to take full advantage of French academic instruction, a group of progressive French artists, soon known as the Impressionists, were starting to undermine this very

same system. Monet, Pissarro, Degas, Renoir, Morisot, Sisley and others had wearied of the conservative tastes of the salons and the academies, and having suffered rejection or ridicule for their avant-garde styles, these artists decided to form an independent organization. Yet, much as their art broke with convention, it was still very much tied to it. Most of them had some sort of academic education; their style could not have developed without the example of earlier artists, such as the Barbizon School of French painters – or even the masters of the seventeenth and eighteenth centuries, such as Velázquez and Fragonard, whose dashing brushwork and investigation of contemporary themes they deeply admired. Degas' *Mary Cassatt at the Louvre* (1885) pays homage to his American friend, but also to the old masters of the Louvre.

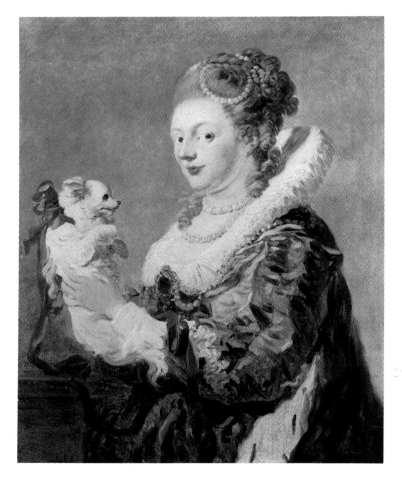

Jean-Honoré Fragonard, *Portrait of a Lady with a Dog.*

In 1874 the first Impressionist exhibition of the "anonymous cooperative society of artists, painters, sculptors, engravers, etc.," as the group called itself, was an occasion for mockery. The press and public alike found the painters' sketchy brushwork offensive. The critic Louis Leroy likened it to "tongue lickings"; slapdash paint was fine for preparatory studies, but considered too slovenly for finished works. Leroy inadvertently gave the movement its name when, taking his cue from the title of Monet's *Impression: Sunrise* (a morning scene of a misty port), he headlined his scathing review, "Exhibition of the Impressionists." Yet the Impressionists attracted a handful of loyal supporters among progressive writers and patrons, whose numbers grew with each exhibition.

Although each Impressionist developed an indivi-

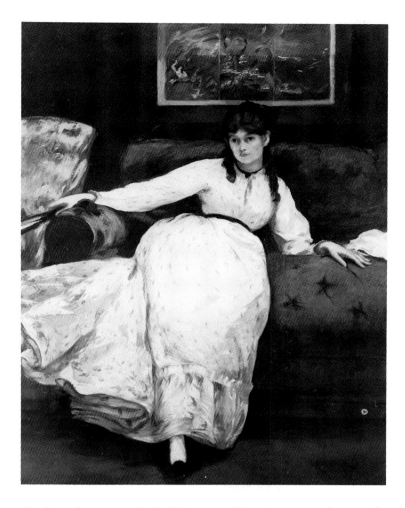

considered picturesque enough to represent (e.g., Pissarro's *St. Sever Bridge from Rouen, Fog* and Monet's *Haystacks*).

In general, the Impressionists favored loose, sketchy strokes ranging from long and fluid (Morisot), light and feathery (Renoir), to small and dabbing (Monet and Pissarro). A painterly style encouraged the illusion of immediacy, as if a scene had been both glimpsed and recorded casually, if not hurriedly. The flurry of brushstrokes suggests that the world is not fixed and static – ruled by eternal truths and absolute facts – but rather is in a state of constant flux. In addition, the Impressionists believed that painterly brushwork replicated more faithfully the way the eye (which cannot discern every minute detail) actually perceived the world.

The Impressionists found that the only way to approximate effects of light, air, and color was to paint in the open air, *en plein air*. Monet said that he was not interested in painting objects, but the atmosphere enveloping them – a task impossible to undertake by remaining indoors. Renoir's *Monet Working in his Garden in Argenteuil* (1873) illustrates the practice of plein-airism. Technology aided the Impressionist cause, as the invention of the collapsible tube allowed pigments to be portable, whereas earlier they had to be ground and mixed in the studio.

Moreover, advances in chemistry led to the development of new, brighter pigments. The Impressionists felt that, as much as possible, these colors should be laid directly on the canvas rather than muddied by mixing on the palette; this allowed the viewer's eye to blend the pure colors, and so preserve their brilliancy. The Impressionists were versed in the treatises of color theorists who explained that colors do not exist in isolation, but are significantly altered by hues of adjacent objects. Thus, the "white" tablecloth in Monet's *Breakfast in the Garden* picks up blues and reds from the flowers, greens from the lawn, and yellows from the wicker tea cart.

dual style, some helpful generalizations can be made about their work. Unlike previous painters who found contemporary life unsuitable for art and preferred lofty historical scenes or rustic views of peasants, the Impressionists were devoted to exploring the modern life about them. As in Manet's paintings *Repose* (1870) and *Bar at the Folies-Bergère* (1881-82), the Impressionists particularly focused on the fashionable dress and leisure activities of the middle and upper classes. Their subject matter also encompassed ordinary views of the city and countryside, which in the past were seldom

Opposite right: Fragonard (1732-1806) set a precedent for loose brushwork.

Above: Édouard Manet, *Repose: Portrait of Berthe Morisot*, 1870. Typical of his concern with contemporary life, Manet shows his future sister-in-law and fellow Impressionist Morisot as a slightly anxious modern woman in a fashionable interior, dressed in the latest attire.

Right: Camille Pissarro, *St. Sever Bridge from Rouen, Fog*, 1896. This painting is unusual even for Impressionism; instead of celebrating the glamour of Paris, the socialist Pissarro shows the grimy industrialization of Rouen.

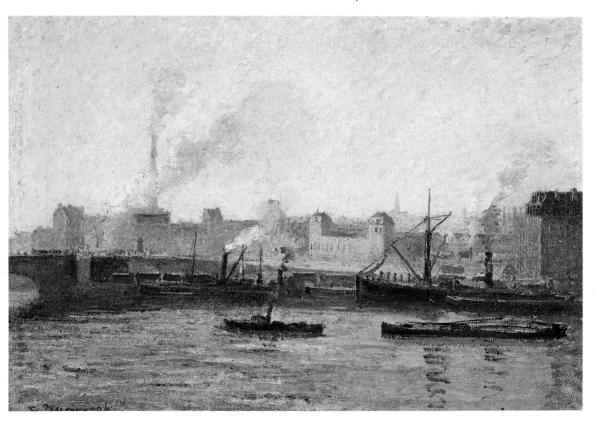

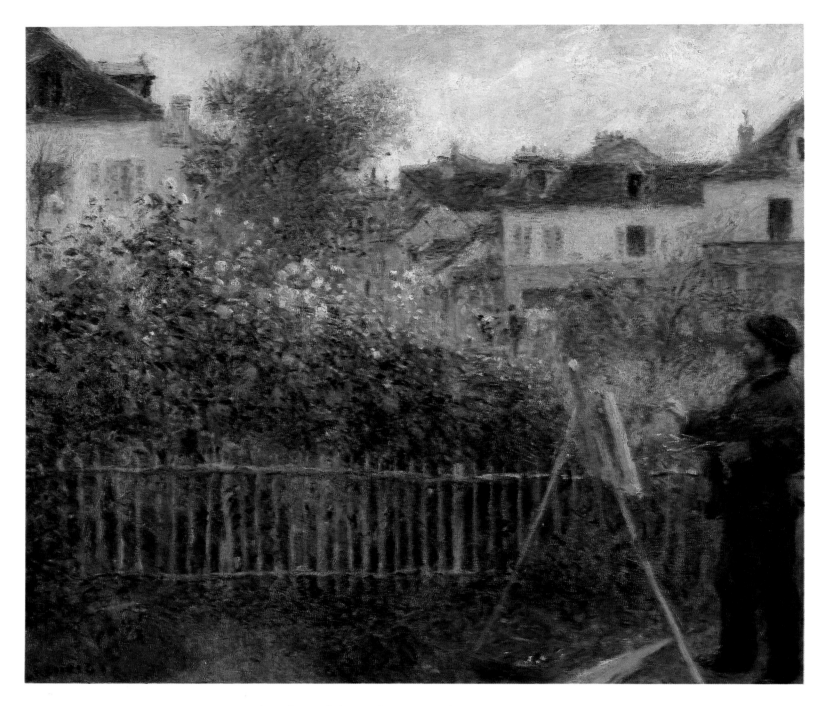

The Impressionists even painted reflected hues in shadows, which they never treated as negations of light, but as translucent pools of cool color. Black was used sparingly, if at all. From the color theorists, the Impressionists also learned to exploit the properties of complementary colors. When placed side by side, complementaries grow more vivid to the point where they seem to vibrate and radiate light.

The Impressionists, like physicists, in effect did not distinguish between color and light. By using unmixed, high-keyed colors, introducing complementaries, and eliminating transitional tones between light and shadow, they were able to create pictures more dazzlingly luminous than anything seen before. They relished investigating how brilliant sunlight distorts objects, by seemingly dissolving their solidity and rendering edges and details indistinct. For example, in Monet's *Woman with Parasol, Turned Right*, the tailoring of her dress and the specifics of her facial features are blurred by light. Apparently weightless, she seems to float like a white sail above the hill. The picture is more a portrait of afternoon light than of a woman.

In addition to experimenting with color and light *en plein air*, the Impressionists invented new types of compositional formats, intended to heighten spontaneity and informality. For inspiration, they looked at non-western and unconventional art forms – especially the asymmetrical, flattened, and cropped compositions of Japanese prints, and to a lesser extent, the accidental effects of photography. For example, Degas' *Carriage at the Races* (1870-72) uses an off-kilter composition with abrupt juxtaposition of near and far. The carriage looming obliquely on the right has nothing of equal weight to counterbalance it on the left. The figures and horses are unexpectedly diminutive compared to those on the right. In addition, the picture's edges crop the bodies and carriage wheels. We sense that this scene must extend beyond the painting's boundaries and that it is merely a segment randomly cut from the much larger continuum of life.

After the "anonymous society" disbanded in 1886, the individual Impressionists, partly influenced by younger Post-Impressionists, went in independent directions. Pissarro experimented with the disciplined Pointillist technique, Renoir combined Impressionism with a new respect for the suavely-drawn classical nude

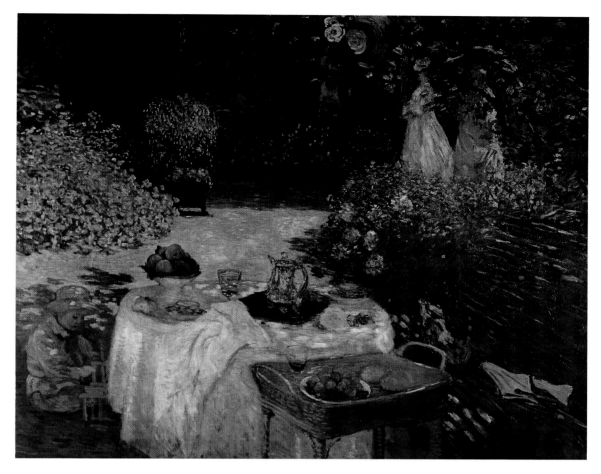

Left: Claude Monet, *Breakfast in the Garden;* 1872-73. Another view of Monet's garden at Argenteuil, a suburb of Paris, this painting leaves out much of what Renoir included. Monet's home seems secluded and pastoral when in fact it was surrounded by neighboring dwellings. Americans also adored the theme of the idyllic garden. At left, Monet's son is practically swallowed up by the palpable atmosphere, colored shadows, and dappled light. A sense of bourgeois contentment reigns over this scene.

Opposite: Pierre-Auguste Renoir, *Monet Working in his Garden in Argenteuil.* Renoir's picture of Monet at his easel illustrates the practice of painting out-of-doors. Impressionists felt that working *en plein air* was the only way to capture accurately sensations of light, air, and color.

Right: Edgar Degas, *Carriage at the Races.* Degas' asymmetrical composition, with its abrupt juxtaposition of near and far, voided spaces, and cropped edges derives from Japanese art.

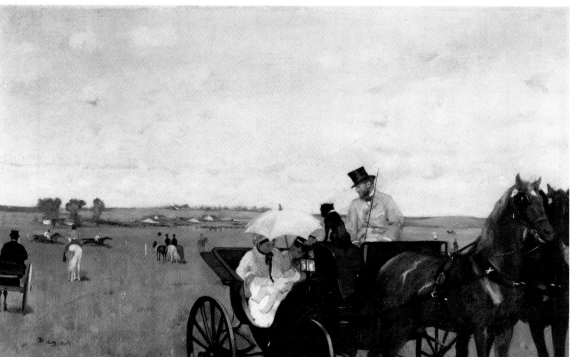

(e.g., *The Bathers*, 1884-87), and Monet pushed his coloristic, form-dissolving effects to the brink of abstraction.

In 1886, the same year as the last Impressionist exhibition, the dealer Paul Durand-Ruel brought the first comprehensive show of Impressionism to America. Although very few American painters or collectors had shown interest in the movement up to this point, the exhibition was a modest critical and financial success: roughly 25 percent of the paintings sold, reportedly netting about $40,000. One surprisingly friendly American reviewer, contrasting the show with academic exhibitions, wrote that it was "like a bright May morning compared with a dark November day." Durand-Ruel recalled, "As opposed to what happened in Paris, it provoked neither uproar, nor abusive comment . . . The American public does not laugh, it buys."

In contrast to the French, Americans were receptive to this new art for a number of probable reasons. Americans had already developed a taste for the predecessors of the Impressionists, the Barbizon painters (whose work Durand-Ruel also sold). In addition, the revered academic values against which the Impressionists rebelled were deeply entrenched in France, but barely had time to take hold in the U.S. Americans, then as now, could also relate to the bourgeois sense of well-being that the Impressionists projected in their subject matter, as well as their wholesome appreciation of the outdoors.

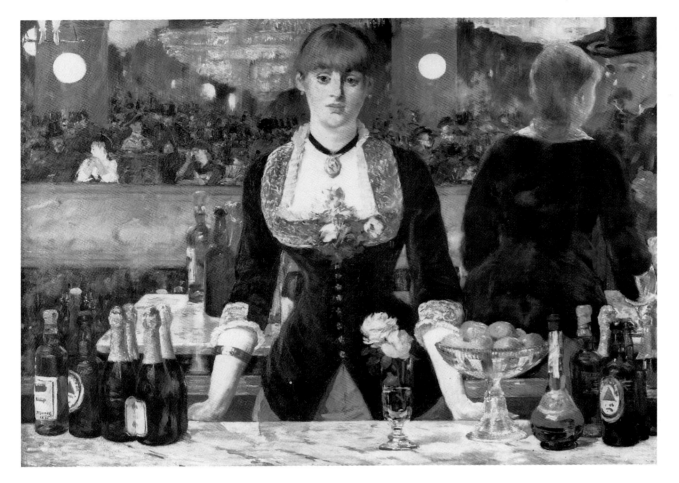

Left: Édouard Manet, *A Bar at the Folies-Bergère.* This scene of a bar at a popular Parisian nightspot depicts Manet's fascination with contemporary urban life. In this setting different classes mingled, giving Manet a lively cross-section of humanity to paint. Impressionists liked using mirrors in their compositions to create dazzling optical effects. In the glass we see not only reflections of gaslights, smoke, and spectators, but a top-hatted gentleman speaking to the barmaid. The sparkling still life and barmaid's weary face show Manet at his best. The worldly, slightly risqué tone of this painting did not find favor with the Americans, who preferred refined subjects. Glackens was an exception to this rule.

As Americans began to accept the Impressionist style, a number of American painters, to varying degrees, adopted Impressionism. The expatriates, James Abbott McNeill Whistler, Mary Cassatt, and John Singer Sargent, each developed a highly original, extremely sophisticated style of painting, closely related to Impressionism, but still distinct from it. Other American artists, such as Theodore Robinson and Theodore Butler, having resided in Giverny near Monet at some point in their careers, assimilated Monet's art at first hand. Another group of American Impressionists exhibited together as the Ten. The members of the Ten – which included J. Alden Weir, Childe Hassam, Edmund Tarbell and William Merritt Chase – had also trained in Europe, attaining an aca-

demic foundation before experimenting in Impressionism. Artists such as Edward Redfield and Elmer Schofield studied at the Pennsylvania Academy of Fine Arts, where a tradition of realism predominated; in their landscapes, Redfield and Schofield, rejecting the purely decorative aspect of Impressionism, aimed for a harsher, home-grown style.

Impressionism in America began to attract wealthy, sophisticated collectors, including Louisine Havemeyer, Erwin Davis, Bertha Honore Palmer and Alfred Pope. Ironically, these "robber barons" of the post-Civil War period purchased almost exclusively French examples; feeling more secure in collecting European art, they usually acquired works of the old masters along with those of the French Impressionists. Not until

Right: Claude Monet, *Haystacks,* 1889, Hill-Stead Museum, Farmington, CT. In his serial pictures, Monet observed how changing atmospheric conditions affected the lighting and color of monumental forms, such as these haystacks.

Opposite: William Merritt Chase, *James Abbott McNeill Whistler,* 1885. Chase's friendship with Whistler ended after Chase exhibited this portrait, which, though an homage, was interpreted as a caricature. Photos prove that Whistler actually looked as Chase depicted him.

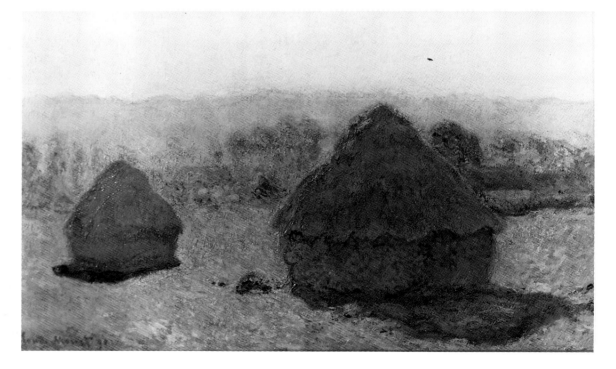

slightly later did another breed of American collector emerge who was interested primarily in contemporary indigenous art. These supporters of the American Impressionists included Charles Lang Freer, George H. Hearn, William T. Evans, and John Gellatly; their holdings now form the basis of many important museum collections.

Amid the popularity of French Impressionism in America, the art exhibition at the 1893 Chicago World's Columbian Exposition proved to be crucial in the consolidation of American Impressionism. Here, the American Impressionists were given a chance to outshine their French counterparts. Since the French government was still skittish about Impressionism, the French Impressionists were hardly represented; the official French display consisted mainly of academic art. On the other hand, the American Impressionists participated in this brilliantly successful world's fair as jurors, exhibitors and mural painters.

For some critics and collectors, championing American over French Impressionism eventually became nearly a patriotic duty. Their ambivalence about admiring an exported style led them to identify native traits in the Americans' work, and to believe that domestication "improved" Impressionism. Americanness for writer-painter Eliot Clark meant Theodore Robinson's "unaffected and uncultivated simplicity" and for critic Anne Seaton-Schmidt, Frank Benson's "spirit of optimism, of daring, or surety of happiness." Critics referred to the "democratic" subject matter of the Pennsylvania landscapes of Redfield and Schofield. Writers today are more likely to discuss the reasons that the American Impressionists did not sacrifice illusions of solidity and three-dimensionality in their work to the same extent as the French. Some point out that historically, American artists had always maintained a pragmatic respect for representing physical reality. Others point out that the American Impressionists resisted giving up altogether skills only recently acquired in European academies.

With the exception of the early careers of the expatriates, Whistler, Cassatt, and Sargent, the American Impressionist movement flourished largely between Durand-Ruel's landmark show in 1886 and the end of World War I. The pivotal 1913 Armory Show in New York introduced new European art styles to America, making the decline of American Impressionism inevitable.

Whistler, Cassatt, and Sargent all chose to practice their profession abroad, mainly in England or France, yet they maintained firm ties to their homeland. Expatriation for each of them was a matter of habit, if not destiny. As children, Cassatt and Whistler shuttled back and forth between Europe and America with their families, and Sargent didn't even set foot in his native country until he had to declare citizenship at the age of 20. Difficult as it is sometimes to think of these artists as American, their host countries never regarded them as anything else.

These expatriates came in close contact with the French Impressionists early on because of their Euro-

pean residence, and their acceptance into cultivated, high-bohemian circles. Whistler, the oldest of three, was the first to study in Paris (1855) where, immediately attracted to a bohemian life, he befriended avant-garde painters – Manet, Degas, Fantin-Latour – and writers like Baudelaire. By 1858 he was in London, where he settled more or less permanently in the early 1860s. Wherever he went, Whistler generated controversy. He was known and feared for his scathing wit, which won him as many friends as it lost him. William Merritt Chase, whose 1885 portrait of him is at once homage and caricature, declared, "Few men were as fascinating to know – for a brief time." The fastidiously dressed Whistler always wore a handkerchief embroidered with little butterflies, a reference to the stingered-butterfly insignia which served as his signature on paintings. This emblem condensed his two outstanding gifts: pictorial delicacy and verbal pungency.

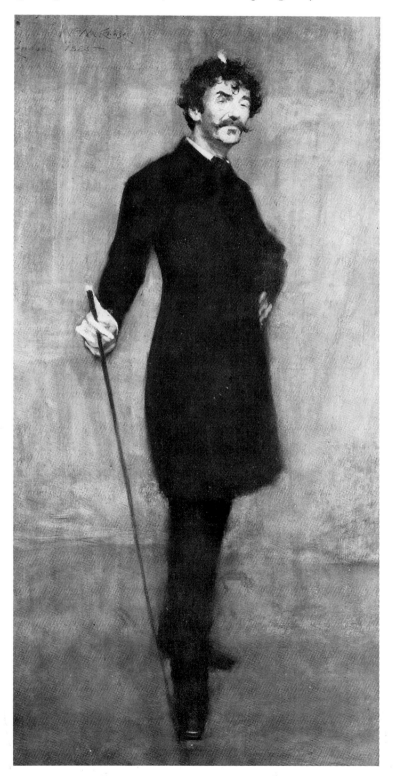

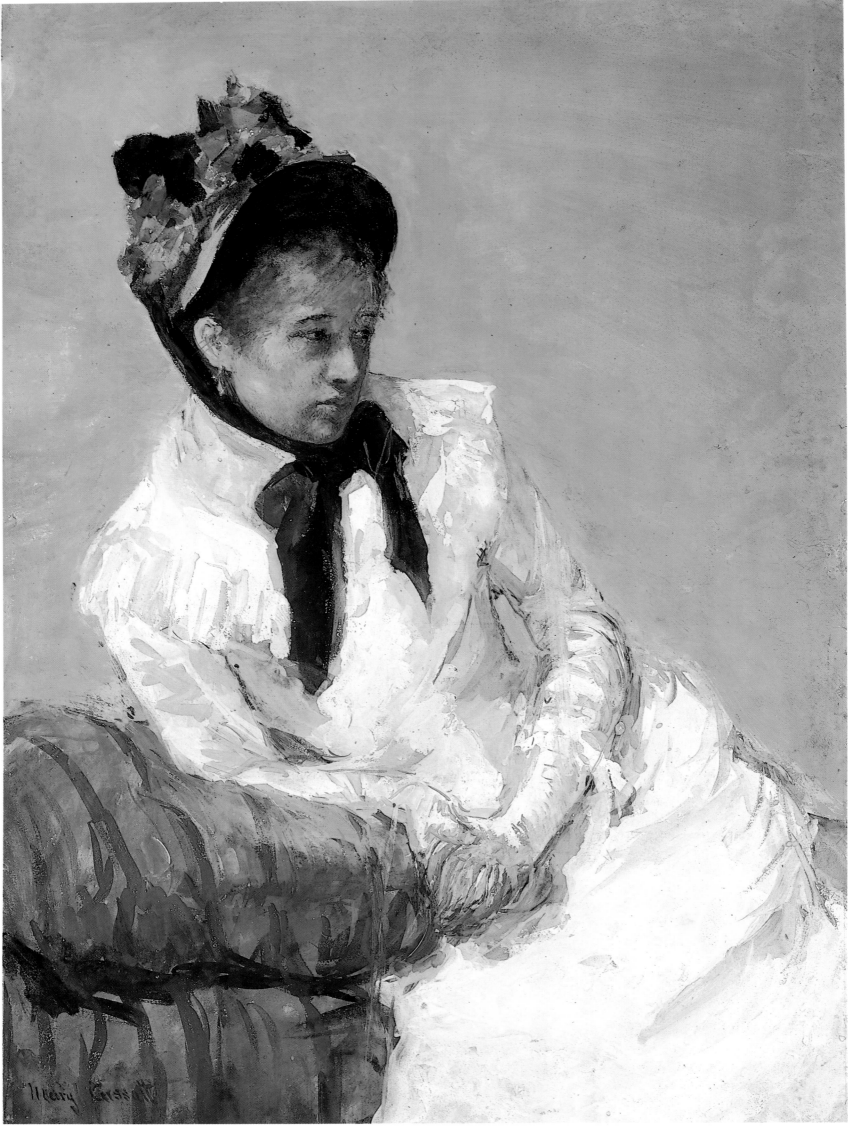

Mary Cassatt, *Self-Portrait*, gouache on paper, 1878.

Whistler was one of the earliest champions of art for art's sake; in his words, "Art should be independent of all clap-trap, should stand alone, and appeal to the artistic sense of eye or ear, without confounding this with emotions entirely foreign to it, as devotion, pity, love, patriotism, and the like." His revolutionary views about art extended to the way pictures should be framed and hung. His exhibitions and his home created a muted, serene environment for paintings which, rather than being "skied" (stacked above one another) were hung "on a line," a de-cluttering practice based on Japanese principles and still used by museums and decorators today. Whistler's invincible egotism kept him going, even when derision and bankruptcy might have discouraged him.

He was among the first painters to collect Oriental art and assimilate its design principles. His passion for Orientalia attracted the patronage of two of his most important supporters, who shared this mania – Frederick Leyland in England and Freer in the United States. Oriental objects already appeared prominently in his paintings, *The Princess from the Land of Porcelain* (1863) and *Symphony in White, No. 2: The Little White Girl* (1863-64). His *Variations in Flesh Color and Green: The Balcony* (1865), with its up-ended floor plane, linear patterning, cropped blossoms, and kimono-clad girls lounging above the Thames, Westernized Japanese woodblock prints.

After the Orientalizing series of the 1860s, Whistler turned primarily to portraits and cityscapes painted in subtle tonal harmonies, which he named "Nocturnes" or "Arrangements" to deflect prosaic concerns with subject matter. Whistler's influence spread to the American Impressionists fairly early, since he met Weir by 1877 and Robinson during his stay in Venice from 1879-80. His spare, delicately drawn etchings and pastels, which were more acceptable than his paintings, were especially popular with the Americans.

Mary Cassatt molded the course of American Impressionism chiefly through her activities as advisor to collectors such as the Havemeyers, Palmers, Harris Whittemore, and her brother Alexander. She steered them mostly to Degas, but also to Manet, Pissarro, and Monet. Selections from these private collections frequently toured in loan exhibitions, most notably at the Chicago World's Columbian Exposition, which helped spread the style. Cassatt also maintained friendly relationships with Chase, Edmund Tarbell, and Weir, whom she hoped would "create an American School."

A native of a well-to-do Pennsylvania family, Cassatt studied as a young woman at the Pennsylvania Academy of Fine Arts, and independently. In 1866, when the end of the Civil War permitted European travel, Cassatt sailed for Paris, where she enrolled in Charles Chaplin's women's art classes (unlike the Pennsylvania Academy, the École des Beaux-Arts did not matriculate women). She also had lessons with Gérôme (Eakins' teacher) and Couture (Manet's teacher). Her sound academic training paid off: in 1868 the Salon accepted her first submission. Yet she already was growing disenchanted with the official art estab-

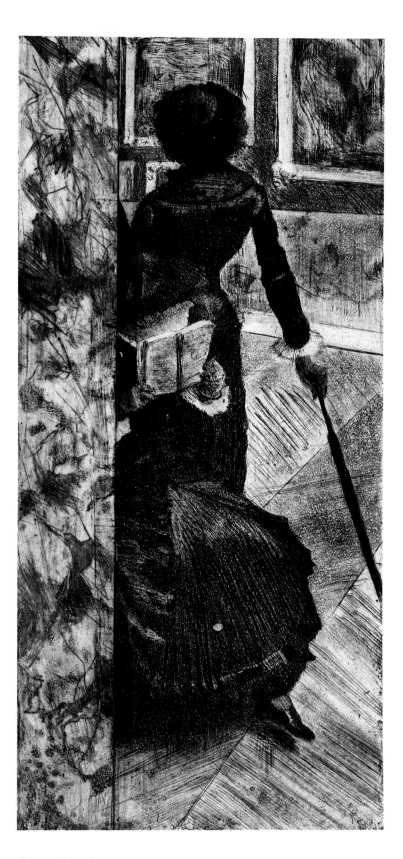

Opposite: Cassatt was the only American who actually exhibited with the original French Impressionist group.

Above: In this Japanese-inspired print, *Mary Cassatt at the Louvre*, Degas pays tribute to Cassatt and the old masters.

lishment. The entry she sent to the 1874 Salon moved Degas to pronounce, "There is someone who feels as I do." Cassatt was mesmerized by her first glimpse of Degas' work in 1875 in a shop window. "It changed my life," she recollected. Two years later the Frenchman invited her to join the Impressionist group. "I accepted with joy," she recalled. "I hated conventional art. I began to live." Adding to the happy events of that year, Cassatt's parents and sister joined her in Paris, providing her with accessible models.

She received her most important commission in 1892, when Bertha Palmer, president of the board for the Woman's Building of the World's Columbian Exposition, hired her to paint a mural depicting "Modern Women." This monumental (12′ x 58′) painting consisted of three sections: at center, "Young Women Plucking the Fruits of Knowledge," and at either side, "Young Women Pursuing Fame" and "Arts, Music, Dancing." Although this ambitious work was destroyed, along with the temporary structure housing it, many related works survive, such as *Baby Reaching for an Apple* (1893). As her eyesight failed, like Degas, she turned to pastel, a medium which ideally suited her talents as both colorist and draftsman.

Cassatt, a remarkable woman for her time and class, defied convention in her art and life. Never marrying, she devoted herself completely to her profession: "I work, and that is the whole secret of anything like content in life." Late in life, she became involved with the woman suffrage movement and lent pictures to a "Suffrage Loan Exhibition" held in New York in 1915. A woman of strong character, she declined several awards and prizes, politely but firmly explaining in 1904: "I . . . must stick to my principles, our principles [i.e., the Impressionists], which were, no jury, no medals, no awards."

John Singer Sargent was much more conventional than either Whistler or Cassatt, both in his art and demeanor. In fact, Whistler called him "a sepulchre of propriety." Sargent was born in Florence where his Philadelphian parents had temporarily settled. His mother, an amateur watercolorist, encouraged her son's artistic talent, even though he was equally accomplished as a pianist. In 1874, the family moved to Paris so that he could study with portraitist Carolus-Duran and at the École des Beaux-Arts. Carolus-Duran's non-traditional methods determined the way Sargent worked for the rest of his life. He instructed students to paint directly on canvas, without benefit of preparatory drawings, and to seek out the effects of light more than solid forms – in effect, to practice a modified version of his friend Manet's approach. Carolus-Duran also exhorted his students to "study Velázquez without respite," advice followed by nearly all the American Impressionists.

Sargent befriended many young colleagues at the time, such as Paul Helleu and Weir, who expressed astonishment at his precocious talents. Unlike his peers, Sargent never felt comfortable affecting bohemian airs. Instead of carousing with his artsily attired studio-mates, he worked diligently, respectably dressed, day and night and even Sundays. In 1876, Sargent saw a Monet exhibition at the Durand-Ruel gallery, and may even have met him. In any case, while preparing his first important painting, *The Oyster Gatherers of Cancale* (1877-78), Sargent began working in the open air for the first time. Searching for an artistic identity, Sargent also flirted with Whistler's nuanced tonal style, a reaction to meeting his older compatriot between 1877 and 1880.

Sargent made a splash in the 1883 Salon with his

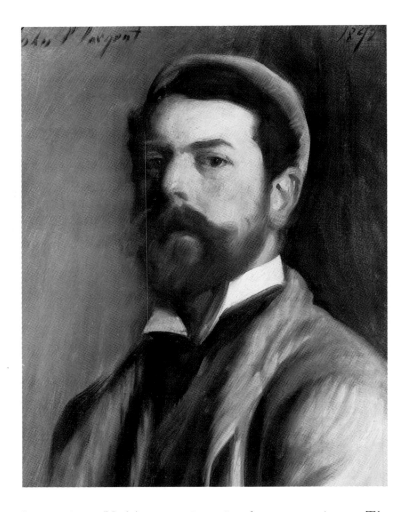

haunting, Velázquez-inspired masterpiece, *The Daughters of Edward D. Boit*, an amazingly accomplished work for a 26-year-old. Cassatt and Morisot thought well enough of him at this point to ask him to join the Impressionists. Though he declined, he did exhibit in a group show with Monet in 1884.

The next time Sargent's name was on everyone's lips, people were not so kind. His *Portrait of Madame X* (1884), a likeness of the notorious beauty Virginie Gautreau, scandalized visitors to the Salon. Attracted by Mme. Gautreau's exotic appearance, Sargent "proposed this homage to her beauty," and labored long and hard to do justice to both their reputations. Having been so recently lauded, Sargent must have been shocked by the public's vitriolic condemnation. Even a friend wrote privately, "She looks decomposed. All the women jeer . . . 'What a horror.'"

In all fairness to Sargent, the public outcry was probably directed as much at the subject – whose indiscretions had already outraged Paris – as at the artist. Figuring it was time to move on, Sargent left for London. During the summer of 1885, while recuperating from a boating accident in Broadway, an artists' colony in the West of England, Sargent started painting in a full-fledged plein-air style. His masterwork of that and the following summer is *Carnation, Lily, Lily, Rose*, a study of children and flowers in crepuscular light. This painting, which was purchased by the Tate Gallery soon after its exhibition at the Royal Academy, redeemed Sargent's reputation.

Sargent apparently passed part of the summer of 1887 perfecting the plein-air style with Monet in Giverny. He not only portrayed the Impressionist master at work (*Monet Painting at the Edge of a Wood*), he

Opposite: John Singer Sargent, *Self-Portrait*, 1892. The gentlemanly Sargent was something of a child prodigy. His reserved manner led Whistler to describe him as "a sepulchre of propriety," though he allowed that Sargent was "charming and all that." This charm and his luscious, flattering painting style eventually made him the preferred society portraitist. While Cassatt faulted him for pandering too much to this clientele, he kindly recommended her to his patrons.

Right: Diego Velázquez, *Las Meninas*, 1656. Velázquez was the old master whom the Americans most revered. Sargent's teacher Carolus-Duran exhorted his students to "study Velázquez without respite." Chase declared that he was "the master I admire above all others." Entranced by his bravura brushwork and complex compositions, both Chase and Sargent painted modern variations of *Las Meninas*.

bought at least four of his paintings. Sargent continued his plein-air work during the next two summers at the English villages of Calcot and Fladbury.

Meanwhile, his fame was growing in America. In 1887, he was invited to Newport to paint a portrait of a railroad magnate's wife, a commission which led to many others in New York and Boston. Bostonians were especially enthusiastic about Sargent; they gave him his first solo exhibition in 1880 (and many more in years to come), and commissioned him to paint murals for the Boston Public Library, a project which occupied him for the next 25 years. Sargent had an incalculable influence on the Boston Impressionists (e.g., Joseph De Camp, Tarbell, Benson), most of whom, like Sargent, were primarily figure painters. Sargent developed the habit, copied by the Bostonians, of reserving his Impressionist style mostly for landscapes, and painting in a more conservative manner for portrait commissions.

Sargent may not have been the first American to work in Giverny – the town 70 miles outside Paris where from 1883 until his death Monet made his home – but he was among the earliest. Monet never intended to take pupils, but foreign admirers, especially Americans, began flocking to Giverny in the mid-1880s. In 1887, a Boston art critic reported, "Quite an American colony

has gathered . . . at Giverny . . . A few pictures just received from these men show that they have got the blue-green color of Monet's Impressionism and 'got it bad'." Willard Metcalf, as good a candidate as any for the earliest Givernyite, arrived in 1885.

Like Whistler, born in Lowell, Massachusetts, Metcalf studied first at the Boston Museum of Fine Arts School and the Académie Julian before settling in Giverny. Returning to America in 1889, he resumed a fairly lucrative career as a book and magazine illustrator. After his sparkling view of *Gloucester Harbor* (1895) won a prize at the Society of American Artists exhibition, he finally felt emboldened to devote himself totally to Impressionist landscape painting.

Theodore Robinson was the most influential of the early residents in Giverny. A native of Vermont, he arrived in Paris in 1876, working first under Carolus-Duran and then under Gérôme. In 1879 he returned to America by way of Venice where he met Whistler, and then was back in France in 1884. Four years later he moved next door to Monet; although he shunned most foreign residents, Monet became Robinson's intimate friend. The self-effacing Robinson confided that Monet's paintings "gave me the blues – the envious blues. They are so vibrant and full of things, yet at a

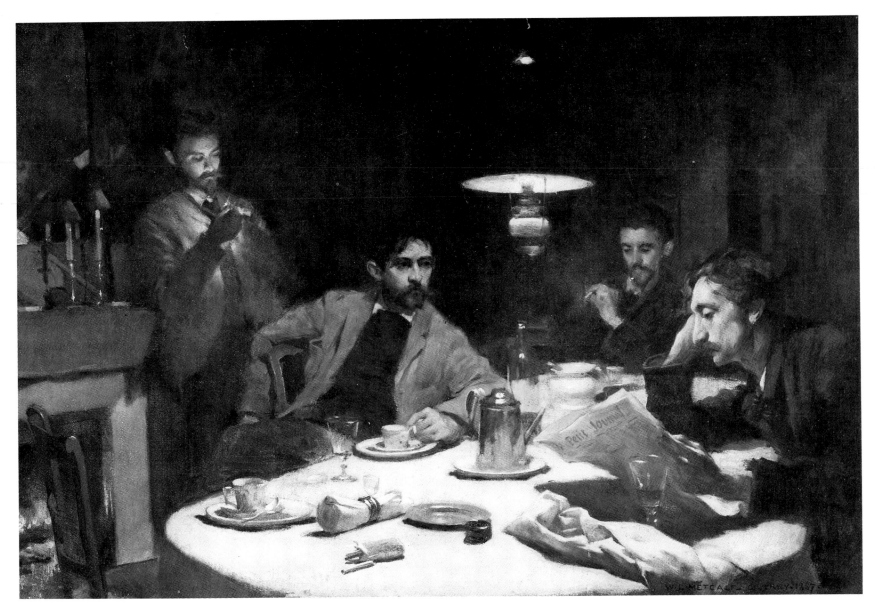

little distance broad tranquil masses are all one sees."
But for all his admiration, Robinson was no mere im-
itator. He successfully combined the realism of Homer
and Eakins with the optical experiments of Monet.

One reason Robinson's forms seem more defined
than Monet's is his habitual reliance on photographs –
a practice for which he constantly berated himself.
"Painting directly from nature is difficult as things do
not remain the same," Robinson admitted. "The
camera helps to retain the picture in your mind."
Monet would have found this idea alien, as he believed
that "nature never stops." Through teaching, exhibit-
ing, and writing, Robinson was highly instrumental in
popularizing Impressionism in America, where he re-
mained from 1892 until his death in 1896.

Theodore Butler not only succeeded in becoming an
intimate of Monet's, he became a family member by
marrying Monet's stepdaughter Suzanne in 1892.
Robinson, who commemorated this event in *The Wed-
ding March*, brought Butler to Giverny from Paris,
where he had been studying at the Julian and Colorassi
academies since 1885. Though a follower of Monet, he
painted scenes, such as *The Card Players* (1898), which
show an independence of subject matter and style. But-
ler became Giverny's only permanent American resi-
dent, marrying another Monet stepdaughter in 1899
when Suzanne died.

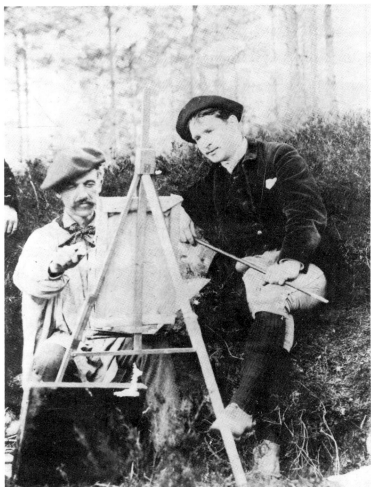

John Leslie Breck must have envied Butler's romantic successes. After studying in Munich and Paris, the Massachusetts-born artist came to Giverny in 1887, where he fell in love with yet another of Monet's stepdaughters, Blanche. But Monet disapproved of this match, and the disappointed Breck returned to America in 1890, where his art never won the appreciation it deserved. Yet during his Giverny years he produced splendid garden views which demonstrate his full assimilation of the Impressionist patriarch's art.

Lilla Cabot Perry, who had studied in Boston with American Impressionists Dennis Miller Bunker and Robert Vonnoh, headed for Paris in 1887 to enroll in Julian's and Colorassi's. First introduced to Monet at Giverny in the summer of 1889, she spent summers during the next two decades in a house next door to Monet, who grew quite fond of her. A painting by her

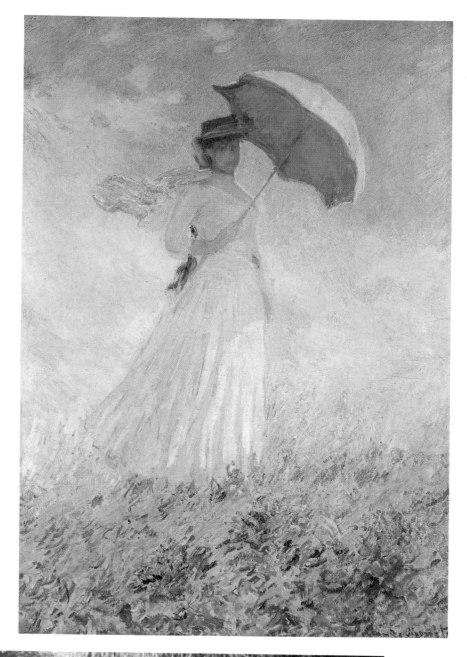

Opposite above:
Willard Metcalf, *The Ten Cent Breakfast*, 1887. Though not Impressionist in style, this painting constitutes an interesting document in American Impressionist history. Gathered round a table at Giverny are poet Robert Louis Stevenson (right), Robinson (rear), and Twachtman (left).

Opposite below:
Theodore Robinson (left), an intimate friend of Monet's, painting outdoors.

Right: Claude Monet, *Woman with Parasol*, 1886. Blinding light blurs facial and costume details in this painting, more a portrait of sunshine than a woman. Apparently weightless, she floats like a white sail above the hill. Similar effects can be seen in works by Homer and Benson.

Below: Giverny, where Monet cultivated gardens and lily ponds to paint, became a mecca for two generations of American Impressionists.

still hangs in Monet's Giverny bedroom. Like Robinson, when back in America she promoted Impressionism by soliciting patrons for Monet, lecturing on the subject, and publishing in 1927 "Reminiscences of Claude Monet from 1889 to 1908." When her husband took a post in Tokyo as an English professor, Perry was one of the very few Impressionists to see Japanese art in its native setting.

The youngest member of the Giverny group, Philip Leslie Hale traveled to Paris in 1887, joining his friend Butler in Giverny in 1888. On a return visit to Giverny the following summer he began working in an Impressionist style, which he perfected there for the next three years. Distinguishing himself as a critic as well as a painter, Hale reported on the latest French art movements for the progressive magazine *Arcadia*. In his writing, painting, and teaching, Hale was open to Post-Impressionist trends such as Pointillism or Symbolism. Stereotyped in the 1890s as "the boldest of the American Impressionists," Hale was denounced as "too extreme." At the turn of the century, feeling isolated by his progressive tendencies and newly inspired by the old masters, especially Vermeer, Hale renounced his difficult, distortive style and embraced a more conservative Impressionism.

Significant as the Giverny painters were in the evolution of American Impressionism, the artists best known to their contemporaries, and to us today, were those involved in the exhibiting group, the Ten, founded in 1897. The original members included: J. Alden Weir, Childe Hassam, Willard Metcalf, John Twachtman, Edward Simmons, Robert Reid, Edmund Tarbell, Frank Benson, Joseph De Camp, and Thomas Dewing. Chase replaced Twachtman when he died in 1902. The Ten seceded from the Society of American Artists, which they complained exhibited too many paintings that ranged too widely in quality and style. For their annual exhibitions each artist chose three or four of his best works, and hung his own installation in a separate section of the gallery. Walls were painted to harmonize with the pictures, arranged sparely "on a line" in the Oriental manner initiated by Whistler two decades earlier, but still revolutionary in New York. Their shows, which continued for 20 years, were instantly popular.

Weir, son of Whistler's West Point drawing teacher, trained at the National Academy of Design and after 1873 at Gérôme's studio and the École des Beaux-Arts, where he became an accomplished figure painter. During his student days, Weir's tolerance of avant-garde art was limited, as his disgust with the third Impressionist show (1877) attests: "I never in my life saw more horrible things . . . They do not observe drawing nor form but give you an impression of what they call nature. It was worse than the Chamber of Horrors." On his way back to New York the same year, he stopped off in London to visit Whistler, "a snob of the first water" whose paintings were mere "commencements." Despite this distaste for Whistler, his paintings left their mark on Weir's work.

During the 1880s Weir began summering in rural Connecticut, where, under the countryside's spell, he turned increasingly to landscape. His friends Robinson and Twachtman may be credited with orienting Weir toward Impressionism, to which he committed himself in the early '90s. Weir, a tireless art activist, helped found both the Society of American Artists and the Ten. Additionally, he promoted the work of his under-appreciated colleagues Twachtman and Ryder, and counseled collectors and museums to buy Impressionist pictures.

Critics often compared Weir's thickly brushed, unassuming views of southern Connecticut to his friend Twachtman's work. Trained in the 1870s to paint in the dark, dashing manner of the Munich Royal Academy, Twachtman, dissatisfied with this education, enrolled in the Académie Julian in 1883. *Arques-la-Bataille* (1885), a restrained, tranquil view of the countryside

Right: The Ten (photo), 1908. Founded in 1897, the Ten included most major American Impressionists. Not a young radicals' group, its members were award-winning artists in their 30s or 40s. A pleased critic described the inaugural exhibition: "The frames are modest. . . . The whole room is a restful place. There are no bad pictures." Benson, Tarbell, De Camp, and Dewing were primarily figure painters, while Metcalf, Twachtman, Weir, and Hassam were essentially landscapists. Simmons, and to a lesser extent Reid, who also specialized in scenes of women with flowers, worked as muralists.

Above: J. Alden Weir, a committed art activist, helped found both the Society of American Artists and the Ten, aided struggling colleagues, and advised collectors.

Above right: *Portrait of John Twachtman* by Weir. A painter's painter, Twachtman never quite found his public, but his colleagues praised him.

near Dieppe, marks his break with the Munich style. The even-textured brushstroke, thin paint application, and limited tonal range indicate his debt to Whistler, whom he had met about 1880. Despite his academic training, Twachtman was never as interested in the figure as he was in landscape. Finding it "necessary . . . to live in the country – at all seasons of the year," Twachtman bought a farm outside Greenwich, Connecticut in 1889. As a result of contact with Robinson, a frequent guest in his home, Twachtman moved from a Whistlerian to an Impressionist style. Yet his paintings, mostly intimate close-ups of the pools, meadows, and falls on his property, continued to retain some of Whistler's quiet tonal poetry.

Among the Ten, Childe Hassam's paintings come closest to French Impressionism. Although he had traveled to Europe in 1883, it was not until a trip in 1885, when he studied at Julian's, that Hassam gave up his dark, conservative manner for Impressionism. His gradual assimilation of the style is fascinating to observe. His turning point, *Grand Prix Day* (1887), a cautious Impressionist experiment, was awarded a gold medal at the Salon of 1888.

Encouraged by this and other successes, Hassam returned to America the next year and moved his studio from Boston to New York, the more important art center. In New York, Hassam soon became known, not so much for his Impressionism, as for his seasonal scenes of New York's neighborhoods. Beginning in

Hassam, *The Etcher: Self-Portrait.* An accomplished printmaker, Hassam was the American whose work came closest to Monet's though he never went to Giverny.

1890, and for 20 years to come, Hassam summered in Appledore, an island off the New Hampshire coast, where he produced his most resplendent paintings. The celebrated garden cultivated there by poet Celia Thaxter inspired a host of glorious floral landscapes (e.g., *Celia Thaxter in her Garden*, 1892).

The triumphs of Hassam's later period are his series of flag paintings, commemorating festive events connected with World War I. Through these pictures, one can trace the history of U.S. involvement in the war, from Allied support to entry to victory. This series – which has antecedents in works by Monet, Manet, and Pissarro – is at once decorative, reportorial and political.

William Merritt Chase's pictures match Hassam's for sheer *joie de vivre* and love of paint. Like Sargent, Chase was a born painter, a worldly individual endowed with precocious and prodigious gifts. He absorbed and synthesized, seemingly effortlessly, all the artistic trends of his day. Born in Indiana, he got his first break when a consortium of St. Louis businessmen raised money to send him abroad, in exchange for paintings. He studied in Munich, where he was the star pupil. A crossroads in Chase's career came in 1881 when the Belgian society painter and friend of the Impressionists Alfred Stevens cautioned him: "Don't try to make your pictures look as if they had been done by the old masters." During this period Chase became an ardent admirer of Manet, and over the years he accumulated not only his and other Impressionists' pic-

tures, but many curios from his travels.

After his return from a trip to Holland in 1885, Chase began to work seriously *en plein air*. In 1886, his marriage and move to the fashionable Park Slope section of Brooklyn brought to his doorstep ideal subjects – the city parks and his own back yard. A devoted teacher, adored by his Art Students League pupils since 1878, he found the perfect outlet for his pedagogical energies and plein-air enthusiasm when he opened the seaside Shinnecock summer art school in Long Island in 1892, which lasted until 1902. Here Chase painted his most memorable pictures, both fresh, spontaneous outdoor views of the scruffy landscape and refined, sophisticated interiors of his handsome country home and family. Chase was prolific, and his idea of a successful picture was one that "looked as if it had been blown on the canvas with one puff."

Thomas Dewing, the oldest of the Ten, produced moody, atmospheric studies of beautiful, fine-boned women in spare but exquisite interiors or lush but vague landscapes. His preference for a mellow, nearly-monochromatic palette links him to Whistlerian tonalism, while his iridescent, painterly touches connect him to Impressionism. Dewing, like Hale and fellow Ten members Tarbell and Benson, was enchanted by the Dutch master Vermeer. Even more than the others, he aimed for Vermeer's technical perfection and quiet, enigmatic mood. He was at his most Impressionistic in the vivid backgrounds of his ravishing multi-paneled

Left: William Merritt Chase with students at Shinnecock Hills (photo), c.1901. A natural pedagogue and consummate showman, Chase was adored by his many students at, among other institutions, the Art Students League, Pennsylvania Academy, and the outdoor Shinnecock Summer Art School, where he spread the practice of plein-air painting. Though he taught them to paint in his own style, several students – including Georgia O'Keeffe, Charles Sheeler, and Joseph Stella – later became important modernists.

Opposite: The Benson family on the lawn at Wooster Farm (photo), 1907. Benson and his large public found agreeable subjects in the artist's attractive family and their island summer home in Maine. Pictured left to right are George, Ellen, wife Sylvia, Eleanor, and Frank. Benson often worked from family photographs.

screens, such as *Morning Glories*.

The public often confused Edmund Tarbell and Frank Benson, two of the most popular painters of the Ten; and indeed, their careers closely paralleled one another. Born in 1862, they studied at the Boston Museum School together and arrived at the Académie Julian within a year of each other. The two friends exhibited jointly, were appointed instructors at the Boston Museum of Fine Arts School at the same time (1889), and even married in the same year. But while Tarbell was painting *en plein air* in the early 1890s, Benson was working on pictures of women in interiors. By the time Benson switched to plein-airism in 1898, Tarbell turned to stylish indoor themes similar to those Benson had abandoned.

These latter pictures are Tarbell's best known works. Paintings such as *The Breakfast Room* (1886) combine Degas' psychological tension with Vermeer's graceful intimacy. The inventory of objects in Tarbell's interiors – antique furniture, old master reproductions, delectable still lifes, and Oriental paraphernalia – became standard among Tarbell's many Boston followers.

Benson's conversion to Impressionism resulted from Tarbell's influence, his awareness of Monet through several Boston exhibitions, and the positive critical response to his first essay in the plein-air mode. His purchase in 1902 of a farm with breathtaking panoramas on North Haven Island, Maine, ensured his commitment to the style. From this point on, much like Chase at

Shinnecock, he devoted himself to incandescent scenes of his lovely children and wife enjoying the sun-soaked, breeze-cooled landscape around their summer home. An adoring critic wrote, "It is a holiday world, in which nothing ugly or harsh enters, but all the elements combine to produce an impression of the natural joy of living."

Outside the immediate circle of the Ten, and for many years after its formation, Impressionism continued to be a vital force in American painting. Just as Boston had a distinct school of Impressionists, shaped by Sargent, Tarbell, and Benson, other parts of the country developed regional variants. Critics loved especially to contrast the "feminine," "aristocratic" Boston group with the "masculine," "democratic" Pennsylvania school led by Edward Redfield and Elmer Schofield. Centering their activities in New Hope, these men painted in a slashing, vigorous style, often completing a scene "in one go." They favored frosty winter scenes painted on huge canvases, preferences which contributed to the myths of their virility.

Both Redfield and Schofield studied at the Pennsylvania Academy, where the tradition of earthy realism instigated by Eakins persisted. William Glackens, another product of this schooling, also reacted against the more precious, decorative strains of Impressionism. An artist-reporter for Philadelphia newspapers, Glackens pursued painting seriously only after he returned from an 1895 trip to Europe. His pastels and paintings

Above: Thomas Eakins, *Max Schmitt in a Single Scull* shows an earthy realism which was carried on by Redfield, Schofield, and Glackens.

Opposite: Cecilia Beaux, *Self-Portrait*, 1894. Like Cassatt, Beaux chose to remain single and dedicate her life to art.

Above: Maurice Prendergast, whose boldly original style, influenced by Post-Impressionism, was more concerned with ornamental simplification than descriptive naturalism.

of the following decade show an indebtedness to Manet's and Degas' sexually charged and intricately composed views of the demimonde. While helping Philadelphia tycoon Albert Barnes form his impressive art collection, Glackens became a devotee of Renoir. Glackens is often remembered for his affiliation with the Eight (or "Ashcan School"), a group of urban realists formed in 1908; but he was never as committed as they to depicting the bleaker side of life.

Even more than Glackens, Maurice Prendergast, another member of the Eight, steered a solitary course; never teaching nor marrying, he created a boldly original, idiosyncratic style. During an extended trip to Europe in 1891, when he enrolled in the academies Colorassi and Julian, Prendergast took advantage of opportunities to see exhibitions by avant-garde artists, including the Post-Impressionists. He traveled to such French resorts as Dieppe where he painted colorful, simplified scenes of gaily dressed vacationers.

On a trip to Europe from 1898-99, Prendergast passed time in Venice where the jewel-toned pageantry of the Renaissance painter Carpaccio caught his eye.

When he returned, Prendergast began devoting himself to watercolors of beach and park scenes animated by festive crowds, often seen against shimmering architectural backgrounds. The notational, translucent medium of watercolor proved to be ideally suited to his subjects and style.

Some of the best works made by later and regional Impressionists were painted by women. Outstanding in this group is the Philadelphia portraitist Cecilia Beaux. As with many artists from this city, in her early years, Eakins cast a long shadow upon her work. Having already established a local reputation, in 1888 Beaux went to Paris, where she updated her style on the advice of an Académie Julian instructor, who urged her to paint with "greater vivacity . . . and brilliancy." In 1895 she began to teach at the Pennsylvania Academy, where she was the first woman appointed full faculty member. During an 1896 trip to France, Lilla Cabot Perry took her to Giverny to meet Monet, an incident which she always recalled with pride. Beaux's most memorable portraits are the superb series of "white-on-white" pictures (*Sita and Sarita*, 1893-94, *Ernesta with Nurse*, 1894, *New England Woman*, 1895), probably painted in response to seeing Whistler's work. Her silky brushwork, inventive compositions, and genteel subjects won her many awards and commissions – including an invitation by the United States government to paint European World War I heroes.

Other notable women Impressionists include Lilian Wescott Hale and Helen Turner. Known for exquisitely crafted charcoal drawings as well as paintings of figures in sun-washed interiors, Hale studied with Tarbell, Chase, and Philip Leslie Hale, whom she married though 17 years his junior. Having started her career much later, at 37 the resourceful and independent Turner moved from Louisiana to New York where she studied at the Arts Students League and Columbia University. A perpetual student, she attended Chase's European summer courses while in her fifties. But Turner was no amateur; she was entirely self-supporting and well-respected by her colleagues. In 1910 she built a house at the artist's colony of Cragsmoor, in the Hudson River Valley, where she produced her trademark works – charming views of young girls in simple but gracious interiors and gardens.

Turner's work was sometimes compared to the paintings of Frederick Frieseke, a great compliment since he was arguably the last of the American Impressionist masters, and his reputation was international. In 1898 Frieseke went to study at the Académie Julian, and remained in France for the rest of his life. He turned Impressionist after 1901, and in 1906 bought the Giverny house formerly occupied by Robinson. Yet he was influenced less by Monet than by Renoir, who, like him, was more interested in the figure, especially the female nude, than in landscape. When he was not painting nudes or prettily dressed women outdoors amid flowers, he depicted private, feminine moments indoors. The settings were usually his own garden or his brightly painted house.

At the height of his fame in 1915, Frieseke was promi-

nently featured at the San Francisco Panama-Pacific International Exposition. This world's fair, where American Impressionists were not only given entire rooms to themselves, but also awarded major prizes, marked their institutionalization. In one of the many panegyrics written about the American Impressionists on this occasion, critic Christopher Brinton astutely summed up their achievement: "The American painter accepted the spirit, not the letter of the new doctrine. He adapted [Impressionism] to local tastes and conditions." And art historian J. Nilsen Laurvik, taking a broad cultural view, added that the paintings shown in "the Panama-Pacific International Exposition may well be regarded as expressing the culmination of that wide cosmopolitanism which has marked America's entrance into the ranks of world powers."

This exposition signaled not just the belated triumph of American Impressionism, but also its swan song. Already, a younger generation of artists, excited by brand-new European art movements, were poised to rebel against the style. They, along with a shocked public, had been treated to a glimpse of the future two years before at the momentous 1913 Armory Show in New York. Included among the familiar works of Hassam, Glackens, and Prendergast were Braque's and Picasso's Cubism, Matisse's Fauvism, and Kandinsky's near-abstractions. So great were the changes wrought by this artistic revolution, over two generations would pass before historians could confidently restore the American Impressionists' reputation.

CECILIA BEAUX

1855-1942

Sita and Sarita, c. 1921
(Replica of painting of 1893-94)
Oil on canvas, 37⅜ × 25⅛ in.
Collection of The Corcoran Gallery of Art, Washington, D.C.
Museum Purchase, William A. Clark Fund

Cecilia Beaux may have painted this picture as a response to Whistler's *White Girl* (p. 178) which was exhibited at the Metropolitan Museum of Art in 1894-95. Like Whistler, Beaux was skillful in depicting white against white. The sleek, fluid surfaces of Beaux's paintings belie the labor that she spent on them; she would start work on the actual painting only after preparing numerous pencil studies. Beaux felt that "painting was a great deal of trouble," and was impatient with artists who were unwilling to work hard.

In *Sita and Sarita*, the sitter is Sarah A. Leavitt, later Mrs. Walter Turke. Befitting a portrait, her face is more highly finished than the sketchy sofa, the floral design of which was created by little jabs with the tip of a brush. The deftly painted cat, Sarita, is not a cute accessory, but appears menacingly protective; it glowers at the viewer with yellow-green eyes, while its mistress looks away. Beaux must have enjoyed the challenge of contrasting the cat's dark, glossy fur with Sarah's pale, luminous flesh and dress.

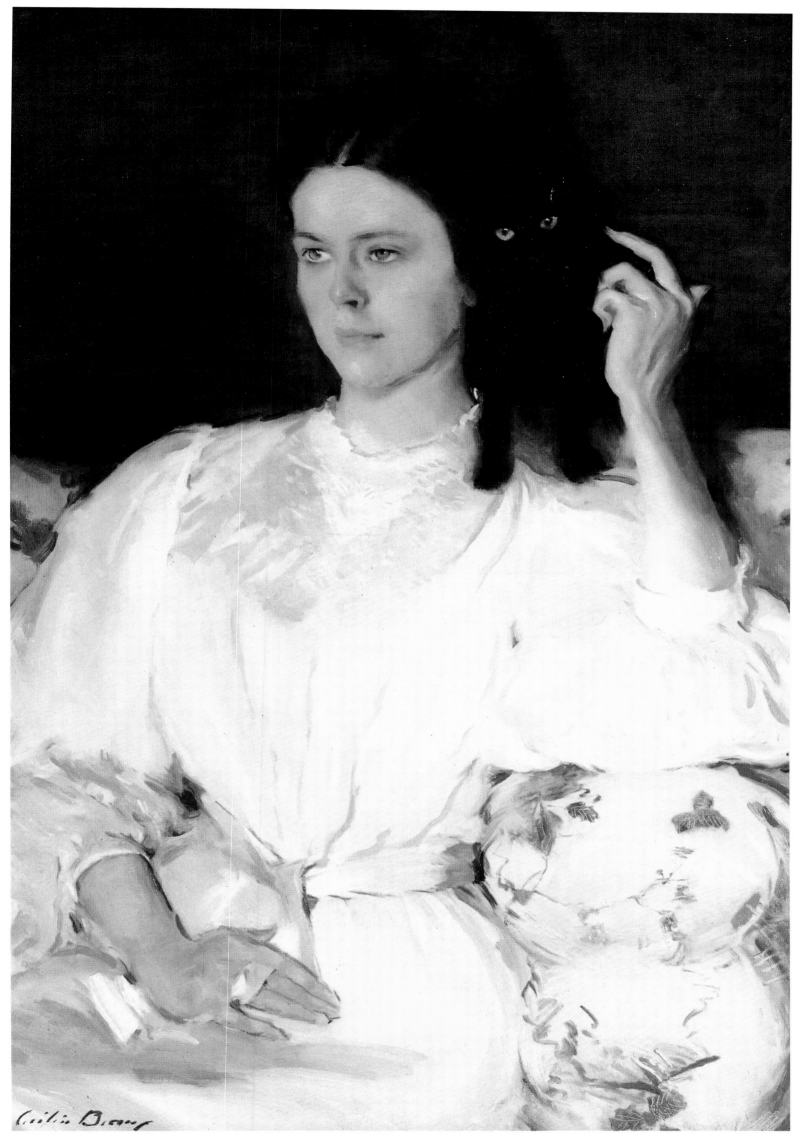

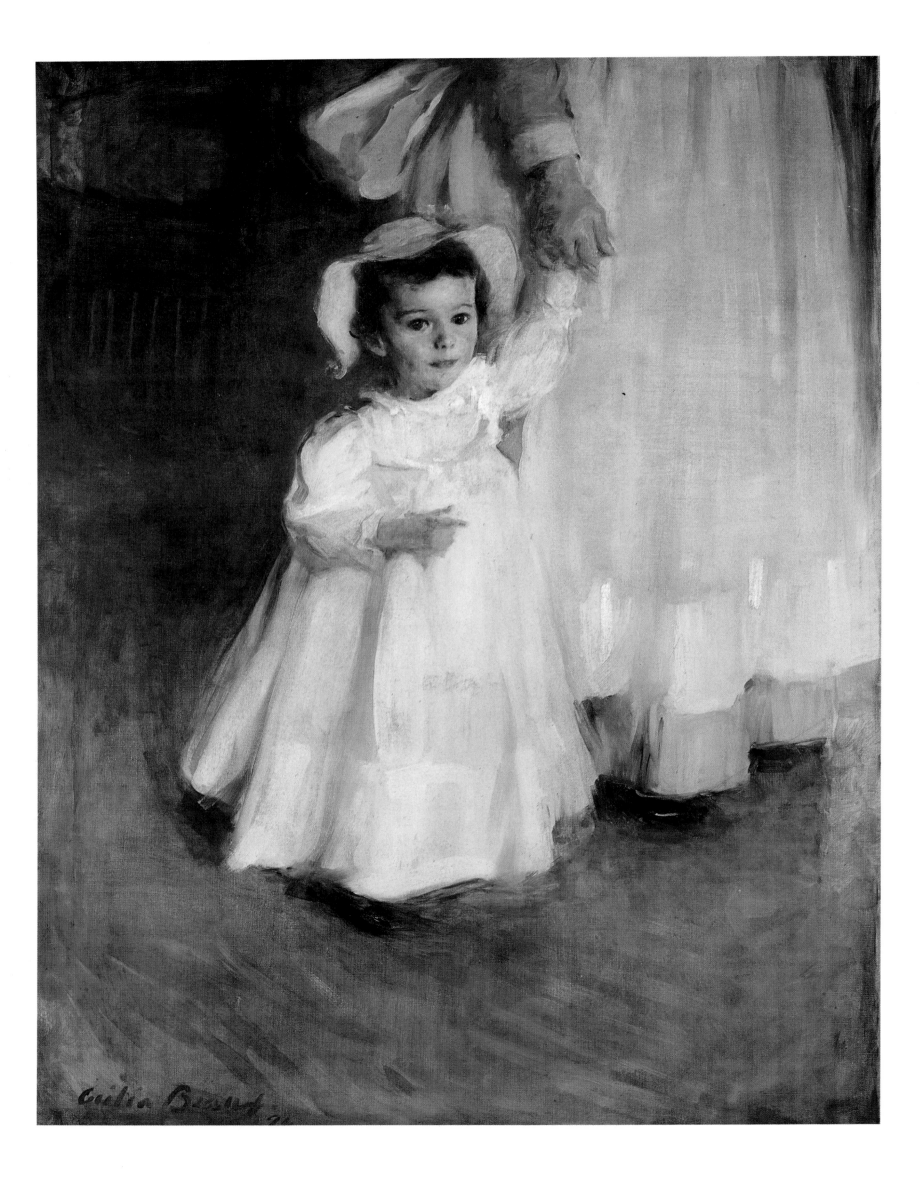

Ernesta (Child with Nurse), 1894

Oil on canvas, 50½ × 38⅛ in.
© 1983 The Metropolitan Museum of Art, New York
Maria DeWitt Jesup Fund, 1965. (65.49)

This next painting in Beaux's "white on white" series is a compositional tour de force. Beaux intended the point of view of the scene to be that of another child; we see no more of the nurse, Mattie, than would another toddler. The cut-off, asymmetrical composition gives a distinct sense of rightward movement, making the work a kind of portrait-in-motion. The uptilted, reflective floor, with its diagonal brushstrokes, accelerates this effect. The child, Beaux's niece and one of her favorite models, seems protected by the nurse's crisply starched skirts, as well as by her gently guiding hand. There is no question which of the two was more important to Beaux; not only is Ernesta the only complete figure, she is placed at the center of the canvas. In *Ernesta with Nurse*, Beaux created a whole little universe out of minimal means.

New England Woman (Mrs. Jededia H. Richards), 1895

Oil on canvas, 43 × 24 in.
*The Pennsylvania Academy of the Fine Arts, Philadelphia
Joseph E. Temple Fund. (1896.1)*

Mrs. Jedediah H. Richards, Beaux's maternal grandfather's cousin, lived in Washington, Connecticut, where Beaux painted this portrait. Beaux was proud of the old New England stock on her mother's side; her father was French. She never knew either parent since her mother died shortly after Cecilia's birth, and her grieving father fled to France. She was reared by her grandmother and two aunts, beside whom, a relative remembered, all "other women seemed like stuffed dolls."

In this portrait, Beaux's overriding concern with color and light shows her at her most Impressionistic. The woman's white dress and bedclothes are flecked with pinks, yellows, greens, and lilacs, colors reflected from the fan and bright daylight. Beaux's repetition of violets and yellows shows her familiarity with theories of complementary colors. In addition, we sense this is morning because of the intensity of morning sunshine filtering through the gauzy curtains, the newspaper on her lap, and the snuffer on the candle beside her. Her light clothing and palmetto fan indicate that the season is summer.

FRANK BENSON

1862-1951

The Hilltop, 1903
Oil on canvas, 71×51 in.
Malden Public Library, Malden, MA

The hilltop, one of Frank Benson's favorite motifs, was also treated by Monet (*Woman with Parasol, Turned Right*, p. 19). It provided both painters with an opportunity to silhouette a sunstruck figure against the open sky, and suggest cooling upland breezes. This painting harks back to Winslow Homer's *Long Branch, New Jersey* (pp. 108-109), which also features somewhat wistful figures meditating the seashore from sun-dappled, wind-blown heights.

The landscape in Benson's picture is not a public area, but the terrain around his summer home, Wooster Farm, in North Haven Island, Maine. The farm was on a 100-yard spit of land with views back to the mainland and out to other islands. Benson had purchased this idyllic retreat the year before he painted *The Hilltop*; for many years he recorded the beauties of this spot. The two children pictured are his oldest girl Eleanor and his only son George, accompanied by the family pet. The scene appears spontaneous but, in fact, is carefully composed. For example, Eleanor's white handkerchief, held aloft, parallels her blue sash trailing in the wind, while the shape of her fluttering hem at right repeats the formation of the curling, diagonal cloud above. George's gesture reappears in many of Benson's works; so convincing is the artist's illusion of dazzling light, the viewer almost feels that he too needs to shade his eyes.

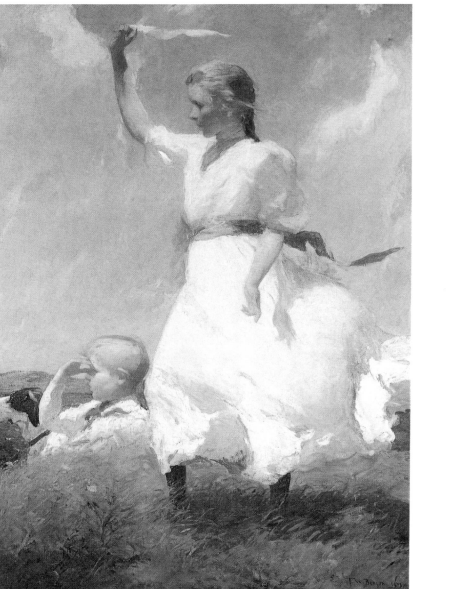

Calm Morning, 1904
Oil on canvas, 44×36 in.
Courtesy, Museum of Fine Arts, Boston
Gift of Charles A. Coolidge Family. (1985.925)

This painting shows Eleanor, George, and Benson's second daughter Elisabeth, fishing off the shore of their island home. Faintly visible on the horizon is the larger island of Vinalhaven. When exhibited in 1905, a reviewer praised the painting for being "well composed, full of light with excellent atmosphere and distances." Benson stressed the importance of composition. He

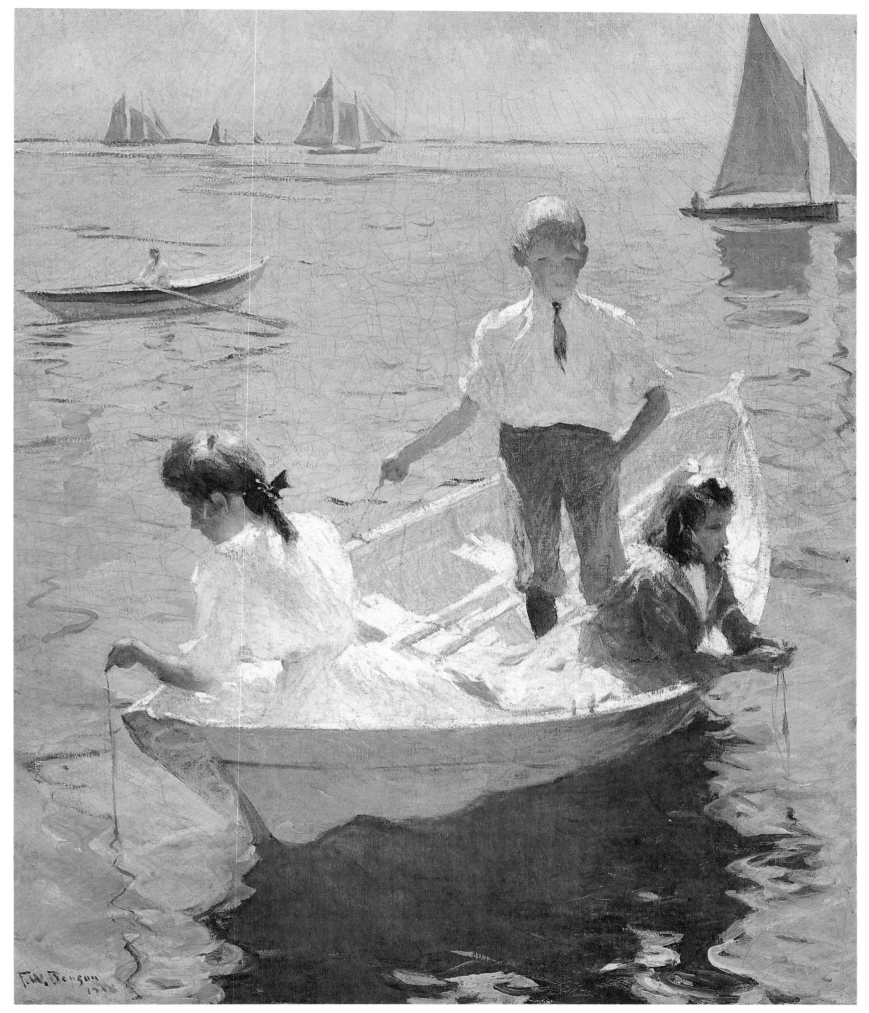

commented, "Few appreciate that what makes them admire a picture is the design made by the painter. If the design is pleasing the picture is good," no matter what the subject.

Characteristic of Benson, the composition and space of *Calm Morning* are rigorously plotted. Despite the flattening high horizon, Benson expands the sense of space beyond the picture's edges by orienting each child's face in a different direction. Other devices subtly create an illusion of depth; gradually diminishing in scale, the boats trace a zig-zag as they recede into space, and the colors of the boats progressively become cooler (less yellow and more blue), suggesting the effect of haze on distant objects.

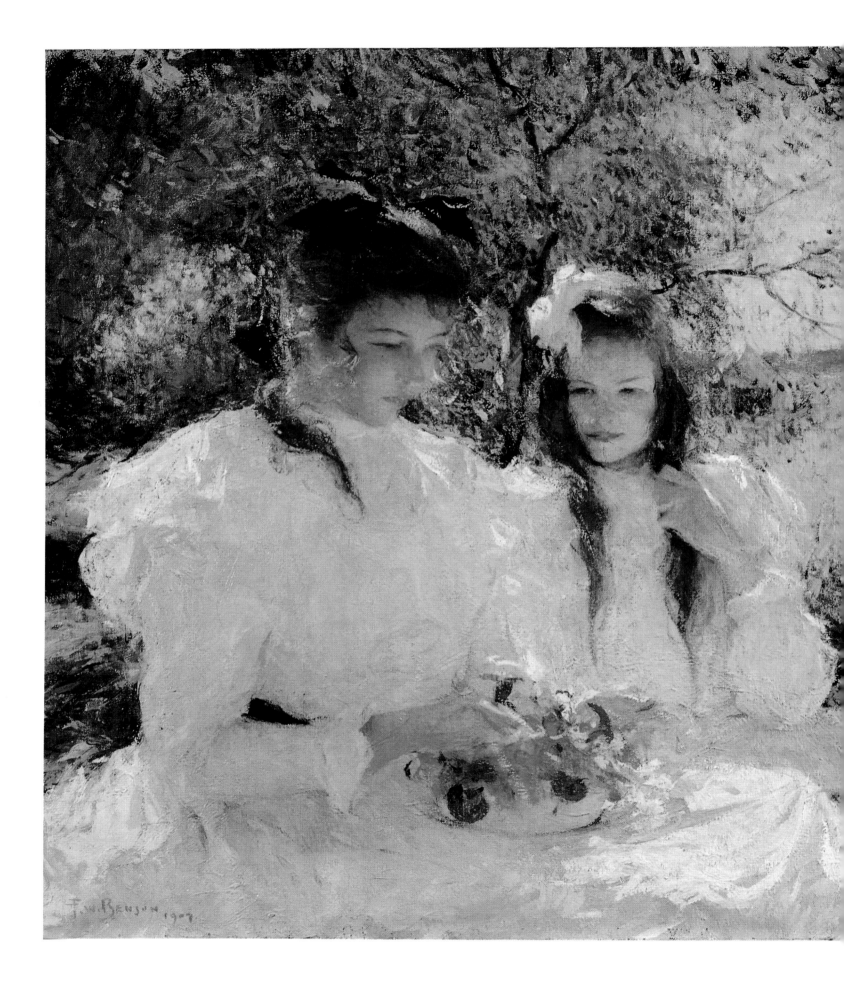

Portrait of My Daughters, 1907
Oil on canvas, 26 × 36⅛ in.
Worcester Art Museum. (1908.4)

In this warm scene, we see Elisabeth at left, Benson's youngest child Sylvia at center, and Eleanor at right. Critics applauded Benson's affectionate paternal tributes. William Howe Downes wrote, "He sets before us visions of the free life of the open air, with figures of gracious women and lovely children, in a landscape drenched in sweet sunlight, and cooled by refreshing sea breezes." In Benson's world, children are never troubled, the weather is always clear, and the sea is always calm. As he was the best-selling painter of the Boston Impressionists, Benson's income at times supposedly reached six figures. This composition is typical of Benson in that the figures are pushed to the foreground, and background elements echo the girls' poses. The vertical tree trunk behind Sylvia reasserts her erect posture, while the diagonal branches at right correspond to Eleanor's bowed head. Moreover, the back rail of the white bench parallels the horizon line, further tightening the pictorial structure.

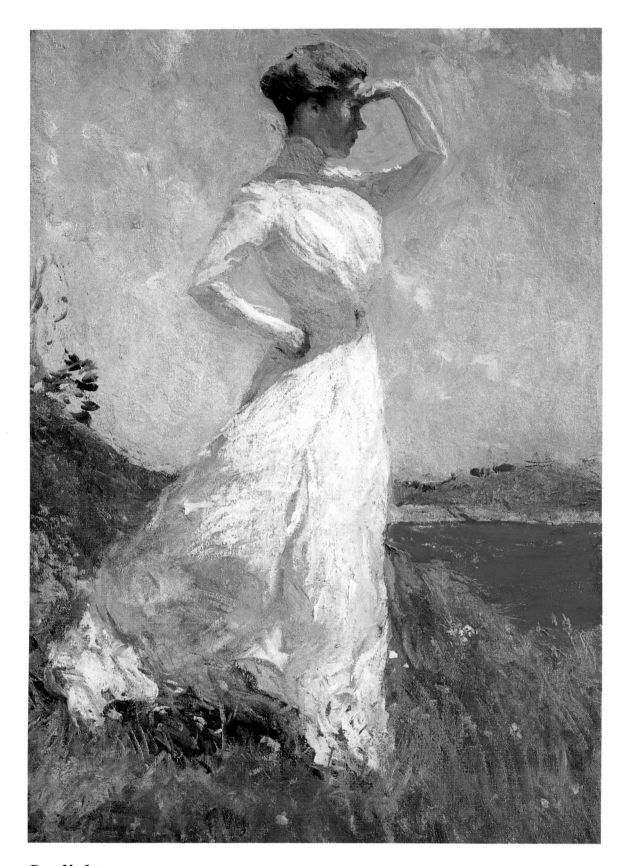

Sunlight, 1909
Oil on canvas, 32½ × 20 in.
© *Indianapolis Museum of Art*
John Herron Fund. (11.1)

In this picture we again see Eleanor, a hilltop, and the eye-shading pose. Though Benson claimed, "I simply follow the light, where it comes from, where it goes to," his working procedure was actually much more complex. Though the paintings look as if they were completed "in one go," they in fact were created in several sessions. Often Benson would work up a painting in his studio, based on watercolor studies made on the spot. In *Sunlight,* and many other paintings, he relied on photographs, which is surprising, considering the sense of spontaneity that he preserved. It is fascinating to compare *Sunlight* with the photograph on which it was based. Not only did Benson lower the horizon to make the figure tower more imposingly over the landscape, he slenderized and elongated Eleanor's body, and added more of an easy grace to her posture. Benson also developed a number of "stock" figures which he reused. This figure of Eleanor, for example, reappears in *Summer* (1909), surrounded by three other girls. Eleanor, who appears to have been his favorite child, is presented here as a golden "queen of all she surveys."

JOHN LESLIE BRECK

1860-1899

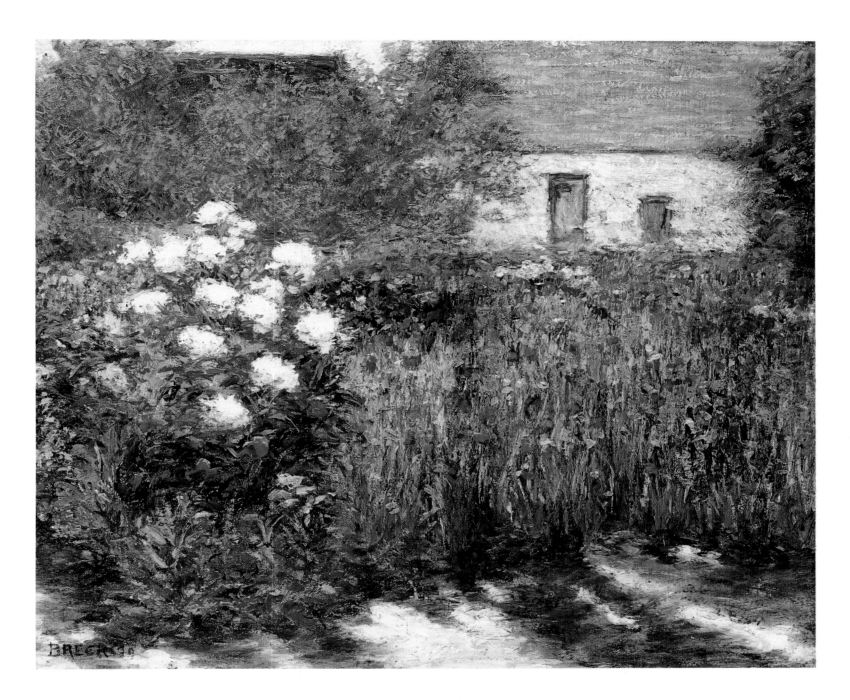

Garden at Giverny, c. 1890
Oil on canvas, 18¼ × 22 in.
Terra Museum of American Art, Chicago
Daniel J. Terra Collection. (25.1987)

Breck studied first at Munich, and later at the Académie Julian before going to Giverny. Some of the paintings he sent home to Boston, which Lilla Cabot Perry exhibited in her studio, were among the first American Impressionist works seen in Boston. These paintings piqued the curiousity of advanced painters, such as Dennis Miller Bunker, who was soon working in the style himself.

Breck's unfulfilled romance with Monet's step-daughter at least gave Breck close access to Monet's painting, which greatly affected his own technique. The garden, with or without figures, was a popular subject for both the American Impressionists and Monet. The garden scene afforded the painter the opportunity to explore the effects of direct sunlight on a riot of bright, complementary colors.

Garden at Giverny divides itself into three distinct zones: the barren-looking foreground where Breck set up his easel; the middle ground, composed of the impenetrably dense floral plantings; and the background, marked by the humble dwelling and the adjacent clumps of trees. In concentrating the viewer's attention earthward, Breck virtually eliminated the sky.

DENNIS MILLER BUNKER

1861-1890

Chrysanthemums, 1888
Oil on canvas, 35⅝×47⅔ in.
The Isabella Stewart Gardner Museum, Boston

Bunker studied during the 1870s with William Merritt Chase and from 1882 to 1885 in Paris. Originally from New York, Bunker settled in Boston in 1885 to teach at the Cowles Art School. His early works – handsome, academic portraits – excited the interest of the imperious, controversial Boston art patron, Isabella Stewart Gardner. However, his art underwent a radical change after 1887 when he met John Singer Sargent, who was then in Boston working on Gardner's portrait. Bunker spent the following summer painting *en plein air* with Sargent in Calcot, where he grew fond of the latter's sister, Violet. Nothing came of this attachment, and in 1890 Bunker married a wealthy Boston girl. But within months the young artist died of influenza. *Chrysanthemums*, a view of Gardner's greenhouse, shows how much Bunker absorbed Sargent's Impressionist style. His long, spiky strokes, which Tarbell called "fishhooks," are very close to those used by Sargent in *Paul Helleu Sketching with his Wife* (p. 143).

Bunker was well-liked by his fellow artists and his wealthy patrons. Yet he seems to have been an unhappy man, depressed by the discrepancy between the glitzy lives of the circle around Gardner and his own rather humble teaching position. This floral landscape nearly induces a sense of claustrophobia, as the garden path does not lead out of the picture, but toward further embankments of flowers.

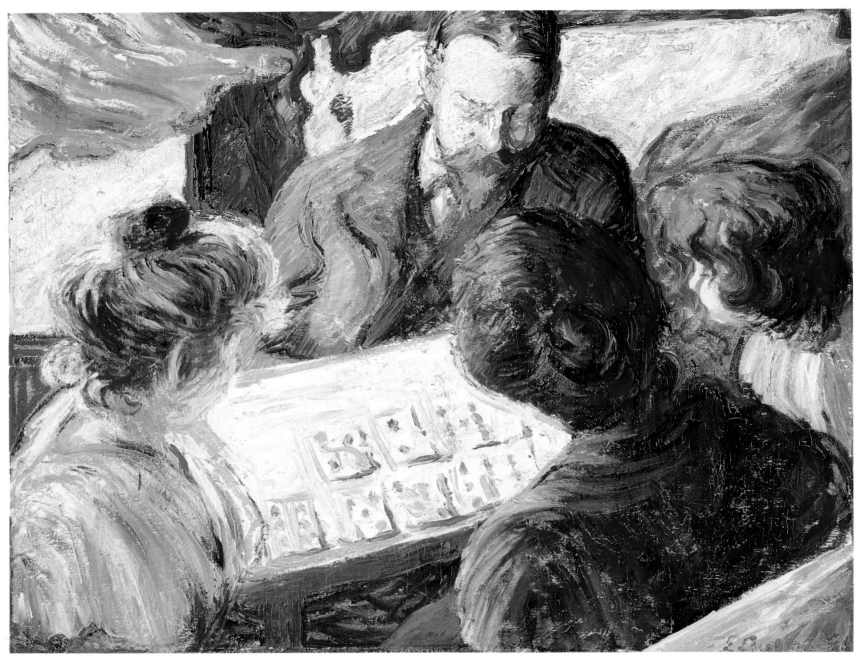

THEODORE BUTLER

1860-1936

The Card Players, 1898
Oil on canvas, 25½ × 32 in.
Terra Museum of American Art, Chicago
Daniel J. Terra Collection. (25.1985)

Butler's hot acid pinks, greens, and yellows – and his wiry, nervous brushstrokes, often forming multiple contours – make this unusual painting seem as close to Expressionism as Impressionism. Such features build up a mood of agitation, in which even the violently blowing yellow curtain at left appears to participate. The space is so compressed, it is hard to sort out who is sitting where, and the playing cards seem in danger of sliding off the acutely tilted tabletop. The picture's underlying anxiety, at odds with the ostensibly relaxed subject matter, may be related to Butler's wife Suzanne's mortal illness. In 1899, Suzanne's sister Marthe, who had been caring for the Butler children (and who might be one of the women in the painting) became Butler's second wife.

MARY CASSATT

1844-1926

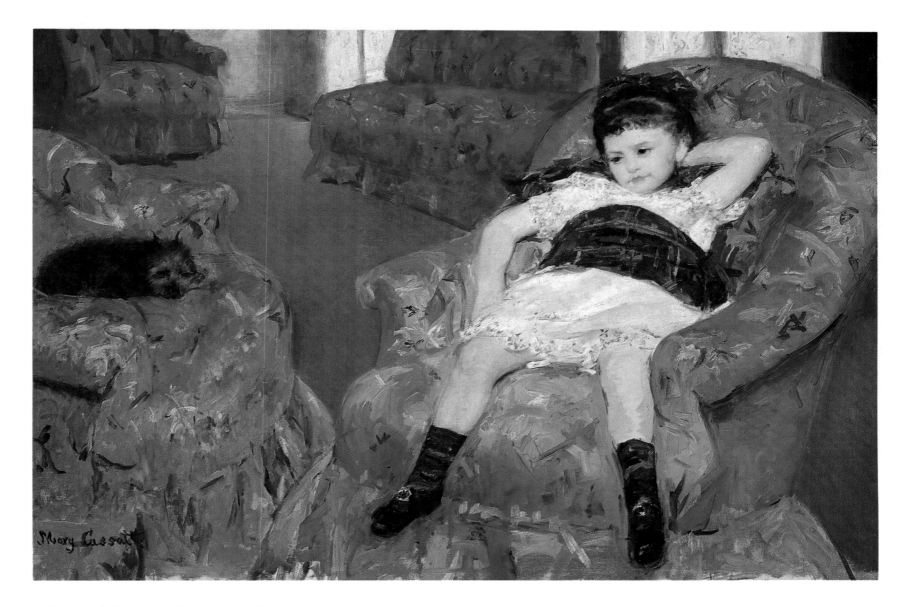

Little Girl in a Blue Armchair, 1878
Oil on canvas, 35¼ × 51⅛ in.
National Gallery of Art, Washington, D.C.
Collection of Mr. and Mrs. Paul Mellon

The rejection of this painting from the Paris 1878 Universal Exposition so infuriated Mary Cassatt that she renounced juried exhibitions forever. Cassatt felt particularly offended by the jury's decision, because Degas had praised the picture and even worked a little on the background. Still irritated 25 years later, she reminisced: "It was the portrait of a child of a friend of M. Degas . . . at that time it seemed new, and the jury consisted of three people, of which one was a pharmacist."

Cassatt's treatment of the sitter and the composition are so original it is hardly surprising that the painting baffled the pharmacist. The child is not a proper little girl; she seems more a squirmy creature, plopped into a world that is too civilized and too large for her. Her unladylike, sprawling pose suggests that the adult who is supposed to watch her is temporarily absent. The napping dog, one of Cassatt's Belgian griffons, shows more decorum in its pose than the girl. The contrast between puerile and adult worlds is underscored by the clash of plaid and floral patterns. The picture is cropped at all four sides, so that neither the suite of chairs nor the French windows are visible in their entirety. Cassatt arranged the furniture such that the negative shapes of the voids are as important as the positive masses.

In the Loge, c. 1879
Pastel and metallic paint on canvas, 26¾ × 32½ in.
Philadelphia Museum of Art
Gift of Margaret Sargent McKean

One of a group of Cassatt's works owned by Degas and retained until his death, this pastel was executed on primed canvas rather than the customary paper – a technique also practiced by Degas. The metallic paint once applied to the fan, which would have made the object resemble some examples in Cassatt's collection, has worn off.

An habitué of the opera, Cassatt was aware that in late nineteenth-century Paris, the elegantly dressed audience was usually a greater spectacle than the show. The young woman seems to be studying fellow spectators rather than the stage, but the exact direction of her glance is intentionally ambiguous. While her face is given the highest finish, her partial profile and obscuring fan further augment the psychological elusiveness.

Cassatt's handling of the pastel and her color choices are bold. The basic color scheme – chartreuse to hunter greens, contrasting with vermillions to crimsons – shows her investigation of the vibratory properties of complementary colors. The composition is built from a series of curves and counter-curves: the arcs made by the fan and the tiers are played against the hollow of the woman's abdomen and the crook of her back.

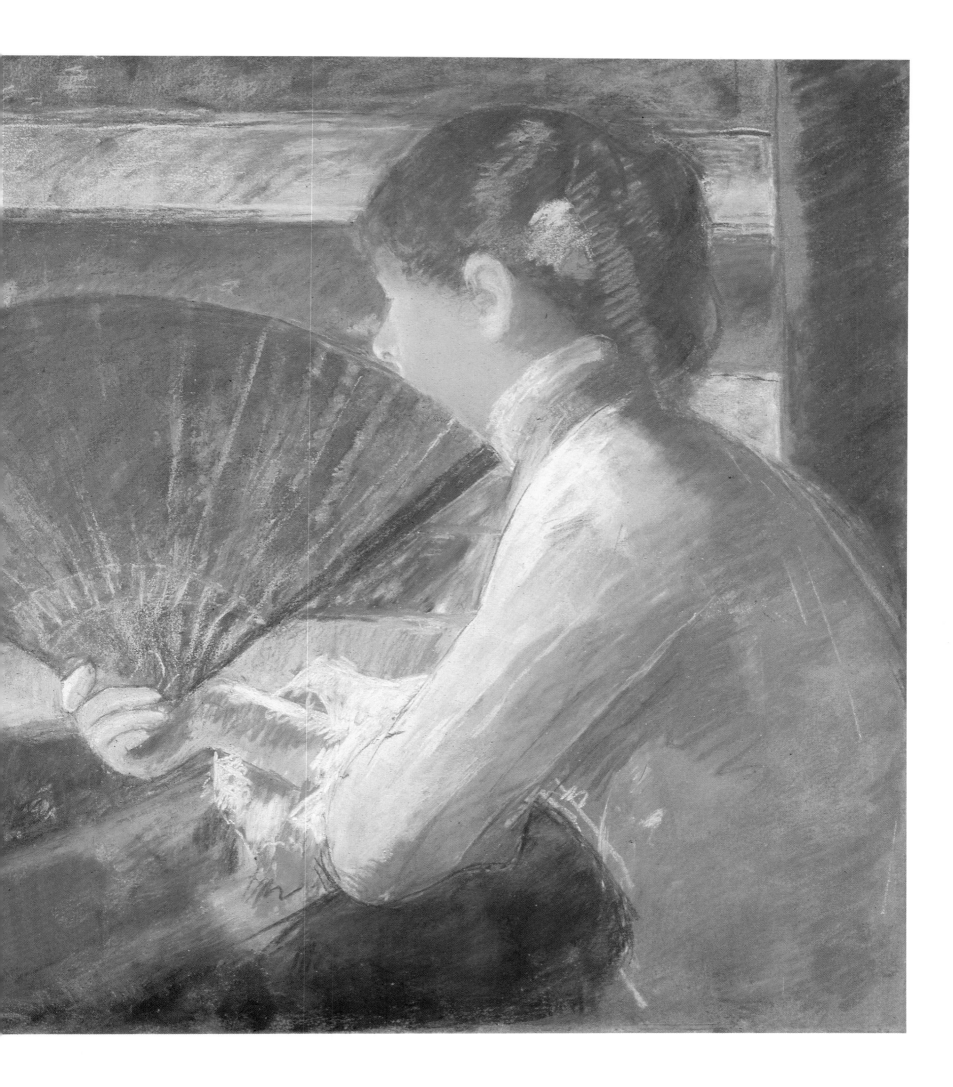

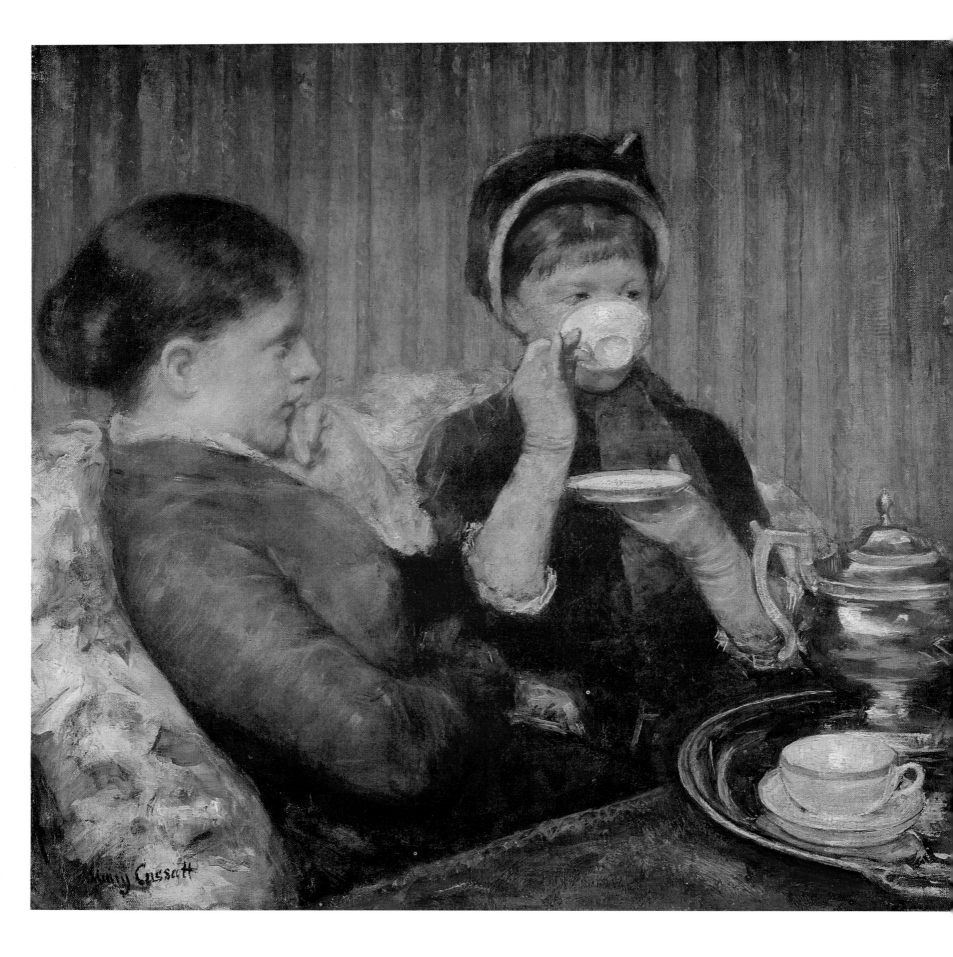

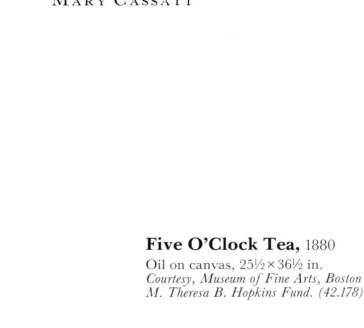

Five O'Clock Tea, 1880
Oil on canvas, 25½ × 36½ in.
Courtesy, Museum of Fine Arts, Boston
M. Theresa B. Hopkins Fund. (42.178)

A visitor once described the genteel accommodations that Cassatt occupied in 1876: "Statues and articles of vertu filled the corners, the whole being lighted by a great antique hanging lamp. We sipped our *chocolat* from superior china . . . Miss Cassatt was charming as usual in two shades of brown satin . . . "

Set in the drawing room of a later residence, this painting offers another glimpse into the artist's private life. Here we see a room equipped with a rococo-style mantelpiece, a gilt frame, a bronze-mounted Chinese vase, a bell pull to summon servants, and usurping the foreground, an heirloom silver tea service. The women wear modish but simple afternoon dresses. The one in blue, with hat and gloves, apparently is a guest. Both ladies seem turned toward a third companion, out of the picture's range. Since no third cup is visible, presumably this unseen visitor is in the act of drinking tea. The composition is divided into two unequal sections. The more severe left side, bounded by the striped wallpaper behind and the table's diagonal below, is dominated by the figures, while the softer right side is given over to the swelling curves and high luster of the decorative objects.

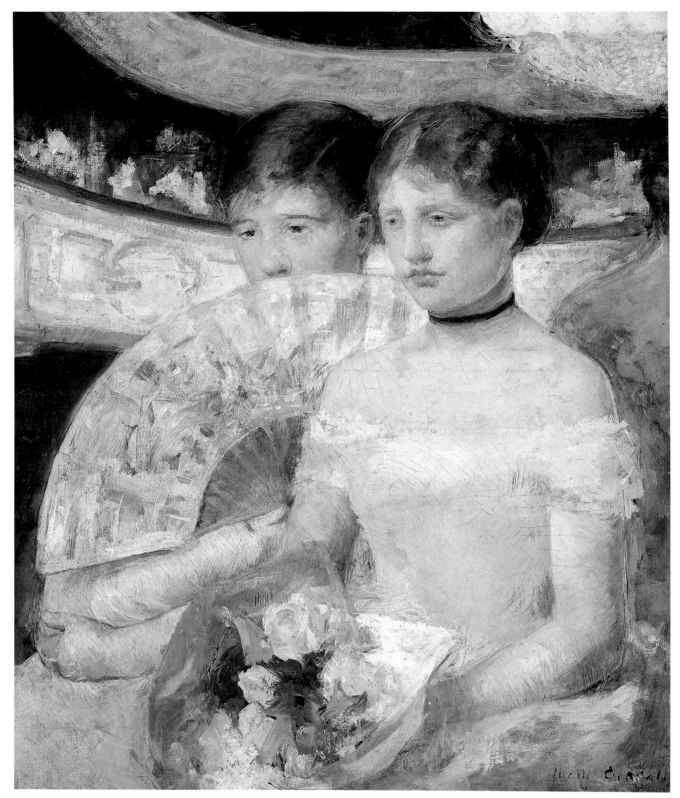

The Loge, 1882

Oil on canvas, 31½ × 25⅛ in.
National Gallery of Art, Washington, D.C.
Chester Dale Collection. (1963.10.96)

Once again Cassatt depicted female spectators at the opera, this time in a more ambitious format. The models for this painting were Mary Ellison, a Philadelphia friend, and at right, Geneviève Mallarmé, daughter of the symbolist poet Stéphan. Cassatt subtly distinguished between the two sitters' personalities. Withdrawn behind her fan and folded arms, Ellison appears much shier. Geneviève, who edges in front of her companion, assumes a more expansive pose, and her bouquet opens frontally toward the viewer.

Seated in a lower box, the two young women seem conscious of being on display. Though their gowns are abbreviated, they are dressed austerely; neither wears jewelry or hair ornaments, and their coiffures are simple. Additionally, compared to the woman of *In the Loge* (pp. 40-41), their posture is stiff. The clothing and body language of these women identify them as proper unmarried daughters of upper-class bourgeois families. Had they been young matrons, they would have adorned themselves more elaborately, and according to a contemporary, be engaged in "gay . . . conversation with the men." Unmarried girls kept their "eyes modestly cast down, or immutably fixed upon the stage."

Strict rules prevailed not only about what one had to wear, but where one could sit; Cassatt shows us one of the best theater boxes. In the mirror, we see reflected the full splendor of the setting, with its ornate chandeliers and richly carved balconies. An expensive box did not necessarily offer a good view of the stage, but superior audience visibility.

Lady at the Tea Table, 1885

Oil on canvas, 29 × 24 in.
© 1980 The Metropolitan Museum of Art, New York
Gift of the artist, 1923. (23.101)

Cassatt painted this portrait of her cousin, Mrs. Robert Moore Riddle, in appreciation of her cousin's housegift, the Canton-style tea and coffee service displayed in the foreground. Mary's mother wrote to her son Alexander, "Mary asked Mrs. Riddle to sit for her portrait thinking it was the only way she could return their kindness. . . As they are not very artistic in their likes and dislikes of pictures and as a likeness is a hard thing to make to please the nearest friend I don't know what the result will be . . ." Mrs. Cassatt's fears were well founded, as both the sitter and her daughter hated the portrait. Consequently, Mary hid it in her studio, where it remained forgotten until 1914. At that date, Cassatt exhumed the painting when Louisine Havemeyer urged her to look for works to display at a woman suffrage benefit. Cassatt recalled to Louisine, "I was so disappointed. I felt I never wanted to see it again. I did it so carefully and you may be sure it was like her – but – no one cared for it." Degas declared it "distinction itself," and vindicated by belated praise, Cassatt eventually presented the painting to the Metropolitan Museum of Art in 1916.

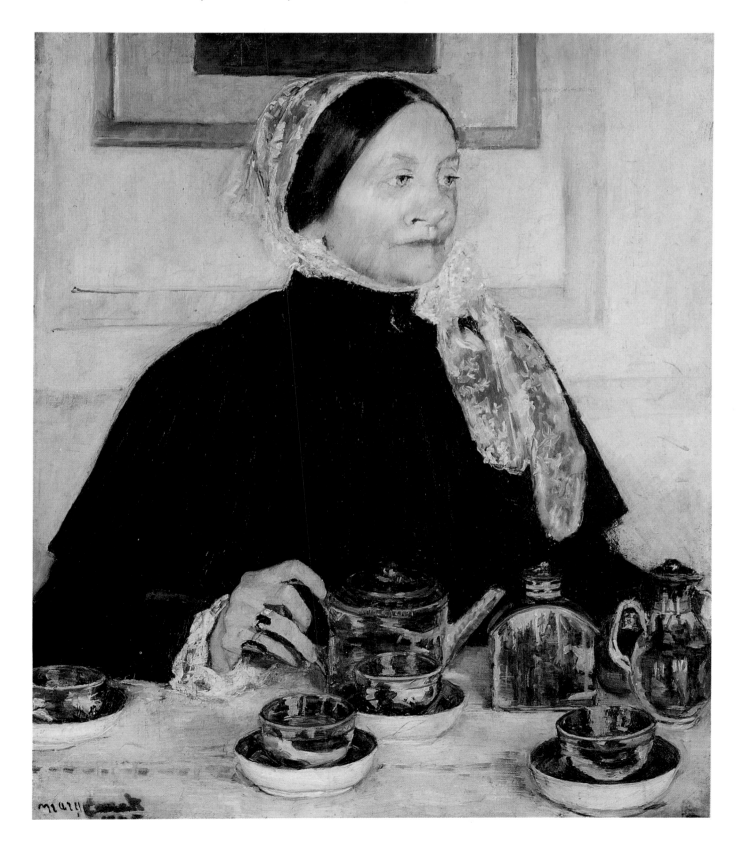

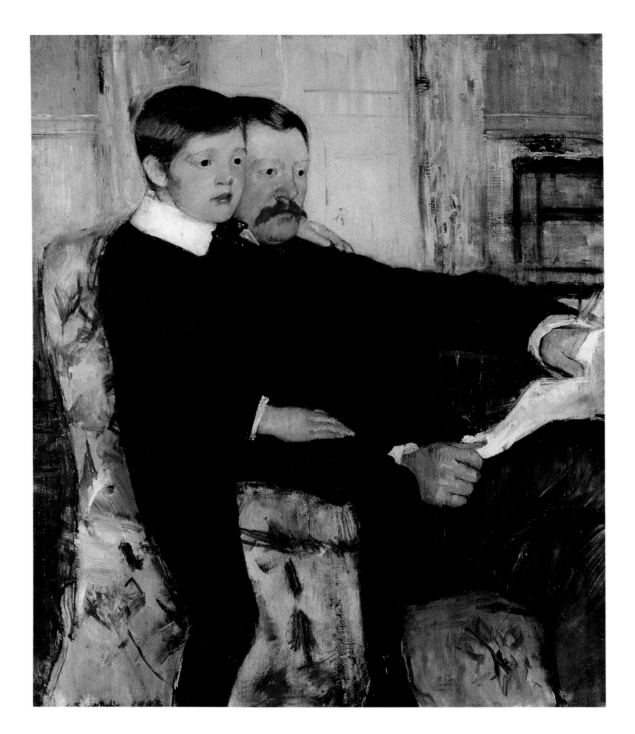

Portrait of Mr. Alexander J. Cassatt and his Son Robert Kelso, 1884

Oil on canvas, 39×32 in.
Philadelphia Museum of Art
W. P. Wilstach Collection

Cassatt commemorated the visit of her brother and nephew in the winter of 1885-86 by painting this double portrait. Alexander, an art collector and executive with the Pennsylvania Railroad, was 46 at the time, and his son, 11. Alexander wrote home to his wife, "I don't mind the posing, as I want to spend several hours a day with Mother any how – and Rob will not have to pose very much or long at a time." Mary's mother wrote to Rob's older sister that her grandson "was wriggling about like a flea," making the painter's work difficult.

In this portrait Cassatt underscored the bond between father and son; their similar-looking faces overlap one another, creating a "twinning" effect similar to that in *The Loge* (p. 44). Not only their faces, but their black-clad bodies merge. The central dark mass is relieved by the two pairs of parallel hands and the white accents of the boy's Eton suit collar and the father's newspaper. Cassatt typically pushed the figures to the foreground, leaving the background space shallow. In the end, she was pleased with the work, finding the likenesses "not bad."

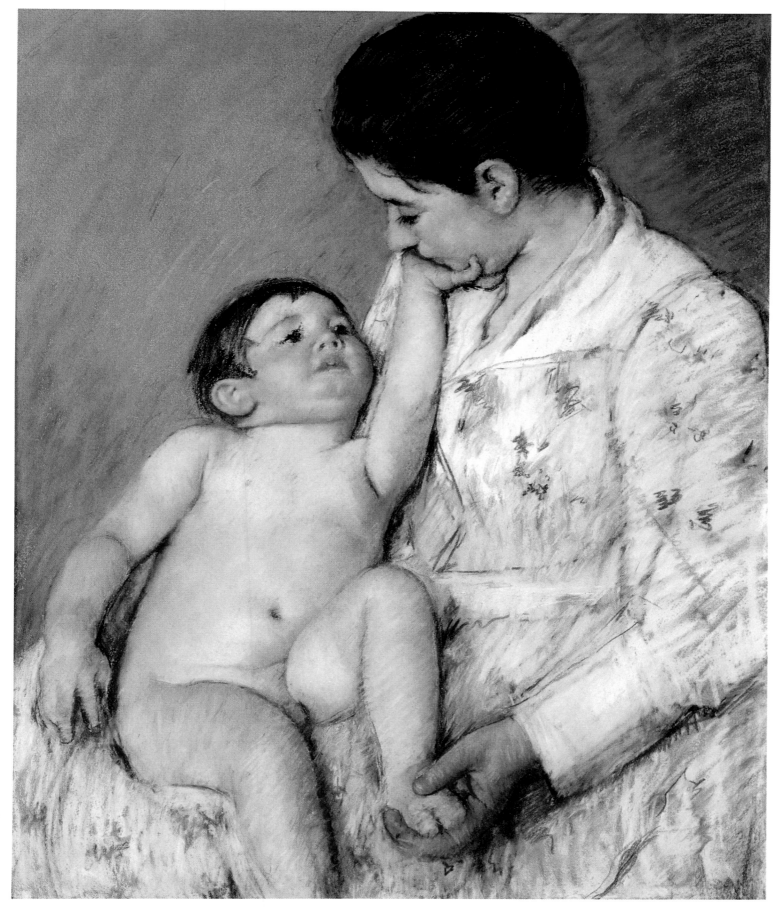

Baby's First Caress, 1891
Pastel on paper, 30 × 24 in.
New Britain Museum of American Art, New Britain, CT
Harriet Russell Stanley Fund

This pastel – once owned by her friend, the affluent collector Louisine Havemeyer – shows Cassatt's mastery of the medium. Like Degas, she used the colored chalks in their pure form, rather than mixing and blending them. In *Baby's First Caress*, individual strokes are visible; if she had blurred or "stumped" the strokes, the effect would have resembled oil painting. Instead, she achieves a fresh-looking result halfway between a drawing and a painting. The mother's skin, rendered in a silken, porous texture, is more highly finished than the background. Cassatt worked on tinted paper, which "breathes" through each colored stroke.

The theme of mother and child increasingly occupied Cassatt from the 1880s until her death. This picture gains emotional power through the figures' interlocking gazes and poses. The two most tender points of contact – the mother's chin, cupped in the baby's hand, and the baby's foot, cradled in the mother's hand – are aligned on one axis.

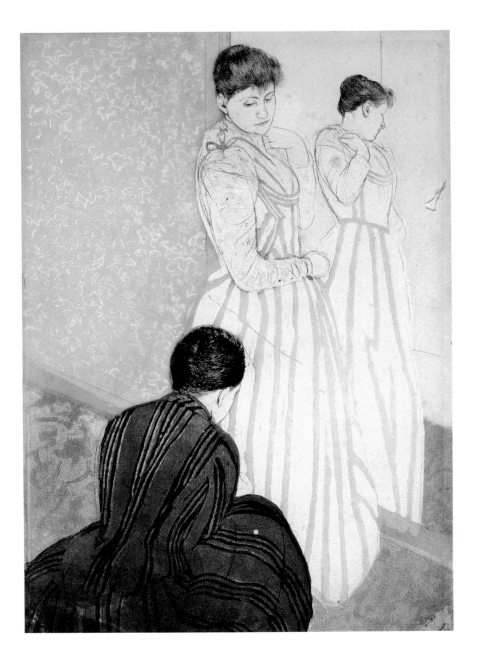

The Fitting, 1891

Drypoint and soft-ground etching in color, 14¾ × 10⅟₁₆ in.
National Gallery of Art, Washington, D.C.
Chester Dale Collection. (1963.10.252)

Cassatt's enthusiasm for Japanese art reached a peak in 1890 when she visited an exhibition of Japanese woodblock prints at the École des Beaux Arts in Paris. In response, Cassatt attempted to recreate their spare boldness using Western printmaking methods. Japanese influences in *The Fitting* include the acutely tilted ground plane, the overlapping, flattened shapes, the pale and powdery tints, and the play of pattern against pattern; moreover, fine outline, not shading, is used to develop form.

Cassatt's combination of printing techniques was so demanding that no one has tried it since. The fine lines come from drypoint, the fuzzier lines from softground, and the grainy effects from aquatint. She used at least three separate plates for each image, mixed her own inks, and printed them herself. Only 25 impressions of each image exist, as the plates wore down very quickly. Pissarro wrote to his son, "Miss Cassatt has realized . . . such effects, and admirable: the tone even, subtle, delicate, without stains or seams, adorable blues, fresh rose, etc. . . . The result is admirable, as beautiful as Japanese work, and it's done with printer's ink!"

The Bath, 1891-92

Oil on canvas, 29¼ × 36¼ in.
© *The Art Institute of Chicago, All Rights Reserved.*
Robert Waller Fund. (1910.2)

This painting shows Cassatt's further exploration of the design issues raised by her Orientalizing print series. Again, she employs a drastically skewed floor plane (were we to step on it, we would slide right off), and a layering of patterns (geometric rug, striped dress, floral wallpaper, etc.). The bird's-eye view, which permits each figure to be seen in its entirety, is also a common Japanese device. The extreme foreshortening of the heads leaves facial expressions ambiguous; Cassatt never liked to "give away" everything in a picture.

Even though the floor and viewpoint are out of kilter, the picture remains stable because the girl's body crosses the stripes of the dress at a sturdy right angle. The composition is further unified through repetition of rounded forms: the heads, the child's plump belly, the basin, the pitcher, and the bombé commode in the background. Additionally, the girl's little hand repeats the position of the woman's and the pitcher and bowl are aligned on the same oblique axis. The quiet mood of the scene almost makes the bath seem like a sacred ritual.

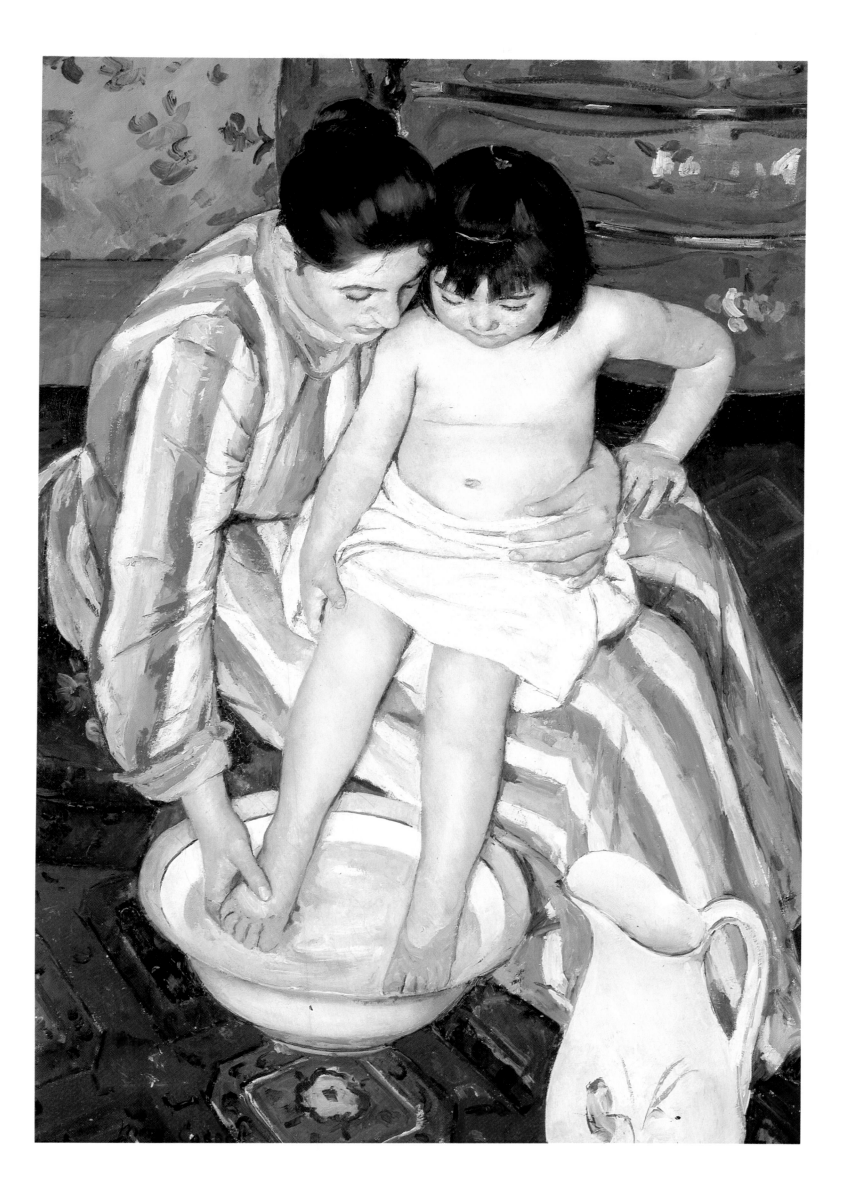

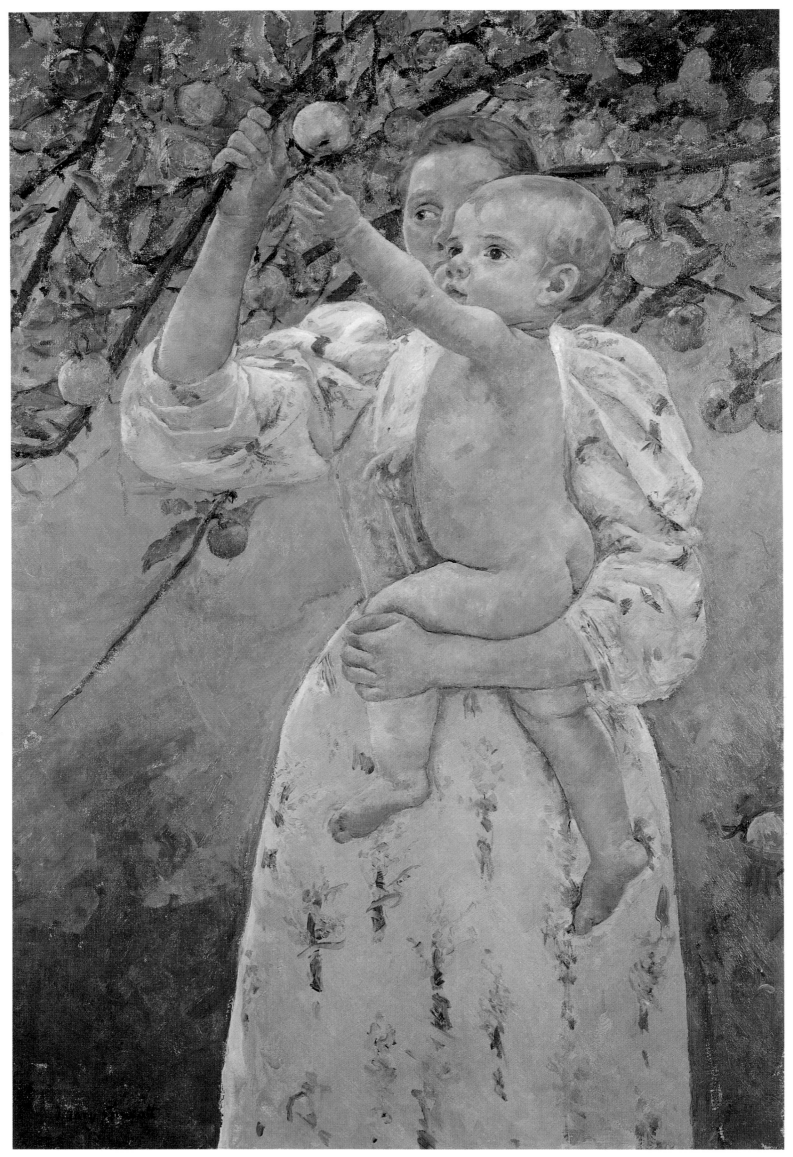

Baby Reaching for an Apple, 1893
Oil on canvas, 39½ × 25¾ in.
Virginia Museum, Richmond, VA
Gift of an anonymous donor

Among the last of a group of paintings related to her "Modern Woman" mural for the 1893 Chicago World's Columbian Exposition, this painting was made at Cassatt's summer house in Bachivilliers, France. Local peasant women, dressed in costumes specially designed by the artist, served as models. Like Degas, Cassatt avoided painting conventionally pretty women. "So you think my models unworthy of their clothes?" Cassatt wrote to a friend. "You find their types coarse . . . I confess I love health and strength . . ." When her series of orchard pictures was exhibited, a perceptive critic recognized that the figures have the "grandeur and simplicity of a young priestess in an antique procession."

Surprisingly, in both this picture and the mural *Young Women Plucking the Fruits of Knowledge and Science* that inspired it, Cassatt stripped away the usual connotation of sin and disobedience from the Eve legend. In *Baby Reaching for an Apple*, the woman bends the tree branch so that the baby can more easily grasp the apple. An American critic noted, there was "no serpent in this nineteenth century Eden . . . For today the forbidden fruit is no longer forbidden."

Mother and Boy, 1901

Oil on canvas, 32⅛ × 25⅞ in.
© *1984 The Metropolitan Museum of Art, New York*
Bequest of Mrs. H. O. Havemeyer, 1929.

In the mother and child theme, Cassatt found an ideal way to combine her investigations of modern life with her admiration for the Madonnas of the old masters, especially Renaissance examples seen on her trips to Italy. Durand-Ruel called Cassatt the painter of "the modern holy family," and the Havemeyers, who owned this painting, nicknamed it their "Florentine Madonna." Degas joked that *Mother and Boy* depicted "the infant Jesus with his English nanny." The baby stands in a too-adult *contrapposto* pose, as the infant Jesus often does in Renaissance images. Moreover, the boy's head rises higher than the mother's, indicating his superior status; and the mother is dressed in blue, the traditional color of the Madonna. The child's face rests at the center of the oval mirror, which forms a sort of halo about his head. This circular form is extended at right by the mother's head and the infant's left forearm, and is repeated in his curving belly and right arm. The interlocking limbs and hands, and the shared contour of his cheek and her brow create a sense of almost symbiotic intimacy.

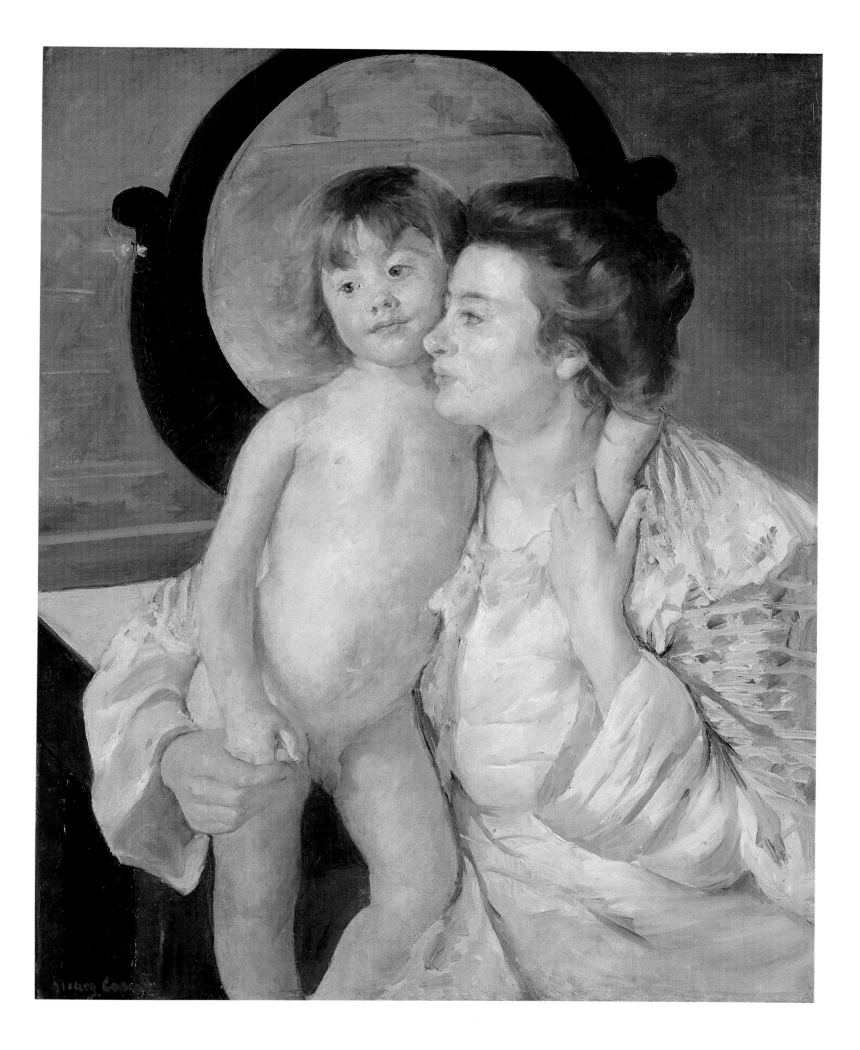

Mother and Child, c. 1905
Oil on canvas, 36¼×29 in.
National Gallery of Art, Washington, D.C.
Chester Dale Collection

Cassatt had explored the pictorial possibilities of the mirror many times before, but never with such striking optic complexity as in this painting. We are presented, so to speak, with three different pictures, each painted with decreasing degrees of distinctness: the total painting, the image in the hand mirror, and the reflection in the large glass. We are invited to ponder not only the varying levels of illusion and reality, but parts of the scene viewed from different angles. The effect is a kind of omnipresent, simultaneous vision. The reflection of the baby's face in the small, round mirror forms the picture's focal point. All four arms and both gazes lead to this one spot. The mirror's circle is reiterated in the sunflower, which strikes the dominant, golden color note.

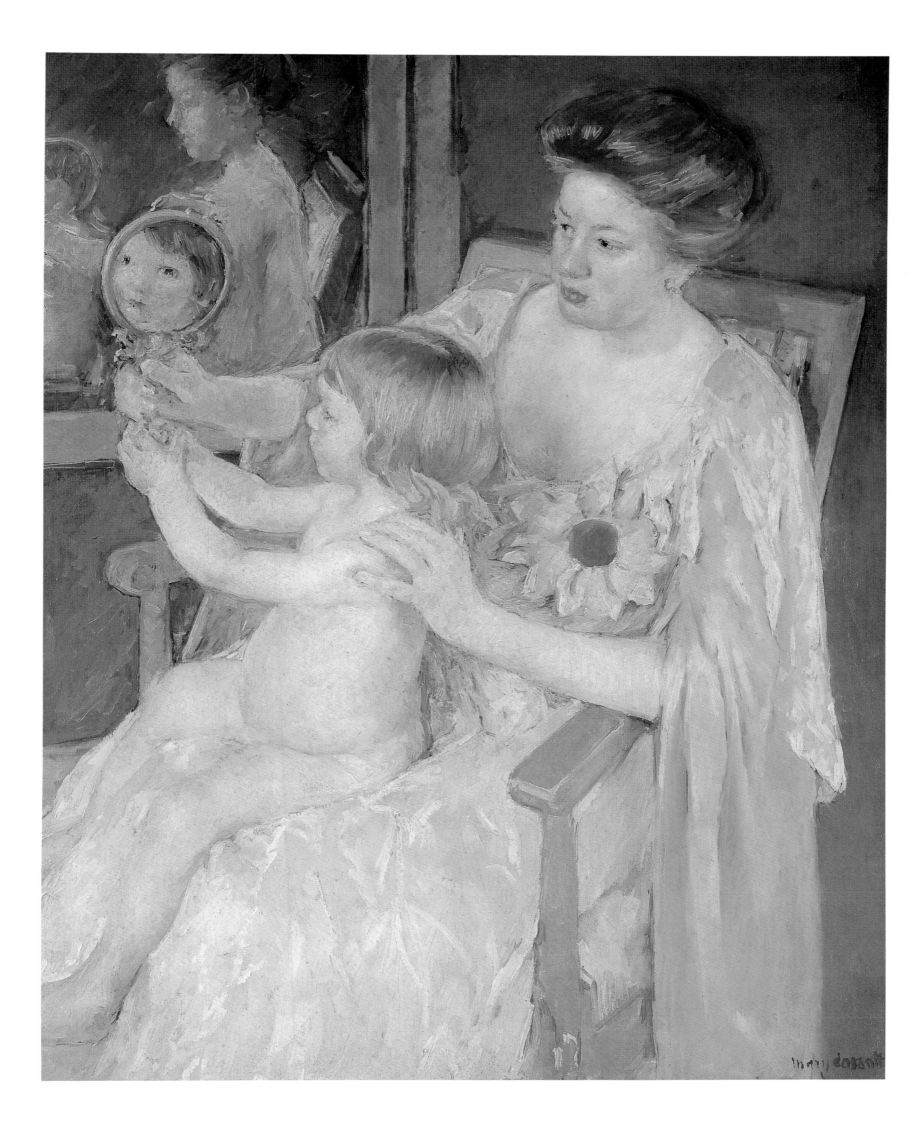

WILLIAM MERRITT CHASE

1849-1916

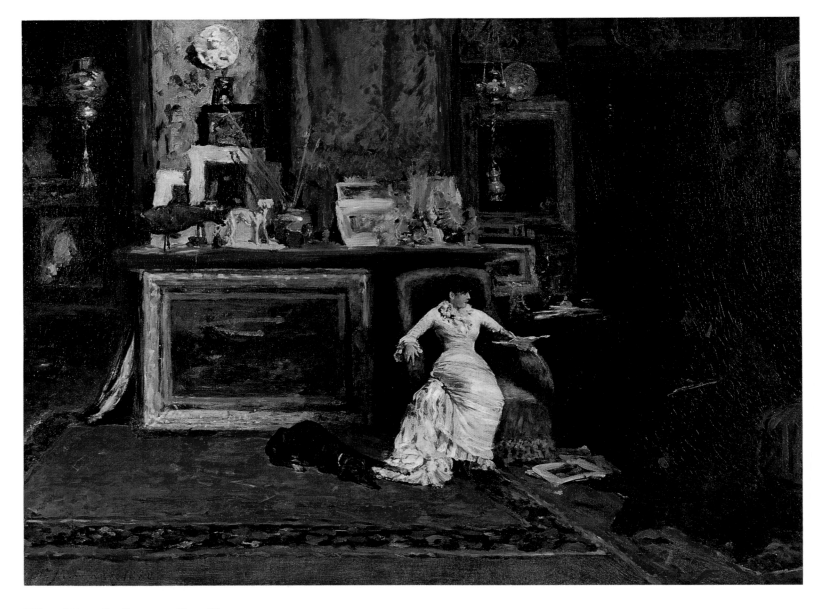

The Tenth Street Studio, 1880
Oil on canvas, 36×48 in.
The Saint Louis Art Museum

When Chase, an audacious newcomer, returned from study abroad in 1878, he astonished the New York art world by leasing the largest quarters in the Tenth Street studio building, which provided working and exhibition space for city artists, including Homer and Weir. Establishing himself in an extravagant manner proved a self-fulfilling prophecy. He quickly gained commissions and students, and the studio was even listed in a guidebook as "one of the sights that artists and students coming to New York desire to see." A fellow artist noted, "He took the town by storm, capturing its chief artistic citadel, and [his studio] became the sanctum

sanctorum of the artistic fraternity." With bohemian flair, Chase furnished the studio with taxidermy animals, Oriental carpets, folding screens, wall hangings, and other curiosities from his travels. He created, according to another observer, "a nook rich in attractions which carry the fancy back to other climes and the romance of bygone ages." In the painting, the cluttered, sumptuous room nearly overwhelms the figures of Chase, to the right, and his visitor. This celebrated fixture of the New York art scene lasted until 1896, when Chase, for reasons unknown, moved out and auctioned its contents.

Portrait of Miss Dora Wheeler, 1883

Oil on canvas, 62½ × 65¼ in.
The Cleveland Museum of Art
Gift of Mrs. Boudinot Keith. (21.1239)

One of Chase's first students, Wheeler is shown here at the age of 26, shortly after her return from the Académie Julian. Dora was the youngest daughter of the early feminist Candace Wheeler, who was the founder of the Decorative Art Society and partner in Louis Comfort Tiffany's interior design association. Dora designed tapestries, greeting cards, and produced portraits for her mother's organization and other firms.

This portrait shows Dora seated in her own studio in front of an embroidered hanging, probably executed by the Wheeler company. The other objects exhibited – a pottery vase, an Elizabethan-revival chair, and a Chinese taboret – also comment on Wheeler's profession, and more generally, on the Aesthetic milieu that both Dora and Chase inhabited. Dora is presented, not as another beautiful luxury item, but as a woman of penetrating intelligence. When the painting was exhibited in Munich, a German critic surmised that Wheeler was "apparently gifted with more cleverness than feeling. The way she fixes her piercing look on you, without herself betraying anything, puts you in mind of a sphinx."

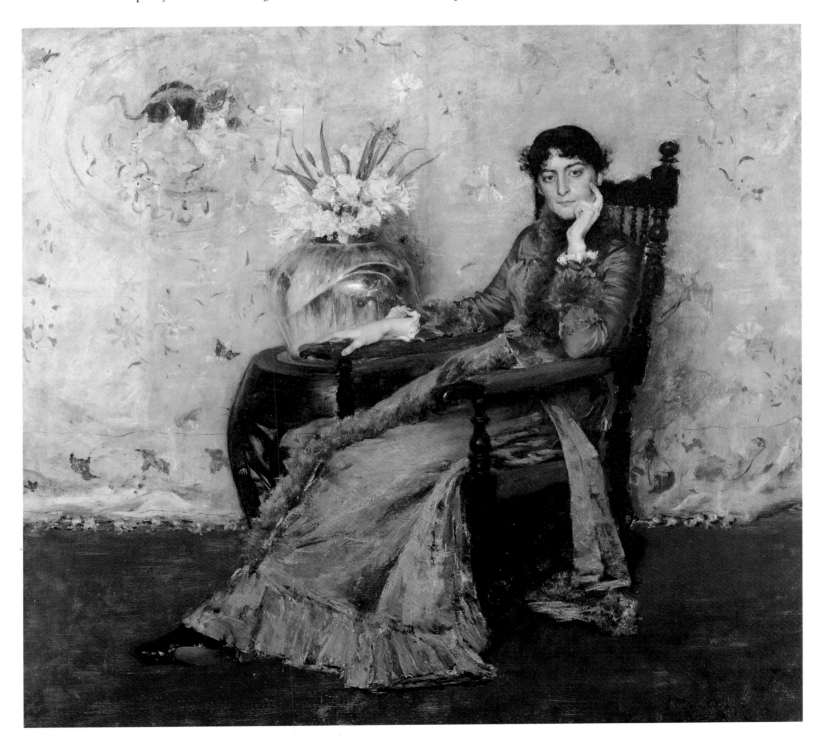

End of the Season, c.1885

Pastel on paper, 13¾×17¾ in.
© 1987 Mount Holyoke College Art Museum, South Hadley, MA
Gift of Mrs. Jeanette Dickie Bogle

In the 1880s, as part of the Aesthetic movement, the "secondary" media of pastel, prints, and tempera underwent a revival. Chase played an important role in this trend by becoming the founding member of the Society of Painters in Pastel, and participating in their first exhibition in 1884. The "pastel craze" probably indirectly facilitated American acceptance of Impressionism, because the Impressionists' richly colored, abbreviated approach was tolerated first in this minor medium.

In *End of the Season*, Chase invented a design of nearly abstract beauty out of the rectilinear tangle of tilted grey chair legs and tabletops. Deprived of their normal function, these objects almost lose their identities, and become random, bristly clusters of neutral colors. Their spiky forms and cool tones are repeated in the pleats, folds, and trimming of the woman's dress. Chase created an overpowering mood of wistfulness; the beach is practically deserted, the foreground shadow appears ready to engulf the sunny landscape, and the woman stares reflectively out to sea.

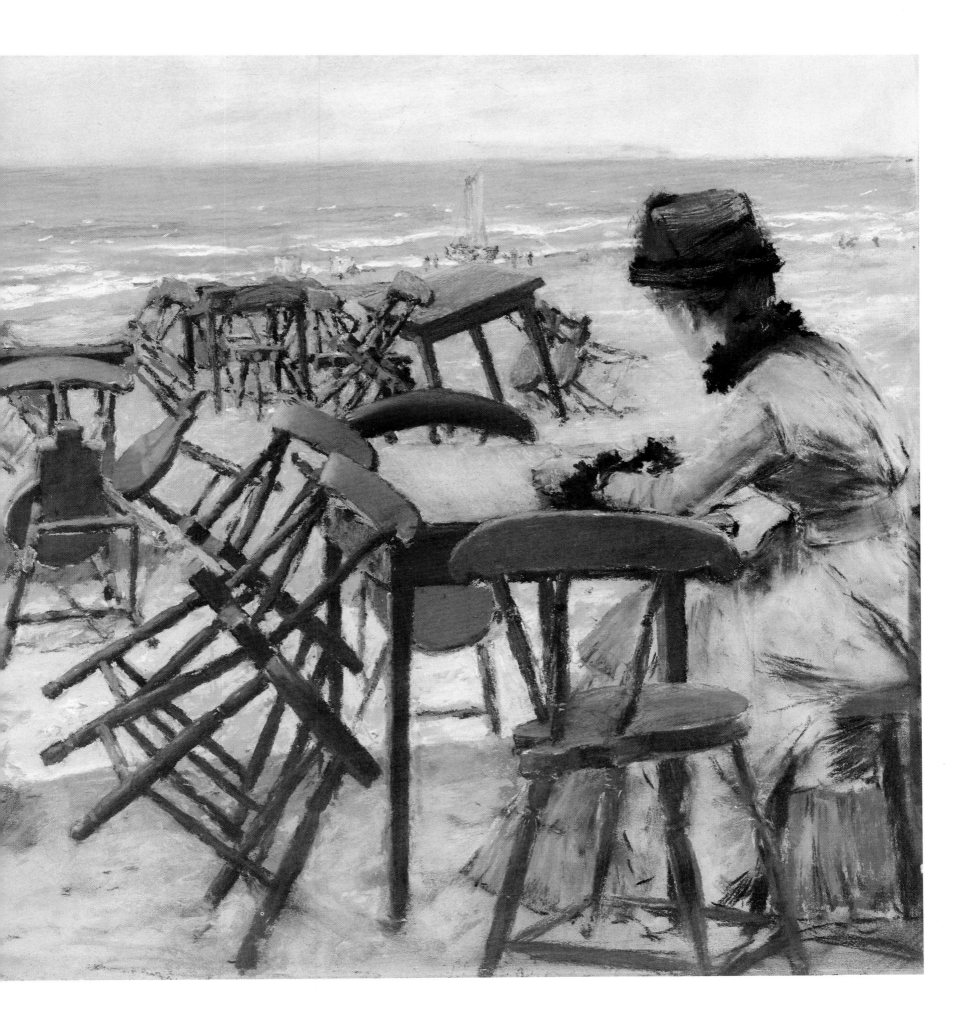

Hide and Seek, 1888
Oil on canvas, 27⅝ × 35⅞ in.
The Phillips Collection, Washington, D.C.

The pictorial strength of *Hide and Seek* comes not from what Chase included, but from what he omitted. The main subject is a vast expanse of glossy brown floor, and a nearly empty, tonally related stretch of wall. Chase plays with a minimum of means. He not only restricted the subject – we can't even see the girls' faces – but the palette as well. Indeed, the viewer has to play "hide and seek" with the painting in order to discover the children sneaking in and out of the room. Chase seems primarily concerned with creating a pleasing arrangement of rectangles: the larger one of the floor, and the smaller ones of the wall, picture, portière, and seventeenth-century-style chair.

Chase advised his students to assimilate other painters' styles: "Be in an absorbant frame of mind. Take the best from everything." The reductive composition and muted color harmony of this painting is clearly inspired by the "color arrangements" made by Whistler, whom Chase had visited and painted in 1885. His placement of the little girls in a cavernous, shadowy interior also recalls Sargent's *Daughters of Edward D. Boit* (pp. 136-137).

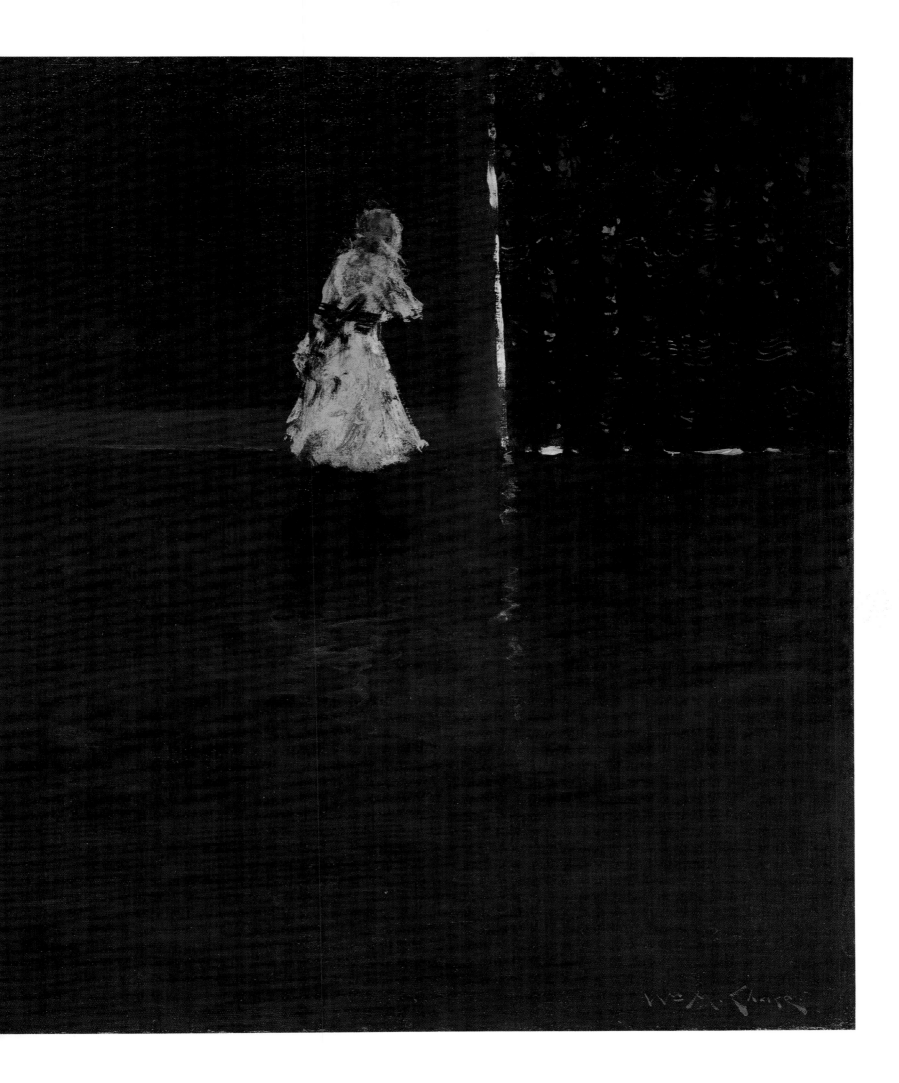

The Open-Air Breakfast, c. 1888

Oil on canvas, 37⁷⁄₁₆ × 56¾ in.
The Toledo Museum of Art
Gift of Florence Scott Libbey

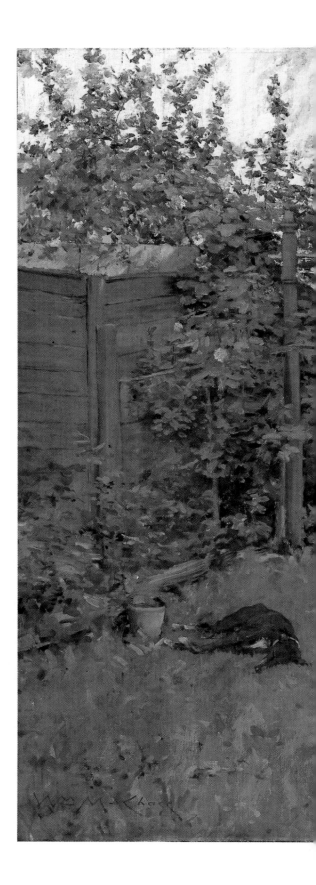

In the late 1880s, Chase painted many plein-air studies of Manhattan's Central Park and Brooklyn's Prospect Park. *The Open-Air Breakfast*, set in the back yard of his Park Slope, Brooklyn home, is an extension of these idyllic urban views. This very large picture celebrates domestic comfort and the artistic life. Chase represented his young wife Alice, seated at right, their first child, Alice Dieudonné in the high chair, his sister-in-law Virginia relaxing in the hammock, and his own sister Hattie standing in front of the screen.

Chase not only brought his easel outdoors, but also his studio props. In this painting, props such as the Japanese screen, Oriental porcelains, cashmere shawl, and seventeenth-century Dutchman's hat prevent the scene from looking like an ordinary casual gathering.

In addition, Chase's extended family seems snugly protected by the wooden fence, overhanging trees and the lolling wolfhound at left. Chase may have had in mind Monet's painting of backyard repasts (*Breakfast in the Garden*, p.11), but his handling of paint is quite different. He employs small, dry strokes which create a matte, chalky texture similar to his pastels.

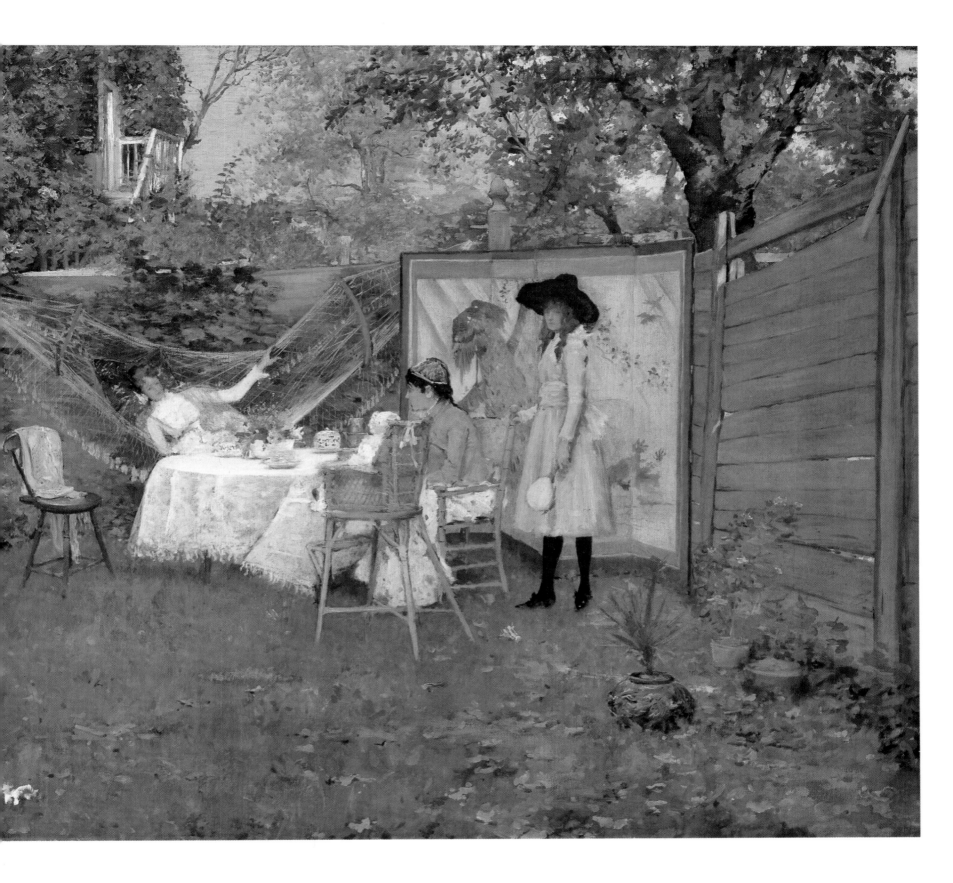

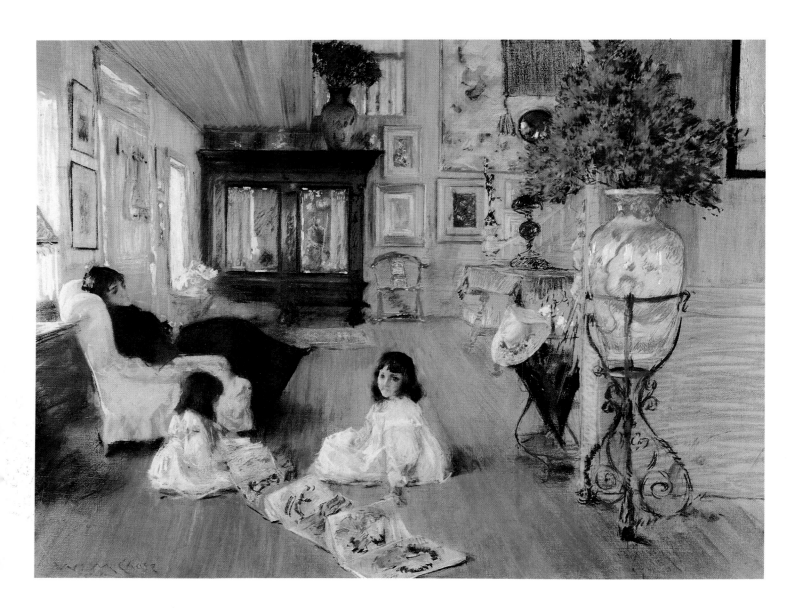

Shinnecock Hall, 1892

Pastel on canvas, 32 × 41 in.
Terra Museum of American Art, Chicago

From 1891 to 1902, Chase, under the patronage of wealthy Long Islanders, ran the Shinnecock summer school, the first important outdoor painting school in the country. One of Chase's perquisites there was a beach house with an attached studio, designed by Stanford White. Chase found as much inspiring material within his home as in the surrounding landscape.

This pastel of the house's central hall pays homage to Velázquez, who for Chase was "the master I admire above all others." Chase identified with Velázquez's ability to paint all types of subjects and to absorb traits from all the painters before him. Chase carried his enthusiasm to the point of naming one of his daughters Helen Velázquez.

Shinnecock Hall is a kind of modern restatement of *Las Meninas* (p. 17) The reflection of Chase at work in the armoire's mirror refers to the reflection of the king and queen in Velázquez's masterpiece, as well as to the Spaniard's inclusion of himself at the easel. The true subject of this painting is art itself; while one daughter looks out at the viewer, as does the princess in *Las Meninas*, the other studies a portfolio of Japanese prints.

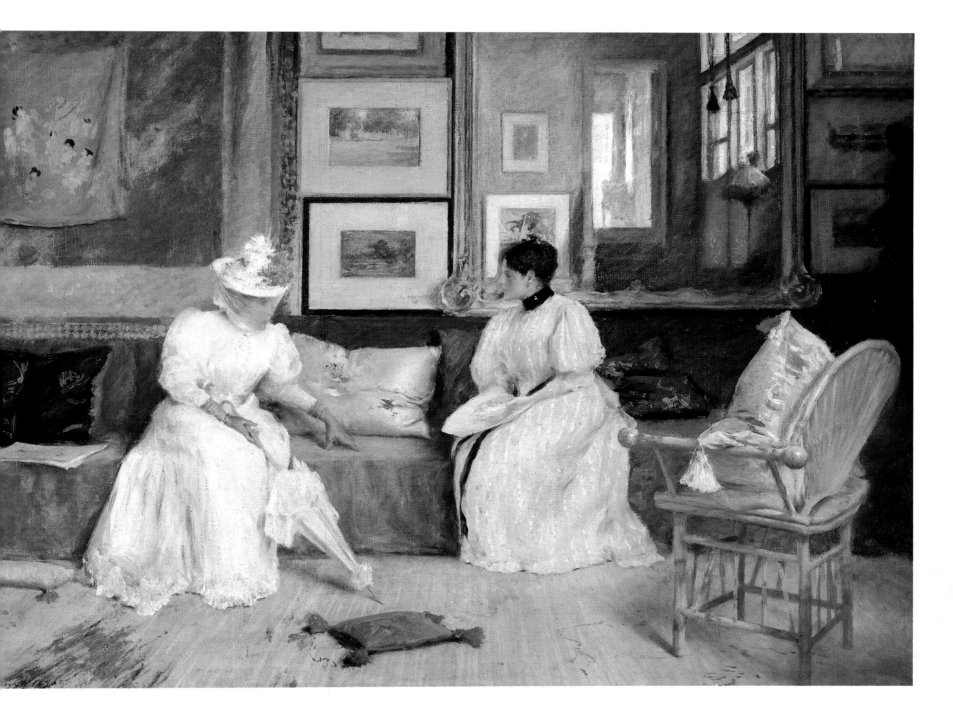

A Friendly Call, 1895
Oil on canvas, 30⅛ × 48¼ in.
National Gallery of Art, Washington, D.C.
Chester Dale Collection. (1943.1.2)

Another scene inside Chase's Shinnecock home and another tribute to Velázquez, *A Friendly Call* shows his wife receiving a visitor in the studio. The hall featured in the previous painting, and the staircase leading to it, are reflected in the gilt mirror. The reflected doorway corresponds to the portal and stairs in the right background of *Las Meninas*, just as the studio wall hung with pictures and mirrors reworks the far end of the Velázquez painting. Most of the pictures on the wall are by Chase; an exception is the engraved reproduction, reflected in the mirror, of a painting by Henri Regnault,

which forms a kind of thought bubble around Mrs. Chase's head – as if she had "art on her mind."

Mrs. Chase appears reserved compared to her conspiratorial-looking visitor, who seems to be "making a point" rather aggressively with her frilly pink parasol. Ironically, for all her withdrawal, Mrs. Chase's face is exposed, while her companion's is swathed in a veil. The viewer is offered a second glimpse of Mrs. Chase, invisible to her friend, in the form of her reflected profile. It is as if we, but not the guest, are permitted to see beyond her public persona and into her private self.

Near the Beach, Shinnecock, c. 1895
Oil on canvas, 30×48⅛ in.
The Toledo Museum of Art
Gift of J. Secor

Outdoor teaching and the windswept, shadeless landscape – "the whole of Shinnecock can hardly boast of one tree" – inspired Chase to paint his sunniest, most joyful pictures. The dunes, uninterrupted horizon, and nearby sea provided him with infinite paintable subjects. An 1893 article on the Shinnecock school stated, "The advantage to living in such a place is that all an

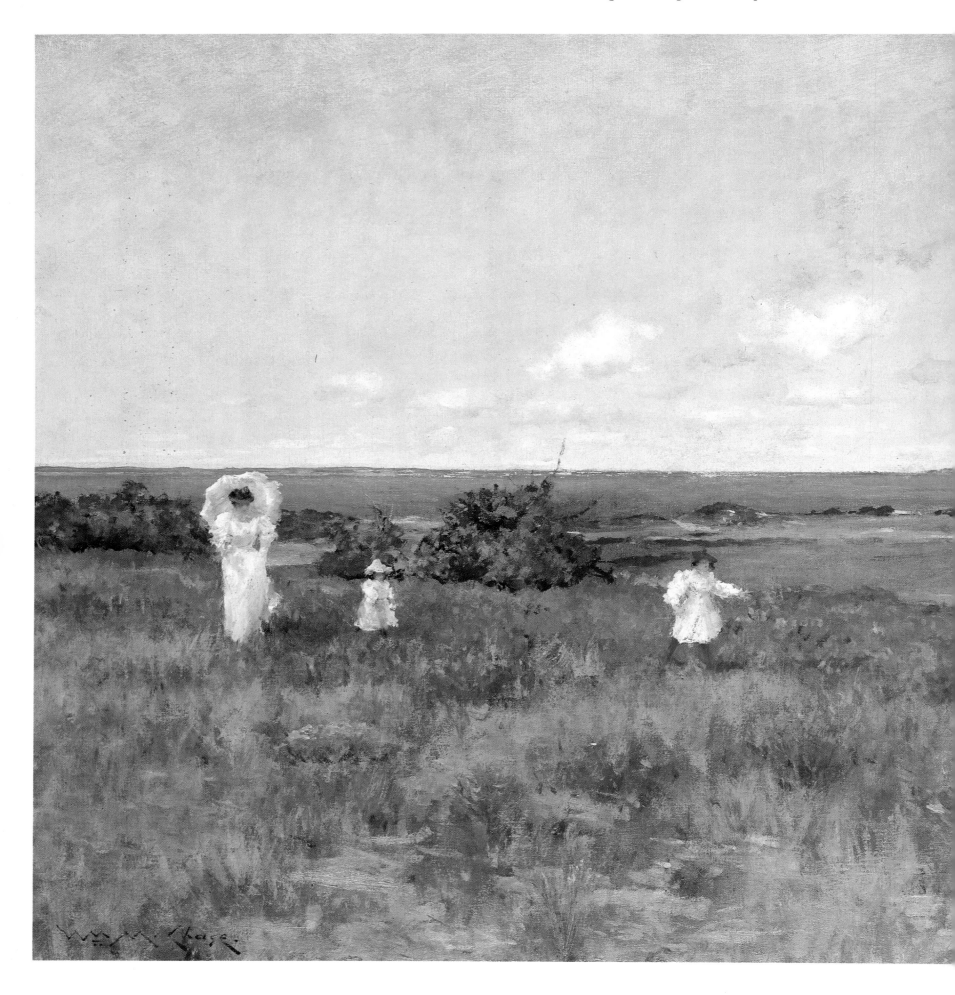

artist has to do is to take out his easel and set it up any-
where, and there in front of him is a lovely picture.''
This painting shows Chase's wife and two of his three
daughters strolling in a scrubby meadow not far from
the water. The feminine accessories form animating
color notes in the composition, and the whites of their
frothy dresses are echoed in the cloud puffs overhead.

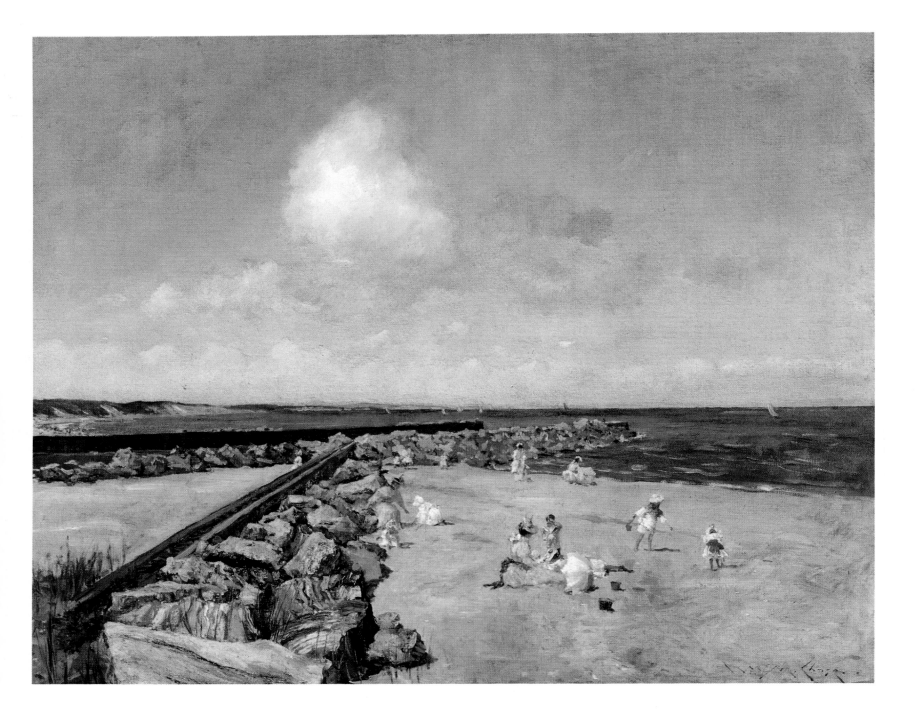

Morning at the Breakwater, Shinnecock,
c. 1897

Oil on canvas, 40×50 in.
Terra Museum of American Art, Chicago
Daniel J. Terra Collection

The deep space of this picture, created by the rushing orthogonal breakwaters, distinguishes it from similar French Impressionist scenes, which appear much flatter. Most of the painting is given over to the expansive sky. Chase advised his students, "Try to paint the sky as if we could see through it, and not as if it were a flat surface, or so hard you could crack nuts against it." Chase followed his own recommendations: his sky seems convincingly airy, breathable, and light. A delighted critic had seascapes such as this in mind when he queried, "With whose landscapes does one better get the tang and thinness and crispness of our air and the whitey brightness of our light?"

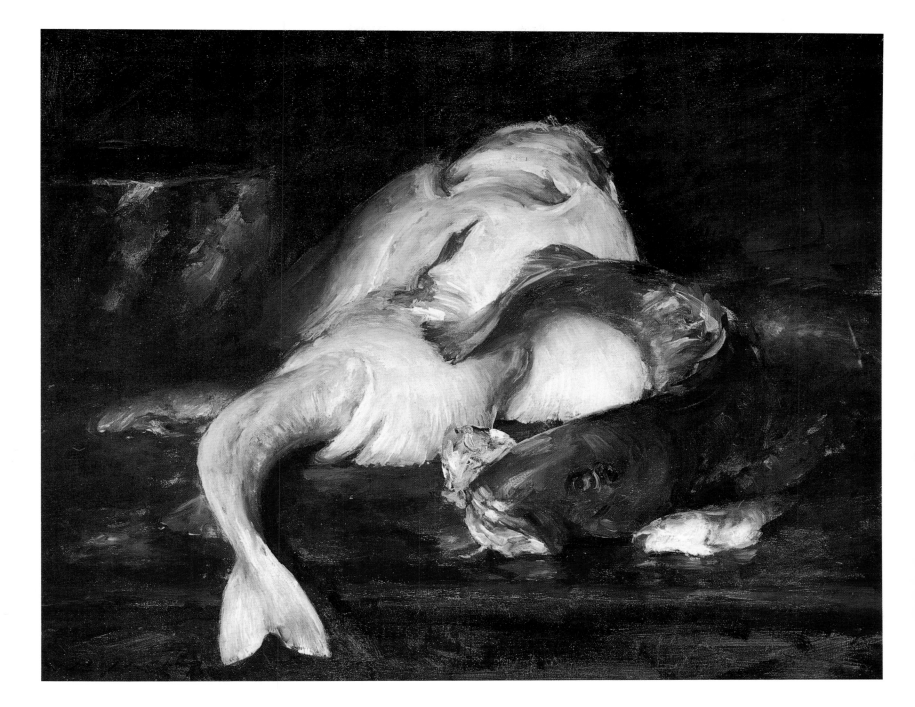

Still Life, Fish, 1912

Oil on canvas, 32⅛ × 39⁹⁄₁₆ in.
The Brooklyn Museum
John B. Woodward Memorial Fund. (13.14)

Chase ended the Shinnecock school in 1902, and for the following 11 summers took students abroad instead. He often painted still lifes of fish as demonstration pieces for his class. Chase worked without preparatory sketches and could dash off a picture, like this one, before an audience in a few hours. (A more ambitious picture like *A Friendly Call* still would have taken only a few days.) Chase liked to relate how he would rent fish to paint and return them to the fishmonger in less than two hours, still fresh enough to be sold. He admitted, "I enjoy painting fishes; in the infinite variety of these creatures, the subtle and exquisitely colored tones of the flesh, fresh from the water, the way their surfaces reflect light." Because of the huge demand for these pictures, Chase wondered if he would be remembered by posterity only as a fish painter. His virtuoso technique captured perfectly the shimmery slickness of this humble subject matter.

JOSEPH DE CAMP
1858-1923

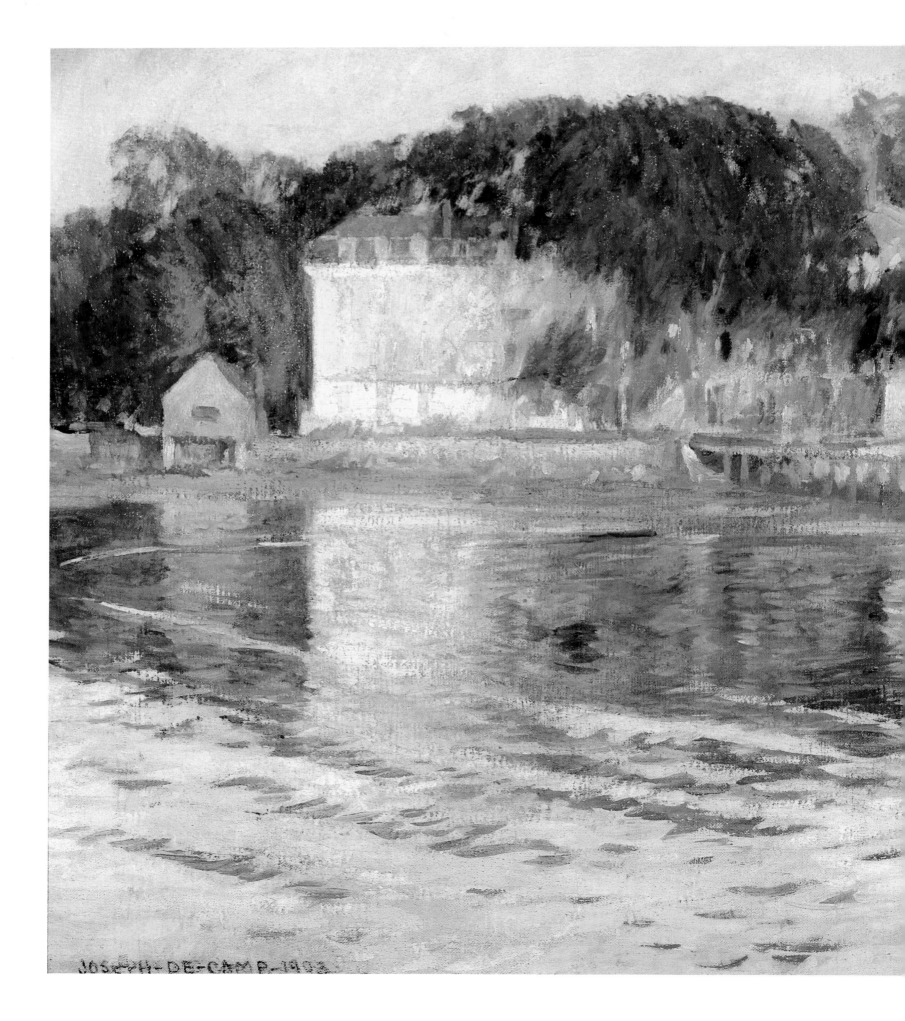

The Little Hotel, 1903

Oil on canvas, 20 × 24 1/16 in.
The Pennsylvania Academy of the Fine Arts, Philadelphia
Joseph E. Temple Fund. (1904.2)

Like his fellow Ten member, John Twachtman, De Camp was a Cincinnati native and a student at the Munich Royal Academy. A believer in sound academic training, De Camp taught at many institutions, including Wellesley College and the Boston Museum of Fine Arts School. Based in Boston, De Camp established a reputation as a figure painter, undertaking such prestigious commissions as a portrait of Theodore Roosevelt. Given this background, it is surprising to see how successfully De Camp absorbed Impressionism during the summer of 1900, while working in Gloucester, Massachusetts, with Twachtman. Yet De Camp never renounced his conservative portrait style; rather, he reserved his freely brushed, colorful manner exclusively for informal landscape studies such as *The Little Hotel*.

De Camp painted this view of a shallow inlet during flood time from the grounds of his rented house in Rocky Neck, Gloucester. The hotel across the water is probably the Hawthorne Inn, where painters in residence for the summer would congregate during the evening. Sadly, De Camp's development as an Impressionist cannot be traced accurately, because in 1904 a fire destroyed all of the contents of his Boston studio.

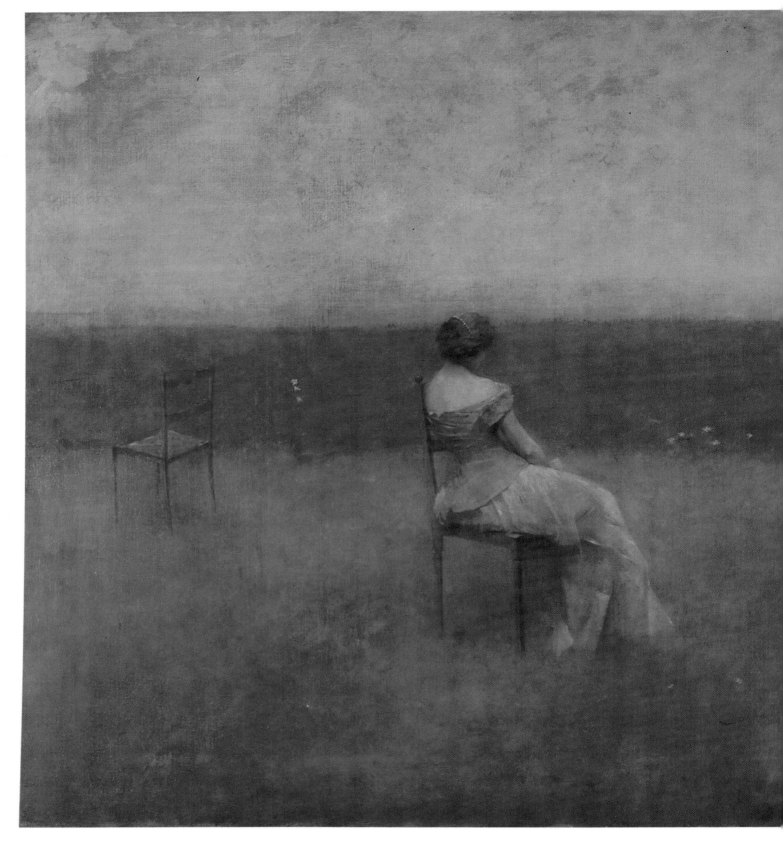

THOMAS DEWING

1851-1938

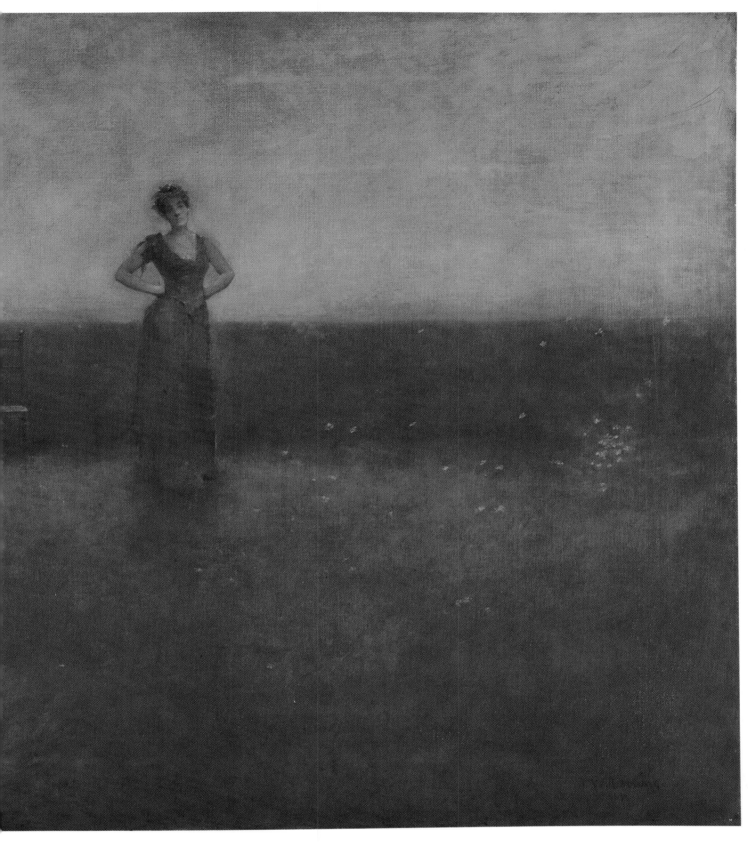

The Recitation, 1891

Oil on canvas, 30×50 in.
© *The Detroit Institute of Arts*
Detroit Museum of Art Purchase, Picture Fund

Thomas Dewing, who had briefly tried his hand at taxidermy before becoming a painter, first studied at the Boston Museum of Fine Arts School and then at the Académie Julian. He married a well-known flower painter, Maria Oakey, with whom he sometimes collaborated. Dewing's very recognizable style did not emerge until the 1890s, when he began his series of remote women inhabiting dreamlike, vague landscapes.

Dewing's soothing scenes, illuminated by a gentle, golden light, look as if they should be viewed through half-closed eyes; his women often do appear heavy-lidded, as if in a trance.

The Recitation seems to be set on some vast teal lawn, extending to the sea, if not to infinity. The women – one turned away, the other facing frontally – and the chairs are carefully positioned in the long empty space like notes on a musical staff. The deliquescent bands of color, variations of blues and greens, are Whistlerian, while the figures – much more substantial than the landscape – show traces of the precise academic style Dewing had recently abandoned. Despite the act of recitation, the mood is hushed. The picture's tranquility derives largely from its restful horizontal orientation and the serenity of its cool palette.

The Necklace, c. 1907
Oil on wood, 20×15¾ in.
National Museum of American Art
Smithsonian Institution, Washington, D.C.
Gift of John Gellatly. (1929.6.40)

This painting reworks a subject treated by Vermeer, the seventeenth-century Dutch master who was very much in vogue among Boston artists in the first decade of the twentieth century. In *The Necklace*, however, Dewing removes Vermeer's allegorical implications of vanity, and converts the theme into a pure meditation on beauty. The woman admires the jewelry that she so delicately handles, along with her reflection in the cheval glass. The viewer, too, contemplates the handsome woman, her finery, and the carefully selected Oriental objects – a celadon vase (which established the color scheme) and a Japanese picture – as well as the painting as a whole. Dewing glorified a long-limbed, fine-boned type of feminine beauty, distinct from the prevailing athletic Gibson-girl ideal. The critic Sadakichi Hartmann remarked that Dewing represented "beautiful ladies, mostly mature women of thirty . . . [who] seem to possess large fortunes and no inclination for any professional work. They all seem to live in . . . mysterious gardens, on wide, lonesome lawns, or in spacious, empty interiors . . . there they sit and stand, and dream . . . though absolutely modern, [they] are something quite different from what we generally understand by modern women."

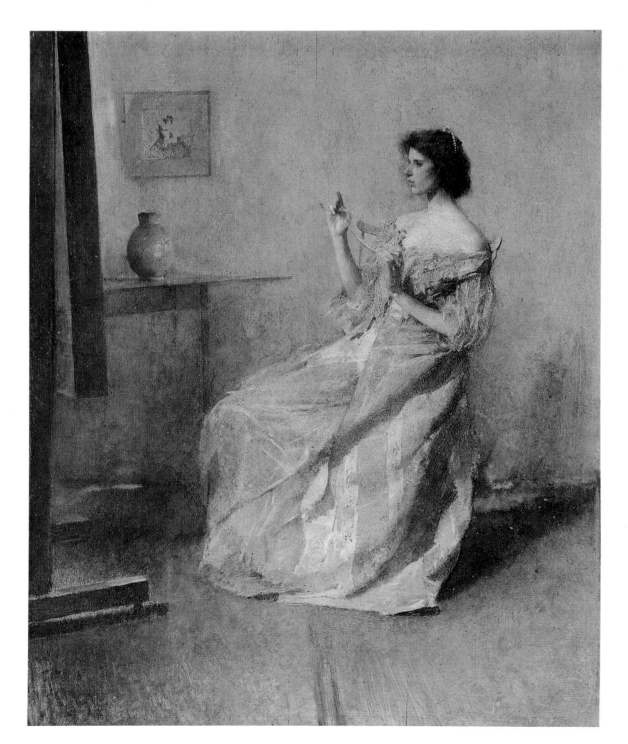

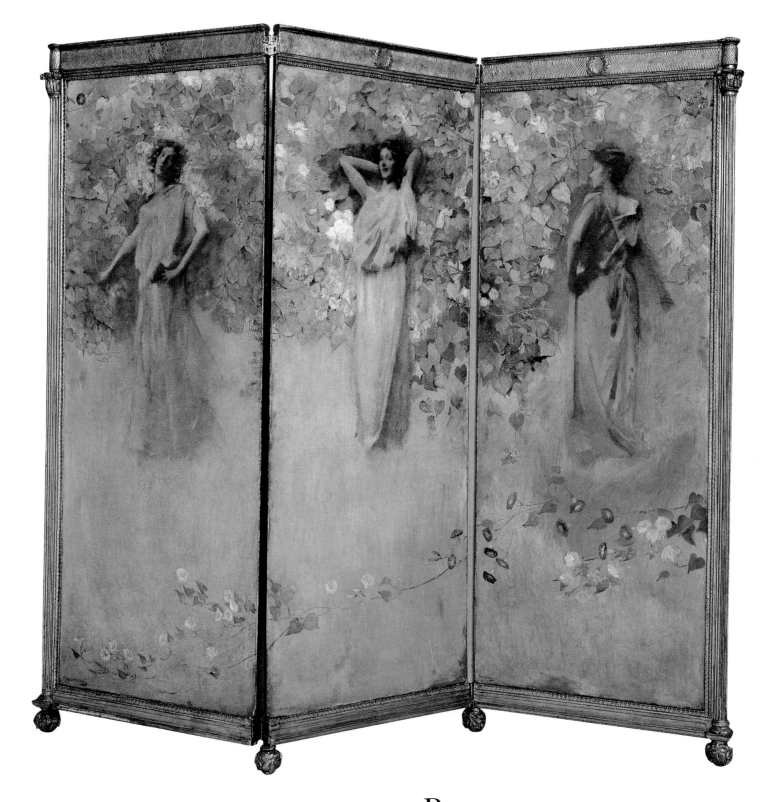

Morning Glories, undated
Multi-panel folding screen, 64½ × 72 in.
Oil on canvas mounted on three wood panels
Museum of Art, Carnegie Institute, Pittsburgh
Gift of the Sarah Mellon Scaife Family

Because of his interest in unified, harmonious interiors, Dewing created aesthetic objects as well as easel paintings. Yet, since he called his pictures "decorations," he did not make the traditional distinction between fine and applied art. Like Whistler, or Prendergast's craftsman brother Charles, Dewing considered the frame an integral extension of a painting, not an afterthought. The famous architect Stanford White often designed Dewing's frames, and introduced the artist's work to Charles Lang Freer and John Gellatly, who became Dewing's two most sympathetic patrons.

Due to the fashion for Orientalia and exquisitely handmade objects, the folding screen became a popular element in tasteful interiors around the turn of the century. On each of its three panels, this screen shows a woman in a languid pose, seen against a lush backdrop of flowers and grass. Dewing very self-consciously celebrates preciosity, as the morning glory, in the language of flowers, symbolizes affectation.

JOHN ENNEKING

1841-1916

Blossoming Trees, 1894

Oil on canvas, 18×24 in.
Courtesy, Vose Galleries of Boston

A native of Ohio and a Civil War veteran, John Enneking moved to Boston in the mid 1860s. In the 1870s he studied in Munich and in Paris, where he became friendly with the Barbizon painter Daubigny. His first solo exhibition after his return was an unexpected triumph; every work of his sold, netting the artist $5000. From this point on, Enneking became one of Boston's favorite and most prolific landscapists. The writer Hamlin Garland declared, "Only Enneking and some few others of the American artists . . . have touched the degree of brilliancy and sparkle of color in the world today." Enneking was considered as a candidate for the Ten until the organizers decided to restrict membership to artists formerly affiliated with the National Academy and Society of American Artists.

Enneking painted his popular woodland twilight scenes in a warm, muted Barbizon style, and his sunnier New England landscapes in a bright, spontaneous Impressionist manner. Even though he constantly reworked his canvases, his densely painted scenes retain an alluring freshness. The tender blond palette and spirited impasto of this atmospheric view of rolling hills shows Enneking's sheer delight in pigment. Enneking was so enamored of New England scenery, he helped develop Boston's park system, and became one of this country's first champions of environmentalism.

FREDERICK FRIESEKE

1874-1939

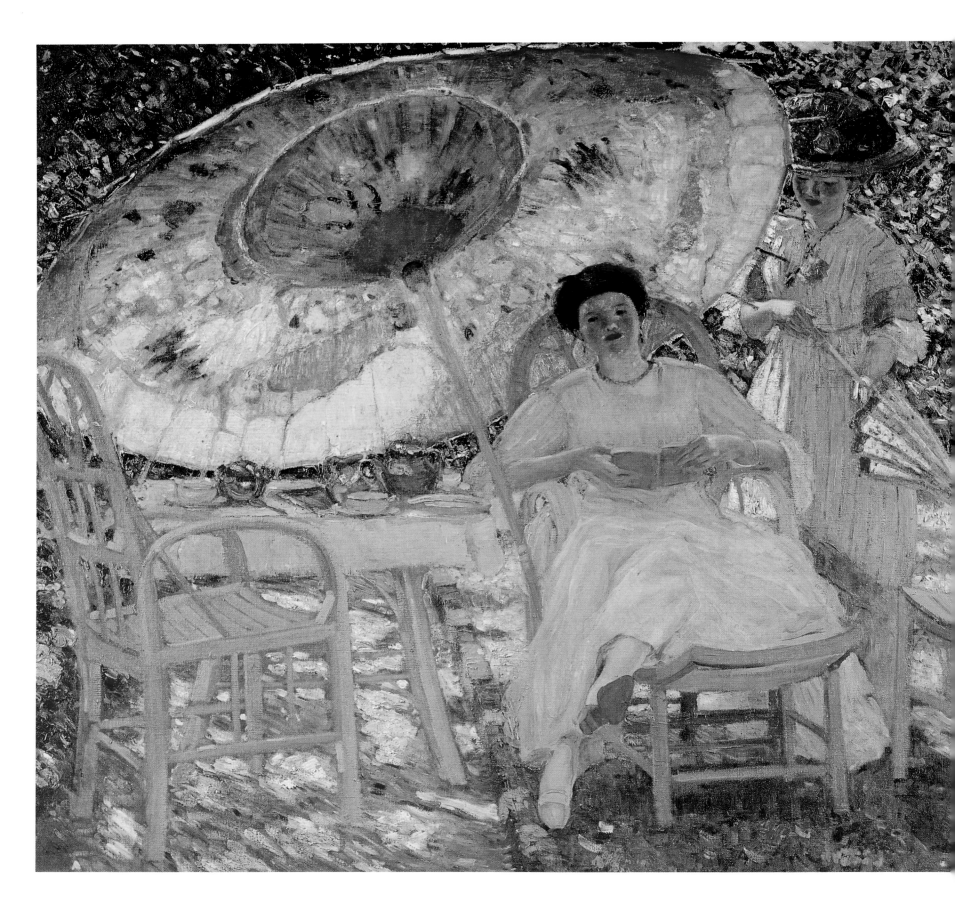

The Garden Parasol, c. 1909

Oil on canvas, 57⅛ × 77 in.
North Carolina Museum of Art, Raleigh
Purchased with funds, State of North Carolina

Frederick Frieseke dominated the second generation
of American Impressionists who flocked to Giverny at
the turn of the century. Born in Michigan and trained at
the Académie Julian, this expatriate received acclaim
in Europe, especially Italy, before his reputation
reached America. Frieseke's pictures set the tone for the
later American Impressionists, who preferred figure
pieces to landscapes and painted in a pleasantly dec-
orative style.

The Garden Parasol, like so many of his paintings, is set
in Frieseke's carefully tended Giverny yard. In 1912 he
stated, "It is sunshine, flowers in sunshine, girls in sun-
shine, the nude in sunshine, which I have been princi-
pally interested in for eight years . . ." Spreading like a
giant sunburst across the composition, the bird-
adorned parasol provides not just an exotic accent, but
a gaily-colored filter through which the blazing light
streams. The sunshine seems to ignite the parasol's
reds, oranges, and golds, and the beams of tinted light –
fallout from this prismatic explosion – scatter all over
the table setting, faces, dress, and lawn.

Torn Lingerie, 1915
Oil on canvas, 51¼ × 51¾ in.
The Saint Louis Art Museum

Lady in a Garden, c. 1912
Oil on canvas, 31⅞ × 25¾ in.
Terra Museum of American Art, Chicago
Daniel J. Terra Collection

Though a committed plein-airist, Frieseke also enjoyed creating intimate interior scenes, usually set within his brightly painted house. His indoor views tend to have a nostalgic, historicizing air, in contrast to his outdoor work's voguish contemporaneity. Like Renoir, his favorite artist, Frieseke looked to rococo art for inspiration. In *Torn Lingerie* the lacy peignoir, confectionary palette, racily exposed legs, and Directoire-style chair, all recall the eighteenth-century "boudoir art" of Boucher, Fragonard, and their followers. The woman's sweet, symmetrical features and bisque-white complexion make her as precious and ornamental as the luxury objects scattered across her dressing table. Her coral beads and dark, upswept hair – whose shiny brunette tones recur in the table's spiral-turned legs – set off charmingly her ladylike pallor.

Important as his magnificent garden was to his art, Frieseke took little interest in horticulture – his wife did all the landscaping for him. Frieseke approached flower painting not as a botanist, but as a colorist: "I know nothing about the different kinds of gardens, nor do I ever make studies of flowers. My one idea is to reproduce flowers in sunlight . . . to produce the effect of vibration, completing as I go . . . If you are looking at a mass of flowers in the sunlight out of doors you see a sparkle of spots of different colors; I paint them that way." The woman is so immersed in the floral profusion, she is nearly camouflaged. One can hardly tell where the long stalks leave off and the pattern of her dress begins. The garment's interrupted stripes break down the solid mass of her body in a manner unusual for American Impressionists. Knee-deep in the tapestry-like weave of color and light, she appears the tallest and loveliest flower in the garden.

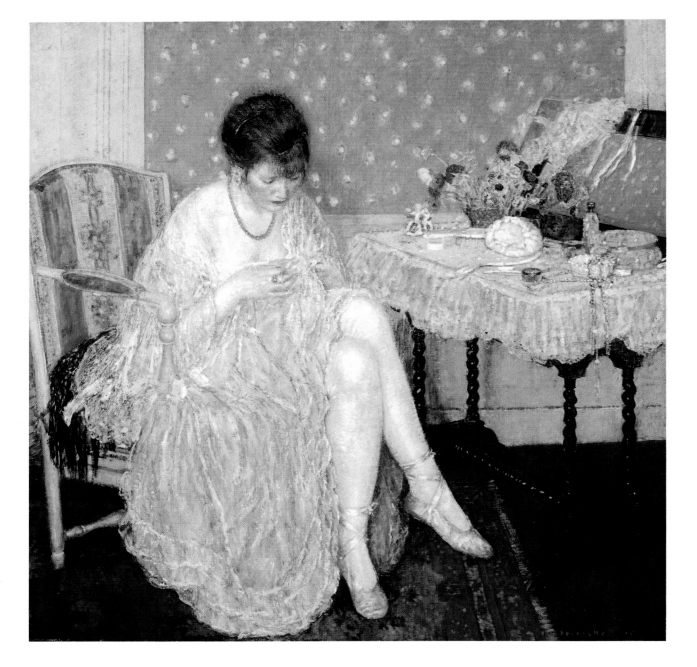

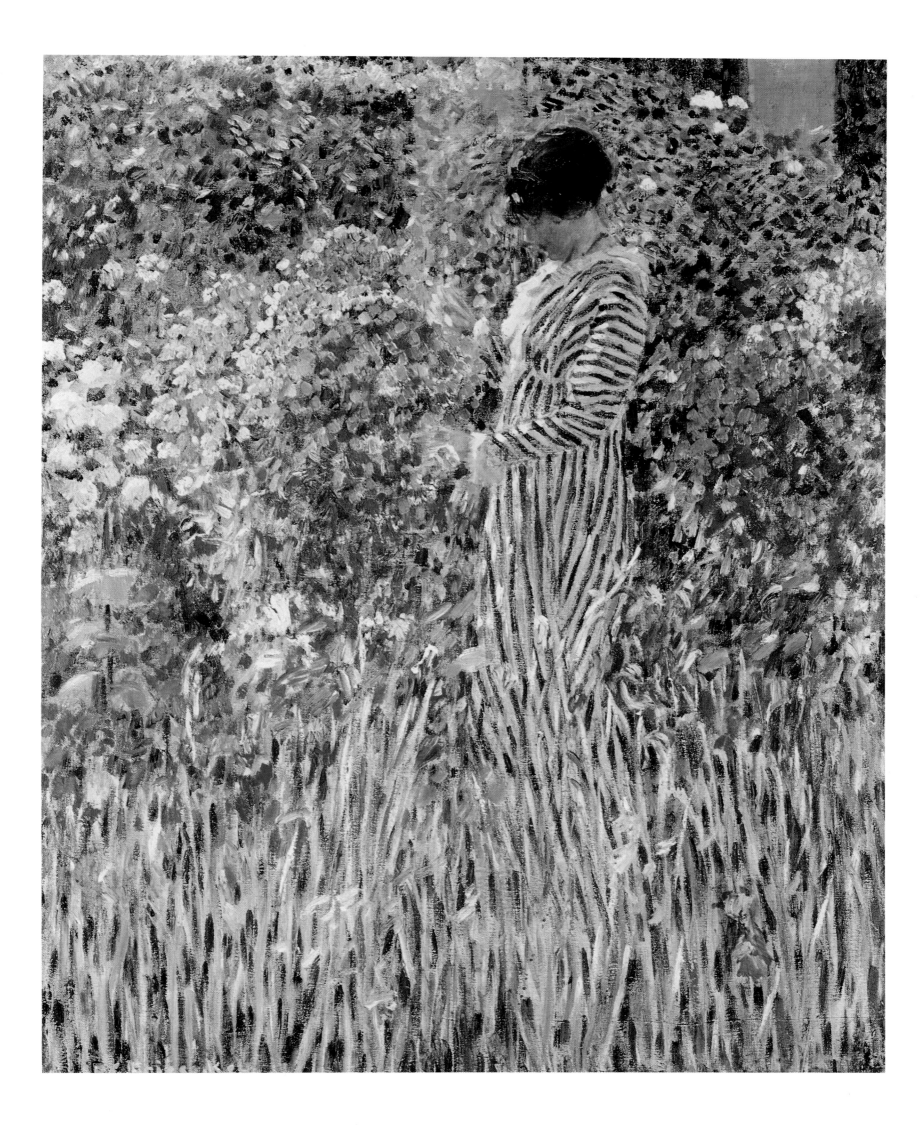

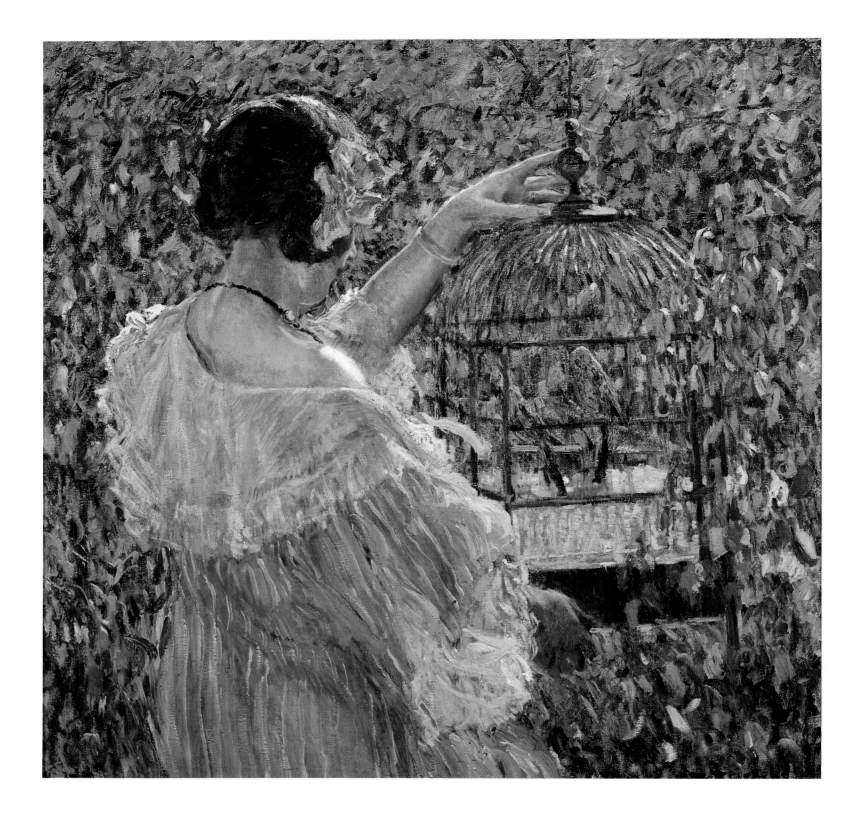

The Bird Cage, c. 1913
Oil on canvas, 31 × 31 in.
New Britain Museum of American Art, New Britain, CT
John Butler Talcott Fund

Even more than usual, in this painting Frieseke is concerned with rich surface pattern and brisk color sensations, rather than creating an enterable pictorial space. Up close, the flurry of strokes making up the striped blue gown, bird-cage wires, leaves and flowers, all seem to merge and overlap; only from a distance does the pigment coalesce into distinguishable forms. Frieseke valued spontaneity in painting: "I cannot scrape down or repaint a canvas. I must take a new one . . . Nor do I believe in constructing a picture from manifold studies." The woman's dishabille – her robe slips off one sun-flecked shoulder – and turned back make the viewer feel like an intruder upon a private, solitary scene.

Summer, 1914
Oil on canvas, 45×57¾ in.
© 1980 The Metropolitan Museum of Art, New York
George A. Hearn Fund, 1966. (66.171)

Frieseke was one of the few American Impressionists who regularly painted the nude. Defending his expatriate status, he stated: "I am more free and there are not the Puritanical restrictions which prevail in America. Not only can I paint a nude here out of doors, but I have a greater choice of subjects." Frieseke's model in *Summer* does not seem "naturally" nude in the landscape, like a latter-day wood nymph; we are quite aware that she has removed her clothes for the painter, since they lie in a heap at her feet. The choker encircling her neck, her passive pose, and the primly dressed woman watching over her highlight her vulnerable nakedness. Most American artists shied away from such frank female sensuality. As art historian Samuel Isham remarked in 1905: "There is no room for the note of unrestrained passion, still less for sensuality. It is the . . . beauty and purity of young girls which [Americans] demand, but especially the last." Frieseke's treatment of the nude is not prurient; the flesh becomes just another sun-dappled substance whose undertones of acrid yellow, delicate pink, and pungent green are brought out by the intense summer light.

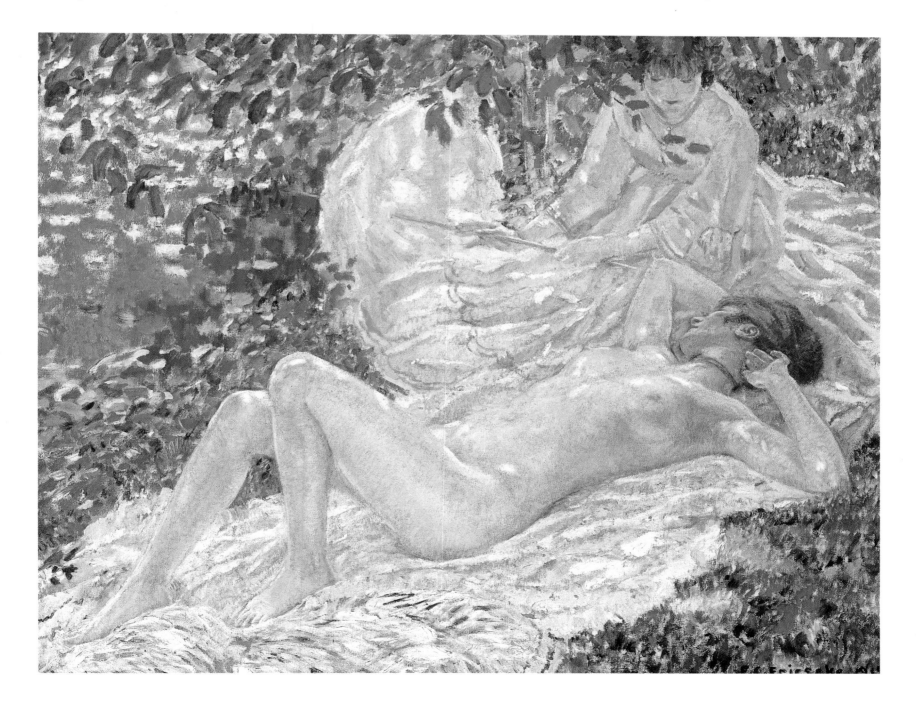

WILLIAM GLACKENS

1870-1938

Interior, 1899
Pastel on paper, 13¼ × 7½ in.
New Britain Museum of American Art, New Britain, CT
Harriet Russell Stanley Fund

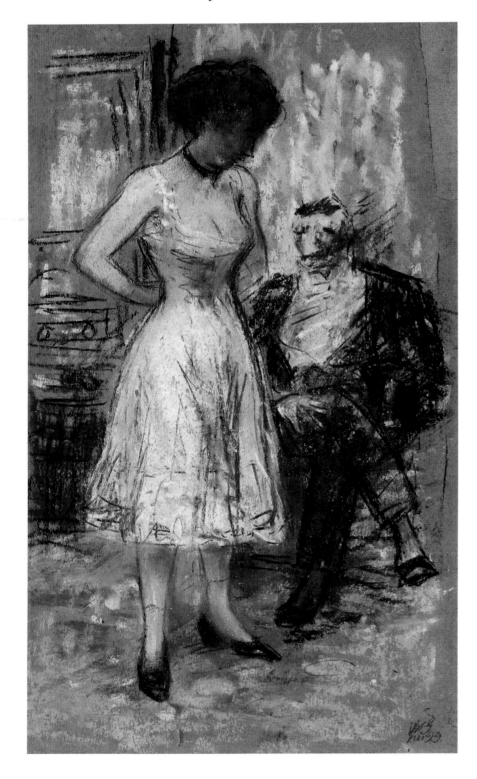

The very notational style of this pastel, which blurs details of face and setting, adds to the illicit atmosphere of the scene – as if we really shouldn't be witnessing this tryst at all. An elegant gentleman relaxes proprietarily as he watches a woman – presumably a prostitute or mistress – undress. This kind of peephole view of the demimonde was popular with the Impressionists, especially Degas and Manet, but very rare among American Impressionists, who preferred wholesome or refined subjects. Glackens' interest in the more sordid aspects of life grew out of his years as a reporter-artist for newspapers, and his affiliation with the Eight, a group whose art regularly confronted gritty, urban realities. It is interesting that Glackens portrays the woman – though standing, and larger-scaled than the man – as a compliant victim rather than a corrupting temptress.

Chez Mouquin, 1905
Oil on canvas, 48 × 39 in.
© *1988 The Art Institute of Chicago. All Rights Reserved*
Friends of American Art Collection. (1925.295)

Chez Mouquin was a Parisian-style restaurant in New York at 28th Street and Sixth Avenue where artists, writers, adventurers and prostitutes congregated. Everett Shinn, a fellow member of the Eight reminisced, "It was at Mouquin's that the crowd really became intimate." The bonvivant at right is James B. Moore, a Mouquin habitué, lawyer, restaurateur, and art patron. He is probably seated beside one of the several mistresses (or "daughters," as he fondly called them) whom he squired about town.

A number of elements in *Chez Mouquin* recall such paintings by Manet as *Bar at the Folies Bergère* (p. 12): the glossy greys and blacks, delectable still life, blasé female face, chinese-puzzle composition (what is a mirror reflection, what is not?) and psychological disengagement of the couple. Though Glackens was sometimes praised for avoiding Manet's and Degas' coarseness, one disgusted critic, after viewing this painting, demanded, "Is it fine art to exhibit our sores?"

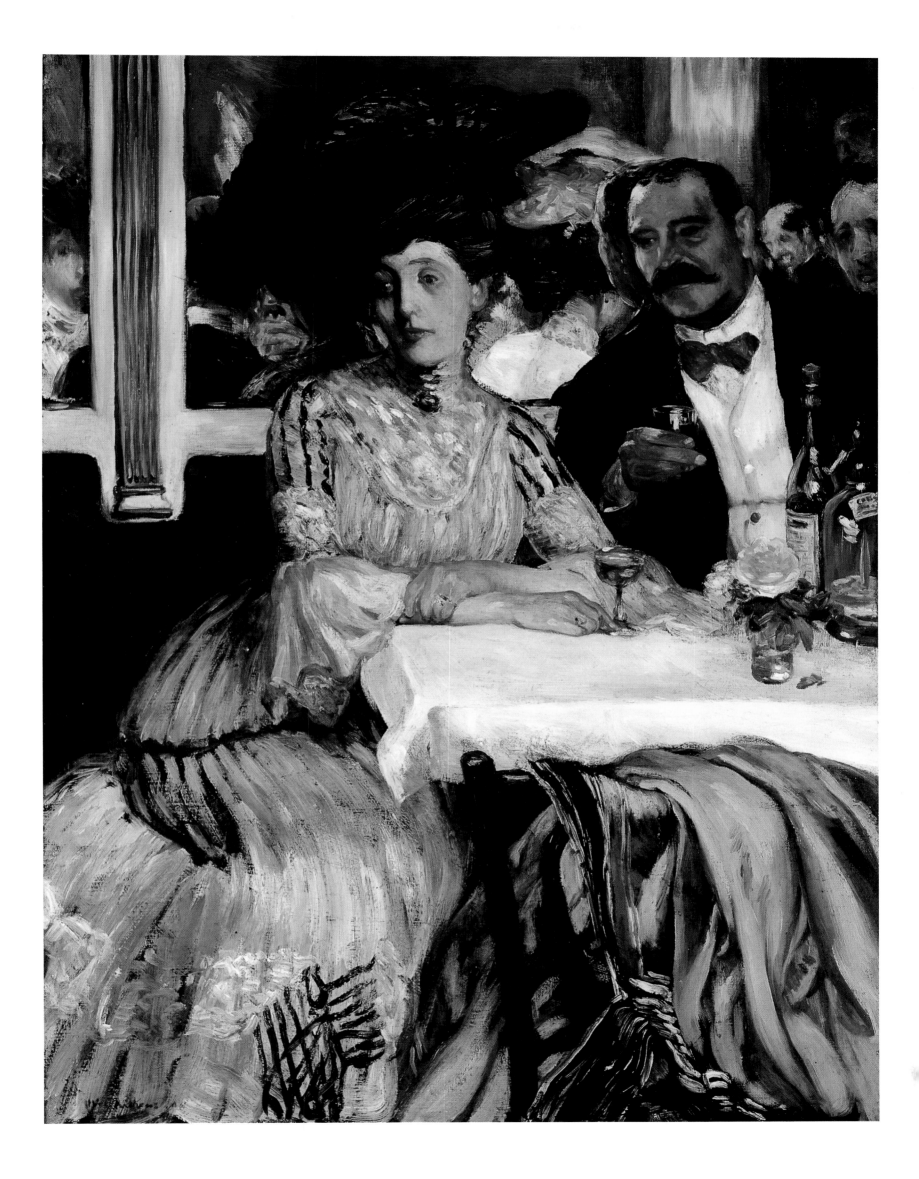

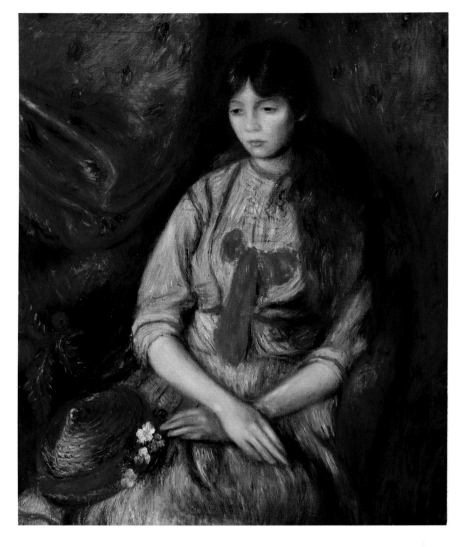

Portrait of a Young Girl, 1915

Oil on canvas, 32 × 26 in.
New Britain Museum of American Art, New Britain, CT
A. W. Stanley Fund

Though Degas and Manet influenced Glackens' earlier paintings, his later works are indebted to Renoir. This change in taste may have evolved from his association with patent-medicine king Albert Barnes, whose collection of work by Renoir and other artists was formed with the help of Glackens. The year after this picture was painted, Albert Gallatin noted, "In many . . . recent portraits and figure compositions the influence Renoir has exerted on his technique and palette is quite apparent." Though Glackens' later dependence on Renoir has been disparaged by recent critics, in his own day it was applauded. Forbes Watson wrote in 1920, "Glackens' gift did not flower fully until he came in contact with the art of Renoir." *Portrait of a Young Girl* resembles Renoir's style in its winsome, feminine subject; feathery brushstrokes, which soften but still define forms; and robust colorism, which in this case involves a rich spectrum of contrasts between the complementary reds and greens.

LILIAN WESCOTT HALE

1881-1963

L'Edition de Luxe, 1910

Oil on canvas, 23¼ × 15 in.
Courtesy, Museum of Fine Arts, Boston
Gift of Miss Mary C. Wheelwright

This painting treats a typical Boston Impressionist theme – a lovely woman in an elegant interior. The figure's quiet absorption in the handsome album of prints, and her sun-washed, comfortable surroundings evoke the art of Vermeer, the subject of a book by Hale's husband, Philip. The majority of the painting is given over to the window, whose filmy curtains diffuse the bright daylight. The filtering sunshine dematerializes the woman's body, and leaves only her bowed head and arched hands solidly modeled. The light also creates a golden nimbus around her pillowy hair, whose auburn tones reappear in the burnished table top. The ellipse of her coiffure is repeated in the openwork porcelain bowl and the embroidered doily beneath it. The blossoming branch, an Orientalizing touch, constitutes the picture's only irregular shape. Hale's porous, gentle paint application enhances the mood of peaceful refinement.

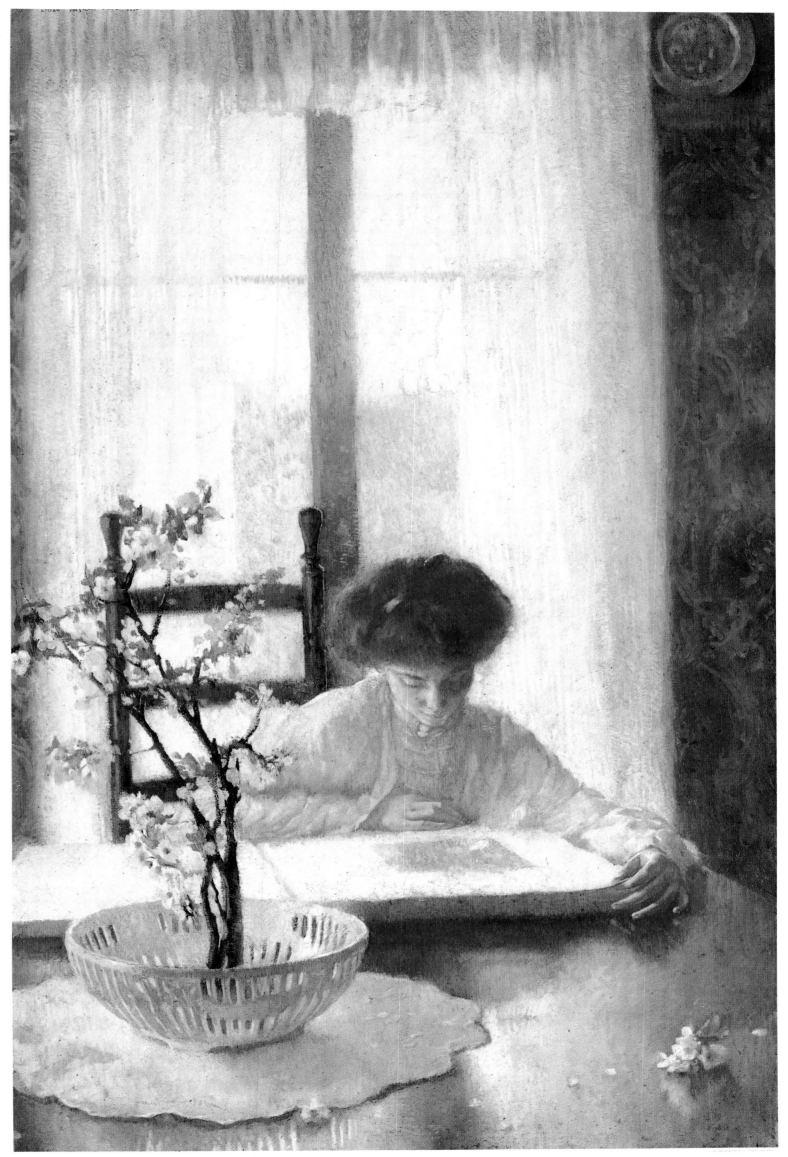

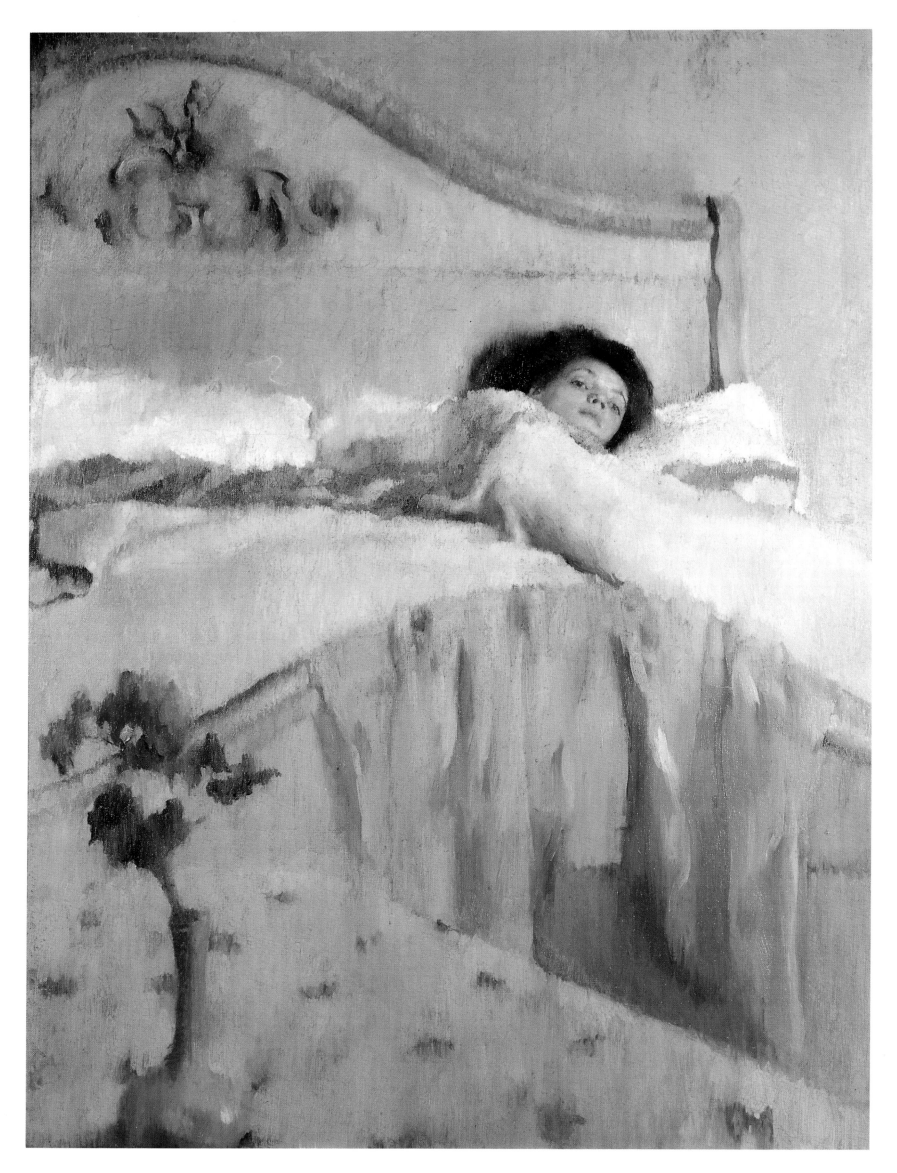

Zeffy in Bed, c. 1912
Oil on canvas, 30⅛×22 in.
Sheldon Memorial Art Gallery
University of Nebraska, Lincoln
Nebraska Art Association, Beatrice D. Rohman Fund

Because Lilian's paintings were better appreciated than her husband Philip's, their daughter Nancy believed that her father was "secretly jealous" of her mother's success. Though the couple occasionally exhibited jointly, they rarely painted together, as Lilian worked at home in Dedham, Massachusetts, while Philip maintained a studio in Boston. Nancy remembered that her parents, though from socially prominent families, "were comfortable not seeing anyone; they just wanted to paint."

Rose Zeffler, or "Zeffy", was a model who sat for both Lilian and Philip; her full, rounded face and sensual "cupid's bow" lips closely matched the feminine ideal of the period. Here, Zeffy's head, on a diagonal axis with the geranium, seems disembodied above the blanket, whose oblique fold parallels the edge of the patterned table top. Hale was known as much for her delicately wrought charcoal drawings as her paintings. In both media she used idiosyncratic parallel strokes that create a soft, blurry effect, as if every scene were viewed through finely ribbed gauze.

PHILIP LESLIE HALE

1865-1931

The Crimson Rambler, c. 1909
Oil on canvas, 25¼ × 30³⁄₁₆ in.
The Pennsylvania Academy of the Fine Arts, Philadelphia
Joseph E. Temple Fund. (1909.12)

One of the few American Impressionists to write about the movement, the scholarly Philip Hale was best known in his time as a teacher and critic. A magazine correspondent during his years in France, he wrote some of the earliest articles on Impressionism and Post-Impressionism to appear in the New World. Virtually the spokesman for the Boston Impressionists, Hale also published the first American monograph on their favorite old master, Vermeer.

Under the influence of the latest French techniques, such as pointillism, Hale in the early '90s painted some of America's most avant-garde pictures. Unfortunately, these works earned him the reputation of "crude" extremist. *The Crimson Rambler* represents Hale's retrenchment from radicalism around the turn of the century, probably a result of the combined influence of his wife's fine figure drawing and his own art-historical scholarship.

Though the forms are more distinctly delineated and the brushstrokes smaller than before, this painting is still very Impressionist. The sun-spangled trailing rose bush sheds its red reflections on the house, lawn, dress, and veil, and iridescent specks of lilac and green flicker everywhere, even among shadows. But Hale eschews the skewed planes of French Impressionist compositions, favoring instead a classically balanced rectilinear grid construction.

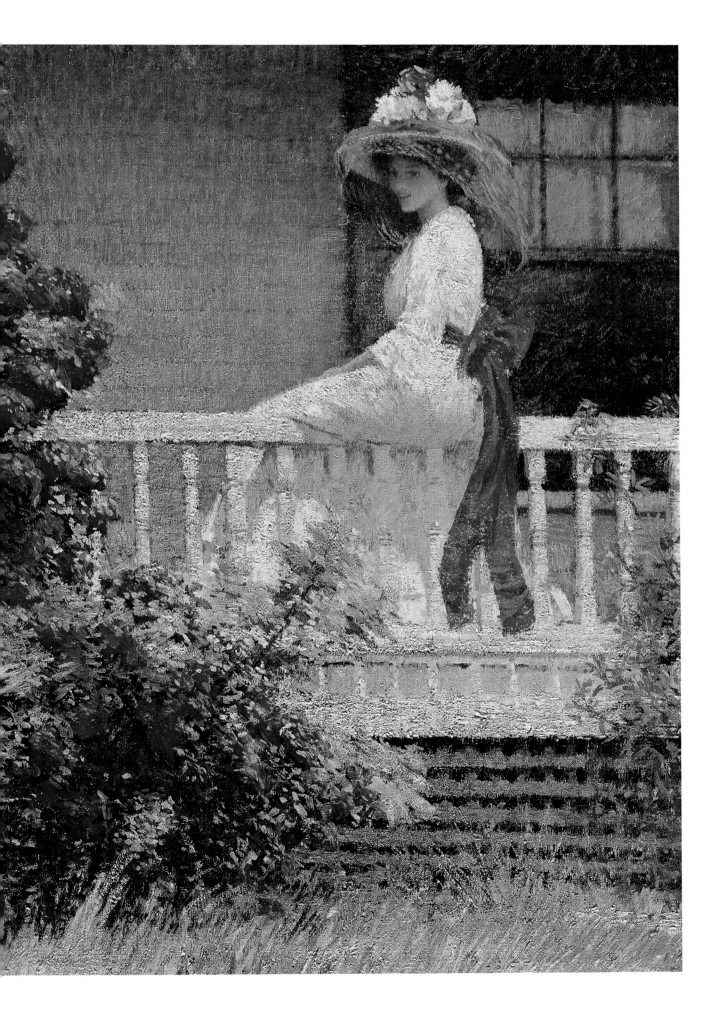

CHILDE HASSAM

1859-1935

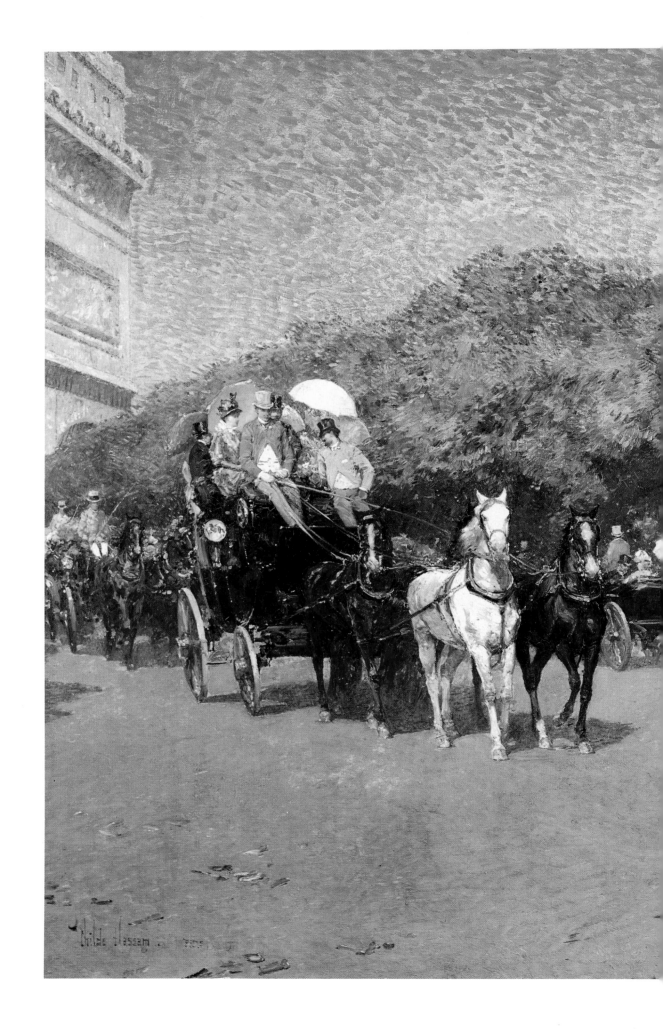

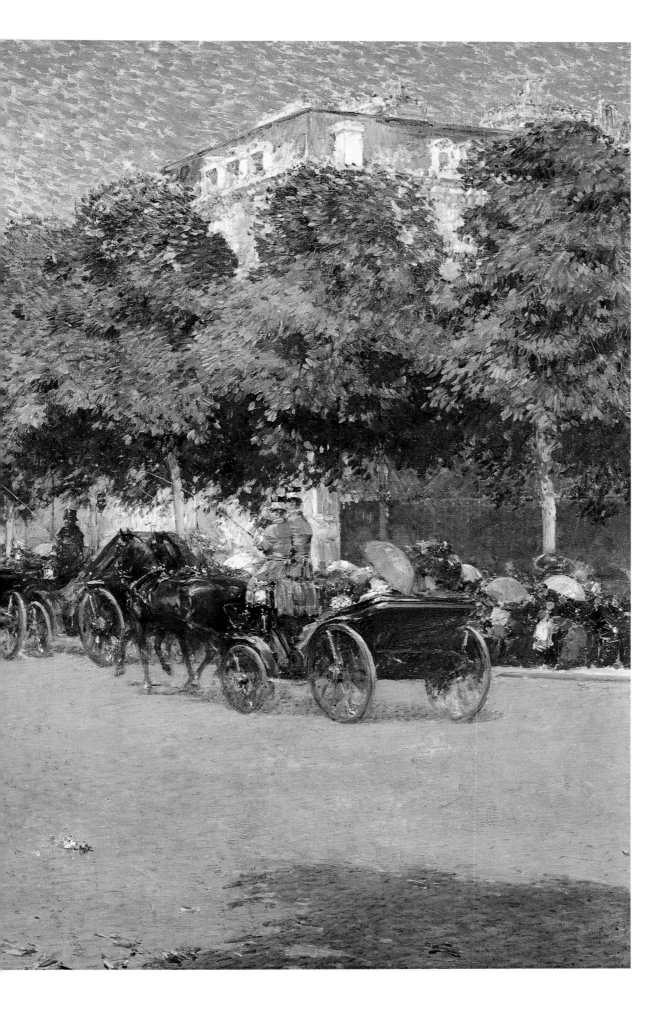

Previous pages:

Le Jour du Grand Prix, 1887

Oil on canvas, 36×48 in.
New Britain Museum of American Art, New Britain, CT
Grace Judd Landers Fund

Au Grand Prix de Paris, 1887

Pastel on paper, 15⅞×12½ in.
Collection of The Corcoran Gallery of Art, Washington, D.C.
Bequest of James Parmelee

Hassam traveled to Europe for the first time in 1883. His three-year stay in France, beginning in 1886, proved to be his watershed. Before this trip, Hassam had specialized in dark-toned Boston street scenes. In Paris, he resumed this theme, but updated it with a bold new Impressionist palette and touch.

In *Grand Prix Day*, traces of Hassam's former style are still visible in the dark, detailed horses, carriages, and figures, which clash with the bright colors and dabbing strokes of the sky and boulevard. Since Hassam worked this painting up from studies, it is not the spontaneous plein-air production it appears to be. Yet the composition, with its large empty foreground, convergent, congested background and oblique viewpoint is every bit as modern as the subject matter. The scene depicts fashionable Parisians along the Avenue de l'Imperatrice on their way to the Longchamp race track for the annual running of the Grand Prix. Longchamp was situated at the western edge of the Bois de Boulogne, a former royal forest which had been converted into a park. The races were reached by specially planned carriage roads, but only the wealthy arrived by carriage; humbler spectators came by foot. Hassam's view of elegant society was so much to French taste, the picture was awarded a gold medal at the Salon of 1888.

Related to the previous picture, this pastel shows the chic crowd who gathered at Longchamp to watch the races. Though Hassam had never worked seriously with the medium until 1886, we must agree with the critic who marveled that Hassam handled pastel with "a gusto that convinces his public in every crayon stroke that it is a fine thing to be a painter." Hassam was clearly attracted to the audience's stylish costumes; in fact he borrowed a convention from fashion plates – showing a side and back view of similar outfits in order to display to full advantage their dressmaking details. The races were as much a fashion show as a sporting event. Milliners and seamstresses mingled among the crowd to admire their creations, and society matrons rubbed shoulders with courtesans. "At first glance they were the same women dressed by the same dressmakers," observed a contemporary, "with the only distinction that the demimondaines seemed a little more chic." But the most striking gowns were worn by mannequins hired by *couturiers* to model their latest designs.

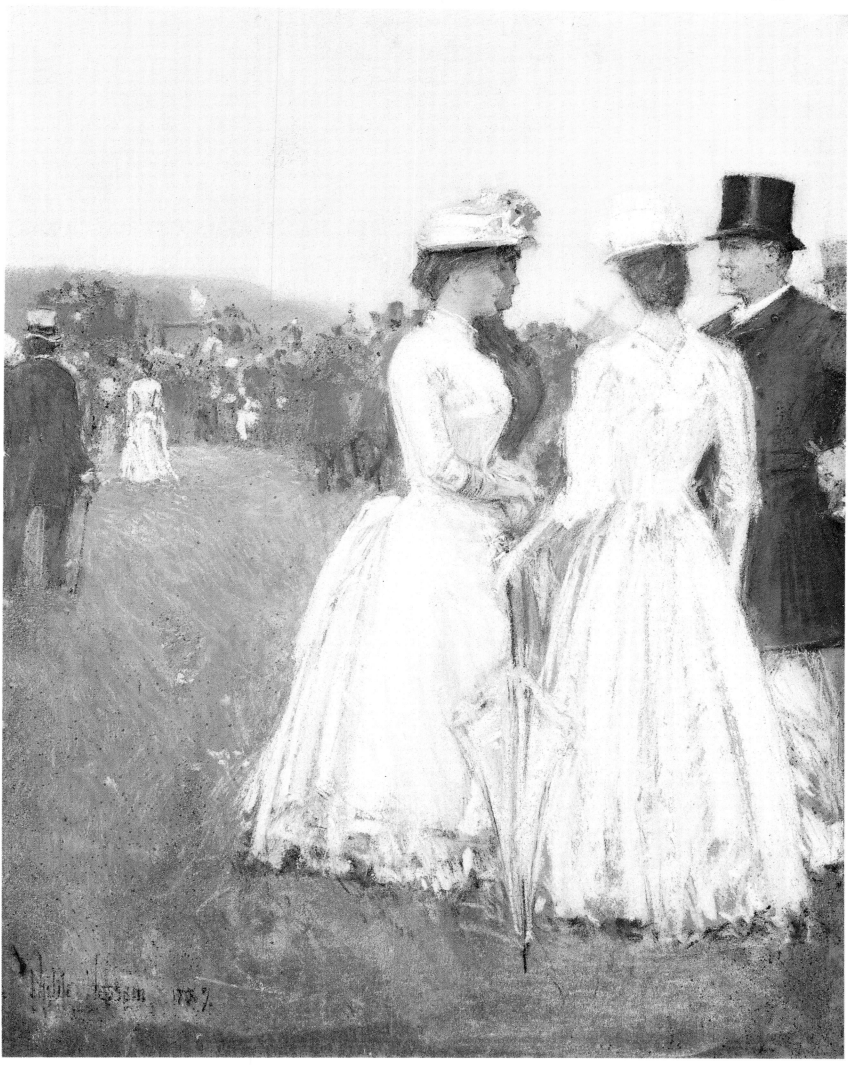

Washington Arch in Spring, 1890
Oil on canvas, 27⅛ × 22½ in.
The Phillips Collection, Washington, D.C.

When Hassam returned to America in 1889, he established a studio at 95 Fifth Avenue in New York City. Lower Fifth Avenue had been an elegant part of town, but by the time Hassam moved there, wealthy New Yorkers were already colonizing the avenue's uptown end. Still, Hassam found agreeable subjects in his neighborhood. A critic described him as "a sort of Watteau of the Boulevards, with unlimited sparkle and gaiety, movement and animation. He suggests a crowd well; he gives you the color of the street and the tone of the city." In *Washington Arch in Spring* Hassam shows a lively cross section of urban humanity; a refuse cleaner, carriages, and all kinds of pedestrians. The spindly foreground shadows, cast by unseen lampposts, give a sense that the world continues beyond the picture's perimeters. The towering arch, designed by Stanford White, was a wooden structure painted to simulate stone. Erected in 1889 to commemorate the 100th anniversary of President Washington's inauguration, it was replaced six years later by a permanent masonry construction. The original monument spanned the street at its terminus, while the later version, which still stands, was built within Washington Square.

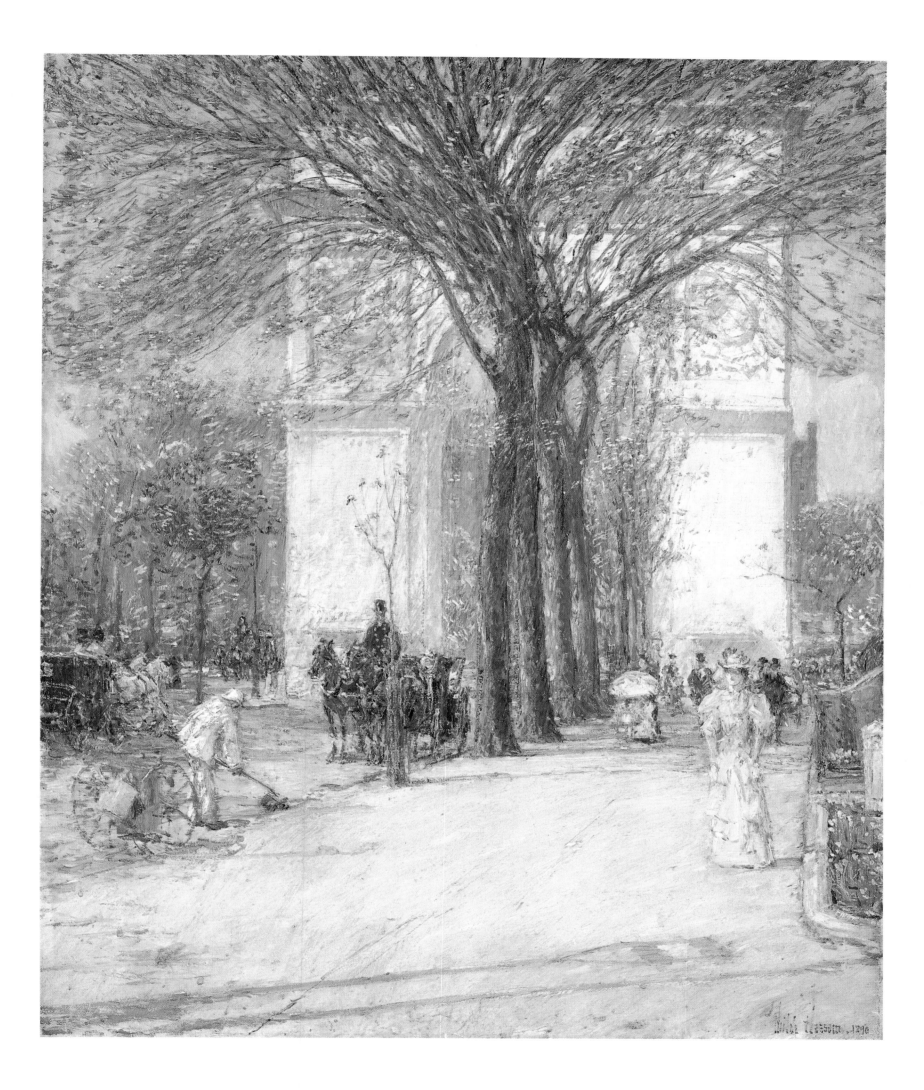

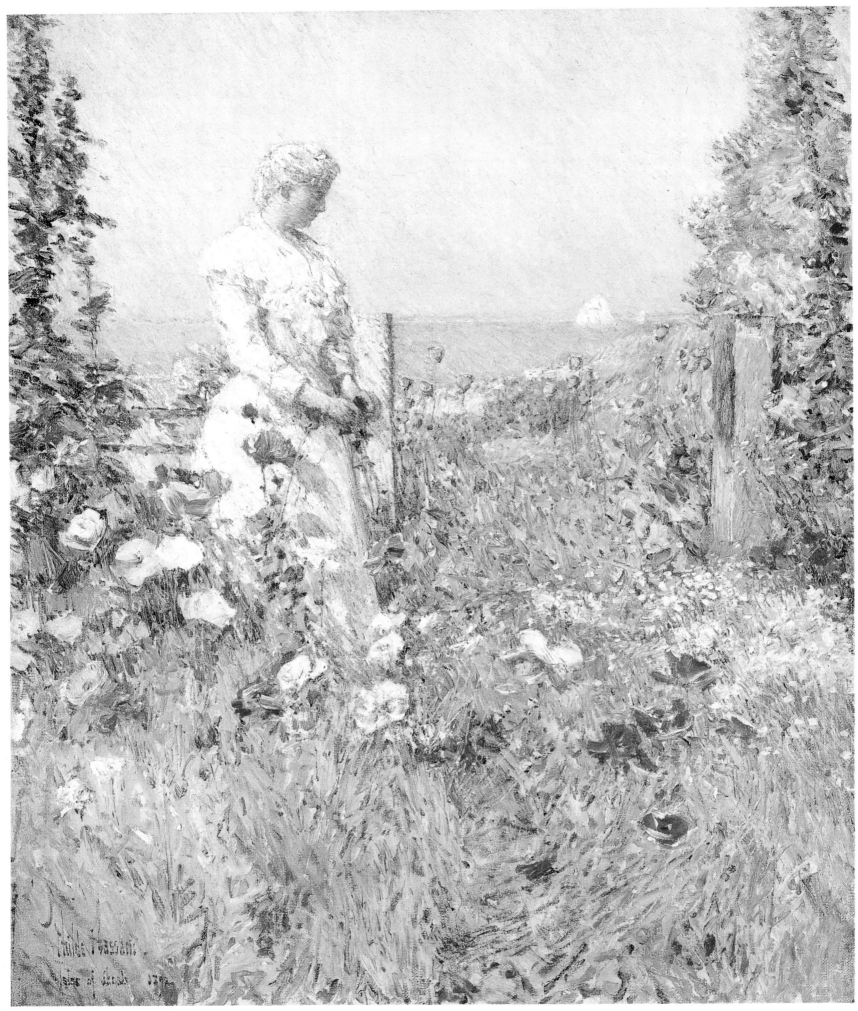

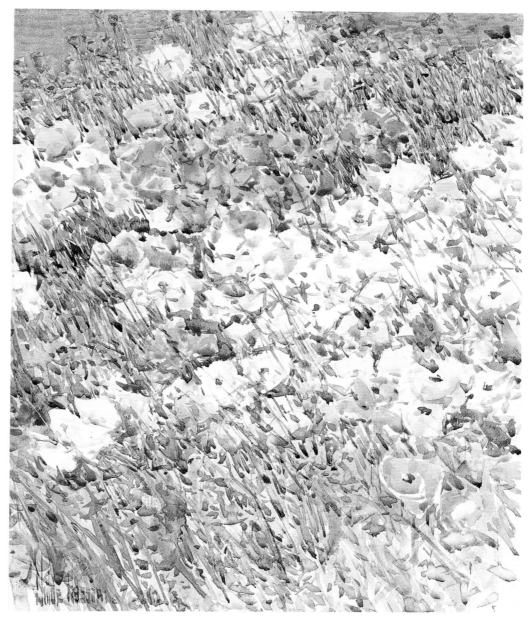

Celia Thaxter in her Garden, 1892

Oil on canvas, 22⅛ × 18⅛ in.
National Museum of American Art
Smithsonian Institution, Washington, D.C.
Gift of John Gellatly. (1929.6.52)

The Island Garden, 1892

Watercolor on paper, 17½ × 14 in.
National Museum of American Art
Smithsonian Institution, Washington, D.C.
Gift of John Gellatly. (1929.6.64)

Beginning in 1890, and for the next 20 years, Hassam summered at Appledore, one of the Isles of Shoals, 10 miles off the coasts of New Hampshire and Maine. Poet and gardener Celia Thaxter, the muse of Appledore, ran a "boarding house for invalids and aesthetic visitors." Hassam's friendship with Thaxter dated back to the early 1880s when she had been a pupil in his watercolor class in Boston. While Thaxter celebrated her "natural" (as opposed to formal) flower garden and the Appledore landscape in several volumes of poetry, the same scenery inspired Hassam's best works of the '90s. Thaxter also wrote poetic tributes to Hassam ("let him but touch a flower, and, lo, its soul is his . . . ''); returning the compliment, he painted homages to her and the environment she created.

In this picture, Thaxter seems to grow from her own garden soil; two years later she was buried in it. Thaxter's own words would provide the best caption for this picture: "Ever since I could remember anything, flowers have been like dear friends to me, comforters, inspirers, powers to uplift and to cheer."

Celia Thaxter admitted, "Yes, I plant my garden to pick, not for show. They are to supply my vases . . . " And, she might have added, to delight her guests. One visitor remarked that staying in this wonderful hostess's house was like "living in a rainbow." This bee's-eye view of the garden is one of the watercolor illustrations Thaxter commissioned for her last published book of poems, *An Island Garden.* In a sense, this project returned Hassam to his origins, as he began as an illustrator of periodicals, and started attracting public attention with a group of watercolors exhibited after his first European trip.

Hassam's light touch replicates the sensations of ocean breezes and sunshine passing through translucent petals. At top, one can see the blue horizontal slashes which define the sea and counteract the stalks' diagonals. Hassam managed to create an illusion of distance in this densely-packed close-up by diminishing the size of his dabs and streaks as the eye moves from the lower left to upper right.

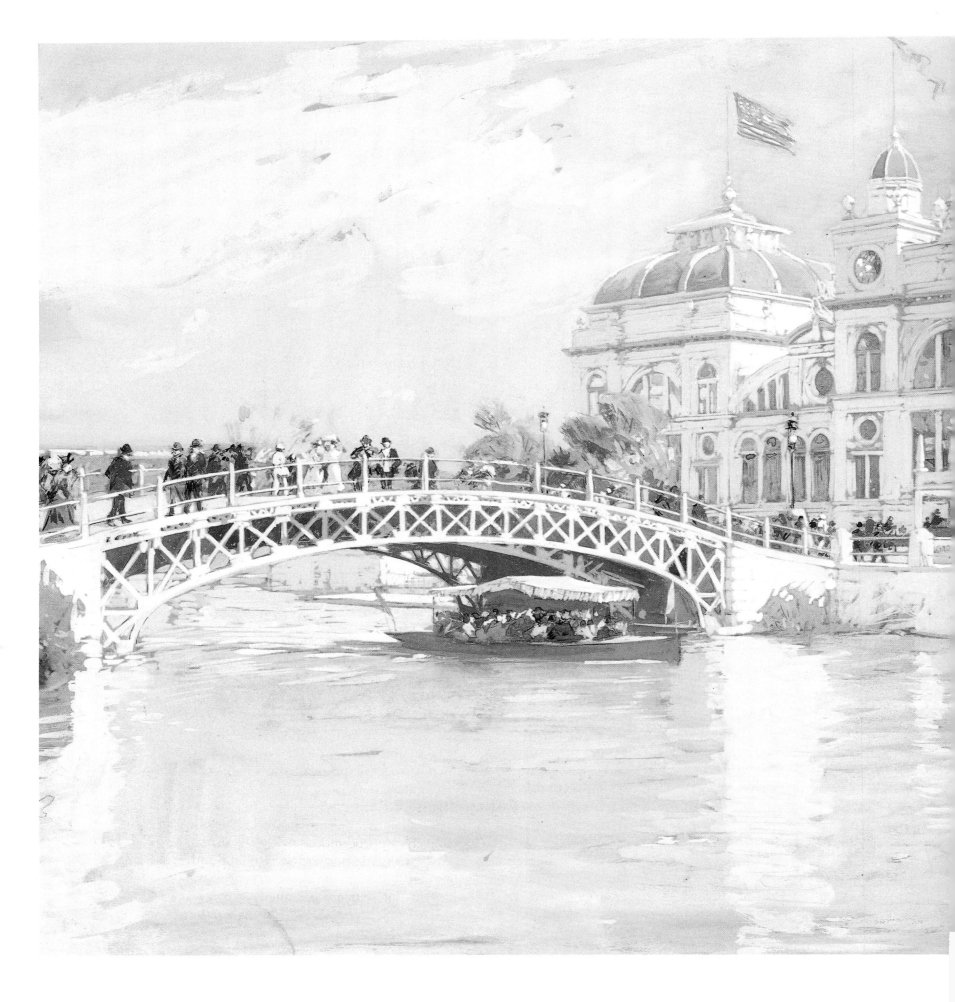

Columbian Exposition, Chicago, 1892
Gouache en grisaille on paper, 10¼ × 13⅝ in.
Terra Museum of American Art, Chicago
Daniel J. Terra Collection

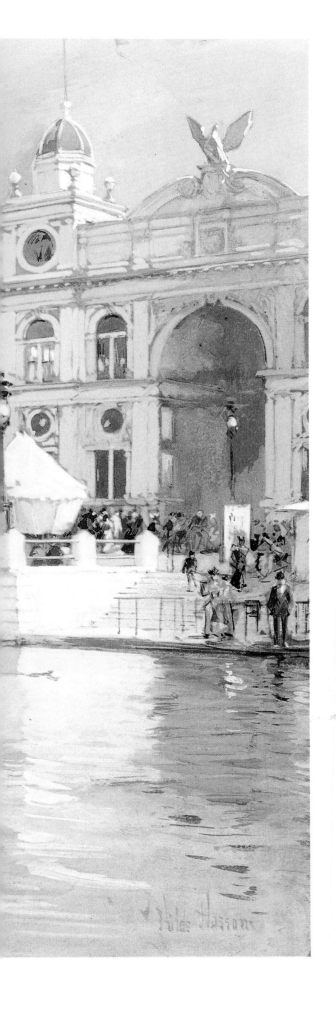

The "White City," the temporary exposition complex for the 1893 Chicago World's Fair, which commemorated the 400th anniversary of Columbus's voyage, rose on 685 acres fronting Lake Michigan. Attended by 27 million people, the fair lasted for an entire year. The spectacular buildings housing the exhibits were designed in the Beaux-Arts style by the country's most illustrious architects, including Richard Morris Hunt (a relative of Hassam's) and Stanford White. Before the fair opened, Hassam made this and other monochromatic gouaches of architectural elevations, which were used by the exposition's planners as visualizations. While the fair was in progress, he executed on-site paintings, one of which was reproduced in a commemorative album documenting the exposition's history. Hassam also exhibited six oil paintings and four watercolors in the fair's fine arts department, and won a bronze medal.

Following page:

Allies Day, May 1917, 1917
Oil on canvas, 36¾ × 30¼ in.
National Gallery of Art, Washington, D.C.
Gift of Ethelyn McKinney in memory of her brother,
Glenn Ford McKinney

When America entered World War I, a changing display of flags decked Fifth Avenue, earning it the nickname "Avenue of the Allies." During the Allied war commissioners' visit to New York in May 1917, the city welcomed them with receptions and parades. As part of the festivities, the avenue was decorated with flags of Great Britain (in honor of commissioner Arthur Balfour) and France (a salvo to commissioner Jacques-Césaire Joffre).

In his depiction of this event, Hassam assumed a viewpoint at about 52nd Street – looking north to St. Thomas's Episcopal Church, the University Club, the Gotham Hotel, and the Fifth Avenue Presbyterian Church. Reproductions of this painting were sold to raise money for the Art War Relief Fund. Hassam's entire flag series (about 24 pictures) was exhibited shortly after the armistice was signed, and again the following year, when a critic wrote, "Never has there been a more marvellous street decoration and never a more brilliant recording of it . . . America speaks in these canvases."

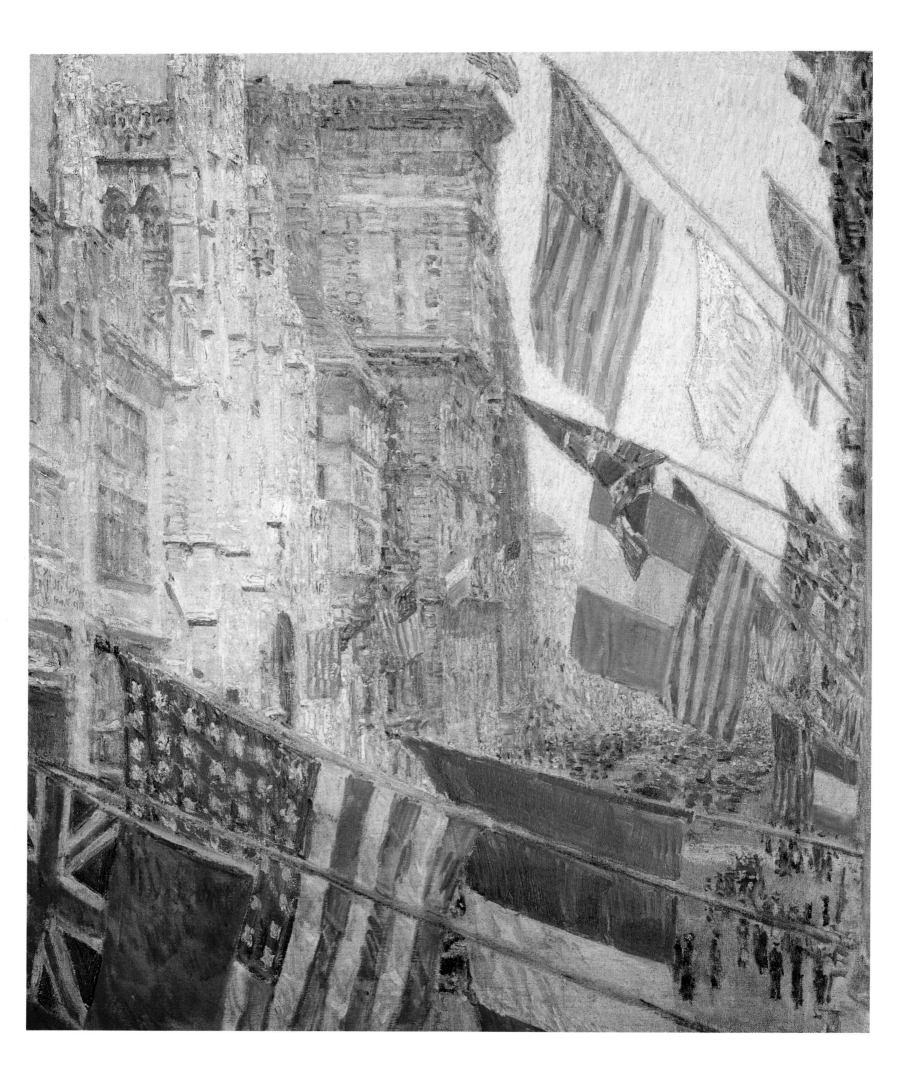

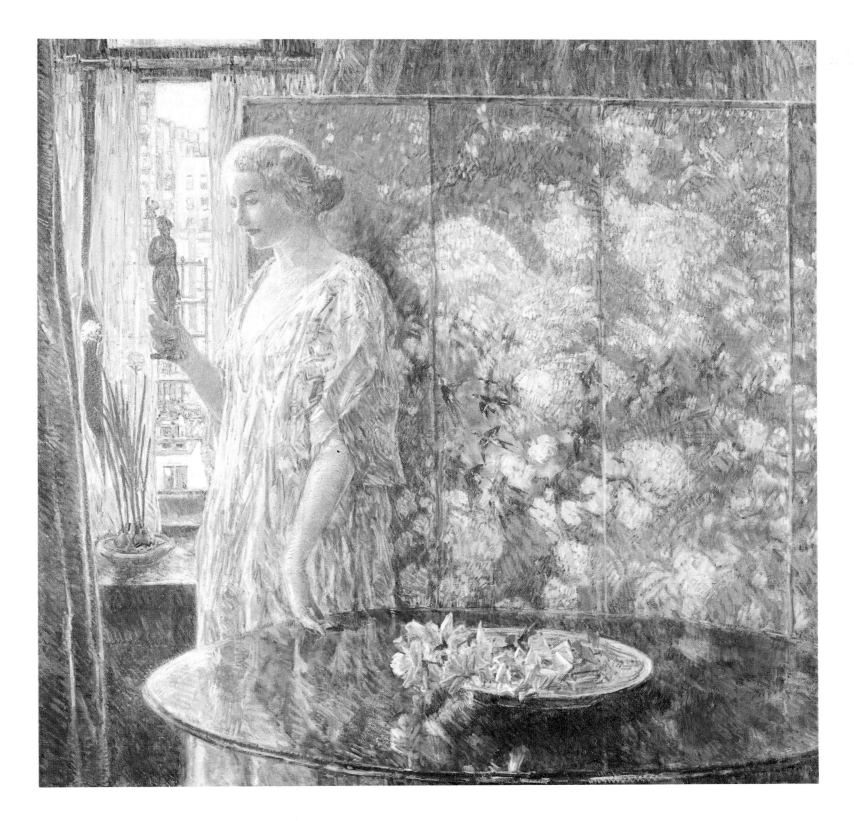

Tanagra (The Builders, New York), 1918

Oil on canvas, 58¾ × 58¾ in.
National Museum of American Art
Smithsonian Institution, Washington, D.C.
Gift of John Gellatly. (1929.6.63)

The picture's title comes from the ancient Greek city which produced the terra cotta figurine held by the woman. In 1874 a large trove of these sensually rendered statuettes of elegantly draped females was unearthed at Tanagra, in northern Boetia. The newly discovered Hellenistic artifacts delighted collectors so much that within a few years expert forgeries appeared. Thus Hassam's example is as likely to be a modern copy as a third-century original. Hassam clearly saw his lovely, loosely-clothed model as a modern Tanagra figure. A smooth, round, solid presence, she is treated quite sculpturally. The contouring, cross-hatching strokes defining the figure retain Impressionist painterliness, yet allow for conventional form-building transitions from shadow to highlight. Hassam added a second visual pun by silhouetting the archaeological discovery against the construction going on just outside his West 67th Street studio window. The real subject here, as in the other pictures of his New York window series, is the transfiguring effects of sunshine on a city interior. Noting how the light irradiates the hair, dress, screen, and table, John Gellatly, who owned the picture, wrote the artist, "It seems to me that no painter's brush has more truly met the command recorded in the Book of Genesis, 'Let there be light.' "

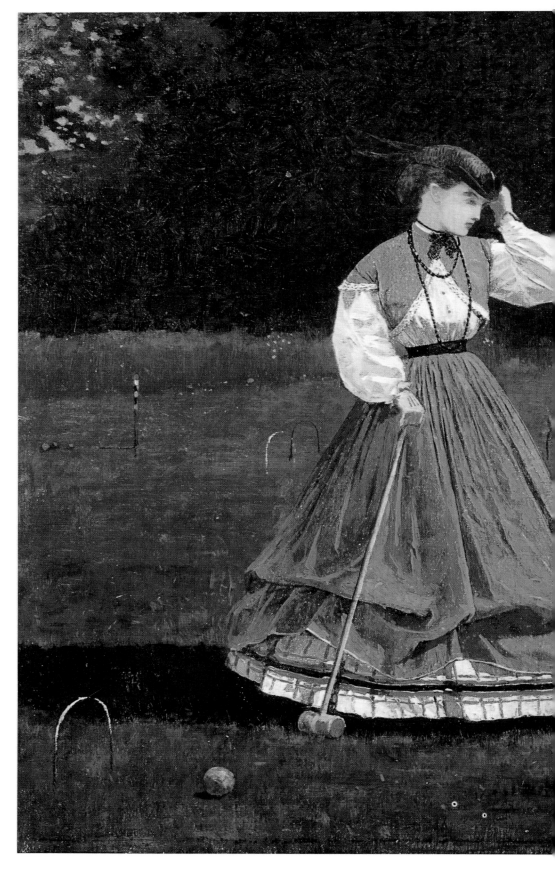

WINSLOW HOMER

1836-1910

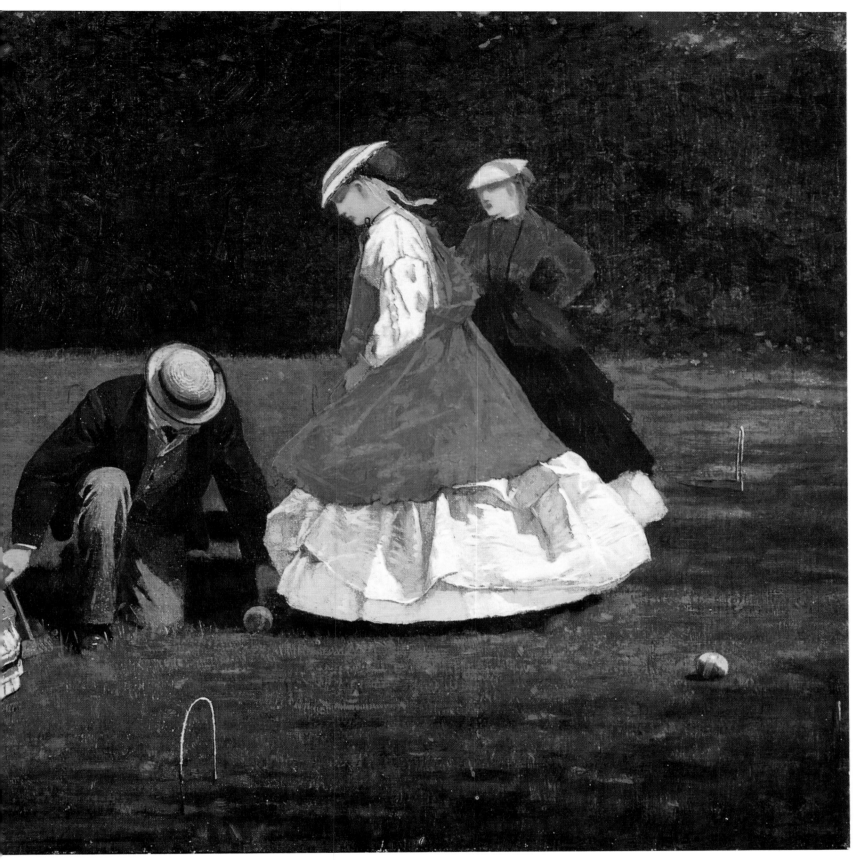

The Croquet Game, 1866

Oil on canvas, 6¼ × 10¼ in.
© *1988 The Art Institute of Chicago. All Rights Reserved.*
Friends of American Art Collection. (1942.35)

In the 1860s, croquet, once a pastime of the upper class, evolved into a fad. One of its chief attractions was that it permitted women to be physically active in male company. Still, the game was more about elegance than sweat; the period rulebooks emphasized the "easy and pleasing attitudes" of the participants' poses. Clearly, these same features appealed to Winslow Homer. He shows a chivalrous man adjusting the ball of a team-mate, who lifts her skirt decorously in order to perform the eponymous "croquet" shot. Their proximity alludes to the popular idea that the real sport on the playing field was not croquet, but flirtation. Yet, the figures' poses, glances, and gestures ultimately negate anecdotal content. The work's emotional inscrutability parallels contemporary achievements of early Impressionist pictures by Manet and Monet – and perhaps mirrors Homer's own famously reticent character. But Homer's concern for illusions of space and solidity relate more to the American realism of Thomas Eakins than Impressionism. Henry James wrote "He sees . . . in gross, broad masses. Things come already modeled in his eye." Indeed, the figures seem as dense and solid as the croquet balls.

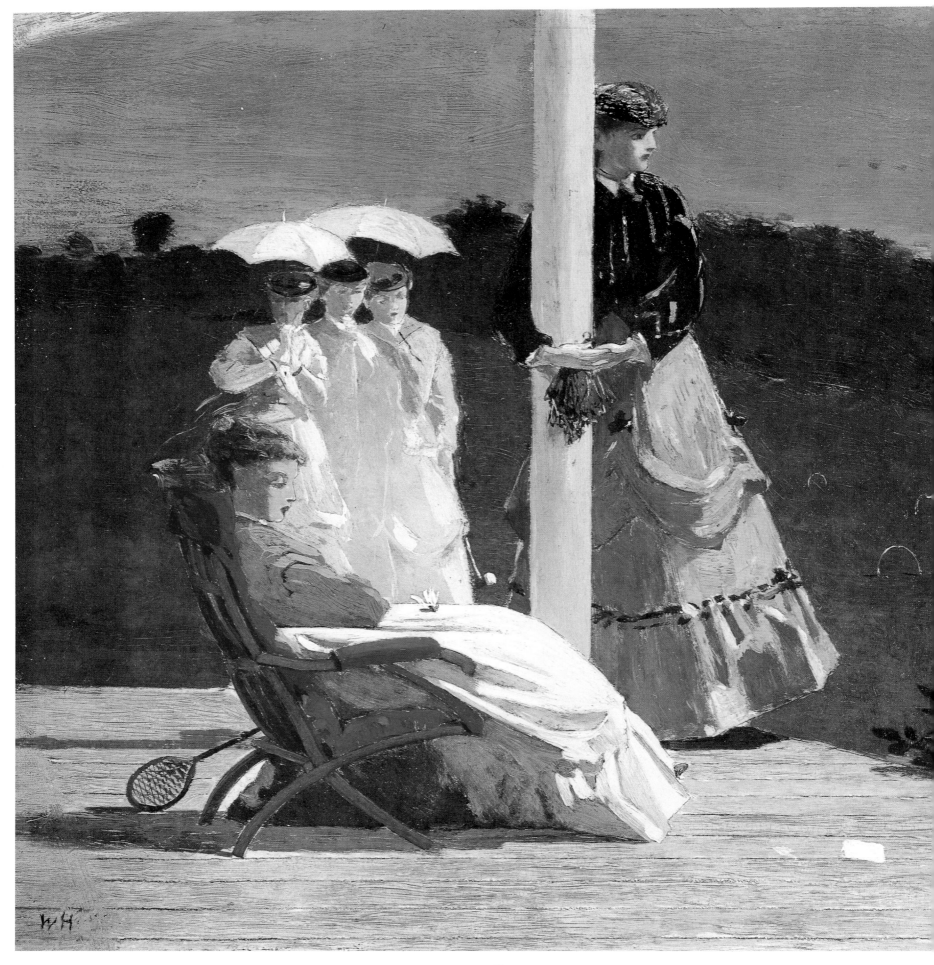

The Croquet Match, 1867-69
Oil on panel, 9¾×15¾ in.
Terra Museum of American Art, Chicago
Daniel J. Terra Collection

In 1867, Homer traveled to France to see his paintings displayed in the Paris Universal Exposition. Apparently, he viewed early examples of Impressionism during this trip. Manet had even set up an independent exhibition right outside the fair grounds, so works would certainly have been accessible to him. Surely Homer's anterior interest in contemporary life, avoidance of narrative, and devotion to outdoor light and color would have predisposed him to Impressionism.

Compared to the previous croquet picture, the

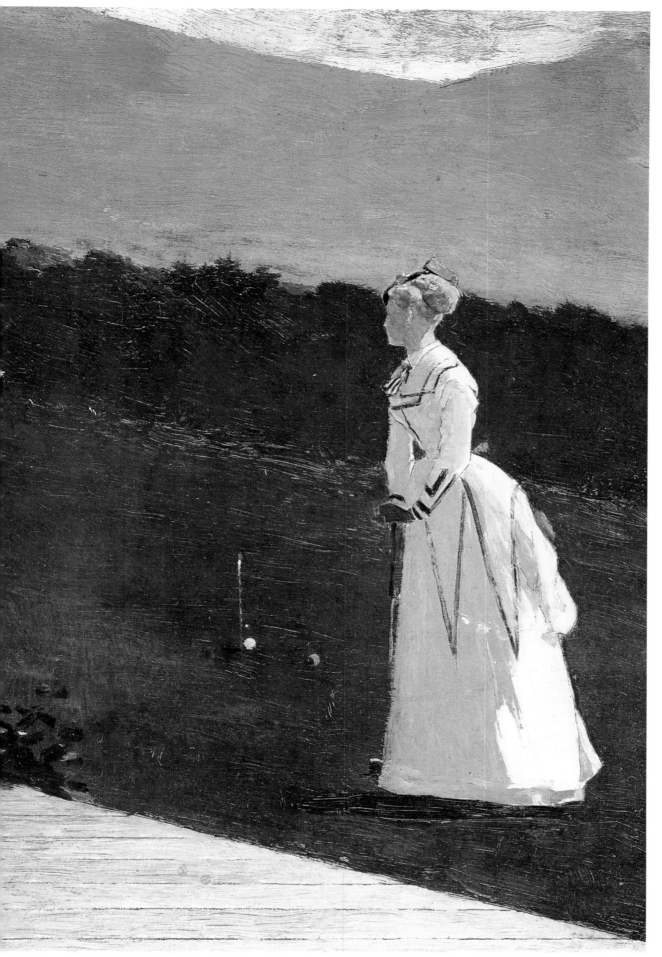

palette is blonder, the figures more buoyant, the composition more asymmetrical, and the forms flatter. The unarticulated spatial zones of mountains, trees and lawn; careening angles of landscape and architecture; off-balance distribution of forms; and voided space also reveal Homer's familiarity with Japanese prints. The picture projects a mood of alienation. Dislocated by scale, none of the figures communicates, while the white pillar and planked porch separate the picture into four disjointed sections.

Long Branch, New Jersey, 1869
Oil on canvas, 16 × 21¾ in.
Courtesy, Museum of Fine Arts, Boston
Charles Henry Hayden Fund. (41.631)

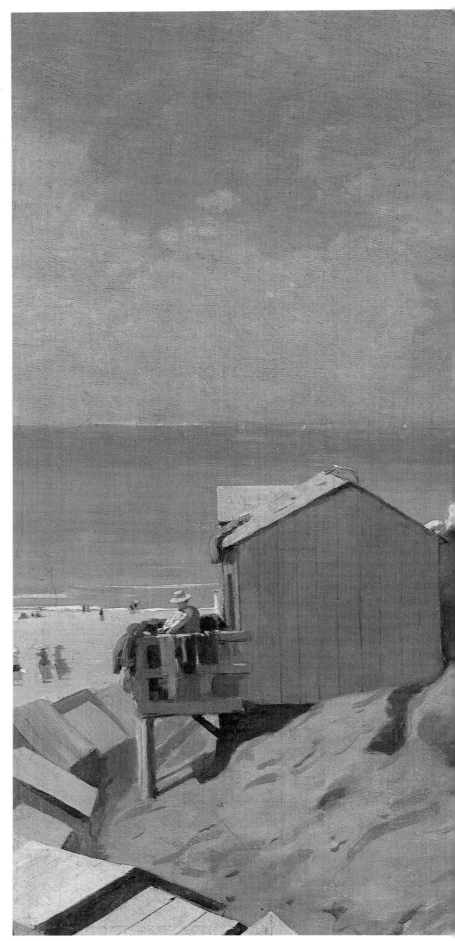

The pale, translucent blues of sea and sky, and the sun-bleached beiges and whites of the sand, bathhouses and dresses show Homer's post-Paris knowledge of Impressionism. In a rare interview, Homer stated, "Outdoors you have the sky overhead giving one light; then the reflected light from whatever reflects; then the direct light of the sun; so that in the blending and suffusing of these several luminations, there is no such thing as a line to be seen anywhere." The motif of a woman protected by a parasol and poised on a breezy hilltop recalls Monet's *Woman with Parasol* (p. 19). But the zigzagging promontories, echoed by the catercornered boathouses and walkways, lead into a space far more deeply defined than anything Monet would allow. The chicly attired women are about to descend from the bluff to the beach for the bathing hour – a fact made more explicit in a related wood engraving executed by Homer the following year for *Harper's Weekly*. Homer's keen eye for fashion extended beyond his paintings; even while a recluse in Prout's Neck, Maine, he sent to Boston for finely tailored suits.

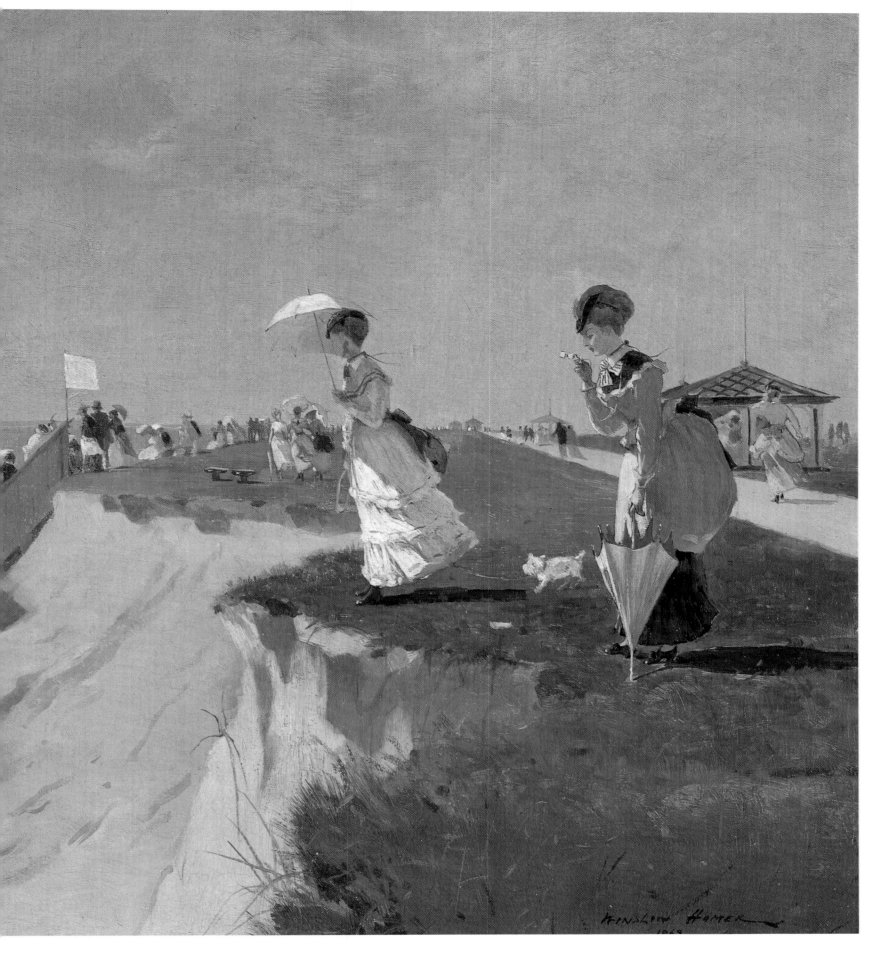

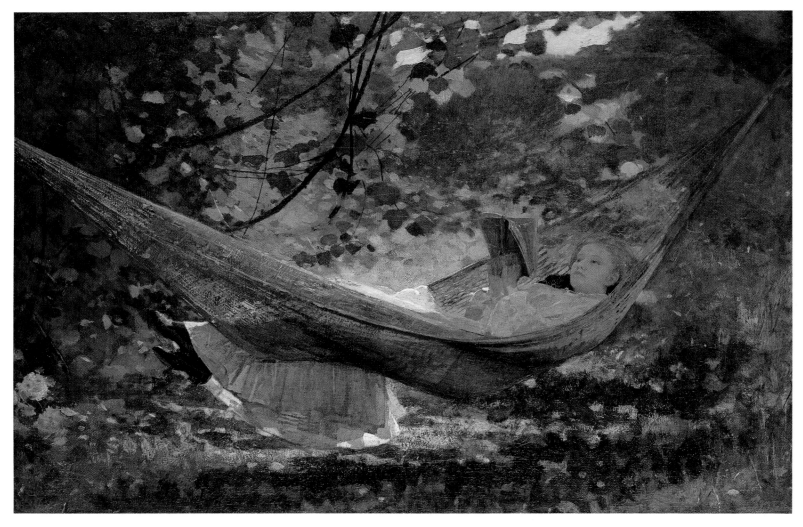

Sunlight and Shadow, 1872

Oil on canvas, 15¾ × 22½ in.
Cooper-Hewitt Museum, The Smithsonian Institution's National
Museum of Design, New York
Gift of Charles Savage Homer

This peaceful picture recalls Homer's comments on painting, transcribed by a writer in 1880: ". . . a painter who begins and finishes in-doors a figure of a man, woman, or child, that is out-doors, misses a hundred little facts, . . . a hundred little accidental effects of sunshine and shadow that can be reproduced only in the immediate presence of Nature . . . I prefer every time a picture composed and painted outdoors . . . This making studies and then taking them home to use them is only half right. You get composition but you lose freshness; you miss the subtle, and to the artist, finer characteristics of the scene itself . . ." One of this painting's many charms is the unexpected way the hammock seems suspended magically from the picture's edges – the branches presumably supporting the hammock are omitted. The weight of the girl's body presses her swinging bed into a crescent shape, repeated in the sun-splattered curve of her skirt's flounced hem. The blast of light at center is the brightest spot; as the eye moves outward, the colors cool off and deepen.

GEORGE INNESS

1825-1894

Apple Blossom Time, 1883

Oil on canvas, 27⅛ × 22⅛ in.
The Pennsylvania Academy of the Fine Arts, Philadelphia
Bequest of J. Mitchell Elliot. (1952.22.2)

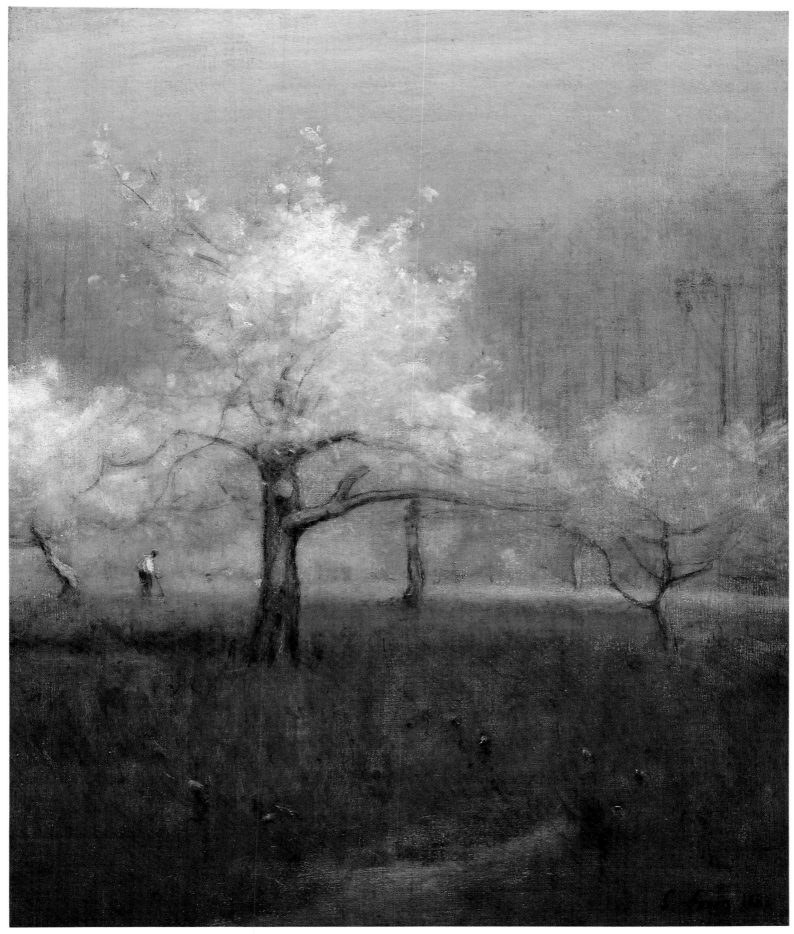

Rather than painting detailed, documentary land-scapes like the Hudson River artists against whom he reacted, George Inness projected his moods onto nature. "I do not illustrate guidebooks," Inness declared in response to criticism that he failed to pro-vide enough topographical information. His subjective response to humble landscape motifs (often in the en-virons of his Montclair, New Jersey home) came from his contact with Barbizon painting; yet his loosely brushed, atmospheric style, which blurs edges and con-tracts distances, links him to Impressionism.

However, Inness bristled at such comparisons. He found Impressionism – "a mere passing fad," arising from a "skeptical scientific tendency to ignore the reality of the unseen" – far too attached to the material world. A follower of the mystic Swedenborg, Inness sought to reveal the invisible spiritual truths within matter. This picture's "delicacy of touch" and "opalescent light" (his son's words) distinguish it from Enneking's Impressionist painting *Blossoming Trees* (pp. 76-77), which is more about retinal sensations than reverie.

The Home of the Heron, 1893

Oil on canvas, 30×45⅕ in.
© 1988 The Art Institute of Chicago
Edward B. Butler Collection. (1911.31)

Painted the year before his death, this dreamlike picture shows the increasing abstraction of Inness's late period. He believed that "the subject was nothing," and that art's true purpose was "to awaken an emotion." Hailed as "one of the finest and most poetical interpreters of Nature in her quiet mood," Inness,

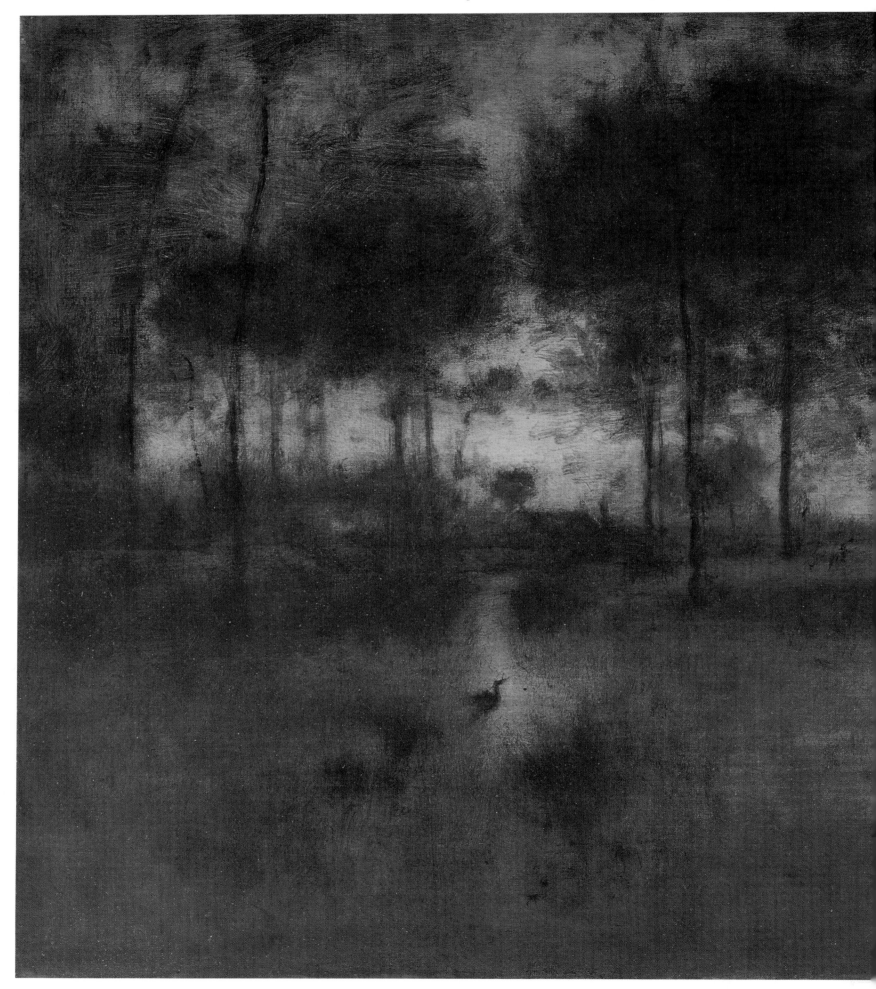

towards the end of his life, was able to live comfortably, albeit reclusively, as his pictures found an appreciative audience.

In this painting the nearly-monochromatic, thinly painted horizontal bands of landscape, offset by vertical trees, recall Whistler more than the Barbizon painters or Impressionists. Symbolically, the heron generally connotes quietness and vigilance, and in ancient Egyptian mythology is associated with the transformation of the soul after death. As a painter and Swedenborgian, Inness was most likely conscious of the bird's emblematic associations.

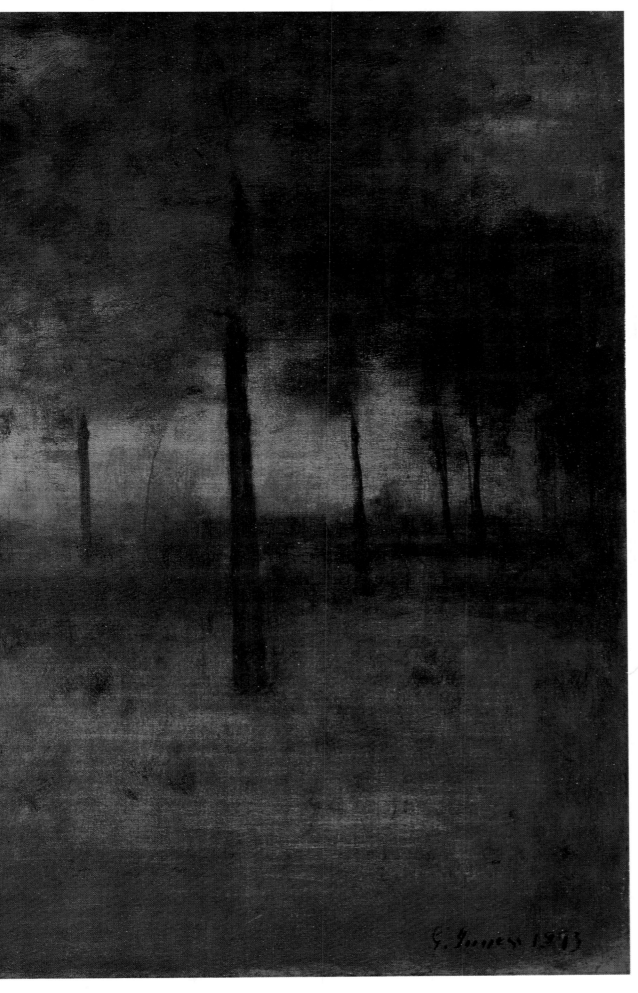

G. Inness 1893

WILLARD METCALF

1858-1925

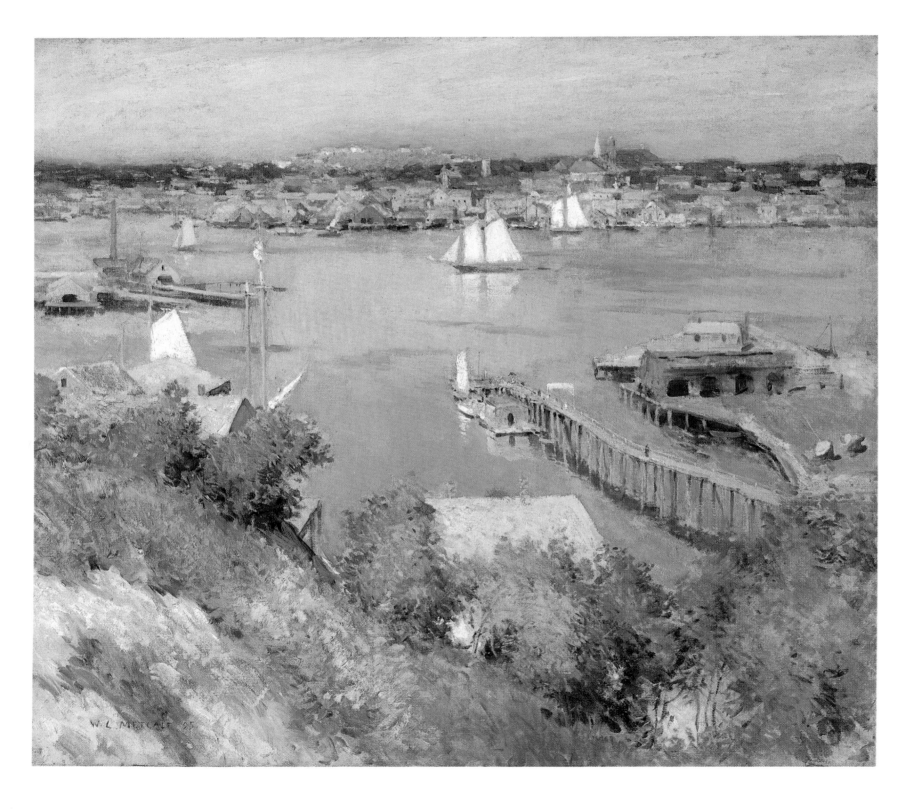

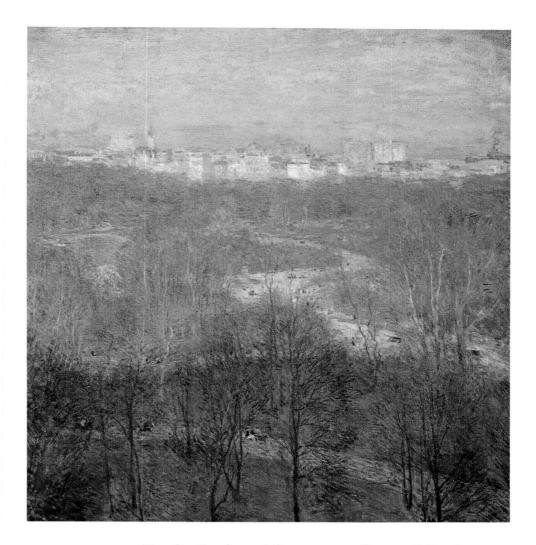

Gloucester Harbor, 1895
Oil on canvas, 26×28¾ in.
Mead Art Museum, Amherst College, Amherst, MA
Gift of George D. Pratt

Early Spring Afternoon, Central Park, 1911
Oil on canvas, 36⅛×36 in.
The Brooklyn Museum
Frank L. Babbott Fund. (66.85)

Willard Metcalf interrupted his early career as an illustrator with a trip to Europe from 1883-85, when he spent time in Giverny. Despite his early visit to this Impressionist mecca, he did not really become an Impressionist until about 1895, when he succumbed to the influence of his friends Hassam and Weir. Until this time, teaching, illustrating, and portrait painting had commanded all of his time. Awarded a prize for *Gloucester Harbor*, Metcalf felt emboldened to continue making plein-air landscapes. Metcalf's strong, clear landscapes became quite popular at the turn of the century. In 1905, the New York *Herald* described him as "a follower of the Giverny School . . . but his work has an originality not often found among American painters influenced by Monet." In 1908, he reportedly sold $8000 worth of landscapes in three days.

Gloucester was a popular summer resort for artists. Fitz Hugh Lane, a native of the Massachusetts fishing village, had immortalized its scenery in the middle of the century. Homer painted his first watercolors there in 1873. Hassam, De Camp, and Twachtman were among the other members of the Ten who worked there, and in the twentieth century, John Sloan, Edward Hopper, and Stuart Davis, among many others, found inspiration along its rocky shores.

Though Metcalf became known as "the poet laureate of the New England hills," he did not limit himself to country subjects. He maintained a studio in New York – on the same block as Hassam's – in the Hotel des Artistes, West 67th Street, near Central Park. This sweeping vista was painted from the roof of his building. From this lofty vantage, we look southeast over the park's bridal path and pond, across to Fifth Avenue, and beyond to points downtown. Metcalf's panoramic view forces the skyline back to the horizon, so that nature overwhelms the city, which is blurred by the spring haze.

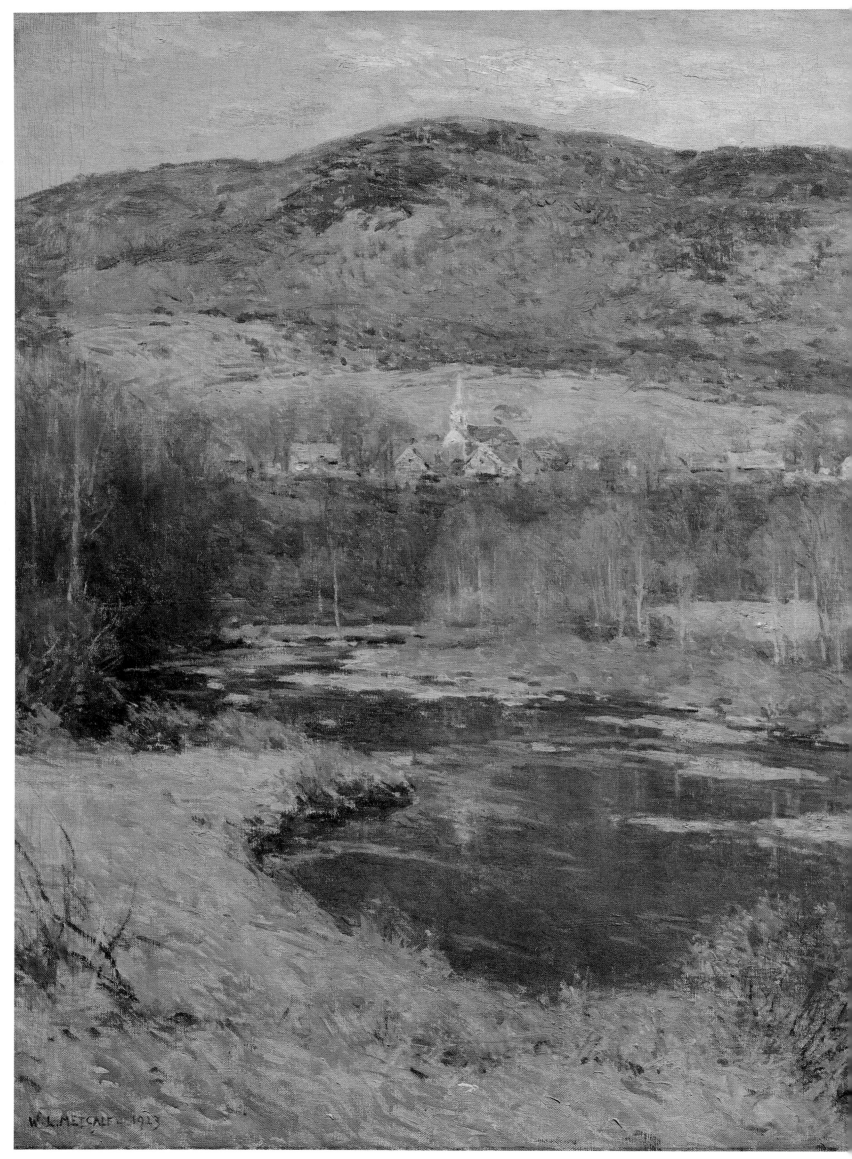

The North Country, 1923
Oil on canvas, 39⅞×45 in.
© *1989 The Metropolitan Museum of Art, New York*
George A. Hearn Fund, 1924. (24.60)

Metcalf was praised for his American subjects and style, issues of great concern to critics eager to discern native traits within the essentially European Impressionist mode. Royal Cortissoz extolled Metcalf's "truth to the very soul of the American Landscape . . . the sincerity and force with which he puts familiar motives before us. He got into his canvases the simple, loveable truths which, perhaps, only an American can feel to the uppermost . . . an inheritor of the very essence of American art." The "familiar motive" here is Perkinsville, Vermont. The Black River winds through the foreground, and Mount Ascutney looms in the distance. In the middle ground, typical boxy New England houses are visible through the leafless trees. The ambitiously scaled composition is organized into alternating zones of pale and deep pigment, applied so freely that bare patches of canvas are detectable between strokes.

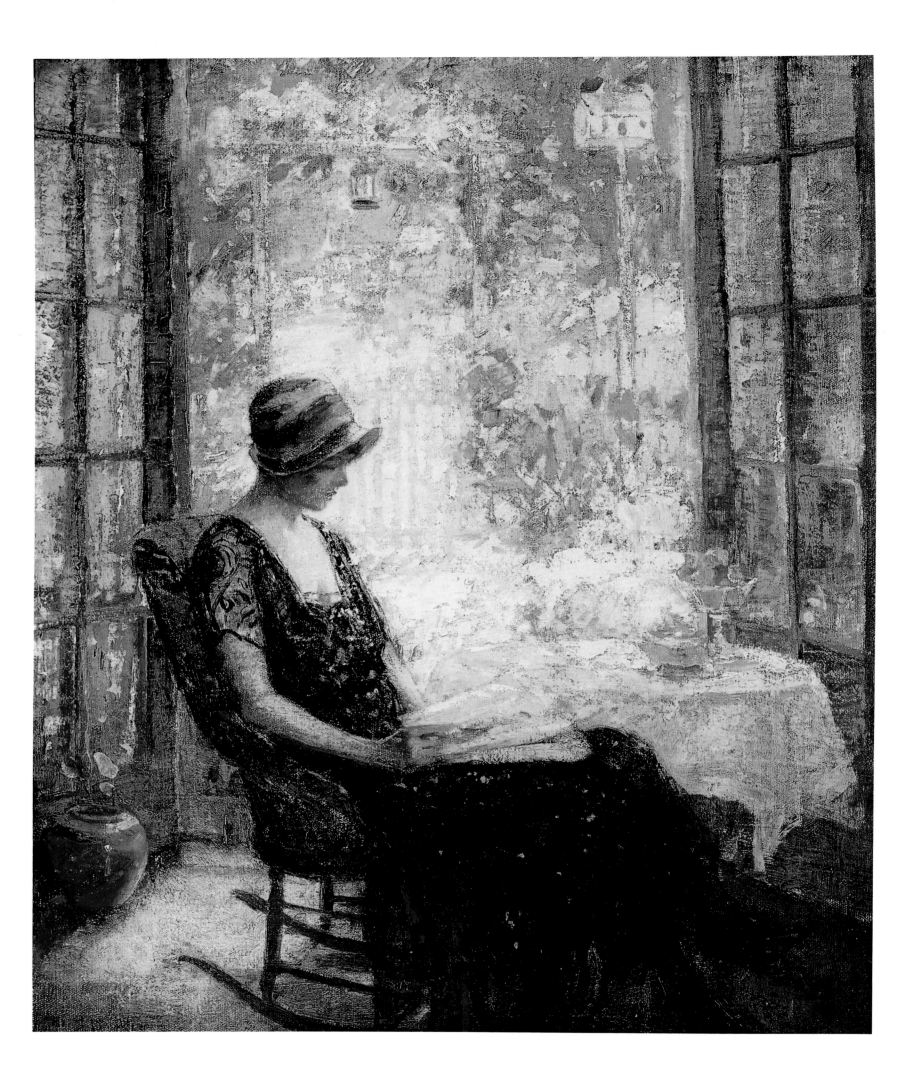

PAULINE POTTER PALMER

1867-1953

From My Studio Window, 1907
Oil on canvas, 30×25 in.
© *1988 Union League Club of Chicago*

A Chicago artist, Palmer studied at the city's Art Institute with Chase, who taught there during the 1897-98 term. She also trained in Paris with both French and American instructors. Her work was exhibited in the Salon, and she continued to win many awards throughout her career. Primarily a portraitist, Palmer sometimes made pure landscapes. After the Chicago World's Columbian Exposition (1893), the city became the major art center of the Midwest, so Palmer was well-patronized. Most of her pictures remain in private hands.

Palmer painted this picture one year after her return to Chicago. The conceit of a woman backlit against a sunny window was popular with the American Impressionists. This motif allowed an artist to combine an interior with a plein-air subject. Palmer's figure is more carefully drawn than the landscape (typical of American Impressionists) and is executed with a more somber palette. The architectural setting gives the composition its firm structure and sense of depth.

LILLA CABOT PERRY

1848-1933

The Trio, Tokyo, Japan, 1898-1901
Oil on canvas, 29 × 39¾ in.
Fogg Art Museum, Harvard University, Cambridge, MA
Friends of the Fogg Art Museum Fund

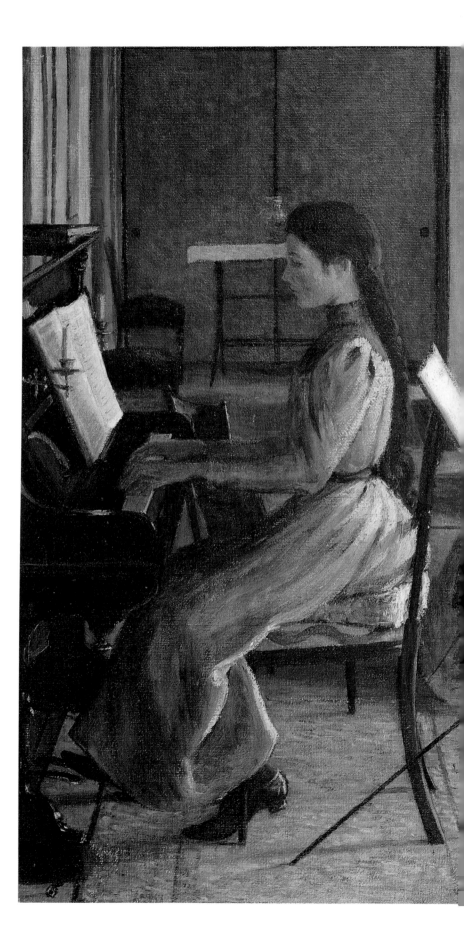

A member of Boston's most prominent clans, the Cabots and Lowells, Lilla Cabot Perry married Thomas Perry, a belletrist and descendent of both Thomas Jefferson and Commodore Matthew Perry. She enjoyed a successful career as a painter, and published poetry volumes and a book on Monet, whom she knew in Giverny. Perry also befriended Cassatt, Morisot, and Pissarro during her years in France. The venerable French muralist Puvis de Chavannes pronounced her work "very original, of charming color and very delicate." She spent three years in Japan, where this picture was painted, after her husband accepted an invitation to teach English literature at a Tokyo college. She was thus able to study at close hand the Japanese art that had inspired so many of her colleagues. Her plein-air technique astonished the Japanese; her daughters once counted 62 spectators gathered round her to witness this curious Western practice.

This indoor subject shows her three girls in a tatami-matted interior. The youngest, Alice, plays the piano, the middle daughter, Edith, plays the cello, and the eldest, Margaret, plays the violin. The grid-like background provides a geometric foil for the girls' graceful, sinuous forms.

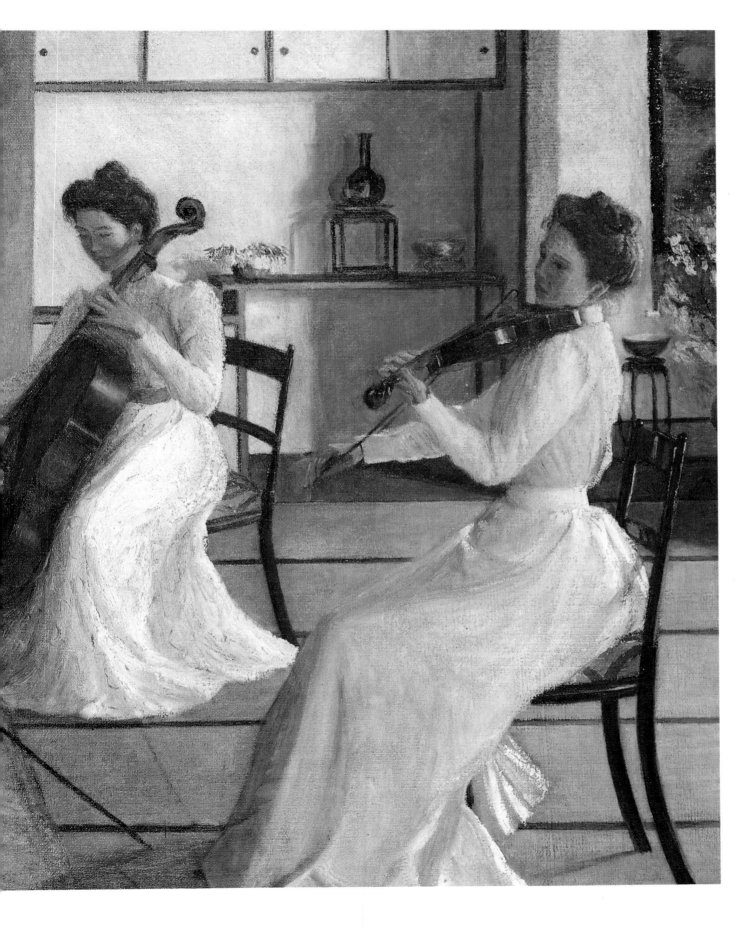

MAURICE PRENDERGAST

1861-1924

Dieppe, 1892
Oil on canvas, 13 × 9¾ in.
Collection of Whitney Museum of American Art, New York.
Purchase. (39.28)

During his second trip abroad (1891-94), Prendergast enrolled in the academies Julian and Colorassi, but he found academic training less seductive than the latest strains of French avant-garde art – including not just Impressionism, but Art Nouveau, and the Post-Impressionism of Toulouse-Lautrec, Bonnard, and Vuillard. Incorporating elements of these latter anti-naturalistic styles – such as flat areas of bright colors, high horizons, and simplified forms – Prendergast painted women on the Parisian boulevards or at the beach. Dieppe, a resort city in northern France, had been frequented earlier by Impressionists such as Morisot and Monet.

In this painting, three featureless women, their backs turned, sit on the short end of a long bench and stare out to sea. Throughout his career, Prendergast remained far more attentive to the cut of a coat, the curves of a parasol, or the arabesques of a hairbow than to details of physiognomy. This concentration on design gave his work an ornamental quality, akin to poster art, which was enjoying a revival at the end of the century.

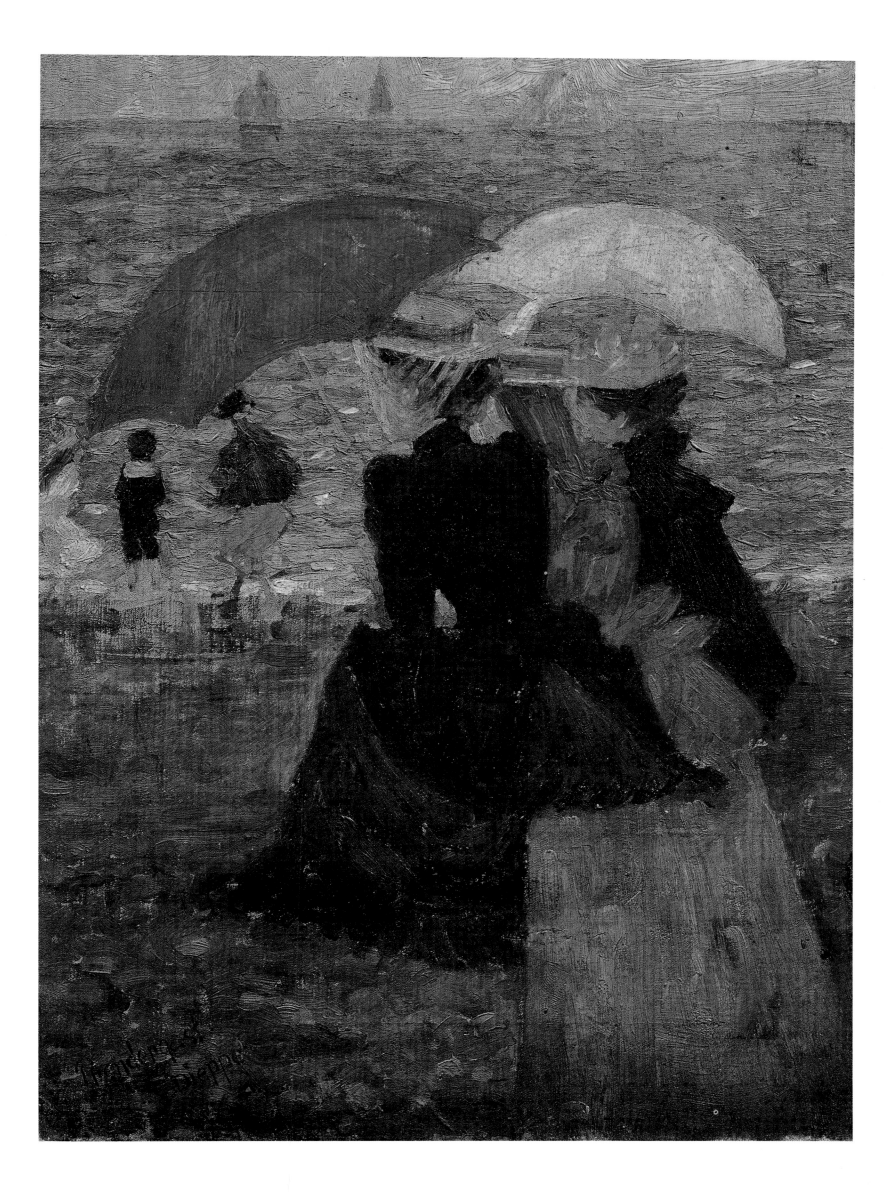

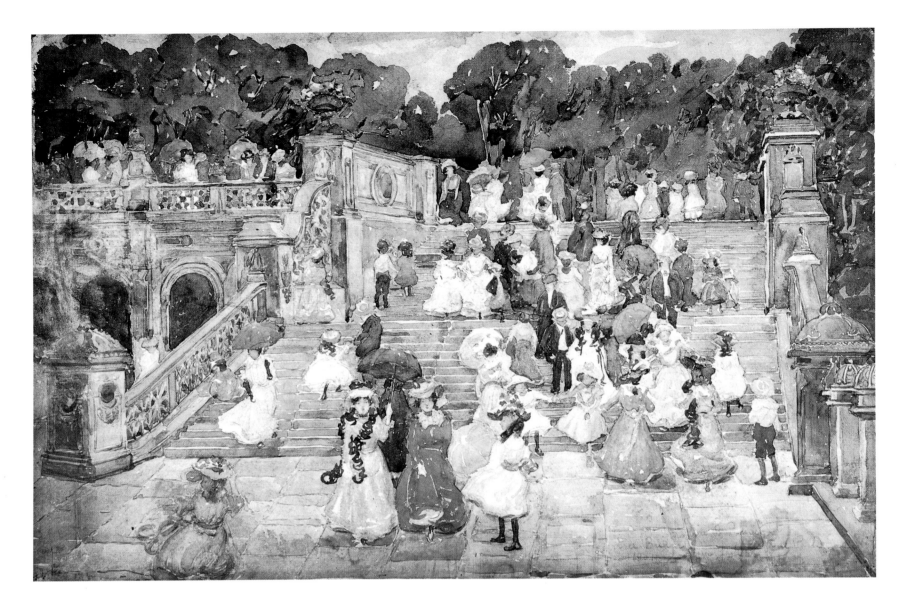

The Mall, Central Park, 1901

Watercolor, 13⅞ × 19¾ in.
© 1988 The Art Institute of Chicago. All Rights Reserved
The Olivia Shaler Swan Memorial Collection. (1939.431)

After his return from Europe, Prendergast began concentrating on watercolor and brought his sketchbook to parks, beaches and avenues. A pleased reviewer of his 1897 watercolor exhibition in Boston wrote that his "figures . . . are full of dainty and buoyant action, and are painted with a most felicitous and suggestive touch. He is a brilliant and distinguished colorist." This show's success enabled him to return to Europe in 1898. In Venice he became enchanted by the pageantry of the gaily-clad figures – played off against somber architecture – painted by the Renaissance master Carpaccio. Prendergast later worked Carpaccio's festival atmosphere into his many views of Central Park.

In this scene, an organizing device, the stairway, prevents the picture from looking, in the words of a critic, like "an explosion in a color factory." Locating the people in space, the architecture allowed Prendergast to choreograph a maximum number of figures with minimal confusion. The view, looking south, shows the western stairway to the plaza surrounding Belvedere Fountain (cut off by the bottom edge). Prendergast's picture was used as a documentary source in the recent restoration of this portion of Central Park.

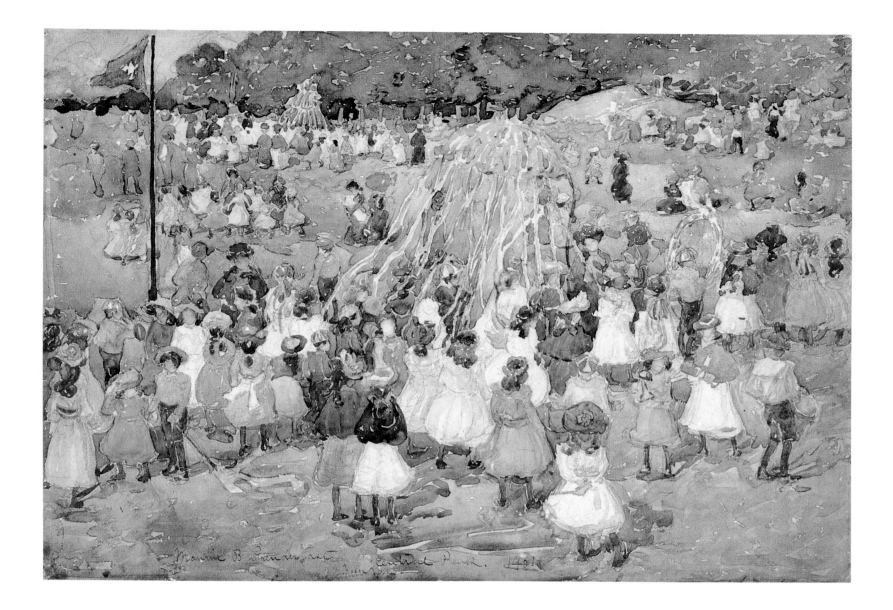

May Day, Central Park, 1901
Watercolor on paper, 13⅞×19¾ in.
The Cleveland Museum of Art
Gift of J. H. Wade. (26.17)

The gay spectacle of boys and girls playing on an early spring day must have struck Prendergast as a living, modern-day Carpaccio tableau. Made to seem even taller by comparison with the children's diminutive stature, the maypoles – with their long, fluttering ribbons – enhance the holiday atmosphere so important to Prendergast's aesthetic. Broken bits of the colorful streamers snake across the foreground, contributing even more color notes to this charming scene of pagan merriment.

Central Park, 1901

Watercolor on paper, 14⅜ × 21½ in.
Collection of Whitney Museum of American Art, New York.
Purchase. (32.42)

Critic Walter Pach said of Prendergast, "Very few men to-day . . . have a vision of such beautiful color." Prendergast heightened local hues – for example, the oranges of horses' hides – to animate this scene. While he was always coloristically vivacious, psychologically, his pictures are evasive. In this watercolor, his featureless figures characteristically turn their backs, or are seen in strict profile, as if Prendergast could hardly bear to face his subjects. The park visitors' poses seem as formalized as figures on an Egyptian frieze. The verticality of those seated and the lateral movement of the processional carriages reassert the two-dimensionality of the scene; nothing moves diagonally into space. The composition breaks down into a sequence of horizontal registers, stacked one on top of the other – the lawn, the benches, the carriage path, and the trees. Most of the color is sandwiched between the upper and lower zones.

For much of his life, Prendergast lived with his brother, a craftsman and advocate of frame reform. The two collected all types of objects adorned with flat decoration – Persian jars, brocades, mosaics – which most certainly influenced Maurice's painting style.

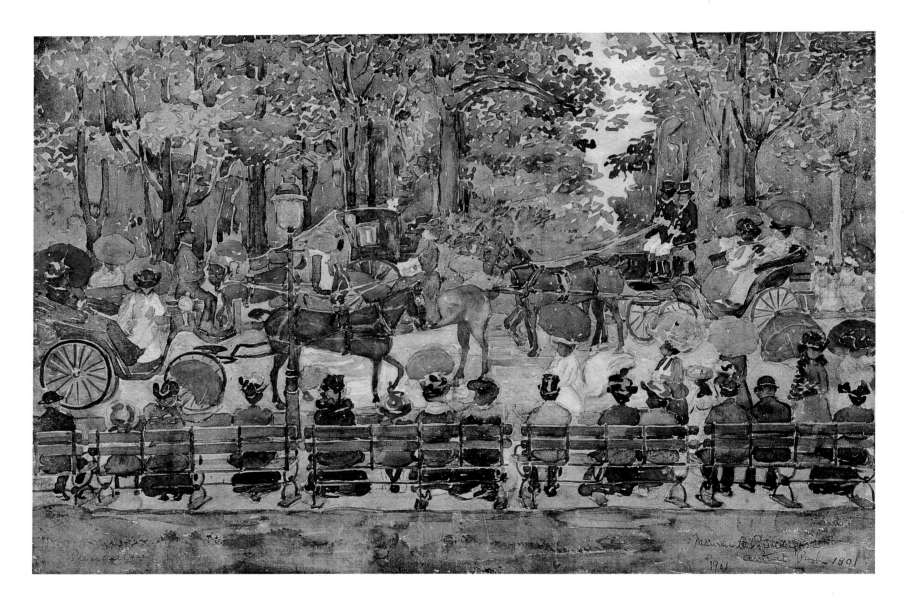

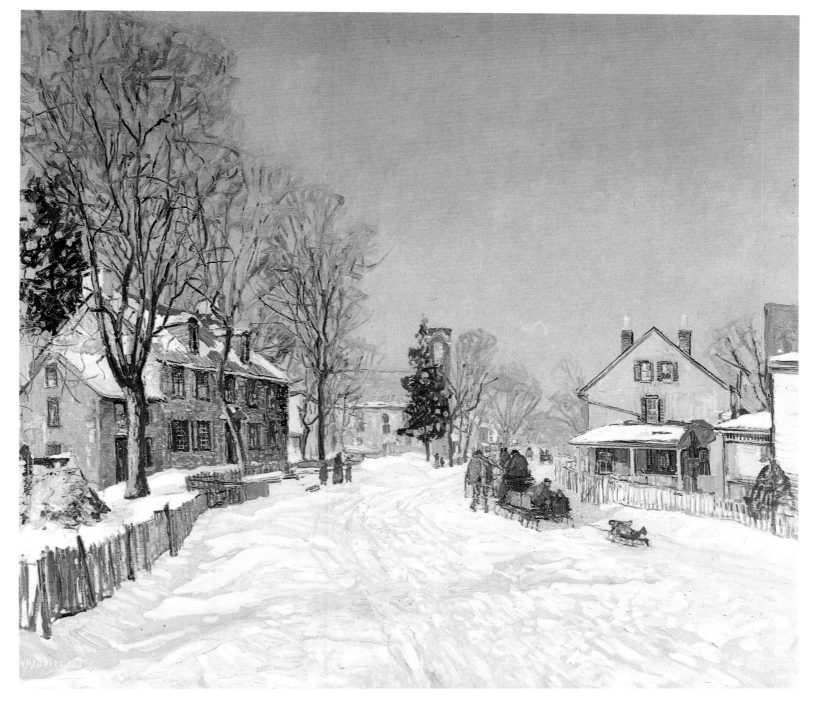

EDWARD REDFIELD

1869-1965

New Hope, c. 1927
Oil on canvas, 50⅛ × 56⅛ in.
The Pennsylvania Academy of the Fine Arts, Philadelphia
Joseph E. Temple Fund. (1927.7)

After studying in Philadelphia and Paris, Redfield settled permanently in Center Bridge, Pennsylvania, near New Hope, where he specialized in large rapidly executed snow scenes. Bundled up, and often tying his easel to trees, Redfield worked even on the most windy, bitter days. "He will fight the winter's hardest weather," one admirer declared, "and struggle through the deepest snows to paint when the fever is on him."

Critics hailed his vigorous approach and rustic themes as democratic, patriotic antidotes to the "elitist" Boston School and French Impressionism: "He is the standard bearer of that progressive group of painters who are glorifying American Landscape, painting with a veracity and force that is astonishing the eyes of the Old World, long accustomed to servile aping of their standards. He is a rejuvenating force in our art."

In *New Hope*, Redfield duplicates the shiny, crunchy texture of snow with thick, slick paint slashes. He made the sleigh tracks by dragging a brush loaded with ice-blue paint over a layer of white. These runner marks pull us back into space, as if we, too, are trudging up the hill. The more evenly applied, opaque paint above effectively recreates a chilly, sunless sky.

ROBERT REID

1862-1929

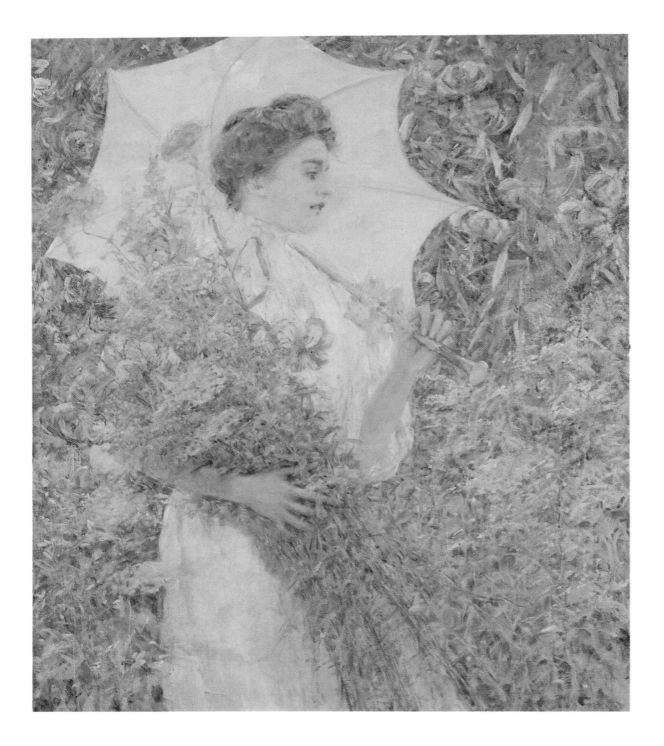

The White Parasol, 1907

Oil on canvas, 36 × 30 in.
National Museum of American Art
Smithsonian Institution, Washington, D.C.
Gift of William T. Evans. (1909.7.57)

According to a critic for *Art Interchange*, Reid "cannot see a girl without seeing flowers, and cannot see flowers without seeing a girl." Clearly Reid exploited the traditional equation of their fragile, ephemeral beauty.

Critic Sadakichi Hartmann noted that "Reid is only an Impressionist in his backgrounds and landscapes. In his figures he paints more smoothly, more solidly." As in *Fleur-de-Lis*, the figure is pressed close to the picture plane and the space behind her, a veritable screen of tiger lilies, is even shallower. The picture is further flattened by the nearly head-on, rather than foreshortened, view of her parasol's underside, and her profile pose. This modish, decorative painting resembles contemporary fashion plates, as well as Manet's personifications of the seasons as stylish beauties. The palette is pale and chalky, almost like a Renaissance fresco.

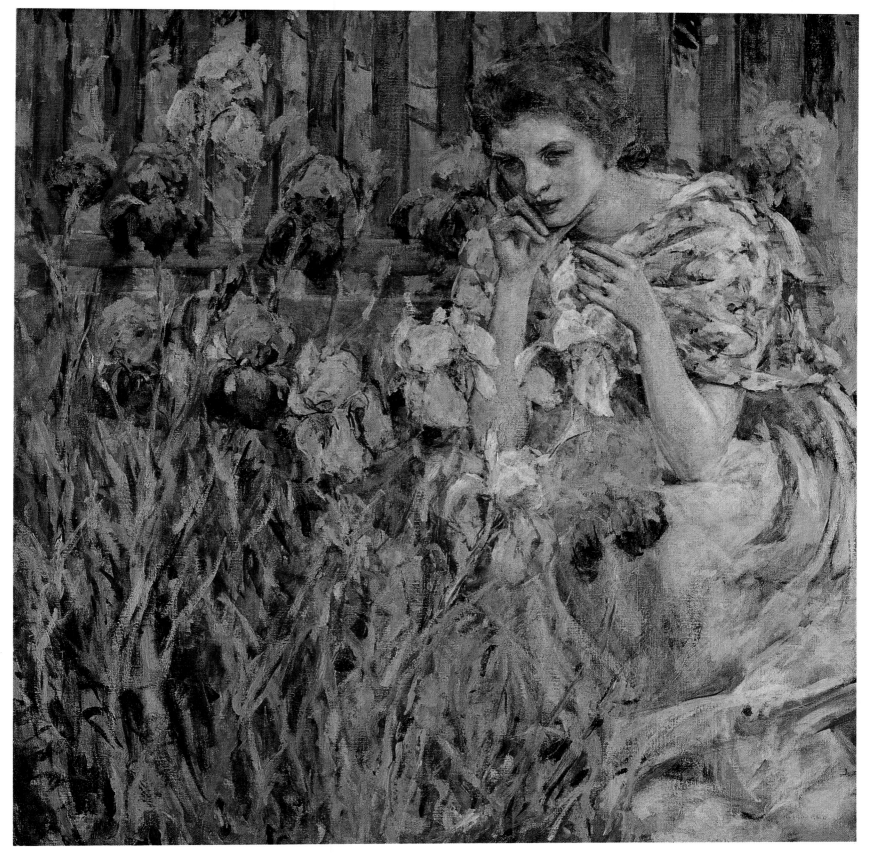

Fleur-de-Lis, c. 1899

Oil on canvas, 44⅛ × 42¾ in.
© 1989 The Metropolitan Museum of Art, New York
Gift of George A. Hearn, 1907. (07.140)

Reid studied at the Boston Museum School, where he befriended future Ten members Tarbell, Benson, and Metcalf, and completed training in New York and Paris. During the 1890s, he devoted himself mostly to painting murals, which were much in demand as a result of the ''American Renaissance'' movement's attempt to unify the visual arts in vast projects. Like Cassatt, he supplied murals for the World's Columbian Exposition, and a few years later, for the Library of Congress. His easel pictures, though less conservative in style, were still influenced by these monumental undertakings; he chose large canvases, and painted grand-scaled figures with long strokes. By 1891 a critic complained that Reid had ''been bitten by the Impressionist tarantula.'' When *Fleur-de-Lis* was shown in the Ten's 1899 exhibition, its palette was described as ''bewilderingly rich.'' The picture's spectrum of sugary violets is determined by the profusion of irises, which nearly camouflage the squatting, pensive girl, clad in a sprigged dress. The picket fence forms a rectilinear counterpoint to the organic shapes of the woman and flowers. Reid added textural interest by applying his ribbony strokes over coarsely woven canvas.

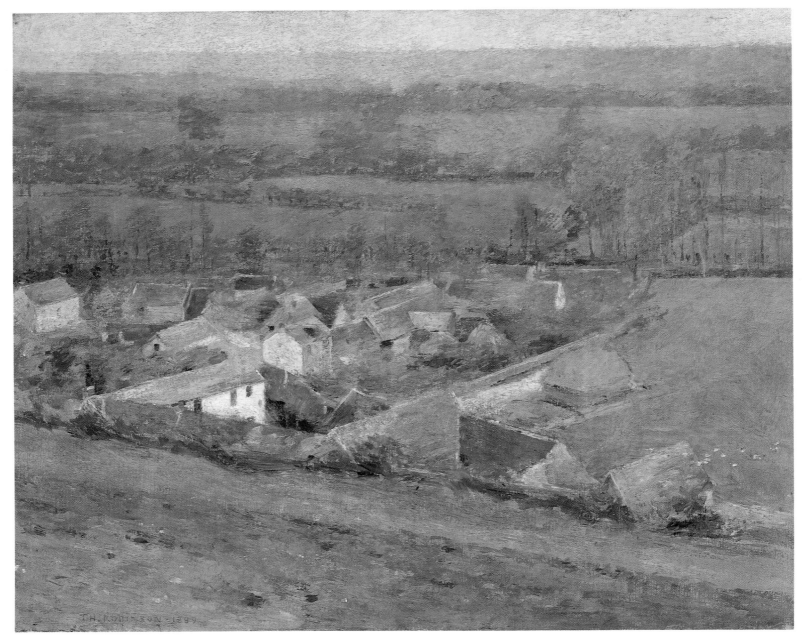

THEODORE ROBINSON

1852-1896

A Bird's-Eye View: Giverny, France, 1889

Oil on canvas, 25¾ × 32 in.
© 1983 The Metropolitan Museum of Art, New York
Gift of George A. Hearn, 1910. (10.64.9)

Theodore Robinson started out painting in an academic realist manner and then in a Barbizon style; after meeting Monet in 1887, he settled on Impressionism. A neighbor and friend of Monet's for over four years, Robinson only submitted partially to the master's style. In this landscape, Robinson used a painterly Impressionist touch and, unlike Monet, a tightly structured compositional framework. The palette of milky mauves and greens softens the basic format of intersecting diagonals, which define a deep space. In addition, Robinson achieved an illusion of depth by means of atmospheric perspective; forms grow less distinct, and color less differentiated toward the horizon. There, the colors become quite faint, as deeper lavenders fade out to ghostly blues.

When this picture was exhibited in New York in 1889, a reviewer, rather tolerant of this early example of American Impressionism, wrote in the *Nation*: "His *Bird's-Eye View*, with its clustered cottages seen in perspective, is most interesting in drawing, though a trifle flat and chalky in its attempt at color in a high key."

More than his landscapes, Robinson's figure pieces show an attachment to tonal values (transitions from light to dark) and solid form. These traits may have arisen from his habit of painting from photographs to "get what I can of it and then go."

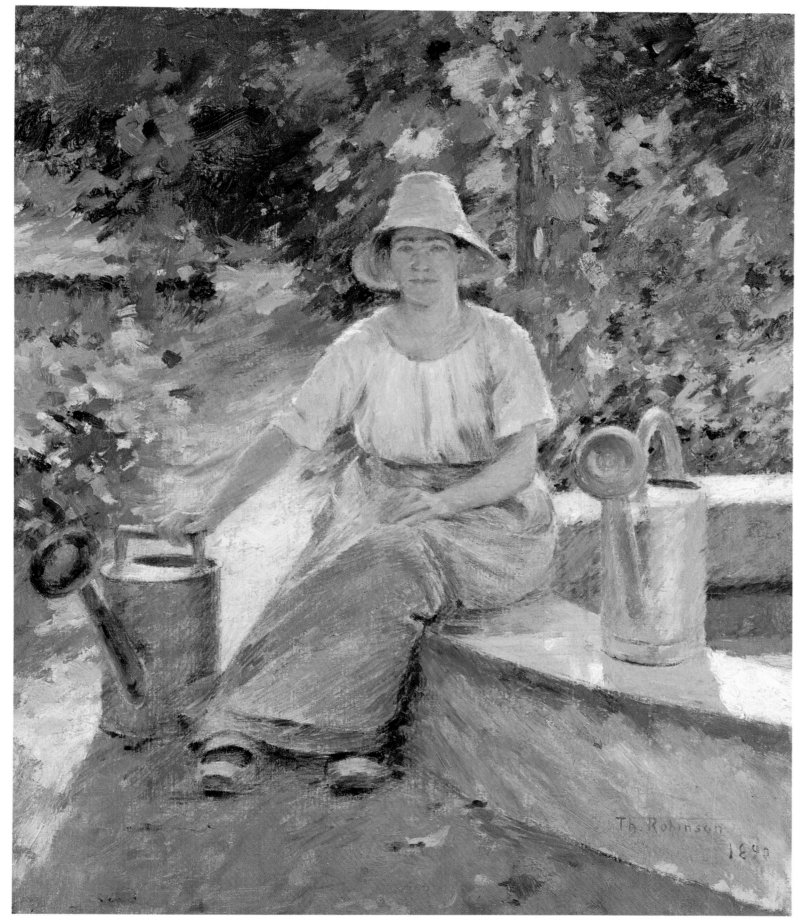

The Watering Pots, 1890
Oil on canvas, 22⅛ × 18¹⁄₁₆ in.
The Brooklyn Museum
Museum Collection Fund. (21.47)

This picture's peasant subject matter is related to Barbizon paintings by Millet and to Impressionist works by Robinson's friend Pissarro, both of whom also enjoyed depicting sturdy, dignified rural laborers. The blur of sunshine beside and behind the flower watering can, and the sliver of light contouring the woman's right arm resemble effects caught on film. Though his paintings always deviate significantly from their photographic sources, Robinson seemed ashamed of his dependence on photographs; as he confided in his diary in 1893, "I don't know just why I do this." Many other artists, including Eakins and Degas, used the camera as an aid. However, they regarded it not as a "crutch," but as an exciting new artistic tool. Robinson generally was hard on himself. At one point he even confessed to having "a horrible fear that my work pleases women and sentimental people too much."

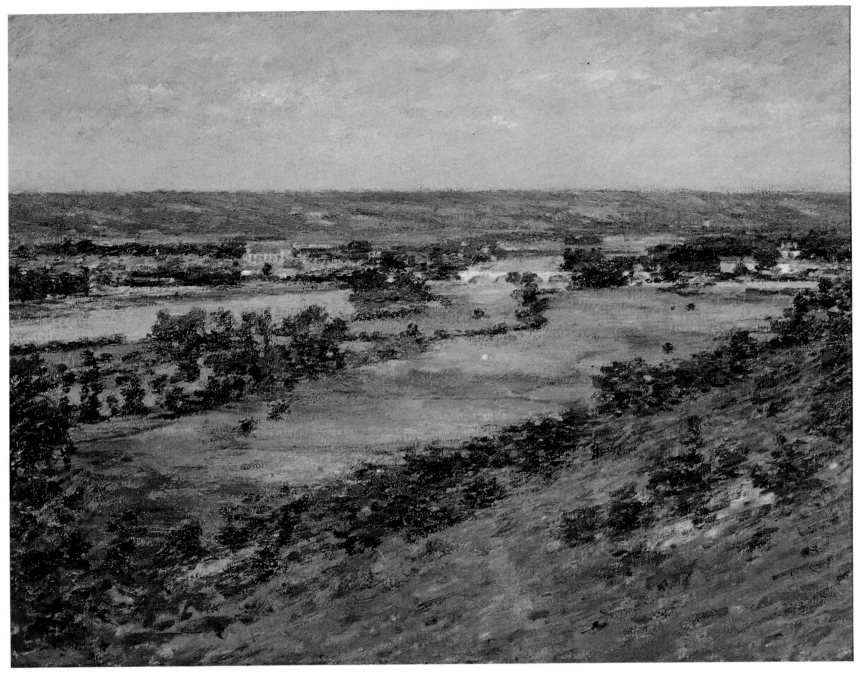

The Valley of the Seine from Giverny Heights, 1892

Oil on canvas, 25⅞ × 32⅛ in.
Collection of The Corcoran Gallery of Art, Washington, D.C.
Museum Purchase, Gallery Fund. (00.5)

Robinson was one of the few Americans to attempt serial pictures like Monet's. Both investigated the variable effects of light, weather, and atmosphere on a fixed subject. Monet chose large, stable motifs – poplar trees, haystacks, the Rouen Cathedral – which served as monumental scaffoldings on which to "hang" evanescent atmospheric conditions. In comparison, Robinson's three panoramas of the Seine Valley town of Vernon – on a sunny, an overcast, and a partly cloudy day – are more modest endeavors. Unlike Monet's, Robinson's serial pictures do not appear to have been painted simultaneously while weather effects rapidly changed, but one at a time. Robinson's meteorological phenomena are perhaps recorded more accurately than Monet's but they are also less fancifully dramatic.

Monet, who regularly critiqued Robinson's work, preferred the grey version of this series. In turn, Monet asked Robinson's opinion of his first few Rouen Cathedral paintings. Robinson praised their "construction and solidity," traits he obviously valued in his own work. He never liked Monet's later, more amorphous landscapes, which he called "wrought-out, elaborate visions."

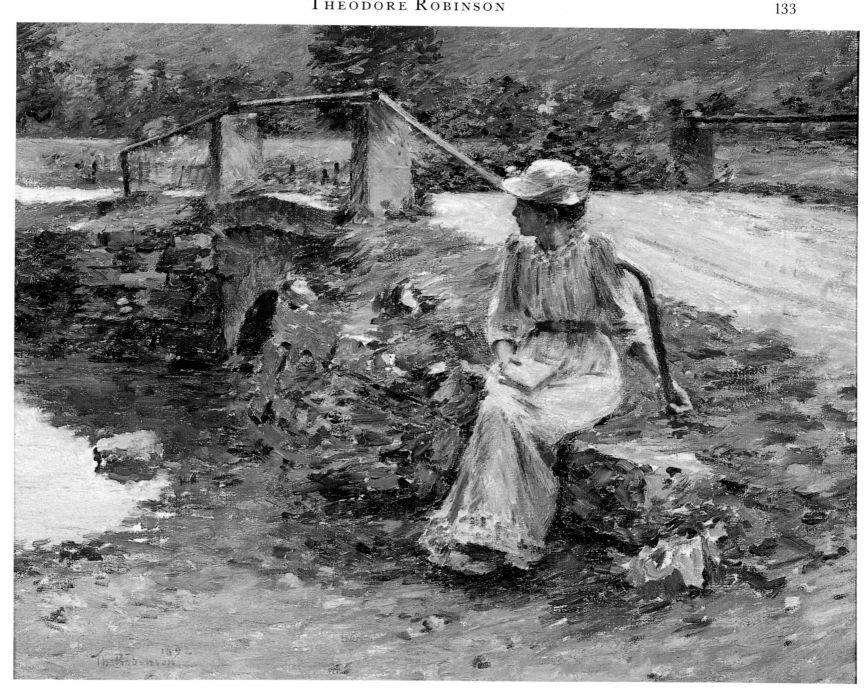

La Débâcle, 1892

Oil on canvas, 18 × 22 in.
Lang Art Gallery, Scripps College, Claremont, CA
Gift of General and Mrs. Edward Clinton Young

The picture's title derives from the paperback Émile Zola novel resting on the woman's lap. When the painting was shown in New York in 1893, a reviewer for the *Critic* commented, "the now familiar Impressionist recipe is followed with more or less success . . . He is much less of a colorist and much more careful of detail than his master Monet." Here, Robinson is most "careful of detail" in the figure and the bridge. While the rest of the painting is fractured into kaleidoscopic shards of color, the woman and bridge preserve their solidity. One can, for example, sense the weight of the knee straining against the dress's variegated fabric, and the buttressing strength of her stone seat. Robinson's iridescent palette takes advantage of the vibratory effects of complementary colors: the yellows of the book and the path are played off against the violets of the sky and the dress, while red and green patches flicker in the foreground soil.

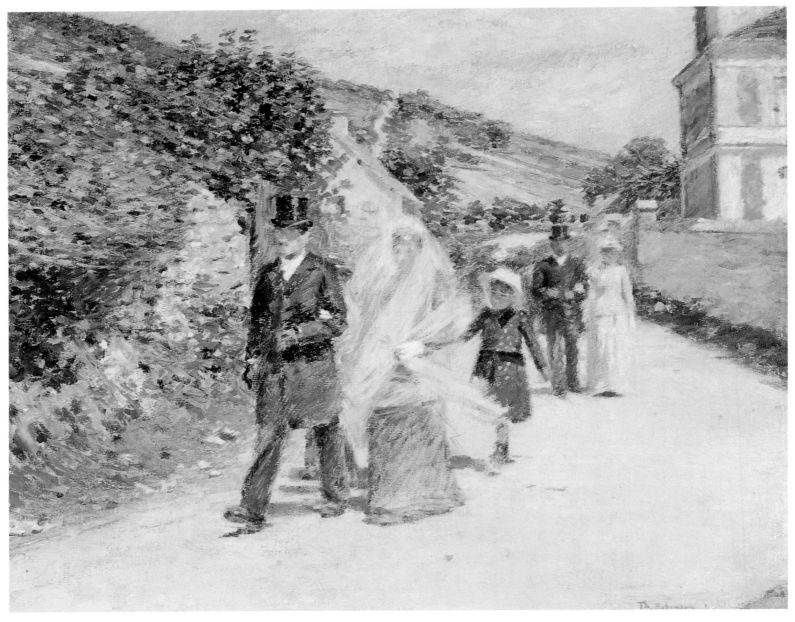

The Wedding March, 1892
Oil on canvas, 22⅛ × 26¼ in.
Terra Museum of American Art, Chicago
Daniel J. Terra Collection

Union Square in Winter, 1895
Oil on canvas, 20 × 17 in.
New Britain Museum of American Art, New Britain, CT
Gift of A. W. Stanley Estate

This appealing scene commemorates the July 20, 1892 wedding of Robinson's friend Theodore Butler to Suzanne Hoschedé-Monet, Monet's stepdaughter. Robinson's diary entry for that date reads: "A great day – the marriage of Butler & Mlle. Suzanne. Everybody nearly at the church – the peasants – many almost unrecognizable . . . The wedding party in full dress – ceremony first at the mairie [town hall] then at the Church. Monet entering first with Suzanne. Then Butler . . . Champagne and gaiety."

Robinson seems particularly fascinated with the bride's trailing veils, which swaddle her from head to thigh and lend her the mysterious solemnity of an Egyptian mummy. The picture provides a pleasurably vivid sense of place, surpassing anything found in modern wedding photography.

Robinson returned to America in 1892, where he spent his four remaining years teaching, painting and spreading the Impressionist style. He came back to his native country determined to paint American rather than French subjects. These indigenous themes included not just the rural scenery of New Jersey, Connecticut, and upstate New York, but urban views of Manhattan, where he lived.

Union Square, a public park since 1809, was decorated with sculptures of important figures from American history – Washington, Lafayette, and Lincoln. Robinson singled out Henry Kirk Brown's equestrian statue of General Washington (1856), with a base designed by architect Richard Upjohn. Painting from within the park, Robinson looked southeast toward 14th Street (at right), then a fashionable shopping avenue, and Broadway (at left). Robinson's dabs of cool, pale blues and greens define the falling snow, which thickens the atmosphere and blurs the people and buildings. The hard edges of the bronze monument gently dissolve under an accumulating mantle of snow.

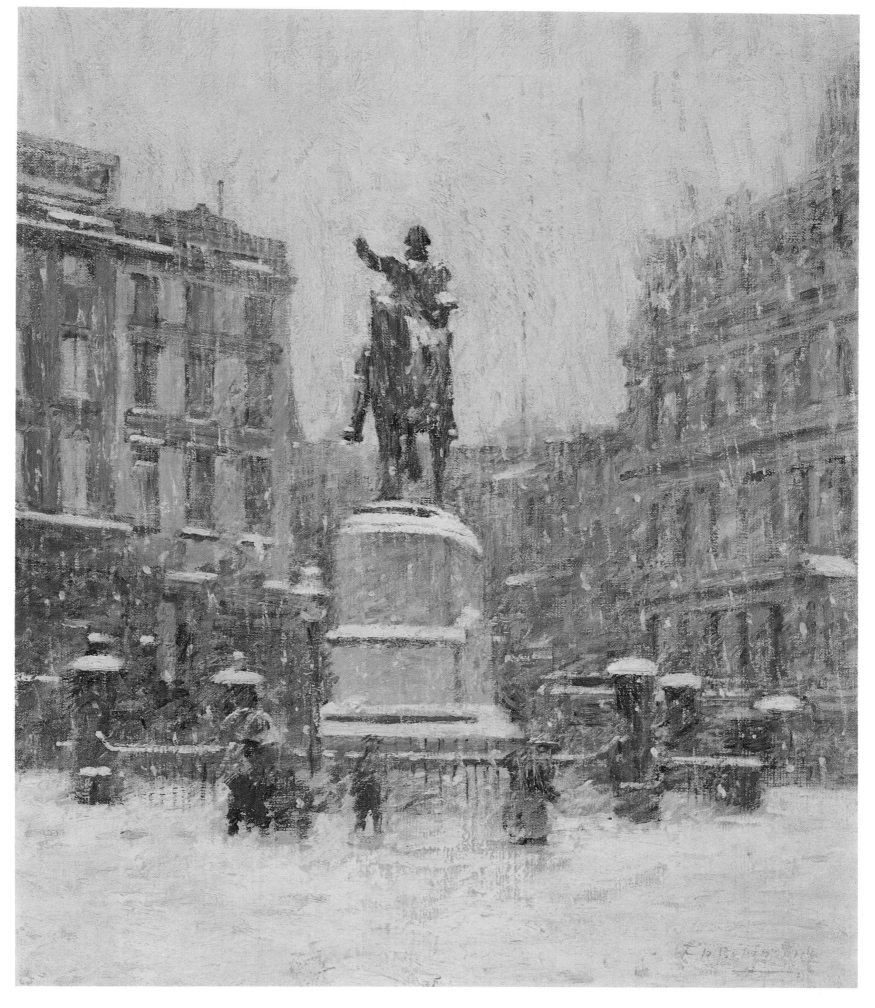

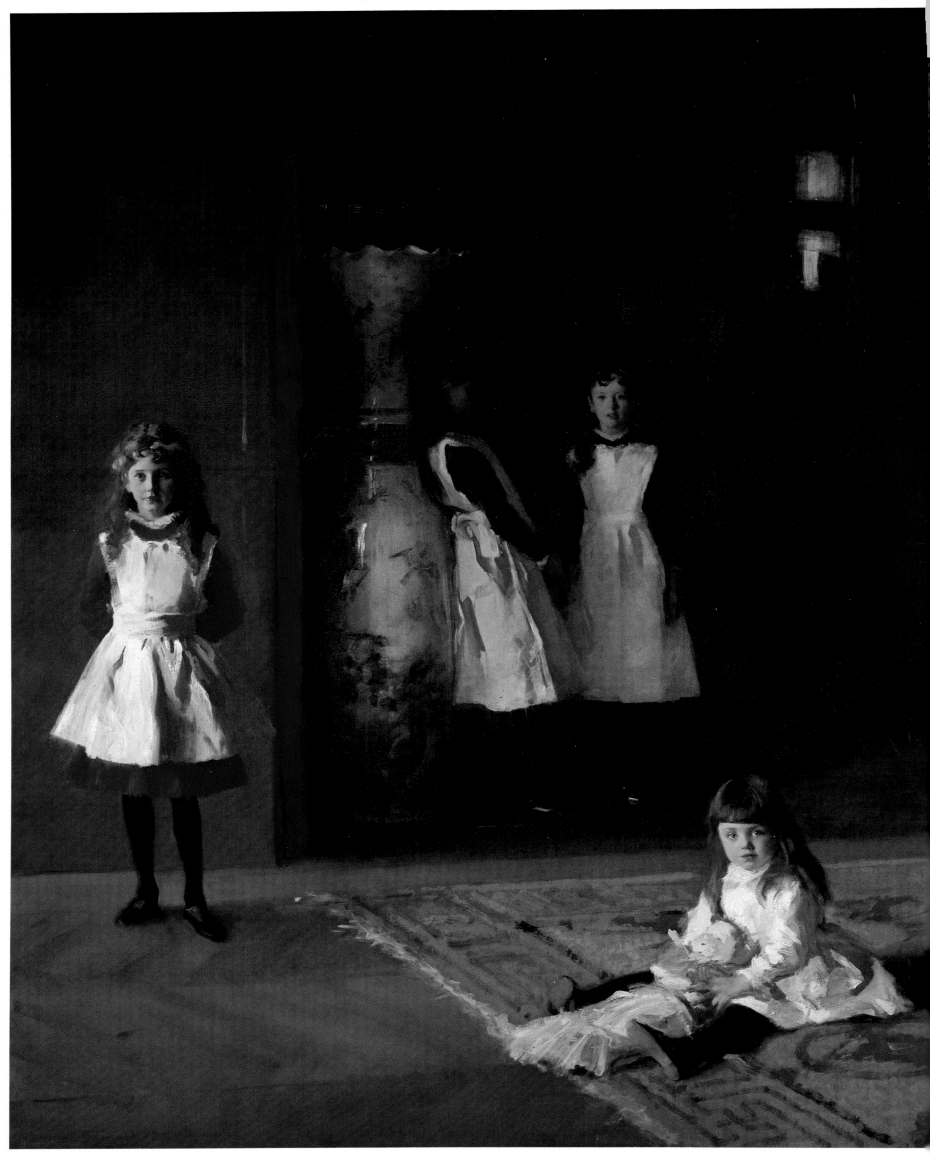

John Singer Sargent

1856-1925

The Daughters of Edward D. Boit, 1882

Oil on canvas, 87×87 in.
Courtesy, Museum of Fine Arts, Boston
Gift of Mary Louise Boit, Florence D. Boit, Jane Hubbard Boit, and
Julia Overing Boit, in memory of their father, Edward Darley Boit,
1919. (19.124)

This painting was commissioned by Sargent's friend Edward Boit, an aristocratic Bostonian and accomplished painter. Set in their father's Paris apartment, this large canvas portrays Florence, Jane, Mary, and Julia Boit at ages four through fourteen. Sargent based the picture's proportions, spatial arrangement, and tonality on Velázquez's *Las Meninas* (p. 17), a painting he had copied during an 1879 trip to Spain. Despite this reference, the painting's haunting voids and peculiar square format (perhaps inspired by the fact that there were four girls) prompted a French critic to say the painting was "composed according to some new rules – the rule of the four corners game." It is not so much the composition that is "new" as the way the portrait mingles girlish guilelessness with a sense of dread; Sargent suggests that childhood is every bit as much about concealed knowledge and disquieting discovery as it is about innocence. The smallest daughter clutches her doll a little too anxiously, the pose of the daughter in red implies she has something to withold, and the two oldest girls are engulfed by ominously deep shadows. Isolated from one another and dwarfed by the cavernous rooms and outsized decorations, the girls seem watchfully, silently accusatory. The sensibility here is nearly identical to Henry James's novels featuring children, such as *What Maisie Knew.* Not surprisingly, James cut immediately and brilliantly to the picture's quick: he found it "astonishing" for "the sense it gives us as of assimilated secrets and instinct and knowledge playing together." None of the Boit girls married, and in 1919 they donated the portrait to the Boston Museum of Fine Arts in their father's memory.

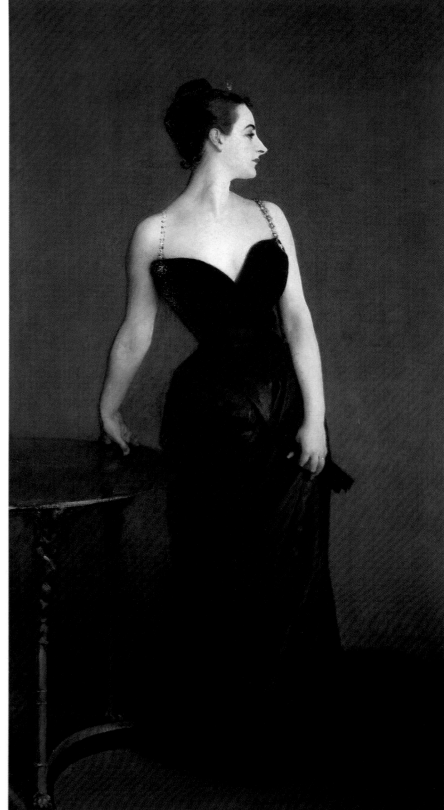

Madame X (Madame Pierre Gautreau),
1884
Oil on canvas, 82½ × 43¼ in.
© 1979/84 The Metropolitan Museum of Art, New York
Arthur H. Hearn Fund. (16.53)

Virginie Gautreau, an ambitious Louisiana belle, moved to Paris to seek fame, fortune, and a husband. Marriage to an infatuated, wealthy banker did not prevent her from taking many lovers. Captivated by her "beautiful lines" and suspecting that she was "waiting for someone to propose this homage to her beauty," Sargent got the 24-year-old adventuress to agree to pose. Both hoped the portrait would enhance their status in the eyes of worldly Paris. Working in her country house, Sargent became exasperated by her "unpaintable beauty and hopeless laziness." They tried several arrangements before settling on the profile view of her standing beside an Empire table.

Unexpectedly, the painting was an abysmal disaster at the Salon of 1884. Its eccentricities, which actually create its strange beauty, were enumerated by the critic Henri Houssaye as faults: "The profile is pointed, the eye microscopic, the mouth imperceptible, the color pallid, the neck sinewy, the right arm lacks articulation, the hand is deboned." Before Sargent repainted it, the left strap slipped provocatively down her arm: "One more struggle, and the lady will be free," sneered a critic. It was one thing to write up this beauty's daring antics – wearing deep décolletage, hennaing her hair, painting her eyebrows, powdering her flesh lavender – in scandal sheets. It was quite another to immortalize this "blossom of the boudoir" in a Salon painting. However, critic Louis de Fourcaud correctly recognized the portrait as a "sort of canon of worldly beauty . . . Like an immense cameo." Thirty-two years later when Sargent sold Madame X to the Metropolitan, he could at last confidently aver, "It is the best thing I have done."

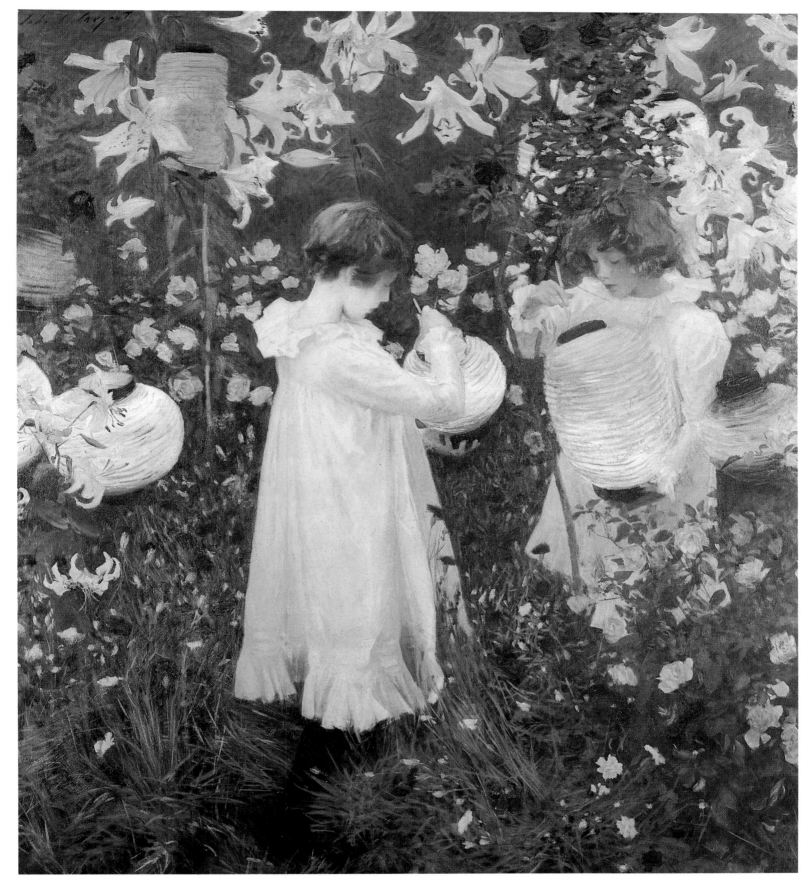

Carnation, Lily, Lily, Rose, 1885-86

Oil on canvas, 68½×60½ in.
Tate Gallery, London

Sargent painted this plein-air masterwork during two summers in Broadway, an artist's colony on the River Avon in England. The models were Dorothy and her sister Polly, ages seven and eleven, daughters of Broadway residents Frederick (an illustrator) and Alice Barnard. The picture took so long to paint because Sargent only worked on it for a few minutes a day, just after sun-

set, when the twilight caused the flowers to glow as if lit internally, like the Chinese lanterns. At dusk Sargent would interrupt a daily game of lawn tennis to work on it and then rejoin the game two or three minutes later. As summer turned into autumn, Sargent had to replace the lily stalks and rose bushes with artificial flowers. Sargent's method resembled Monet's procedures, with the difference that Monet would paint several versions of the same scene throughout the day. The picture's title comes from a song popular that summer; Sargent self-deprecatingly nicknamed it "Darnation, Silly, Silly, Pose." Proclaimed "purely and simply beautiful" when exhibited, it redeemed Sargent's reputation.

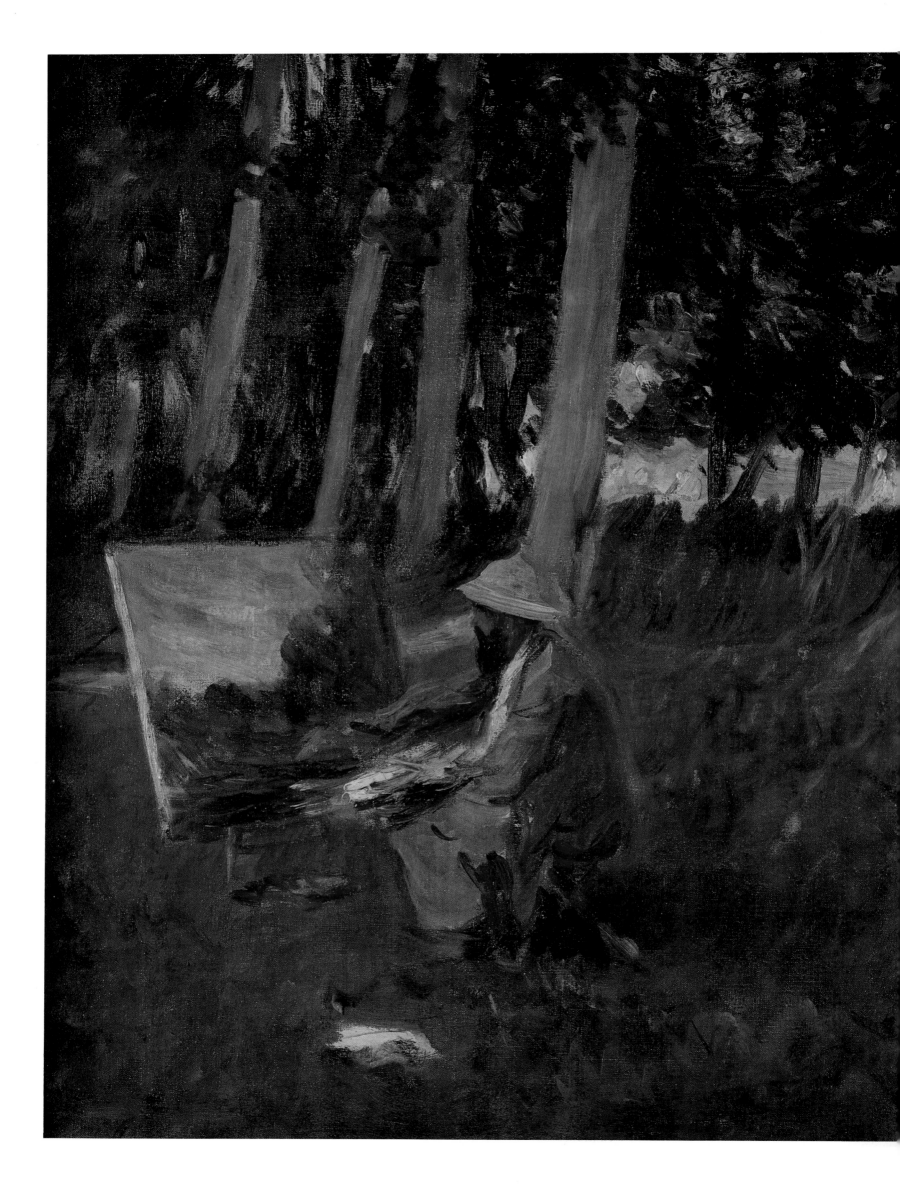

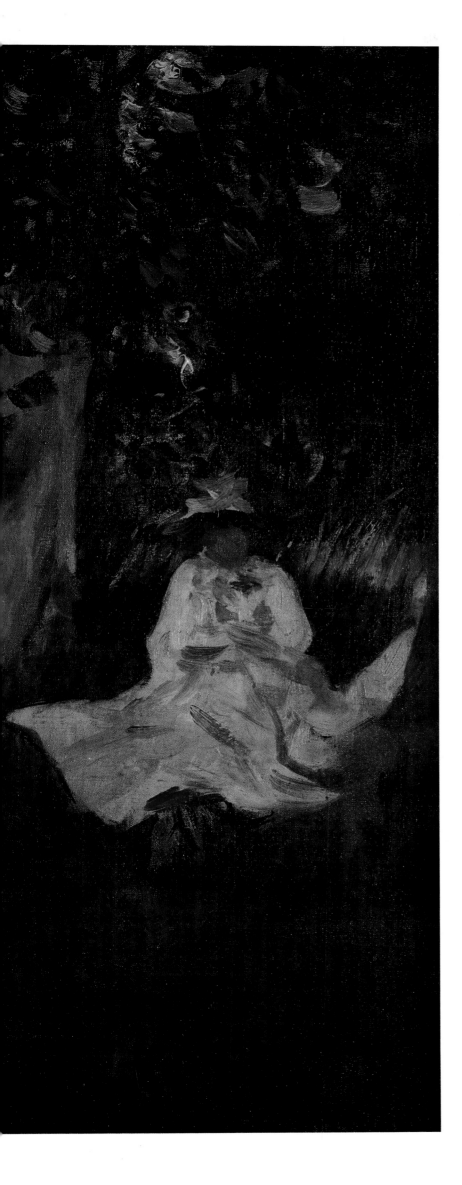

Claude Monet Painting at the Edge of a Wood, c. 1887

Oil on canvas, 21¼ × 25½ in.
Tate Gallery, London

Sargent apparently passed part of the summer of 1887 with Monet at Giverny, where the American not only portrayed his colleague at work, but also painted a profile study of his head. Sargent's reverence for Monet moved him to purchase four of his landscapes, including *The Rock at Tréport*. After he left Giverny, Sargent, thrilled with this picture, wrote to Monet: "It is with great difficulty that I tear myself away from your delicious painting . . . to tell you how much I admire it. I could spend hour after hour in front of this canvas in a state of voluptuous stupefaction – or enchantment, if you prefer. I am stunned to have such a source of pleasure in my possession."

A delightful memento of the two artists' friendship, Sargent's picture may show Monet working on an 1885 canvas, *Meadow with Haystacks Near Giverny*, which would place Sargent in Giverny two years earlier than the generally accepted date – and solve the mystery of the identity of the standing figure in Metcalf's *Ten-Cent Breakfast*, 1885 (p. 18). Sargent's long, thin strokes and use of black indicate his independence from Monet's Impressionist technique.

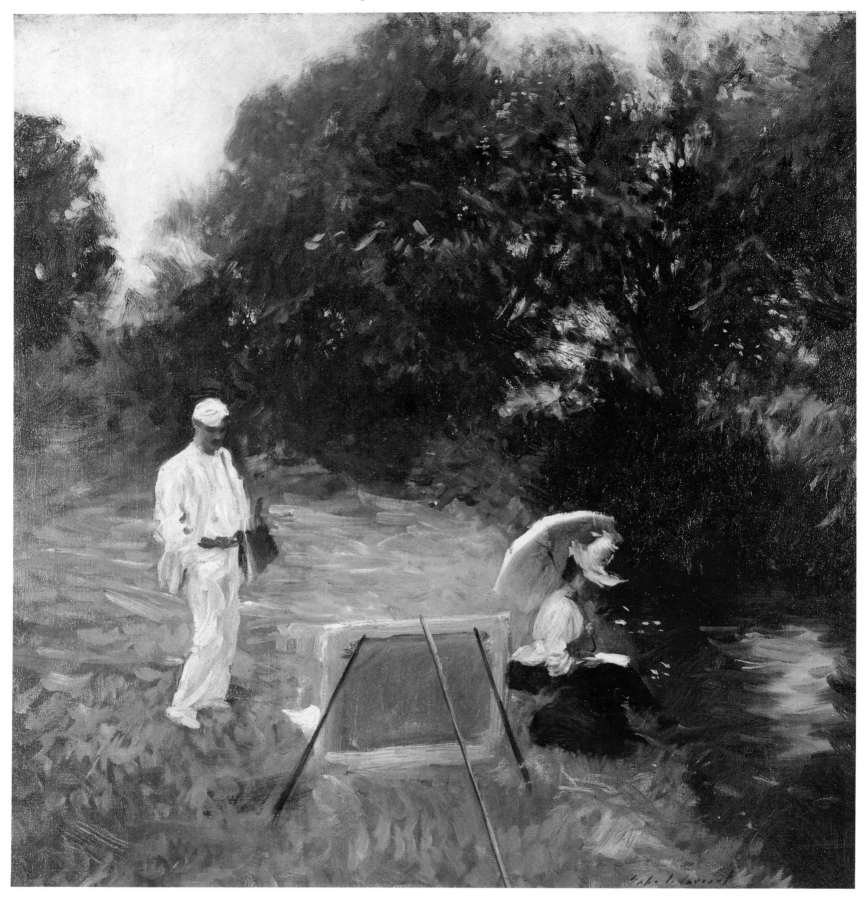

Dennis Miller Bunker Painting at Calcot, c. 1888

Oil on canvas mounted on masonite, 26¾×25 in.
Terra Museum of American Art, Chicago
Daniel J. Terra Collection

In 1888, Sargent moved his mother, sisters, and ailing father to Calcot, a picturesque village near Broadway, England. Continuing his summer plein-air work, he was joined by Dennis Miller Bunker, whom he had recently met in Boston through art patron Isabella Stewart Gardner. Bunker described Calcot to Gardner as "a charming place . . . willows, boats . . ." During his visit, Bunker grew fond of Sargent's younger sister Violet, whom he found "awfully pretty–charming. What if I should fall in love with her? . . . I see it coming." In a relaxed, Impressionist style, Sargent depicted Bunker scrutinizing from a short distance his own canvas, while Violet reads by the stream.

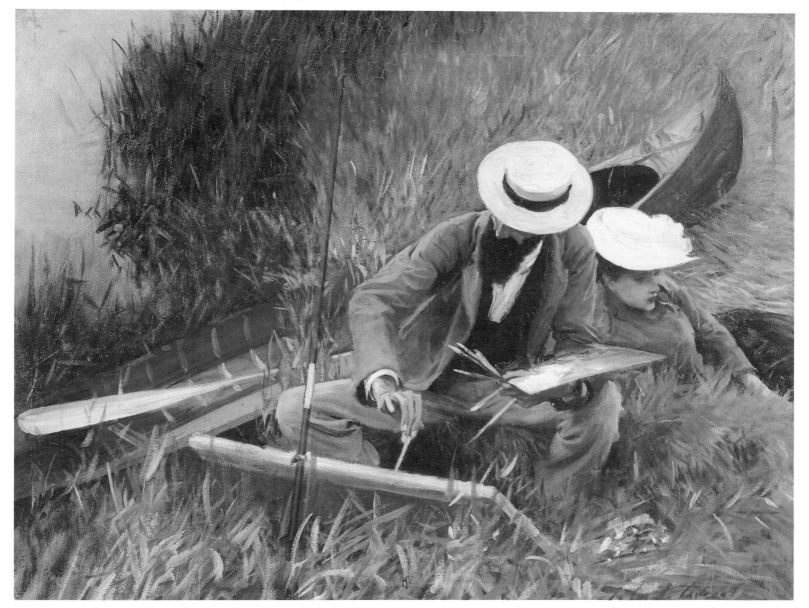

Paul Helleu Sketching with his Wife, 1889
Oil on canvas, 26⅛ × 32⅛ in.
The Brooklyn Museum, Museum Collection Fund. (20.640)

In the summer of 1889, Sargent spent time at Fladbury Rectory, near Broadway, with his sisters and widowed mother. Paul Helleu, his friend since their student days in Carolus-Duran's atelier, arrived with his new wife, 18-year-old Alice. She was not an artist, but liked to join Helleu on his painting excursions. Apparently they reached this marshy spot by canoe. Sargent presents painting as an amiable, gentlemanly activity. A critic once summed up precisely why we derive so much pleasure from his work: "What strikes one first of all is the degree to which he enjoys his métier. As a natural consequence, he provides enjoyment to others." Typical of Sargent's outdoor scenes, this picture, painted from overhead, is a horizonless close-up, not an expansive panorama. "I don't paint views, I paint objects," Sargent declared. Interestingly, he shows Helleu's palette laid out with the same corals and blues used to paint this picture.

Mr. and Mrs. Isaac Newton Phelps Stokes,
1897

Oil on canvas, 84¼×39¾ in.
© *1989 The Metropolitan Museum of Art, New York*
Bequest of Edith Minturn Stokes, 1939. (38.104)

In the 1890s, as the demand for his portraits grew, Sargent had much less time for his more private and relaxed plein-air pictures. Initially, it was considered slightly risqué to sit for Sargent. His paintings seemed a bit more irreverent, a little more tuned in to status anxieties than conventional society portraiture. A friend worried that "John is getting rather into a way of painting people too *tense*." But eventually, Sargent became so inundated with commissions for oil portraits (he had done 500 by 1909), he staved off eager clients by dashing off charcoal sketches instead. "No more paughtraits," Sargent wrote, mocking his upper-class clients' accent. "I abhor and abjure them."

This handsome couple received their portrait as a wedding gift from a friend. Mr. Stokes, who stands where Sargent originally intended to paint a Great Dane, was an architect, and his wife, Edith Minturn, a promoter of early childhood education. Her sporty piqué skirt and blue serge blazer, which still look modern, are so vivaciously executed, they nearly distract from the bravura execution of her jaunty face. The Stokeses, and other sitters, recalled that Sargent muttered strange imprecations and chain-smoked as he worked.

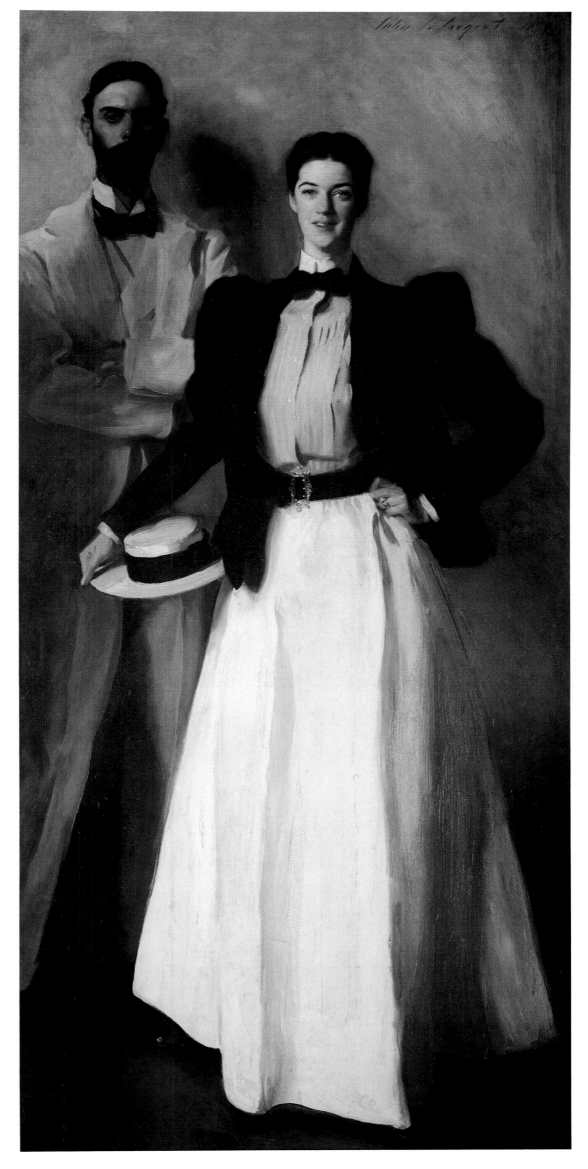

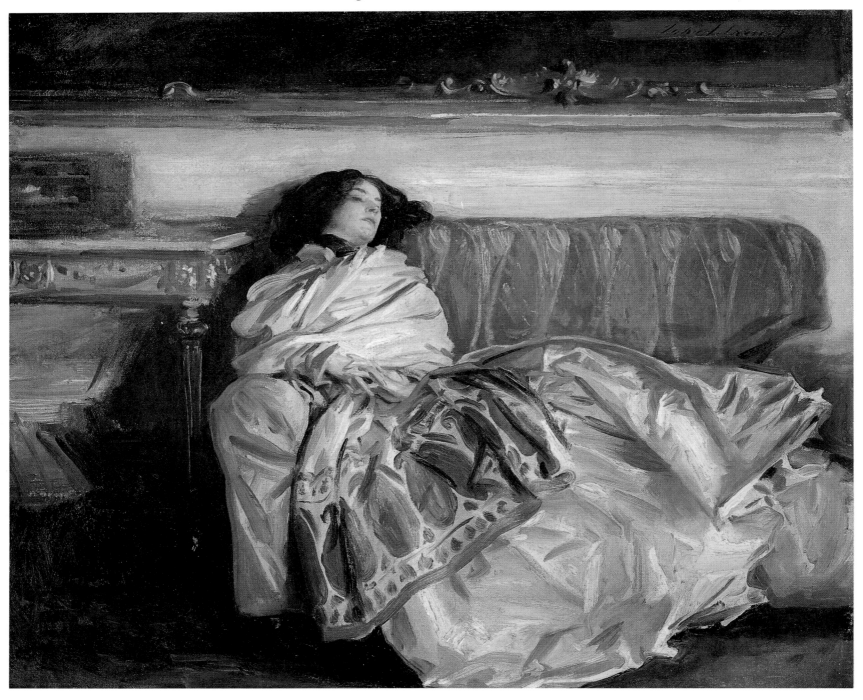

Repose, 1911
Oil on canvas, 25⅛ × 30 in.
National Gallery of Art, Washington, D.C.
Gift of Curt H. Reisinger

This intimate study was not made for a patron, but for his family. The attractive sitter is his niece, Rose-Marie Ormand, daughter of Sargent's sister Violet. Compared to the figure of Berthe Morisot in Manet's similar painting of the same title (p. 9), Sargent's woman is passive and sensual. Her thrown back head, parted lips, and mussed hair give her an air of abandon, curiously at odds with her tensely interlaced hands. The crisscrossing pattern of her fingers is repeated in her cashmere shawl's oblique network of taut folds. The giant paisley border of this luxurious wrap is picked up in the design of the couch's back. Especially in her dress, the brushwork is so free and fluid, it nearly loses its representational function and takes on an almost abstract identity. The limited, creamy palette of green- and gold-tinged ivories pays homage to "Symphonies in White" by Whistler, to whom Sargent sometimes referred clients. The elongated horizontals of the gilt frame, couch, and table repeat and subdivide the restful, rectangular format of this small work.

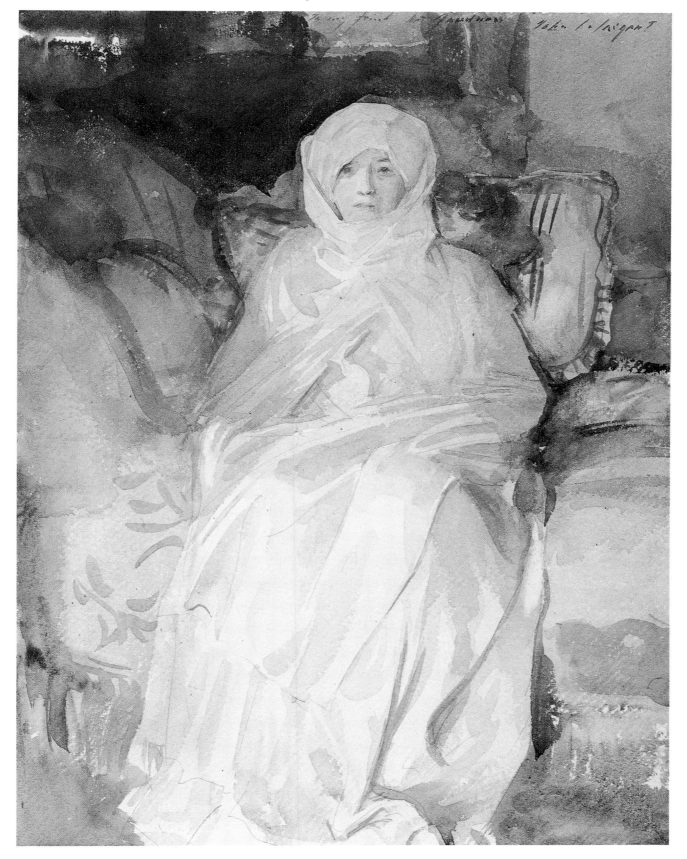

Portrait of Isabella Stewart Gardner, 1922
Watercolor on paper, 16⅔×12⅗ in.
The Isabella Stewart Gardner Museum, Boston

Gardner spent most of her life accumulating master-pieces and fascinating friends, generating controversy with her unconventional behavior and tastes, and final-ly building a wonderfully eccentric mansion/museum to house her treasures and secure her immortality. She is depicted here four years before her death. Five years before Sargent made this sketch, she had suffered a stroke which left her physically incapacitated (her ser-vants carried her around in a Venetian gondola chair), but she was as mentally alert as ever. This spectral watercolor of the frail octagenarian sitting in her palazzo-style home, completely swathed in a white sheet, forms a poignant contrast with the sexy oil por-trait Sargent made of her 34 years earlier. Still playing the part of the indomitable art imperatrice, she presents herself like one of the hieratic goddesses Sargent had painted in his "Pagan Deities" mural for the Boston Public Library. Although one of America's finest water-colorists, Sargent, who often felt an amused disdain for his own work, thought his output in this medium un-suitable for sale.

ELMER SCHOFIELD

1867-1944

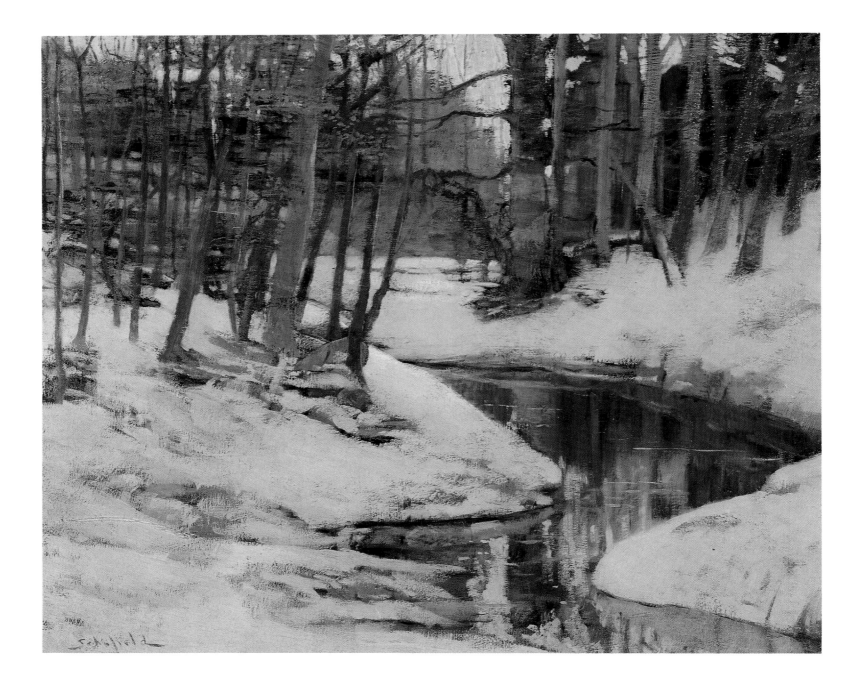

Winter, c. 1899
Oil on canvas, 29½ × 36 in.
The Pennsylvania Academy of the Fine Arts, Philadelphia
Henry D. Gilpin Fund. (1899.3)

A large, rugged man, Schofield liked to paint "those wonderful things out of doors . . . in rain, falling snow, wind – all these things to contend with only make the open-air painter love the fight." Schofield was educated at Swarthmore College and the Pennsylvania Academy, where he befriended Redfield. The two artists' very similar sensibility created a strong bond between them, but also inevitably resulted in a rift. After a falling out over a prize Schofield won in 1904 for a snow scene – of Redfield's back yard – the two became feuding competitors, both painting monumental Pennsylvania winter landscapes. Guy Pène du Bois, an artist and critic, praised both for being "plain men" who expressed "the simplicity of our language and of the prosaic nature of our sight. It is democratic painting – broad, without subtility." *Winter* plunges us deep into the woods; neither horizon, nor treetops, nor people are anywhere visible.

EDWARD SIMMONS

1852-1931

Boston Public Gardens, 1893
Oil on canvas, 18¼×26 in.
Terra Museum of American Art, Chicago
Daniel J. Terra Collection

Simmons, probably the least-known Impressionist member of the Ten, was brought up in Concord, Massachusetts, in the company of such cultural luminaries as Louisa May Alcott and Ralph Waldo Emerson. He left for Paris in 1879, and remained studying and painting abroad for thirteen years. Settling in New York City upon his return, he established a reputation in the 1890s as a mural painter for the World's Columbian Exposition, Library of Congress, and various state capitols and private homes.

Simmons' landscape sketches, such as this one, are rare. This picture's high viewpoint and asymmetrical composition, with its empty foreground and diverging carriage traffic, come from Impressionism by way of Japanese art. The nearly neutral palette is relieved by small accents of primary color – yellow in the dome on the horizon and laden sled, and red in this vehicle's runners and the distant child's dress.

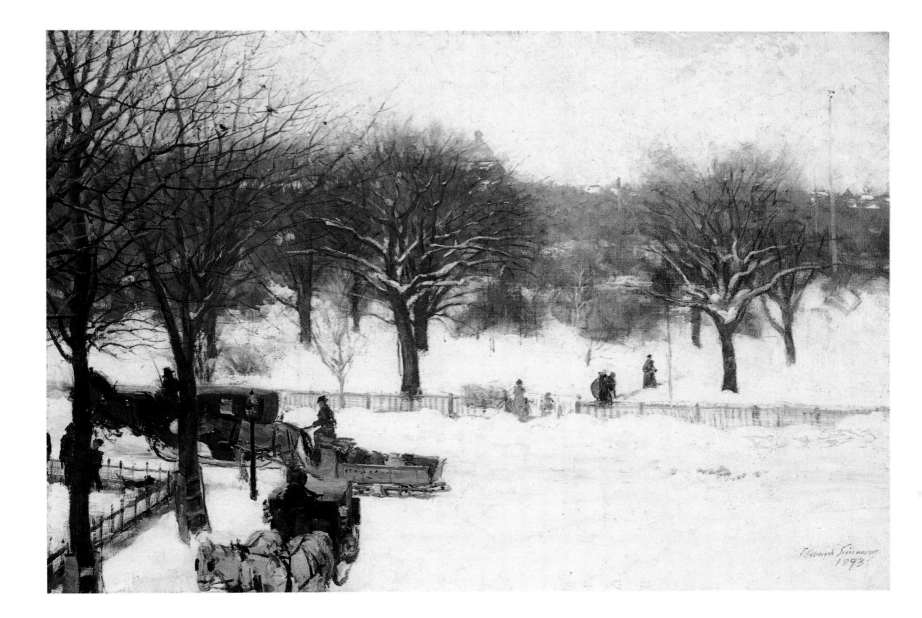

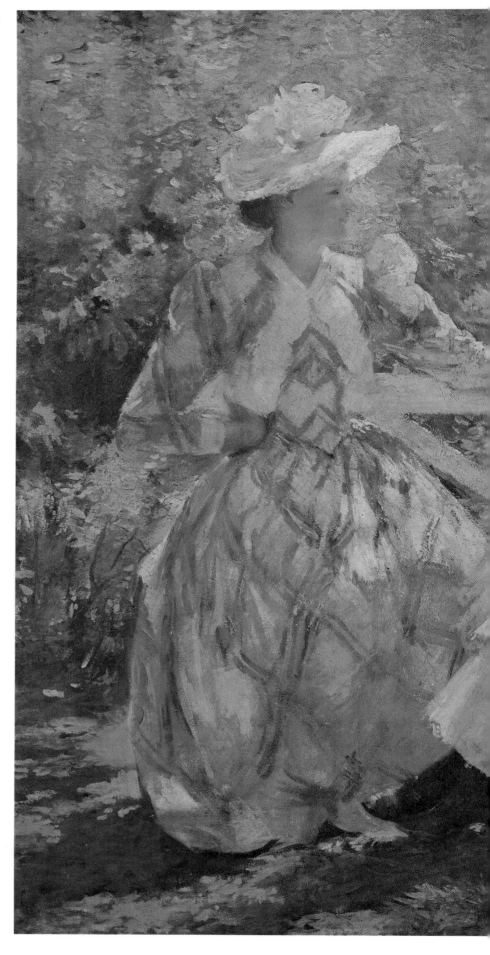

EDMUND TARBELL

1862-1938

Three Sisters: A Study in June Sunlight, 1890
Oil on canvas, 35⅛ × 40⅛ in.
Milwaukee Art Museum
Gift of Mrs. Montgomery Sears. (1925.1)

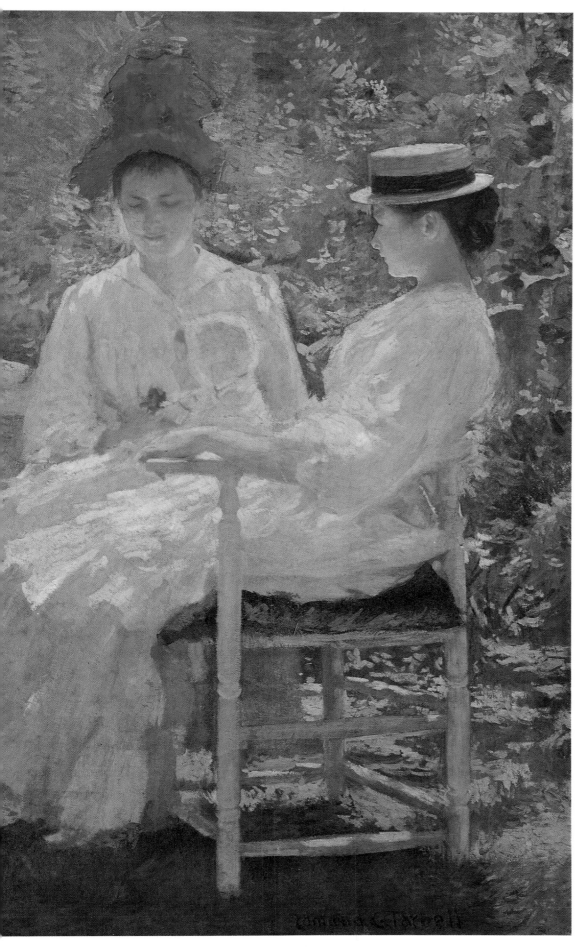

This work represents Tarbell's first attempt at Impressionism, probably a result of viewing the recent Giverny experiments of Perry or Metcalf, and Bunker's plein-air work in Calcot. Most likely Tarbell had also seen some French Impressionist examples while abroad from 1883 to 1886, but preferred to wait before trying out the new style. The colorful, sociable scene recalls a work like Renoir's famous *Luncheon of the Boating Party*, included in an 1883 Boston show at the New England Manufacturer's and Mechanic's Institute – an exhibition for which Tarbell provided catalogue illustrations. However, in contrast to Renoir's rowdy flirts, the women here are refined in appearance and behavior, typical of Tarbell, and Boston Impressionism in general. Impressed with Tarbell's skill at rendering summer light, a critic claimed that the *Three Sisters* "make you squint and blink, they are so saturated with sunbeams." The women are so mottled by the summer light and shadow, one has to look carefully to discover the baby cuddled in the central sister's lap.

Mother and Child in a Boat, 1892

Oil on canvas, 30×35 in.
Courtesy, Museum of Fine Arts, Boston
Bequest of David B. Kimball in memory of his wife, Clara Bertram
Kimball. (23.532)

Tarbell very successfully used Monet's technique of painting water with open, broken strokes to convey a sense of flux and light dancing upon a rippled surface. These painterly notations are effective representational devices, actually sharing some of the slippery, fluid properties of water. Tarbell achieved an illusion of distance by making the brush strokes smaller and closer together as the picture recedes, and by angling the boat back into space. The figures (probably his wife and child) are more clearly defined and solidly modeled than the landscape – which makes the work seem more like a portrait than a landscape. Tarbell cropped the scene so that all we see of the surroundings are a few overhanging leaves and their watery reflections. As the *Art Amateur's* reviewer said of another of Tarbell's Impressionist pictures, "The effect of open air and real afternoon sunshine is unmistakably there. The figures, too, are animated, their poses natural, the grouping interesting."

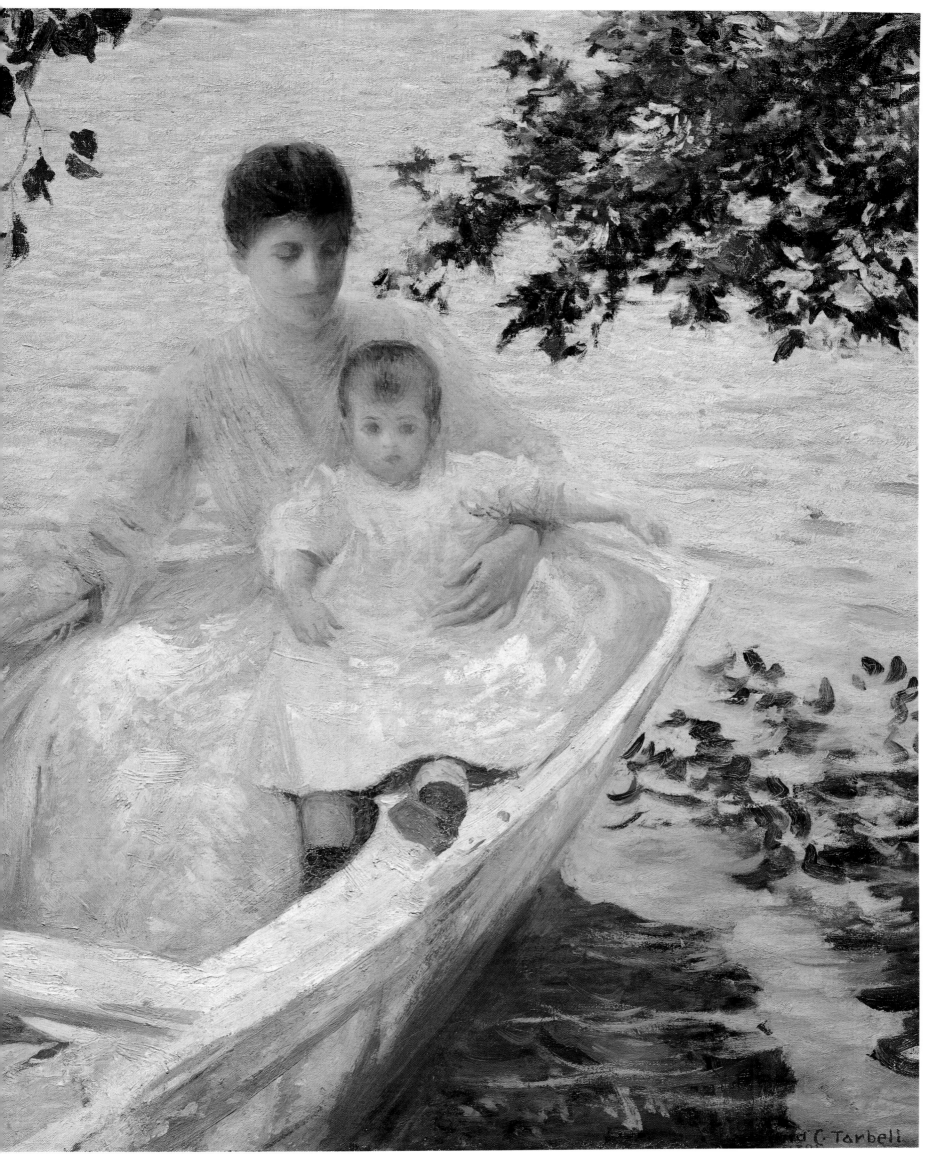

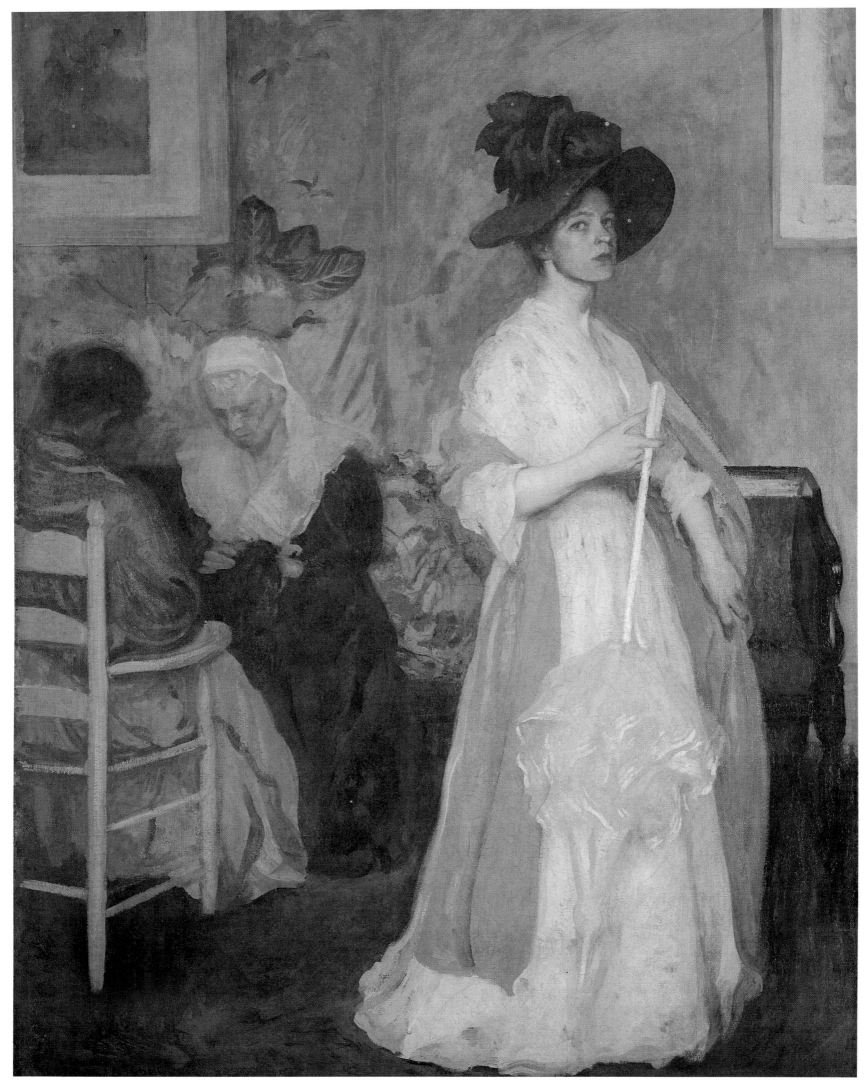

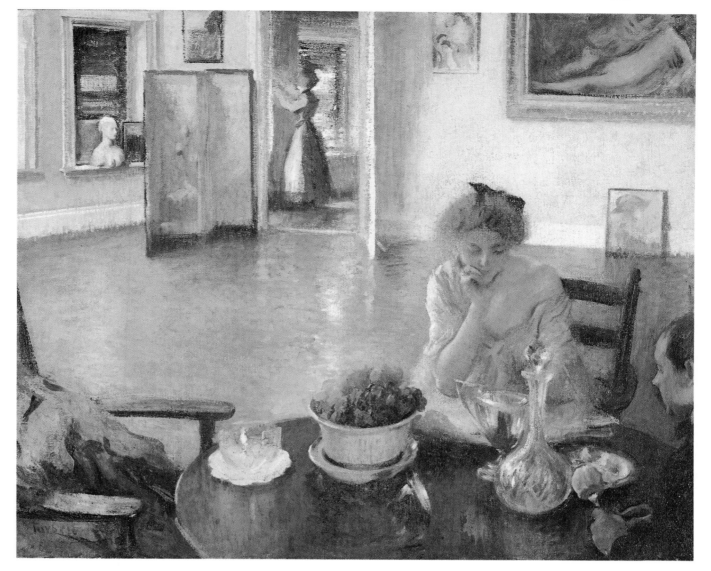

Woman in Pink and Green, 1897
Oil on canvas, 48×36⅛ in.
The Metropolitan Museum of Art, New York
Collection of Mr. and Mrs. Raymond J. Horowitz

The Breakfast Room, c. 1903
Oil on canvas, 25×30 in.
The Pennsylvania Academy of the Fine Arts, Philadelphia
Gift of Clement B. Newbold. (1973.25.3)

In the mid-1890s, Tarbell turned his back on plein-air work and began concentrating on interiors. His vision of genteel life indoors was partly shaped by Vermeer's work, an example of which could be seen in Boston at Isabella Stewart Gardner's house. The appeal of Vermeer to Bostonians perhaps can be traced to a shared Protestant ancestry, which prized cleanliness, order, domesticity, and comfort. Tarbell's interiors, which were imitated by a band of followers dubbed the "Tarbellites," probably also owe something to the stylish indoor scenes of Alfred Stevens, the Belgian painter who had influenced Chase.

This elegant picture, with its sophisticated palette and delicate decorative patterns, shows Tarbell's daughter Josephine at right, his mother Mrs. Hartford at left, and his wife Emeline in the ladder-back chair. The painting, shown at the Ten's first exhibition, almost becomes a parable of the Three Ages of Woman. Youth, personified by the lovely Josephine, is decked in gorgeous finery and seems vain and self-absorbed, while Womanhood and Old Age seem industrious and domesticated. Of the three figures, Josephine, standing in a lilting S-curve pose and painted in the picture's prettiest colors, is the most engaging.

Without resorting to sentiment or anecdote, Tarbell shows an alienated couple at their morning repast. The composition, which crams important details into the right foreground and gives over most of the background to a well-waxed floor, owes something to Degas. Also reminiscent of Degas is the air of sensuality, created by the slouching woman's disheveled appearance (in striking contrast to the man's buttoned-up propriety) and seeming sexual discontent. These erotic notes are rarely found in American Impressionism, and are not even common in Tarbell's *oeuvre*. One wonders who is meant to occupy the third chair – certainly not the maid in the background, who discreetly avoids contact with the two main figures. But the picture's reticence and the sun-washed enfilade of rooms also suggest Vermeer. In 1904, the Boston *Transcript* identified Tarbell's twin sources of inspiration: "Not since . . . the distant years of the Dutch golden age . . . has such an interior been set before us. . . . We can think of no modern painter capable of rivalling it . . ., unless it be Degas." The couple inhabits a vaguely bohemian interior: the room is decorated with art objects, including a Renaissance bust on the window sill, a Titianesque nude and Japanese prints on the wall, and an Oriental screen.

HELEN TURNER

1858-1958

Lilies, Lanterns, and Sunshine, 1923
Oil on canvas, 35×43 in.
The Chrysler Museum, Norfolk, VA
Gift of W. B. S. Grandy

This gentle scene is set on the porch of Turner's home "Takusan" in Cragsmoor, New York, where she spent every summer. An expert gardener, Turner cultivated the tiger lilies growing in the background and arranged in the vase. In painting she always made use of her own surroundings, which were modest and cozy, rather than elegant like the Bostonians'. The round table, for example, was a permanent fixture on her porch, and the model, who posed for both figures, was Julia Polk, daughter of another summer resident. Having taught costume design and illustration for years, Turner chose her models' clothing with an eye acutely sensitive to color, cut, and pattern. This painting pays an unmistakable tribute to *Carnation, Lily, Lily, Rose* by Sargent, whom she met on one of her trips abroad. Turner painted in short, narrow dabs, building up a thick, granular surface. Faces and arms are given a three-dimensional heft, while other forms, such as the dog and lantern at lower right, are broken up by the shaggy web of brushstrokes. For all the brushstrokes' movement, the head-on composition is stable: one lantern marks the canvas's vertical center, while the railing roughly divides the picture in half.

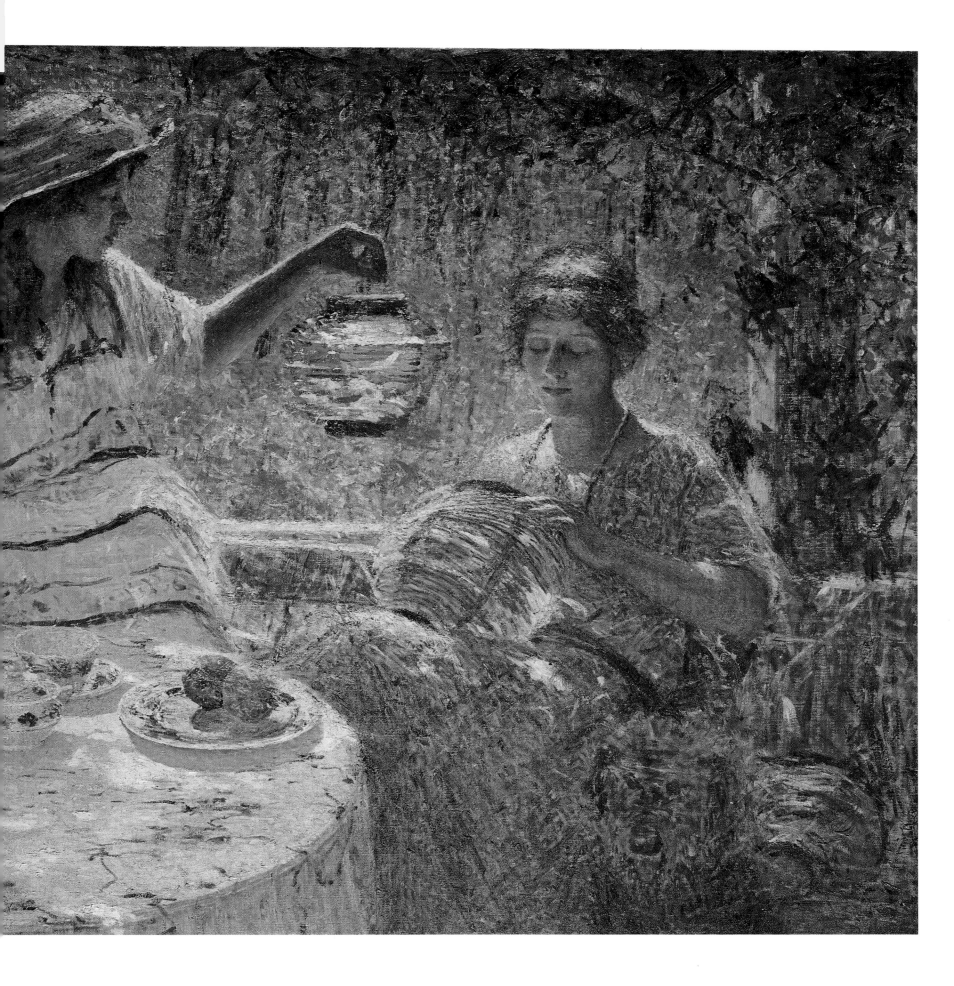

JOHN TWACHTMAN

1853-1902

Arques-la-Bataille, 1885
Oil on canvas, 60×78⅛ in.
© 1983 The Metropolitan Museum of Art, New York
Morris K. Jesup Fund, 1968. (68.52)

This painting signals Twachtman's definitive rupture with the somber palette and bravura brushwork of his Munich period. Unlearning his German training by studying at the Académie Julian from 1883-85, Twachtman spent summers painting in the French countryside using a fine, austere Whistlerian style. *Arques-la-Bataille*, a view painted along the Arques River about four miles southeast of Dieppe, is his indisputable masterpiece of this period. The pigment is so thin and translucent, the canvas is not so much painted as stained. Twachtman is far more concerned with creating a mood of serene contemplation than in describing the material substance of things. The picture's spareness, its reduction of natural forms to calligraphic notations, its preternatural calm, and elimination of the painter's "hand" link the work to Oriental art. The cool muted colors – wide, alternating bands of soft greens and misty greys – and the horizontal format make the scene appear very restful. The horizontal orientation is relieved only by the reeds' long and graceful silhouettes.

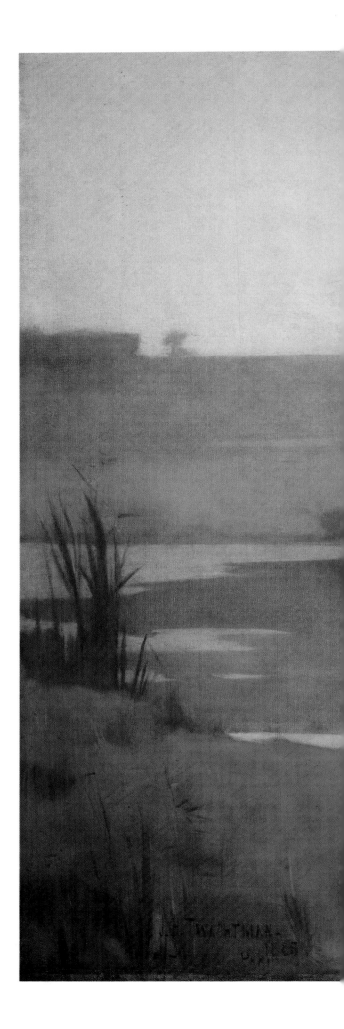

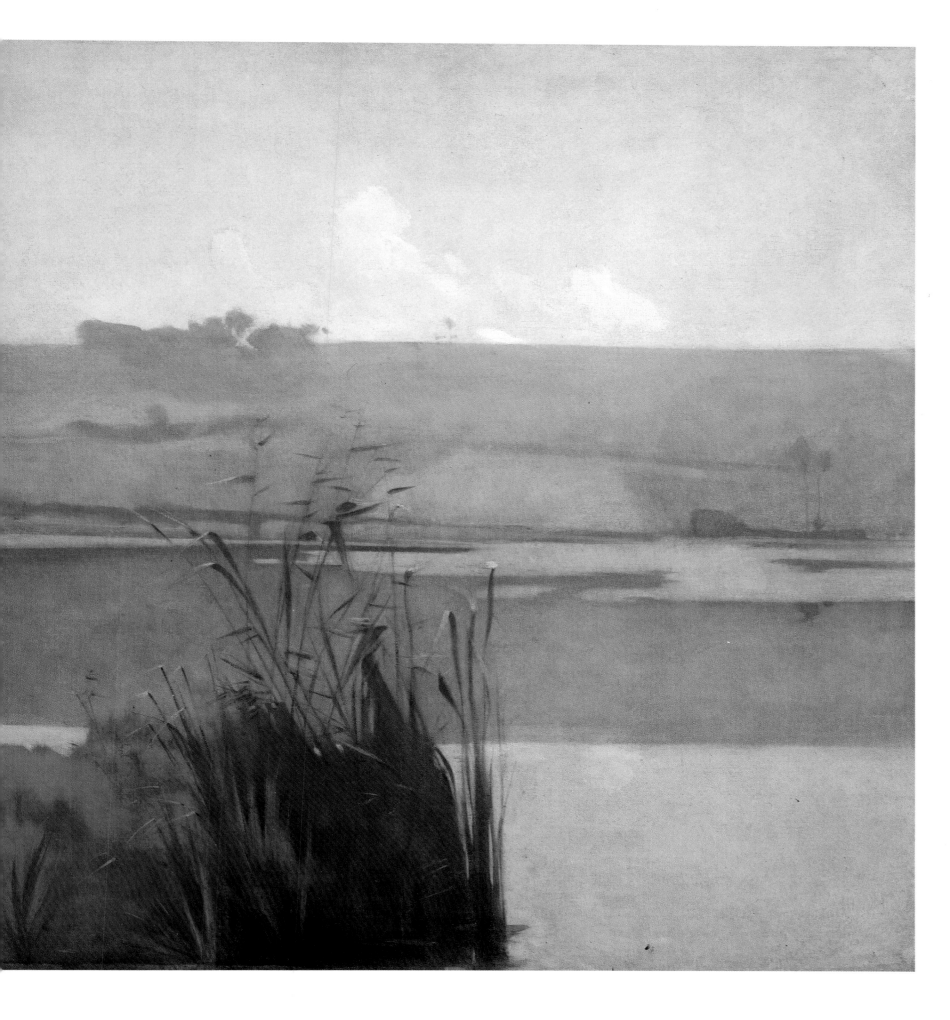

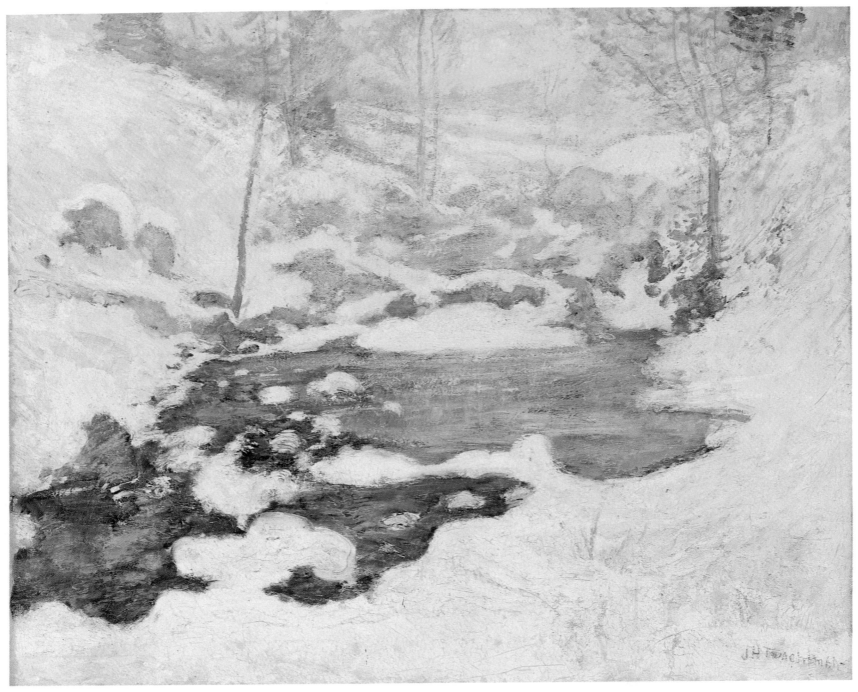

Icebound, c. 1889

Oil on canvas, 25¼ × 30 in.
© *1988 The Art Institute of Chicago. All Rights Reserved.*
Friends of American Art Collection. (1917.200)

When Twachtman returned to America, he moved to southern Connecticut, and around 1889 he purchased a 17-acre farm in Greenwich. Surrounded by the gentle Connecticut countryside, and inspired by his friends Weir and Robinson, Twachtman evolved a very personal Impressionist style. *Icebound* depicts Hemlock Pool on his property, a motif he painted in all seasons and from many different angles. Twachtman's farm became for him what Giverny was to Monet – his own private universe providing inexhaustible material for paintings, and subject to constant improvements through landscaping and structural adornments, such as foot bridges. Here, he painted Hemlock Pool clotted with embankments of snow. Twachtman's favorite season was winter, when all nature is brought into close color harmony. "When it is snowing," he wrote to Weir in 1891, ". . . the whole earth seems wrapped in a mantle. . . . All nature is hushed to silence . . ." During the 1890s, his palette grew lighter, and his strokes looser, but his surfaces are encrusted with impastos, which create a heavy, gritty texture almost at odds with his fragile, reductive vision. The sinuous curves of this composition – closely related to the organic lines of Art Nouveau – distill the scene into an almost abstract pattern. The nearly monochrome blue-white palette is enlivened by his tiny accents of complementary oranges.

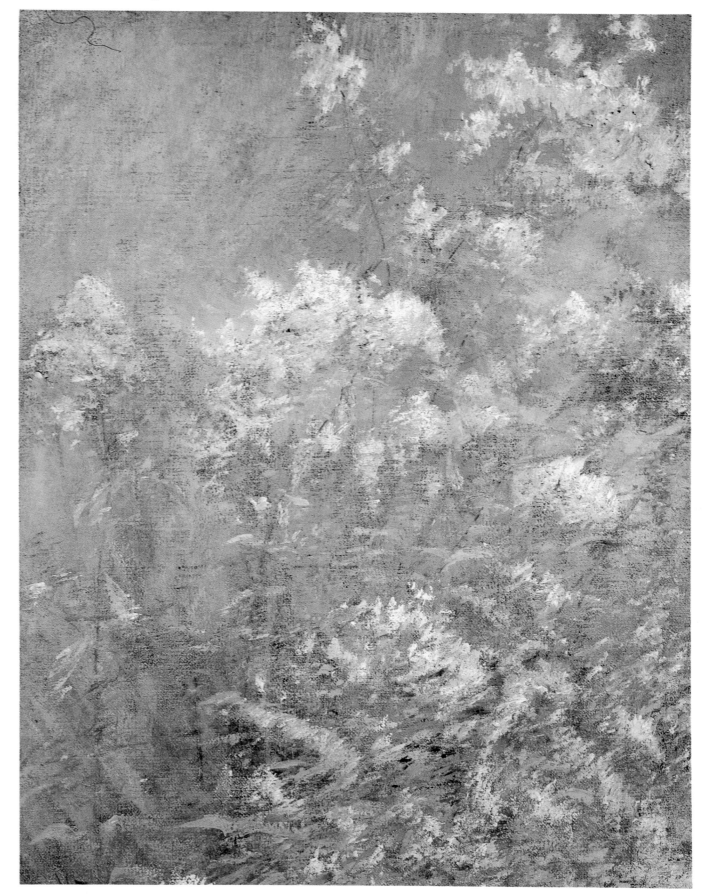

Meadow Flowers, c. 1890-1900
Oil on canvas, 33⅟₁₆ × 22⅟₁₆ in. *(detail)*
The Brooklyn Museum. Polhemus Fund. (13.36)

This unusual picture, which could almost be mistaken for a nonrepresentational work, is certainly as near to abstraction as Monet's waterlilies, painted over 20 years later. Twachtman took flower painting out of the expected realms of still life or landscape, and practically invented a new genre. Harrison Moore, director of the Pennsylvania Academy from 1892-1905, called Twachtman's paintings "fragile dreams in color." Paintings were for Twachtman more like manifestations of inner visions than objective records of natural phenomena. Sounding more like a romantic dreamer than a plein-airist, he wrote, "In my mind I have finer pictures than ever before. Ten thousand pictures come and go every day and those are the only complete pictures painted, pictures that shall never be polluted by paint and a canvas." Yet Twachtman possessed an acute sensitivity to the world outdoors. Weir said, "He was in accord with nature, winter or summer, and a day with him in the country was always a delight."

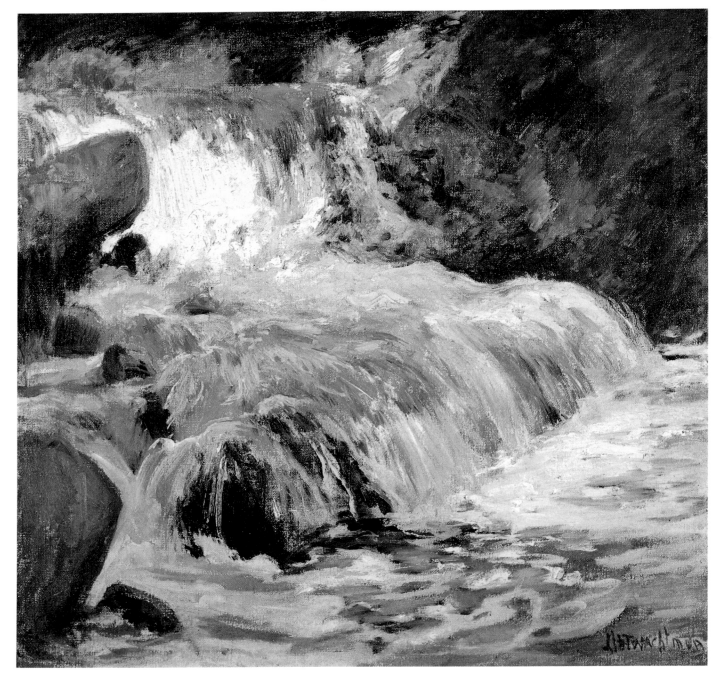

The Waterfall, c. 1890-1900
Oil on canvas, 30 × 30¼ in.
Worcester Art Museum. (1907.91)

Niagara Falls, c. 1894
Oil on canvas, 30 × 25⅛ in.
National Museum of American Art
Smithsonian Institution, Washington, D.C.
Gift of John Gellatly. (1929.6.142)

Located just above the Hemlock Pool, the Horseneck Falls was one of the farm's most picturesque attractions. Twachtman's son J. Alden (named for Weir) remembered exploring the property with his father before he decided to buy it. Coming upon the cataract, which is in fact more modestly scaled than it appears here, the elder Twachtman declared, "This is it!"

By choosing to paint the falls from a skewed viewpoint, Twachtman made the water seem to course at more dramatically acute angles. The liquid rush of the luminous cascade is played off against the solid, dark forms of craggy rocks. We seem to be standing at the base of the falls, right in the eddying water, rendered in strokes so loose and free, the canvas is laid bare. Twachtman omits the horizon and bank that would give us our bearings, forcing an intimate, close-up view.

Having painted his own humble cascade many times, Twachtman was well-prepared to take on the challenge of a commission, proposed by Charles Carey of Buffalo in 1894, to do a Niagara Falls series. Unlike earlier treatments, such as Frederic Church's (p. 6) which show panoramic vistas of this natural spectacle, Twachtman painted Niagara from below, resulting in a more intimate and less overwhelming interpretation. The fuming falls become a kind of liquid prism, sparking motes of pink, green, and peach light. Twachtman was very much at ease with the amorphous, sloshing subject, since highly structured compositions were not to his taste. The mist created by the splashing torrents and rising foam gave him an opportunity to unify the elements of earth, water and air into one harmonious substance. As Charles De Kay wrote in 1918, "All is fluid, all motion, all color."

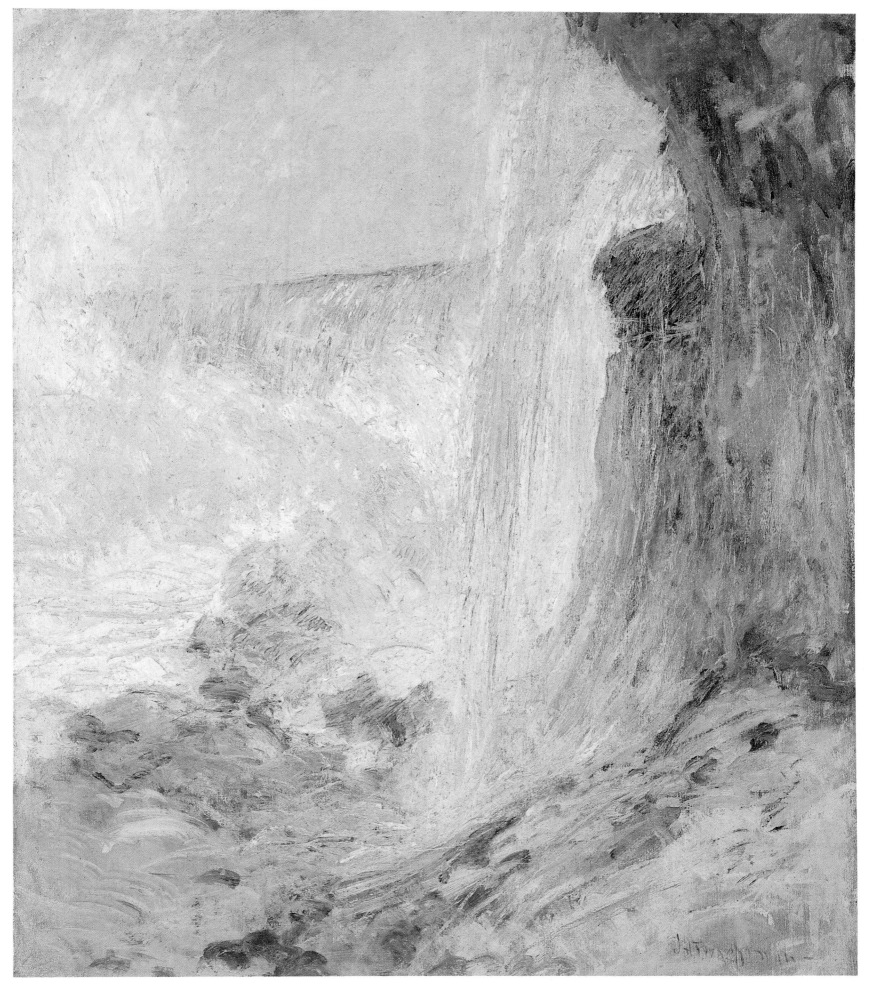

Emerald Pool, Yellowstone, c. 1895

Oil on canvas, 25¼ × 30¼ in.
© Wadsworth Atheneum, Hartford
The Ella Gallup Sumner and Mary Catlin Sumner Collection

The success of Twachtman's Niagara series convinced Major W.A. Wadsworth of Buffalo, New York, to commission painted views of Yellowstone Park. Referring to this picture, Twachtman's pupil Eliot Clark wrote, "He brought back some splendid bits of color from its opalescent pools." The undulating, spiraling rhythms of this painting are related to Art Nouveau, and to the imaginary landscapes of Albert Pinkham Ryder (p. 7), also executed with caked, rough impasto. Challenged to make a picture out of next to nothing, Twachtman came up with a nearly abstract study of color and pattern. There is no sense of scale, or of space.

Though he had a few enlightened patrons, Twachtman's paintings were difficult for contemporary audiences. He complained in 1901 that he had exhibited "85 paintings this year and not sold one" and warned in an 1893 address to students at the Art Institute of Chicago, "some day . . . you will do distinguished work, and then the American public will turn you down for second- and third-rate French painters." A painter's painter, Twachtman won the highest respect from colleagues. Hassam eulogized in 1903: "The great beauty of design . . . is what impressed me always . . . his works were strong, and . . . delicate even to evasiveness."

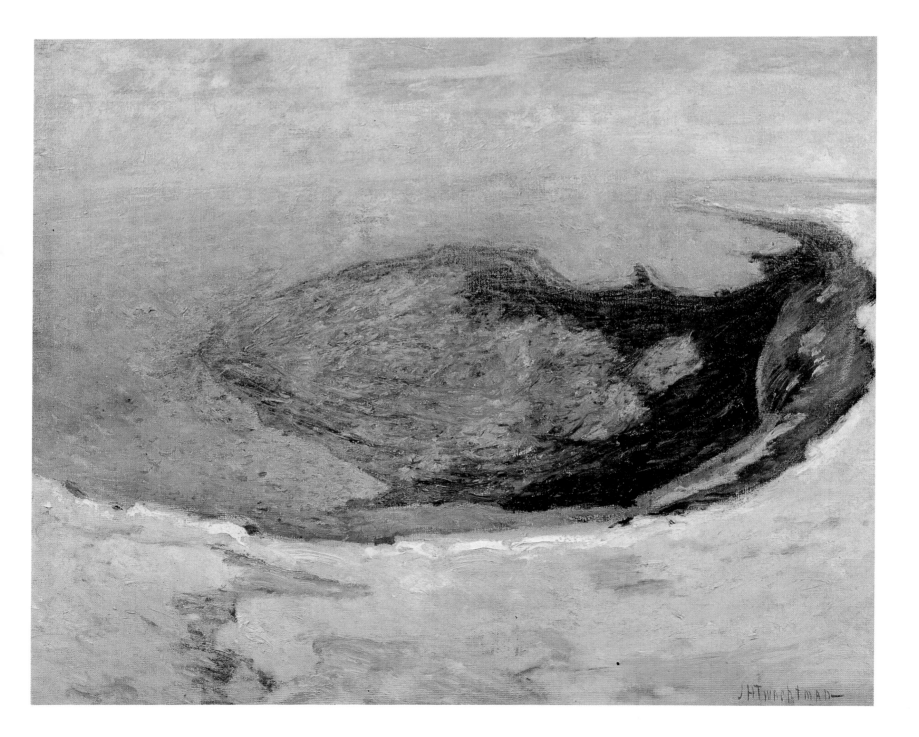

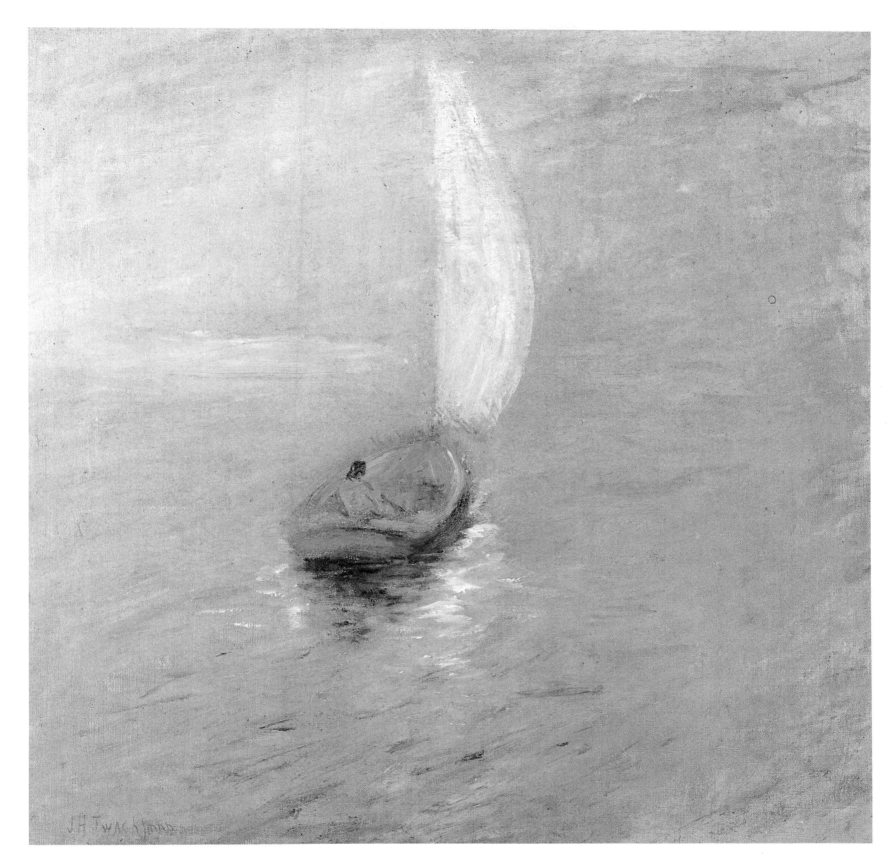

Sailing into the Mist, c. 1895

Oil on canvas, 30½ × 30½ in.
The Pennsylvania Academy of the Fine Arts, Philadelphia
Joseph E. Temple Fund. (1906.1)

Twachtman, most comfortable with landscape, rarely painted figures. Even here, the lone sailor is depicted at a distance, with his back turned. The solitary austerity of this scene is almost Oriental in feeling. A critic for the *Art Amateur* observed in 1891, "few painters, out of Japan, have ever been more given to abstracting the quaint essence of a scene and ignoring all that a vulgar realist would think is necessary to include." The pigments – blues, violets, seafoam greens, and in the reflections, oranges – are lightly and thinly brushed, mostly with diagonal, directional strokes. Toward the right, the paint grows even sparser, the horizon fainter, and the space flatter. The picture suggests the kind of "voyage of life" parables treated explicitly by Thomas Cole, and more implicitly by Ryder in his many marines (p. 7). Attracted to misty weather, Twachtman wrote to Weir in 1891: "Tonight . . . a cloudy sky to make it mysterious and a fog to increase mystery. Just imagine how suggestive things are."

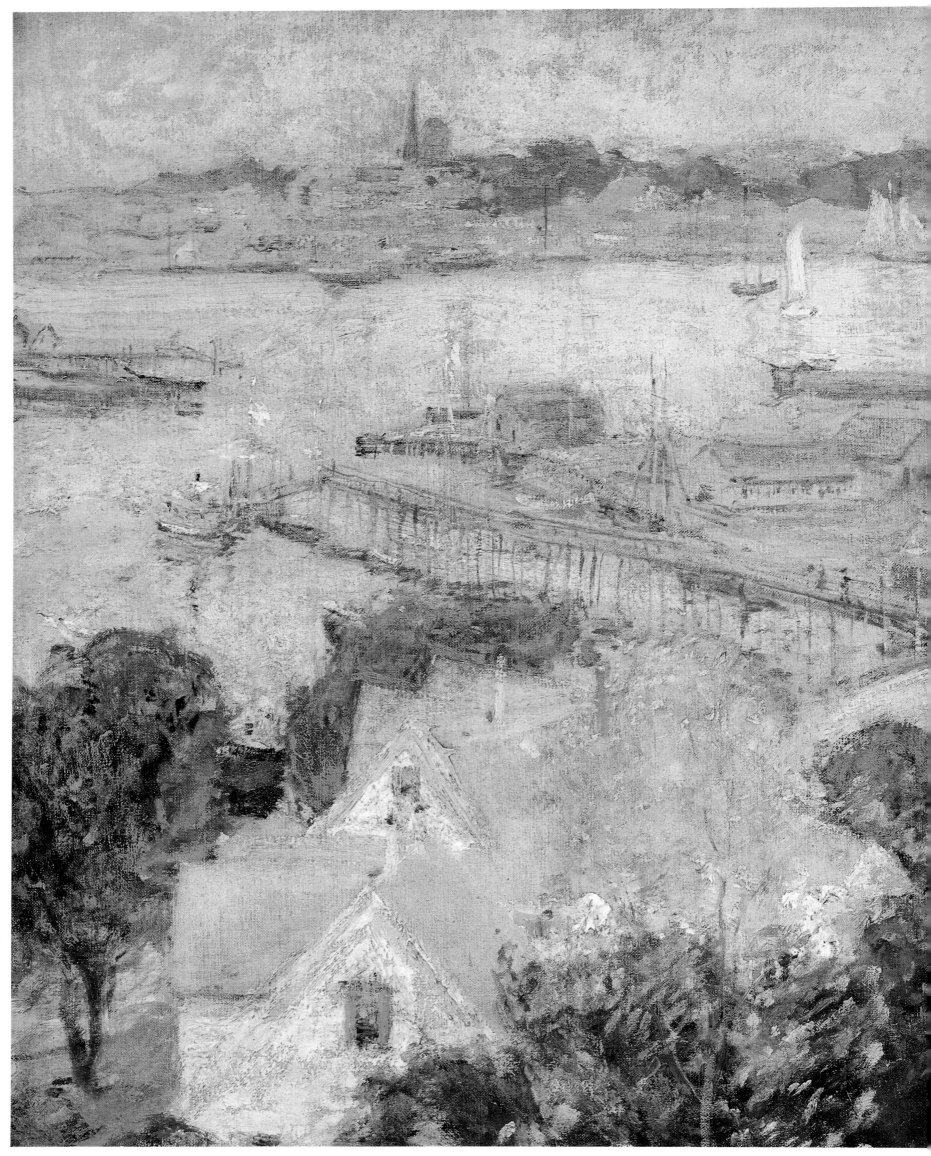

Gloucester Harbor, c. 1901
Oil on canvas, 25 × 25 in.
Collection of the Canajoharie Library and Art Gallery, NY

Twachtman passed the summers of 1900 to 1902 (the year of his death) painting in Gloucester, Massachusetts, at that time both an artists' resort and the largest fishing port in the world. For unknown reasons, Twachtman's style underwent a significant change during these last years of his life. The serpentine contours of his earlier canvases gave way to more angular, geometric compositions, and his heavily worked surfaces were superseded by a light, grazing touch applied all at once, instead of over multiple sessions. Widening his palette and deepening his sense of space, he also reintroduced black and outlining, features not seen since his Munich phase. Eliot Clark, who worked with Twachtman in Gloucester, felt that during the artist's final period, "each picture seems to a certain extent an experiment, a venturing into new realms of consciousness and appreciation, and it is precisely this quickened spirit that the painter has so successfully imparted to the spectator." This viewpoint, similar to the one Metcalf assumed (p. 114) is painted from East Gloucester's Banner Hill, looking over the wharves and fish houses toward the spires of West Gloucester on the opposite shore.

ROBERT VONNOH

1858-1933

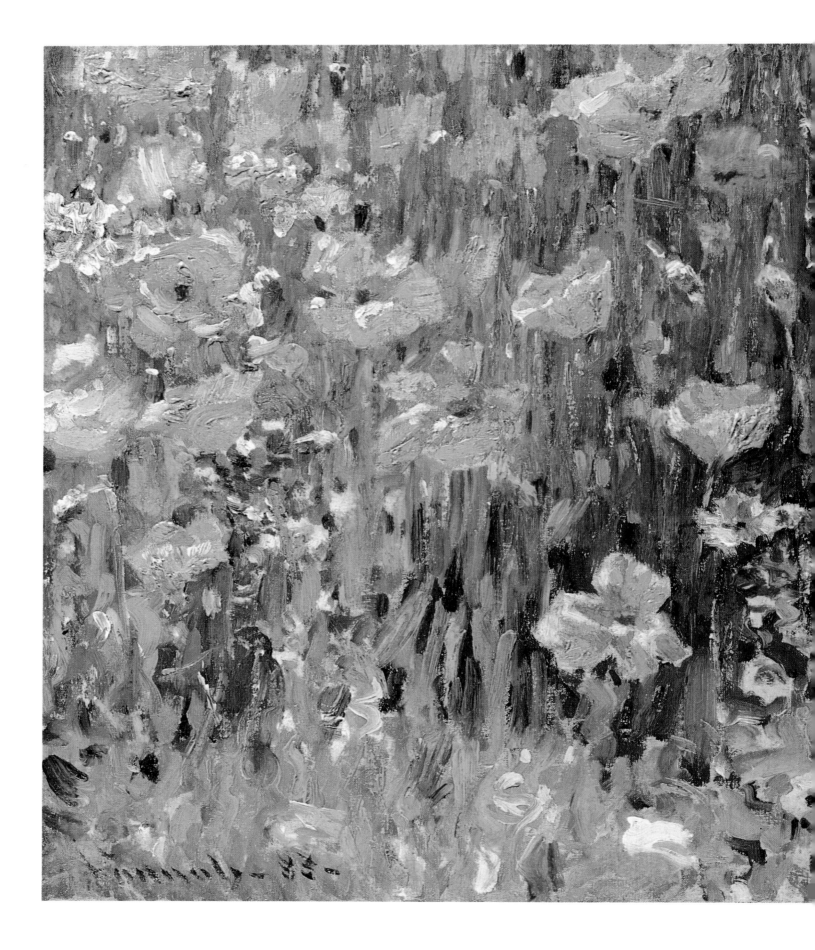

Poppies, 1888
Oil on canvas, 13 × 18 in.
© *Indianapolis Museum of Art*
James E. Roberts Fund. (71.8)

An artist who worked in Boston, Philadelphia, New York and Chicago, Robert Vonnoh studied at the Académie Julian from about 1880-83, and subsequently continued to divide his time between America and France. Vonnoh was known primarily for his portraits, painted in a fairly conservative style, but he also made some of the most radical landscapes painted by an American Impressionist. While staying at the French art colony of Grez in the late 1880s, he produced – under the influence of Irish artist Roderick O'Connor (an early admirer of van Gogh) – flaming, almost crudely brilliant, floral studies. The searing palette and rough handling of *Poppies* generate a raw energy perhaps closer to Fauvism than Impressionism. The loose, thick blobs and dashes of pigment sitting on the canvas's surface (especially at bottom) make the picture as much about the act of painting as about representation. Reviewing an 1896 exhibition of Vonnoh's work, Susan Ketcham described the pleasures of Vonnoh's vigorous execution for *Modern Art*: "One sees the artist's joy in pure color, the fun he has had in using big brushes and the palette knife, in putting paint on direct from the tube, in 'loading,' in scraping down. His work is spontaneous, vital."

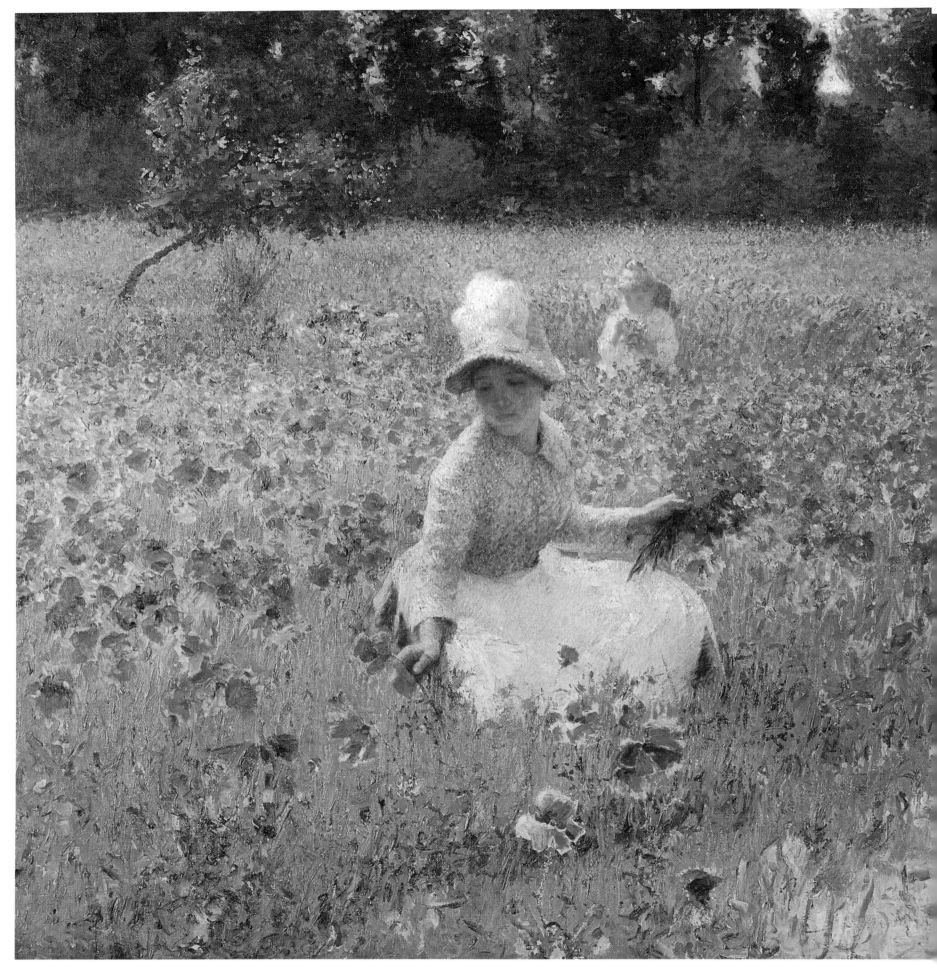

**In Flanders Field where Soldiers Sleep
and Poppies Grow,** c. 1892

Oil on canvas, 58×104 in.
The Butler Institute of American Art, Youngstown, OH

The boldness of the previous picture derives not just from an awareness of post-Impressionist trends, but from the fact that it was intended as a study for this far more finished canvas. The coarse brushwork has been refined into neater, less irregular dabs (particularly in the figures), and the wild chromatism has been tamed into a gentle brightness. Though more restrained, this

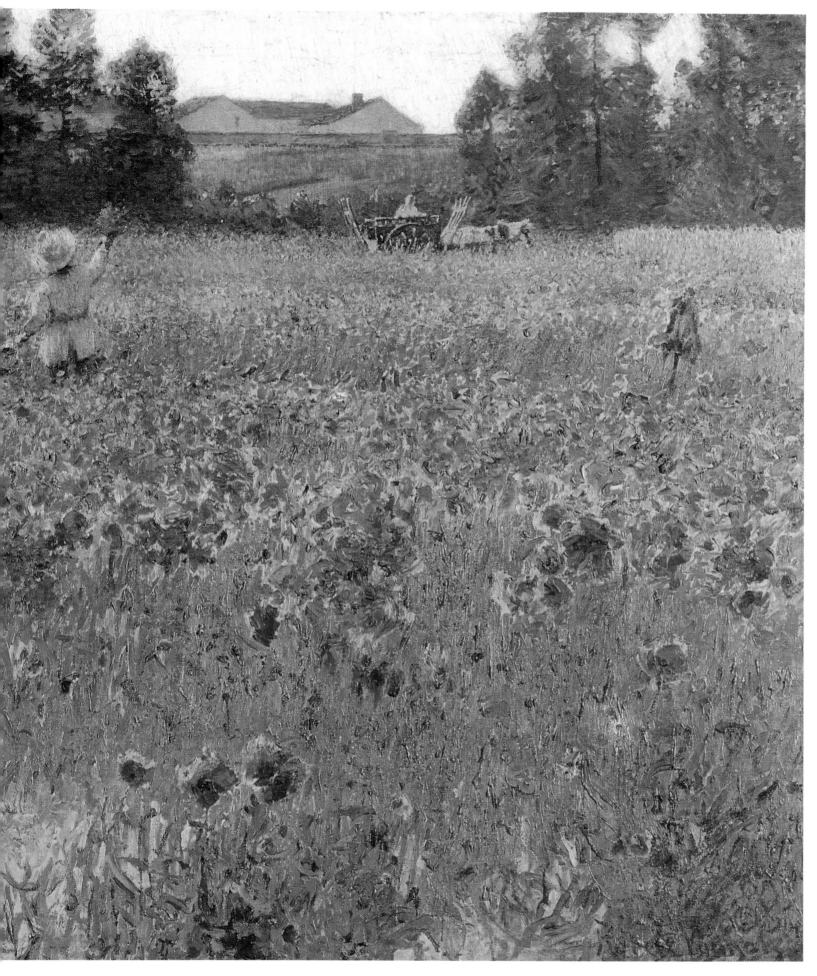

work provides its own satisfactions, such as evoking a very distinct sense of place. Susan Ketcham wrote, "All who have seen in France . . . the superb fields of yellow grain ablaze with poppies, fragile and flickering like flames in the slightest suspicion of a breeze, will enjoy this." In his Impressionist works, Vonnoh was above all a colorist, as the artist himself acknowledged in an 1891 catalogue essay: "He worked with a definite purpose to interpret as directly and simply as possible the truths of Nature, not in a literal sense, but solely with reference to color sentiment. . . ." Through his teaching activities Vonnoh spread his aesthetic to students, including the American Impressionists Perry, Redfield, Schofield, and Glackens.

J. ALDEN WEIR

1852-1919

The Red Bridge, 1895
Oil on canvas, 24¼ × 33¾ in.
© 1982 The Metropolitan Museum of Art, New York
Gift of Mrs. John A. Rutherford, 1914

Weir's Impressionist canvases of the 1890s have a very distinct surface of thick but evenly brushed paint. Though his colors range widely across the spectrum, they are kept at an equal intensity, resulting in a general tonal unity. Weir's daughter Dorothy recalled that on a visit to his wife's family home in Windham, Connecticut, Weir was disturbed to discover that a quaint covered bridge had been replaced by an iron structure. But after beholding it once an undercoating of cheery red paint had been applied, "he saw in the ugly modern bridge a picture." Not only did the new bridge give him a chance to explore the effects of red seen against its complementary, green, and industry juxtaposed with nature, it provided an opportunity to update and Westernize a Japanese print that he owned, Hiroshige's *Maple Trees at Tsuten Bridge* (c. 1834). The major diagonals of the bridge and branch, the trellis effect of the foreground trees, and the distance-blocking high horizon are all features borrowed from this Oriental source. The year before this picture was painted, Robinson noted in his diary that his friend Weir had gone "Japanese-mad."

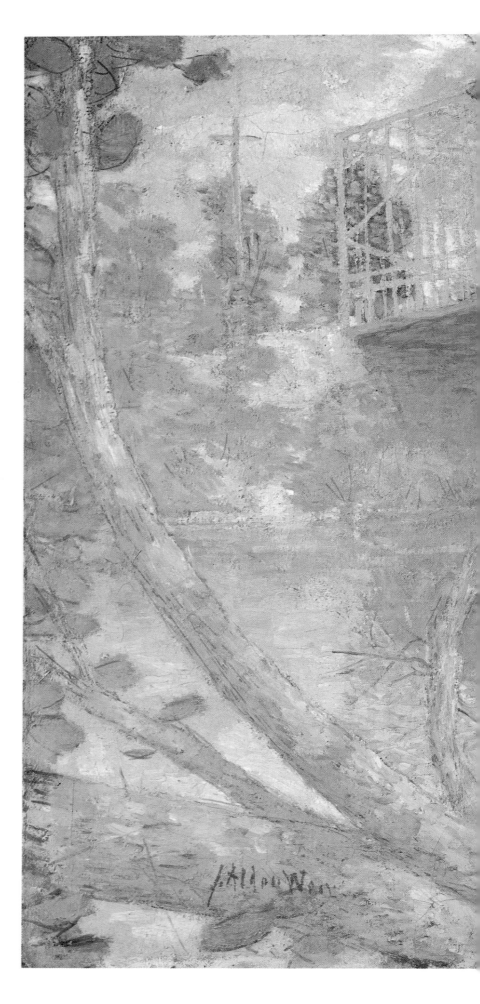

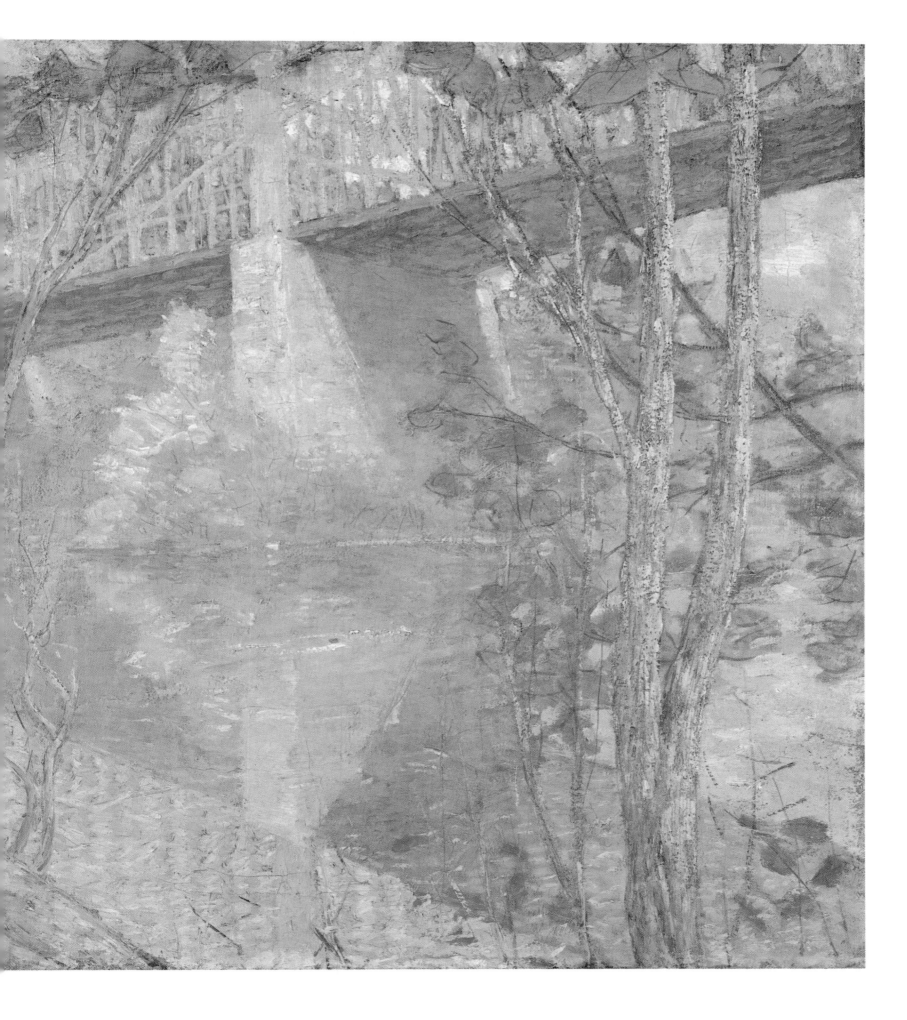

The Factory Village, 1897
Oil on canvas, 29×38 in.
Jointly owned by Cora Weir Burlingham and The Metropolitan Museum of Art, New York, 1979. (1979.487)

This rather idyllic view of the factory town of Willimantic, Connecticut, near Windham, is the climax of a series painted between 1893 and 1897. Here, Weir makes more explicit the theme treated in the previous picture – the compatibility of nature and industry. The smokestack at right and the electrical pole at bottom center seem as natural a part of the landscape as the giant tree trunk, while the puffs of smoke emitted by the chimney seem as innocuous and elemental as the wispy clouds. In the rare instances where they depicted industry, neither the French nor American Impressionists dealt with it as a noxious intrusion, nor did their art often acknowledge the existence of industrial laborers. Impressed with the Willimantic pictures, Robinson wrote, "I liked immensely a Conn. factory town, modern yet curiously medieval." The "medieval" traits Robinson probably had in mind were the flattened forms, strong surface patterning, and luminous, outlined areas of color, reminiscent of stained glass or illuminated manuscripts.

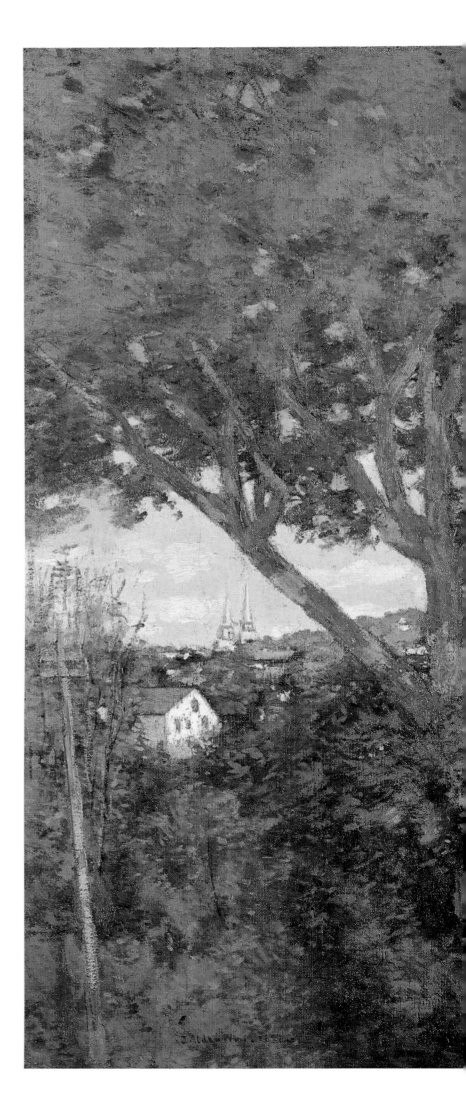

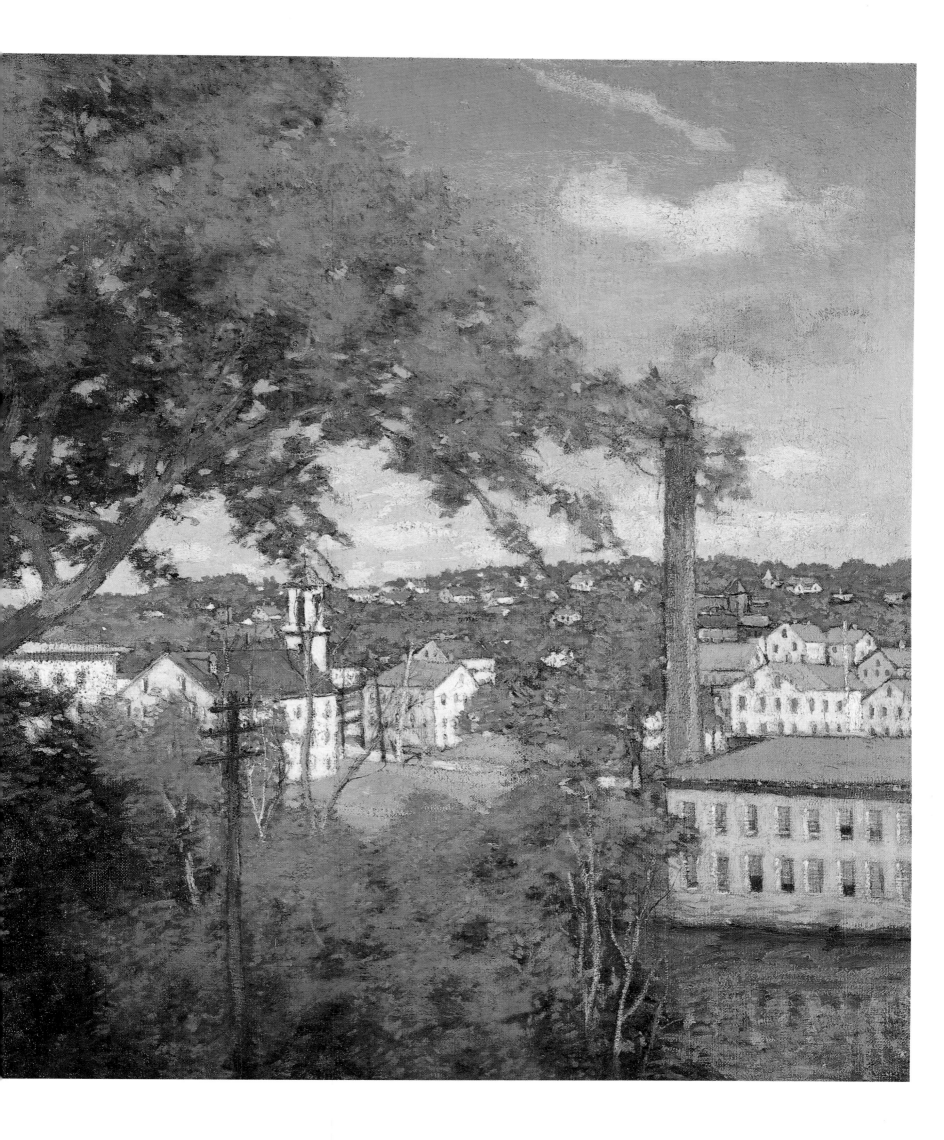

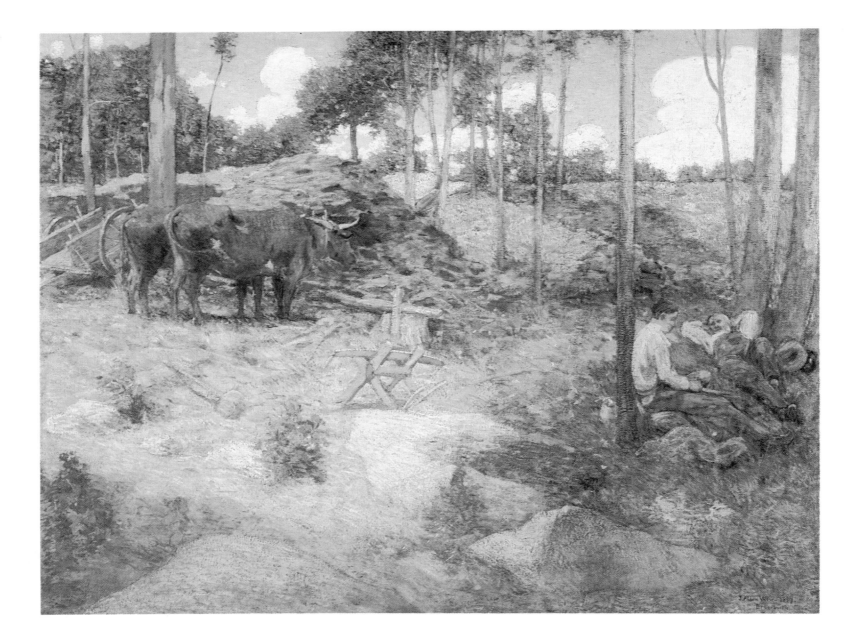

Midday Rest in New England, 1897

Oil on canvas, 39⅝ × 50⅜ in.
The Pennsylvania Academy of the Fine Arts, Philadelphia
Gift of Isaac H. Clothier, Edward H. Coates, Dr. Francis W.
Lewis, Robert C. Ogden, and Joseph G. Rosengarten. (1898.9)

Painted at his Branchville, Connecticut farm, *Midday Rest* celebrates the rocky New England land, and the simple life of the farmers who till it. The view of rural labor is pastoral. The men are not shown working; instead, they set their tools aside and eat or relax on a shady slope. Man, animals, and nature are all of a piece. Nearly lost in the landscape, the laborers' bodies hug the earth rather then dominate it. Weir implicitly compares the two field workers with the pair of oxen unhitched from their cart. Though the style is still Impressionist, the subject matter is closer to Barbizon pictures by Millet (p. 7), with the difference that the French painter showed peasant life as much harsher.

The Plaza: Nocturne, 1911

Oil on canvas mounted on wood, 29 × 39½ in.
Hirshhorn Museum and Sculpture Garden
Smithsonian Institution, Washington, D.C.
Gift of Joseph H. Hirshhorn, 1966. (66.5508)

Though Weir summered in Connecticut, his primary residence was New York City. In 1910-11, while living at 471 Park Avenue, Weir painted nocturnal cityscapes from his window. The title "nocturne," and the subject – an urban view softened and harmonized by a monochromatic, penumbral palette – come from Whistler, whom Weir first met in 1877, and visited again in 1901. The shadowy forms, velvety blues, and flecks of gold and white representing lit windows romanticize the city, lending it a magical, fairyland aura. Weir's interpretation recalls O. Henry's comparison of New York – full of "palaces, bazaars, khans, and byways" – to a vision from the *Arabian Nights*. From his Park Avenue perch, Weir looked down 58th Street, the picture's central artery, toward the Plaza Hotel, the palest and tallest building at right. The phosphorescent glow in front of the hotel, completed just four years earlier, marks the Grand Army Plaza and Fifth Avenue, running along the building's east face. Weir wrote to a friend about this painting, "Of course none of it could be painted direct, having had to make studies – memorandum to use the following day. The thing itself was so beautiful I had to get the big notes which as you know are terribly subtle."

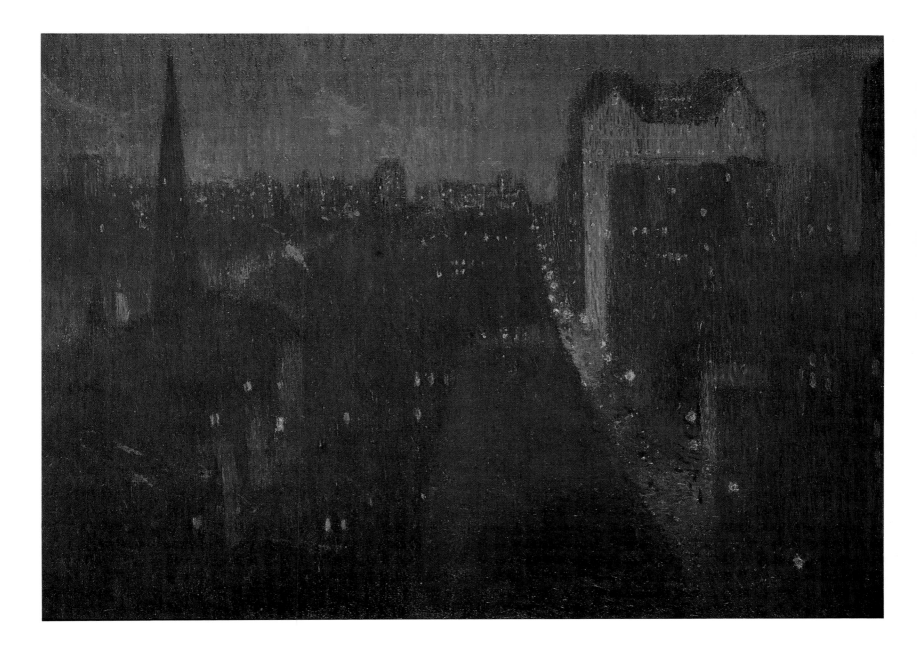

JAMES MCNEILL WHISTLER

1834-1903

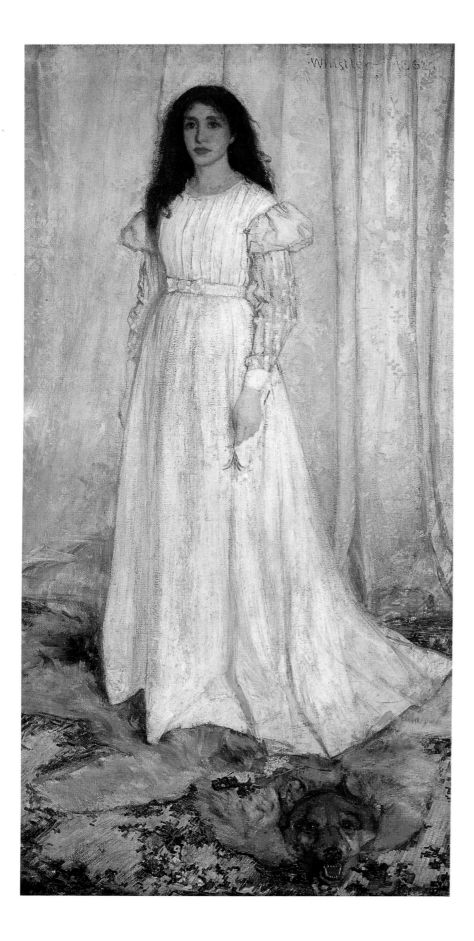

Symphony in White, No. 1: The White Girl, 1862
Oil on canvas, 84½ × 42½ in.
National Gallery of Art, Washington, D.C.
Harris Whittemore Collection. (1943.6.2)

The woman in this picture is the Irish beauty Jo Hiffernan who became Whistler's long-term mistress and frequent model. Whistler had great ambitions for this painting, which he described to a friend as a girl "standing against a window which filters the light through a transparent white muslin curtain – but the figure receives a strong light from the right and therefore this picture, barring the red hair, is one gorgeous mass of brilliant white." When the picture was rejected from the Royal Academy in 1862, Whistler, intransigently self-confident, said, "I knew she was beautiful and was consoled." Also turned down by the Salon in 1863, the painting was exhibited at an alternative show, the Salon of the Refused, where it created a sensation. Baudelaire found it "exquisitely delicate" and Manet thought it "very good." The critic Paul Mantz proclaimed it a "symphony in white," a designation which the pleased Whistler appropriated for future white-on-white canvases. In defending art for art's sake, Whistler often compared painting to music. "As music is the poetry of sound, so is painting the poetry of sight, and the subject matter has nothing to do with harmony of sound or color."

The Princess from the Land of Porcelain, 1864
Oil on canvas, 79⁹⁄₁₀ × 46²⁄₃ in.
Freer Gallery of Art, Smithsonian Institution, Washington, D.C.

The exotic looks of the Sparlati girls, daughters of the Greek consul general in London, moved a friend of Whistler to write, "We were all on our knees before them, and of course, burned with a desire to paint them." Whistler convinced the younger daughter Christine to satisfy this desire, and the resulting portrait became a vehicle for Whistler's growing passion for things Oriental.

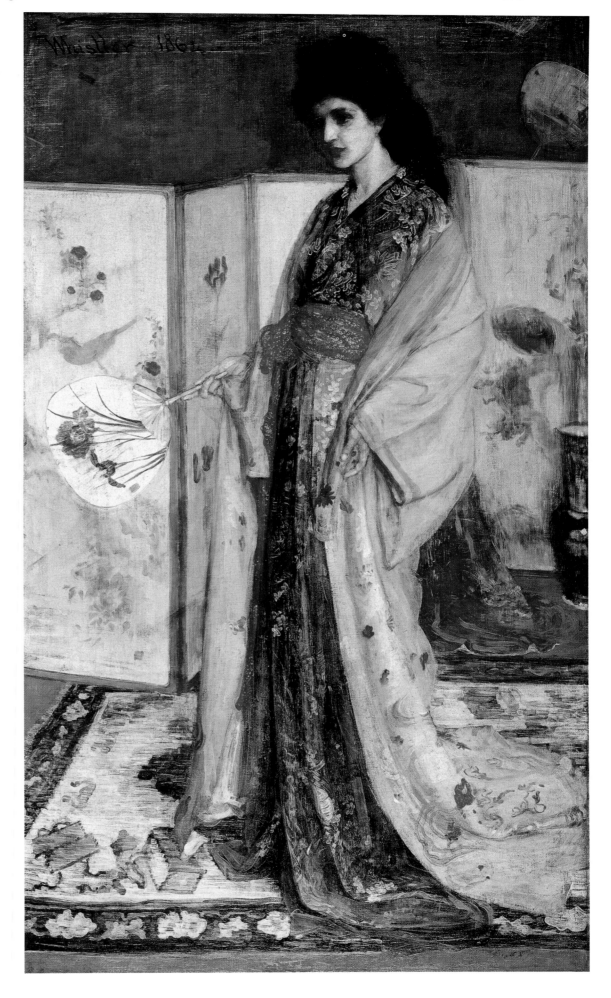

Whistler dressed Christine in a kimono, and surrounded her with Oriental objects from his collection – fans, a rug, a porcelain vase, and a folding screen. He also adapted her slinky S-curve pose and the elongated format from Japanese prints. Both Whistler and his sitters found his painting procedures difficult – both had to endure dozens of fruitless sittings, which would often end with one or the other giving up in disgust. "I am so slow . . . I produce so little because I wipe out so much," he lamented.

Working without preliminary drawings, Whistler envisioned his paintings already complete in his mind's eye. He arranged the pose and accessories with the utmost care, and always mixed his paints in advance, since to him, the success of a painting depended more on color relationships than execution.

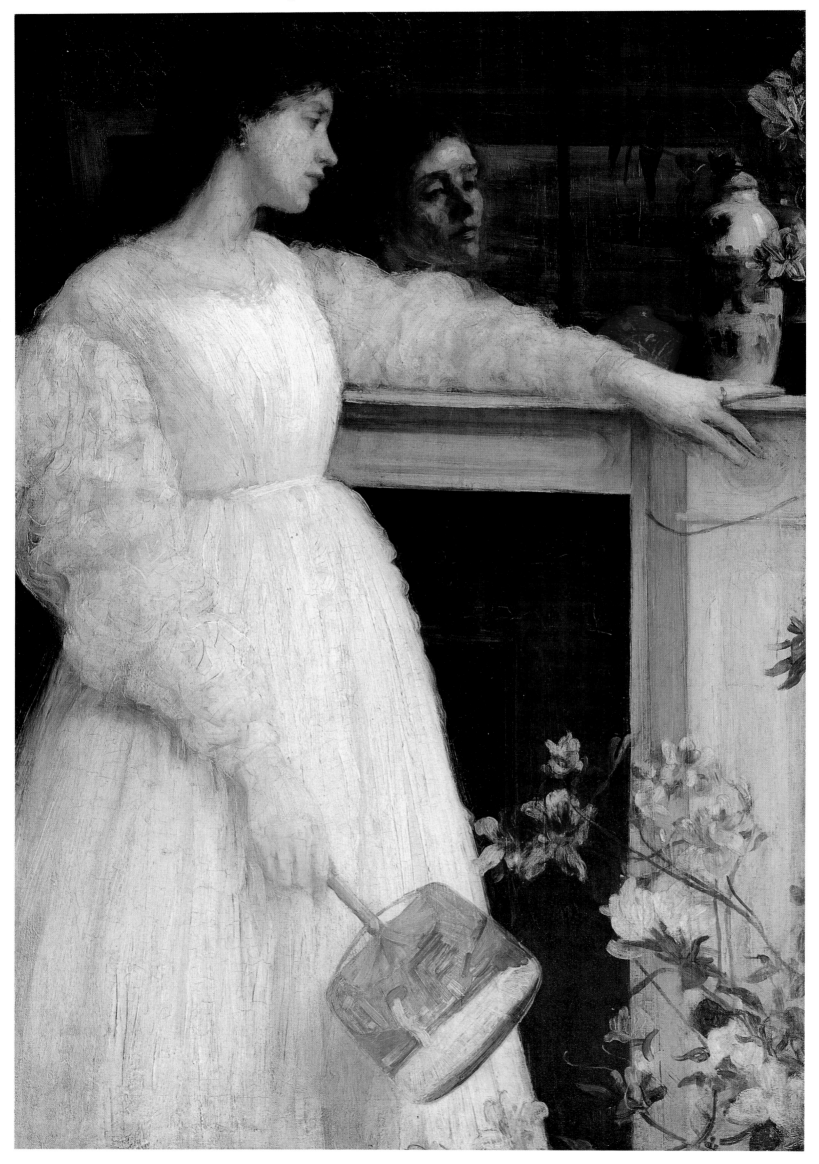

**Symphony in White, No. 2: The Little
White Girl,** 1864
Oil on canvas, 30×20 in.
Tate Gallery, London

Dressed in white muslin, Jo Hiffernan is posed
against the mantelpiece and mirror of Whistler's
London house, her loveliness enhanced by the refined
Japanese accents of the porcelain, fan, and azalea
sprigs. We see two views of her features, which do not
form a bland mask of beauty, but rather are composed
into a compellingly contemplative and wistful face.
Despite her distracted expression, she seems acutely
aware of her sultry beauty, a conceit recognized by the
Aesthetic writer Algernon Swinburne, whose poetic
homage to the painting was affixed to the original
frame: ". . . I watch my face, and wonder/At my bright
hair." With unusual magnanimity, Whistler declared
that Swinburne's verses were "a rare and graceful tri-
bute from the poet to the painter – a noble recognition of
work by the production of a nobler one." This praise
cannot be taken lightly, because Whistler himself was a
brilliant prose stylist: even if he were forgotten as a
painter, he would be remembered for writing "The Ten
O'Clock Lecture" and "The Gentle Art of Making
Enemies," two of the great aesthetic tracts of the nine-
teenth century.

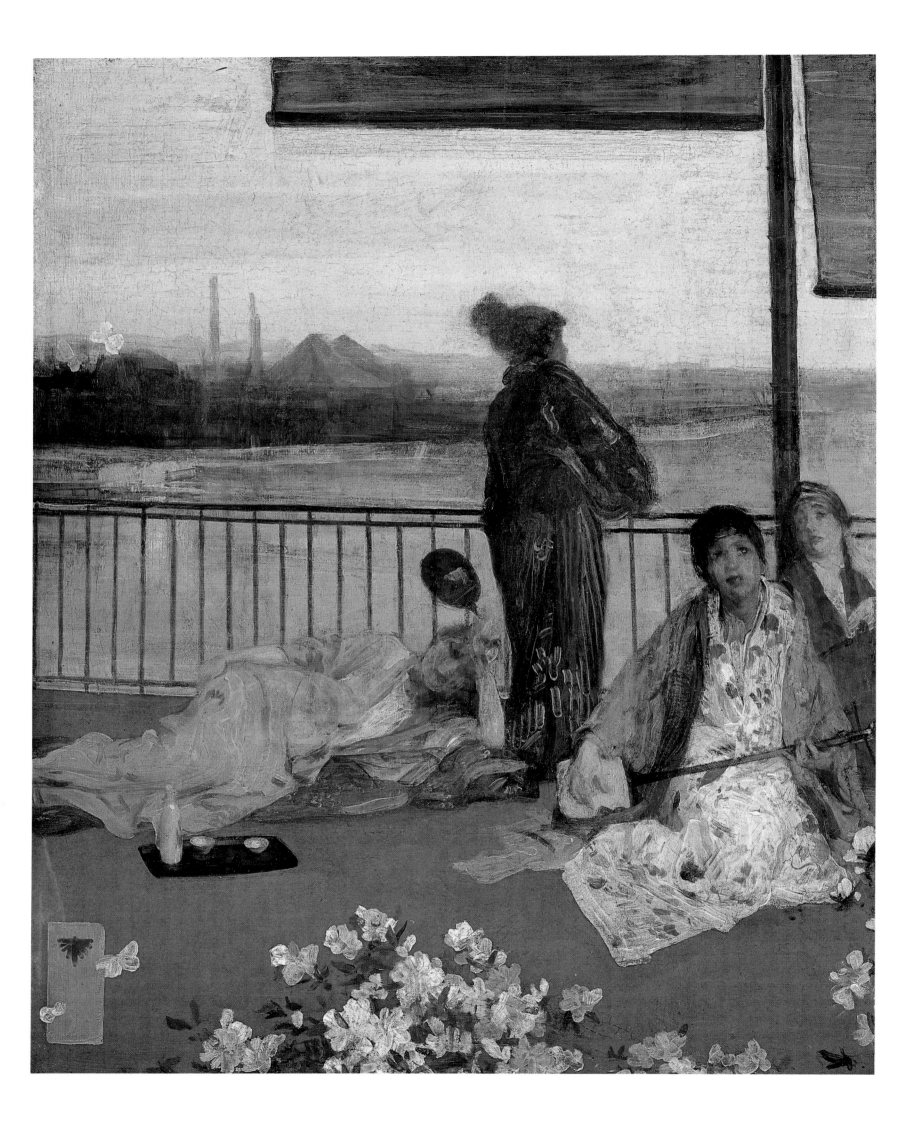

Following pages:

**Variations in Flesh Color and Green:
The Balcony,** 1865
Oil on wood, 24½ × 19½ in.
Freer Gallery of Art, Smithsonian Institution, Washington, D.C.

Symphony in White, No. 3, 1867
Oil on canvas, 20 × 30 in.
The Barber Institute of Fine Arts
The University of Birmingham, England

This scene is unusual in its merging of the two themes that most preoccupied Whistler: the Orientalized interior and the urban landscape. Every bit as much as the exotica of Japan, Whistler loved the views from his windows of the Thames and the factory chimneys along its shoreline. The general mood of the picture, and certain details, such as the tea set, the girl strumming a musical instrument (a shamisen), and the blossoms derive from woodblock prints by Torii Kiyonaga. Whistler may have used little Japanese dolls as compositional aids while planning the picture. His famous butterfly insignia, inspired by Japanese potters' marks, is clearly visible in the cartouche at left.

Here Whistler translated the feminine languor of *The Balcony* into a more Westernized scene. The graceful cascades of white drapery and frieze-like format suggest classical Greece, but the fan and peripheral sprays of Dutchman's breeches and azaleas, echoing the seated girl's pose, introduce Japanese notes. The models are Jo, lounging at left in the same simple dress she wore in *The Little White Girl,* and Milly Jones, an actor's wife. Whistler was especially satisfied with the rhythmic interplay of the women's arms, and the relationship of their gentle curves to the geometry of the sofa. Other painters were impressed with the work as well. Alfred Stevens praised it, Degas made a sketch after it, and Manet probably painted *Repose* (p. 9) in response to it. When the picture was first exhibited, a critic objected that it was "not precisely a symphony in white," since other colors were included. Whistler retorted, "Does he then, in his astounding consequence, believe that a symphony in F contains no other note, but shall be a continued repetition of F, F, F? . . . Fool!"

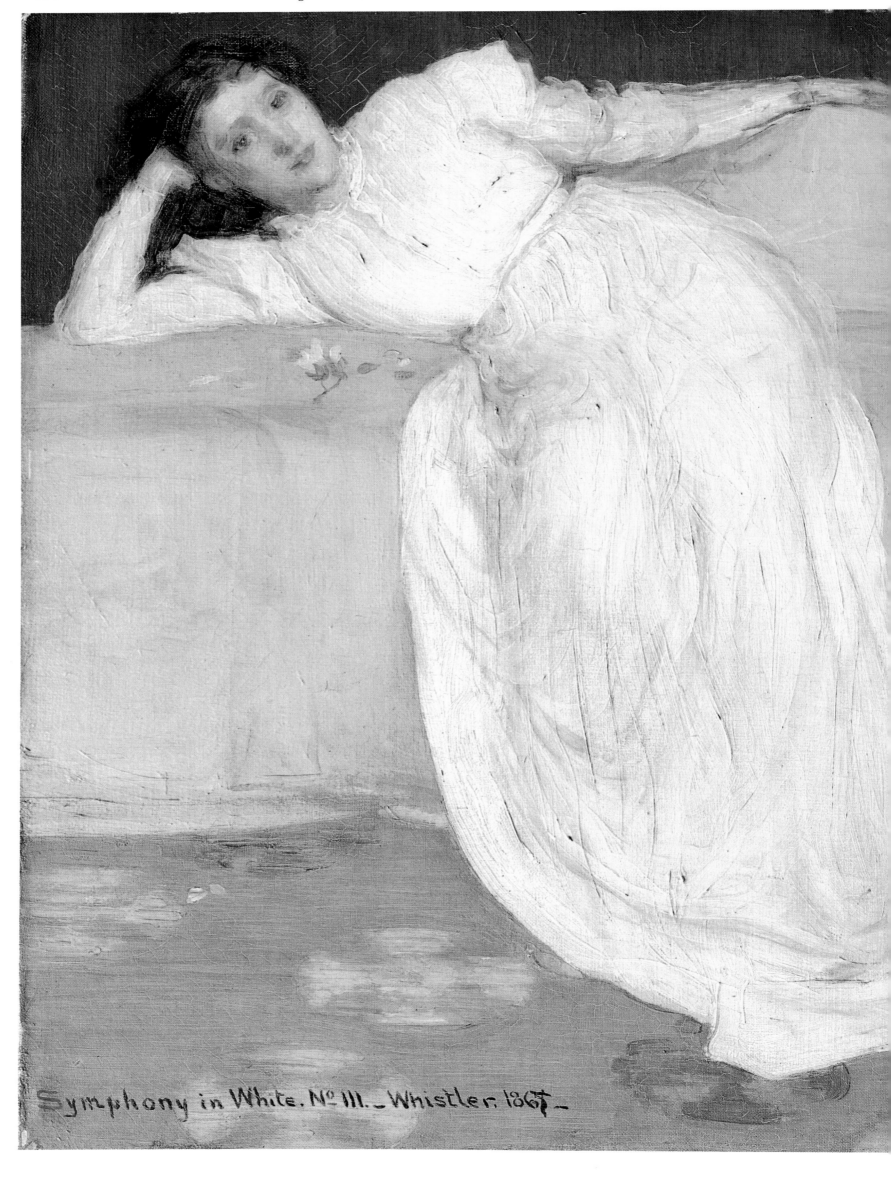

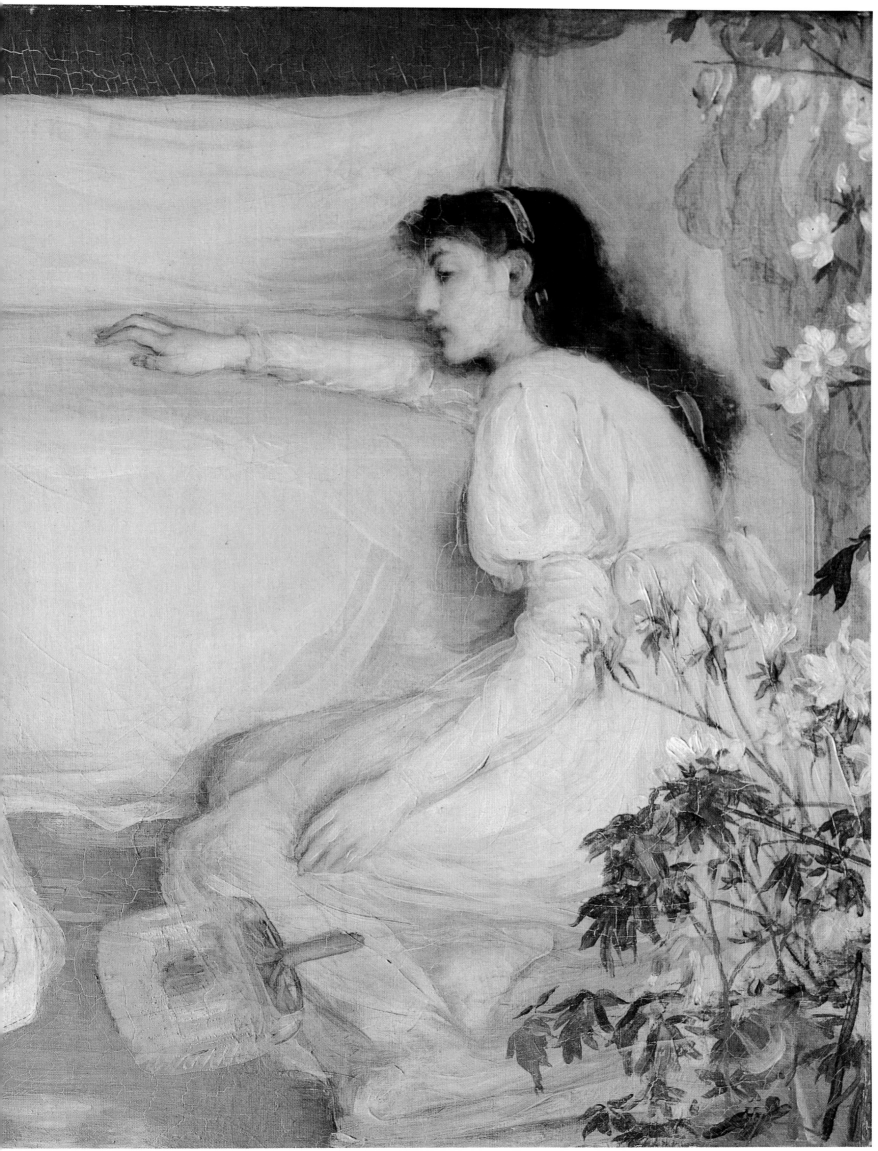

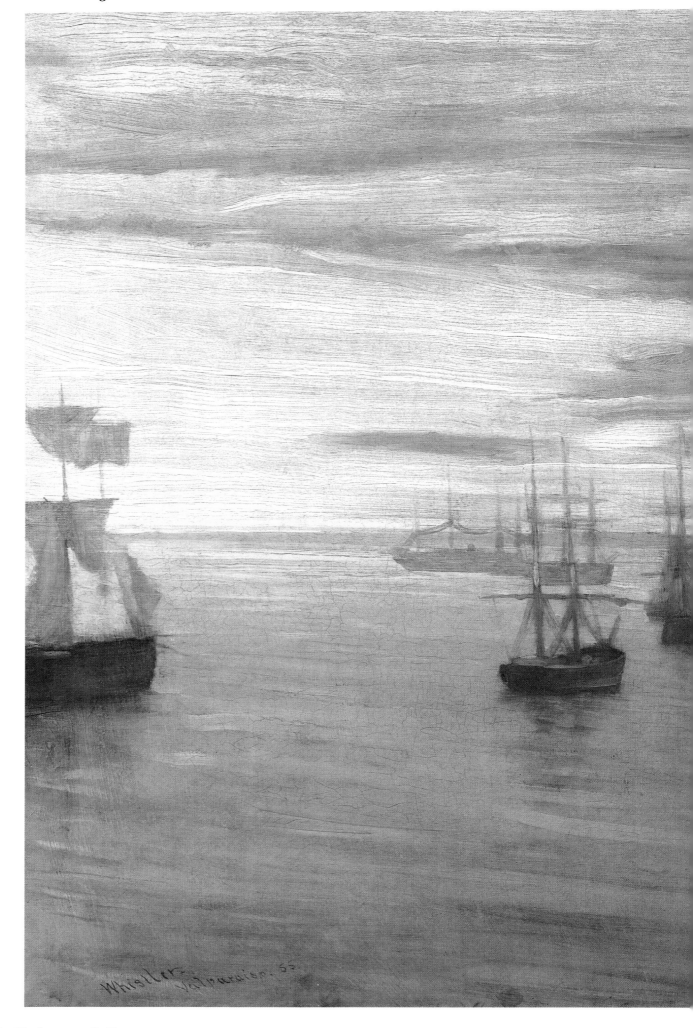

**Crepuscule in Flesh Color and Green:
Valparaiso,** 1866
Oil on canvas, 22½ × 29¾ in.
Tate Gallery, London

Whistler attended West Point in 1851-54 but never graduated. He did not volunteer in the Civil War, though his sympathies lay with the South. Probably as some sort of atonement for not fulfilling their duties, Whistler and a few Southern friends sailed to Chile instead to fight against the Spaniards. Whistler spent

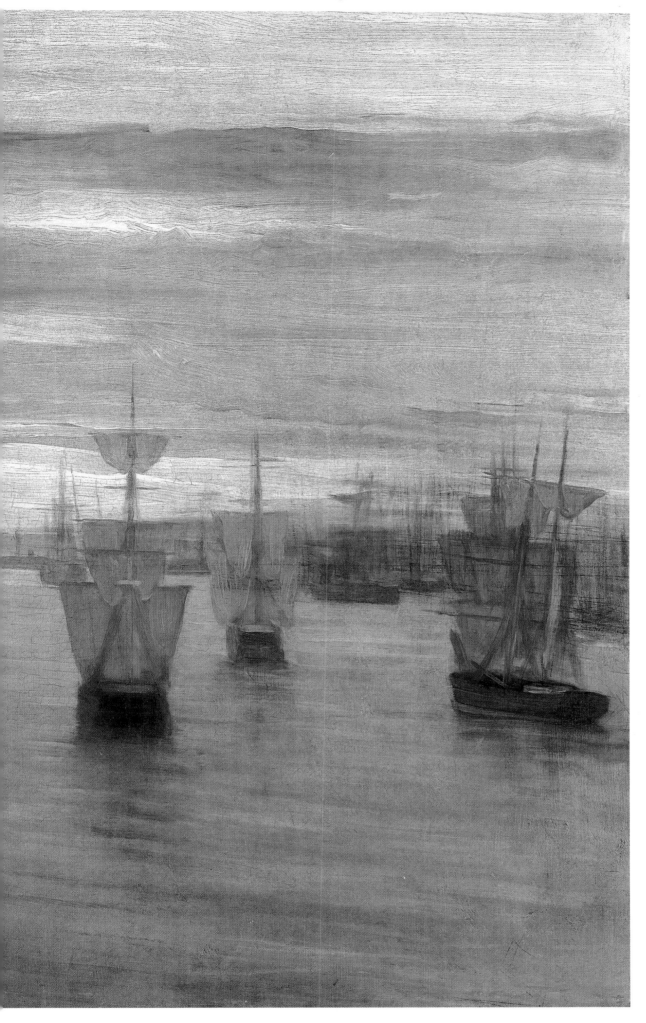

about six months in Valparaiso, Chile, a town usually enveloped in a fine mist due to the meeting of the Humboldt current's Antarctic waters with the warm Pacific. The blurring effect of this strange and delicate fog delighted Whistler, and led him, when he returned to London, to investigate the way night and fog softened that city's severe skyline. *Valparaiso* was reportedly painted in one sitting, with colors very carefully prepared beforehand. In the sky, Whistler let the visible bristle marks, trailing through the thin pigment, suggest atmospheric striations, while in the water they evoke the gentle ripples of the sea.

Symphony in Flesh Color and Pink: Portrait of Mrs. Frances Leyland, 1872-73

Oil on canvas, 77⅛ × 40¼ in. *(detail)*
© *The Frick Collection, New York*

Frances Leyland, a beautiful, intelligent red-head, was the wife of shipowner Frederick Leyland, one of Whistler's major patrons (he owned *Princess from the Land of Porcelain*) until their friendship ended bitterly over money owed Whistler for redecorating their dining room. Before the quarrel, Whistler and Mrs. Leyland were very fond of one another; she told Whistler's biographer she regretted the painter couldn't marry her.

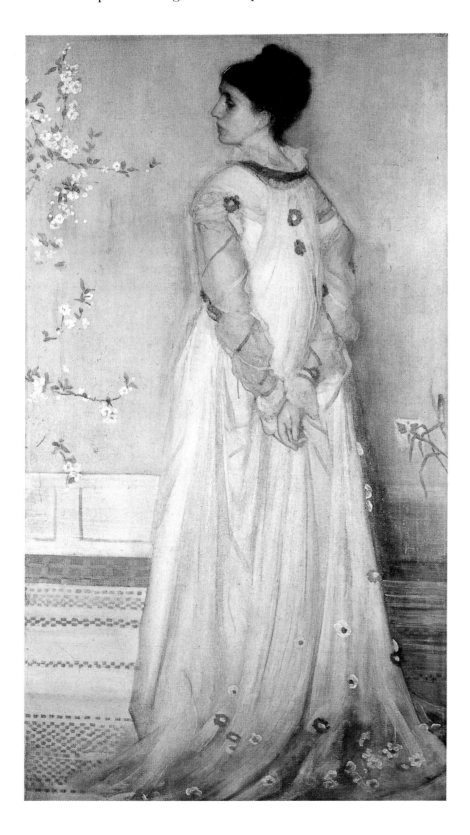

Ignoring Mrs. Leyland's request to be painted in black velvet, Whistler designed instead this magnificent shell-pink gown, scattered with flowers and ribbons. The dress does not conform to prevailing silhouettes, but rather is related to the alternative Aesthetic style. Generally looser and fuller, and worn with softer hairdos and no corset, Aesthetic costumes were vaguely based on medieval prototypes. Whistler adjusted the dress's train so that a giant arc sweeps up from the folds at lower left, rises through her robe and sloping neck, and culminates in her profile head. The combination of a back view of the body and side view of the head allowed him to show the back and face simultaneously, and lent his model an air of guarded hauteur. Mrs. Leyland, framed by blossoms, looms very tall and long against the low dado.

Nocturne: Blue and Gold – Old Battersea Bridge, 1872-73

Oil on canvas, 20⅛ × 27⅞ in.
Tate Gallery, London

While others saw only ugliness in industrialized London, Whistler discerned great beauty: "And when the evening mist clothes the riverside with poetry, as with a veil, and the poor buildings lose themselves in the dim sky, and the tall chimneys become campanili, and warehouses are palaces in the night, and the whole city hangs in the heavens, and fairyland is before us – then . . . Nature . . . sings her exquisite song . . ." After strolling or rowing along the Thames, Whistler would work from memory. "Painting from nature," Whistler contended, "should be done in the studio."

The Battersea Bridge was in fact a low-slung, decrepit structure; for the sake of his spare, elegant arrangement, inspired by bridge views by Japanese artist Hiroshige, Whistler exaggerated the height and curve of the bridge, as well as the distance between the wooden pilings. The shower of gold sparkling in the sky is the fireworks display at Cremorne Gardens, a pleasure park across the river. Unaccustomed to such pictorial economy, most viewers simply could not recognize that the blobs above and below were people, that the diagonal at bottom was a barge, and the dark arch represented a bridge. Yet the critic for the Brighton *Gazette* was unusually perceptive: "There is nothing superfluous; nothing wanting; there is nature itself painted in so few strokes that they can almost be counted, and truthful work, though but a single color has been used in different tones."

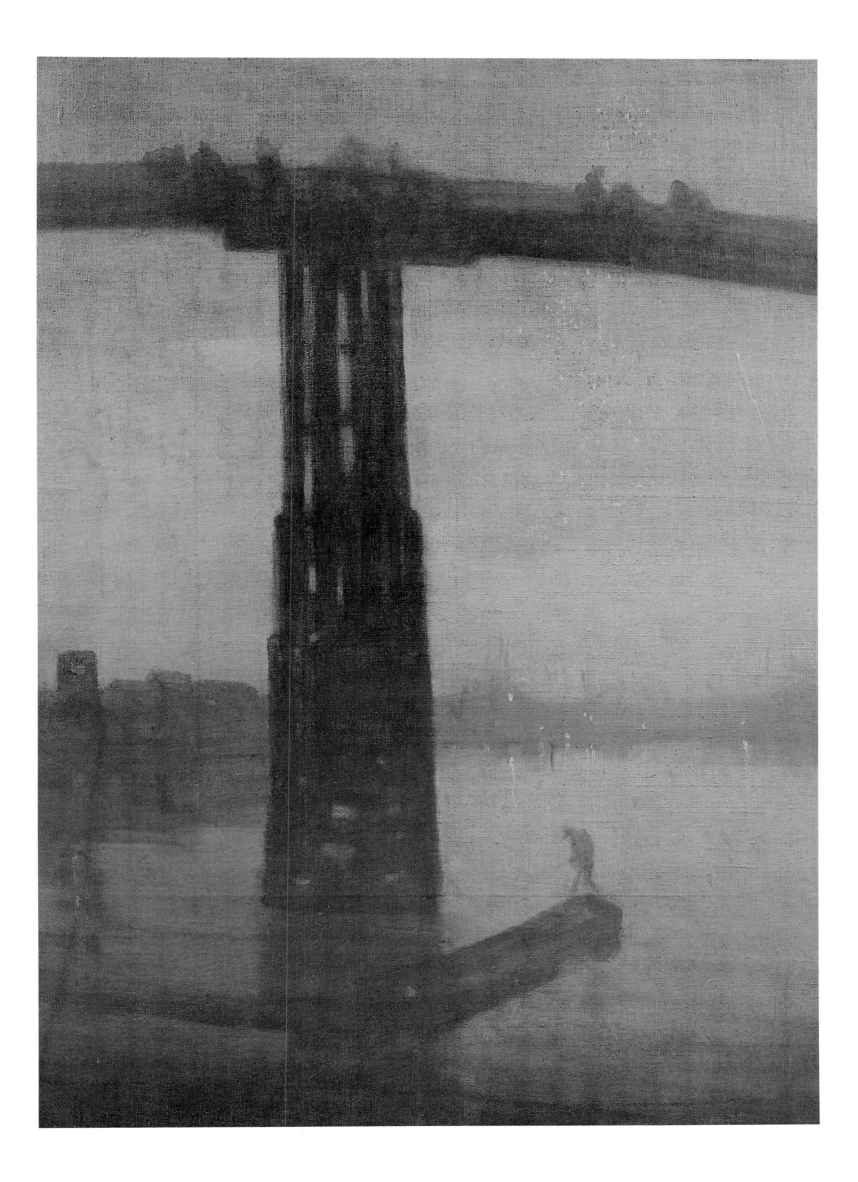

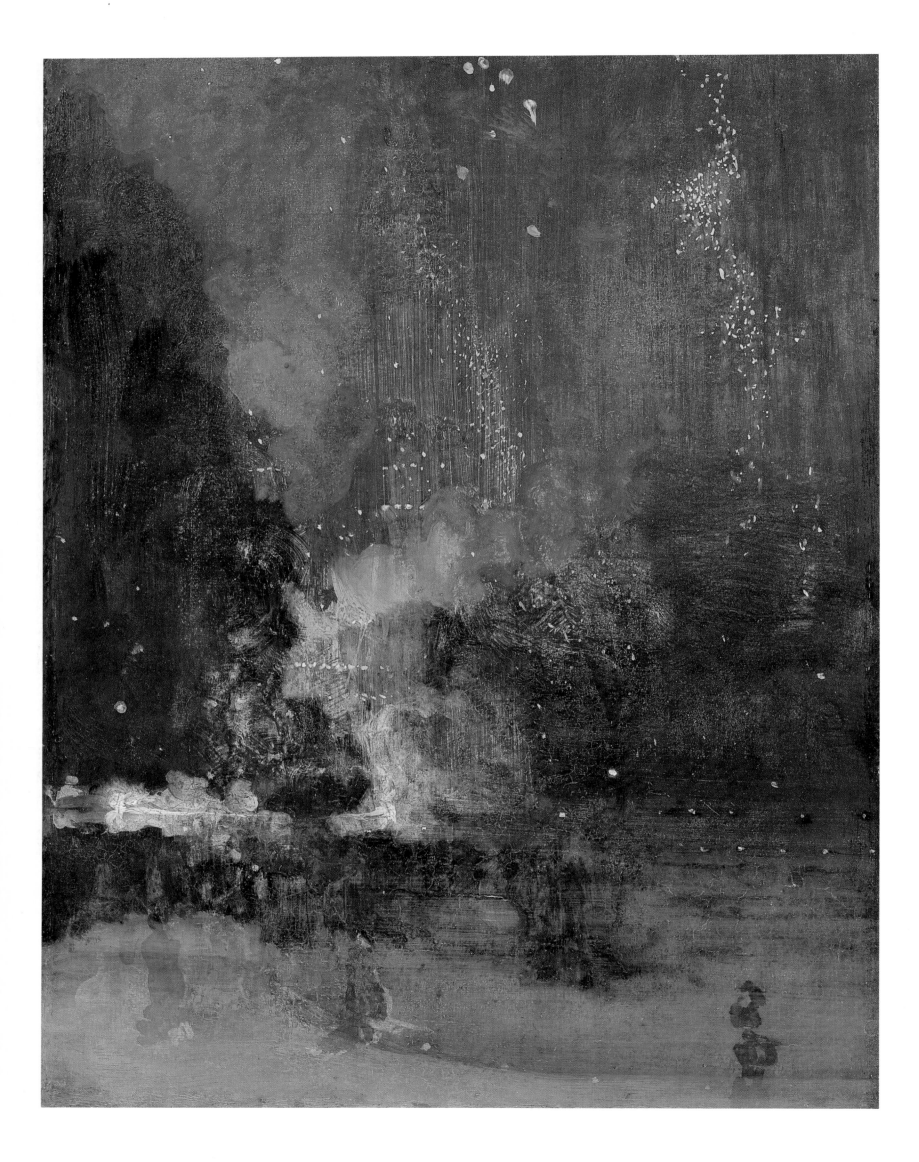

Nocturne in Black and Gold: The Falling Rocket, c. 1875

Oil on oak panel, 23⁴⁵⁄₆₄ × 18³⁄₈ in.
© *The Detroit Institute of Arts*
Gift of Dexter M. Ferry, Jr.

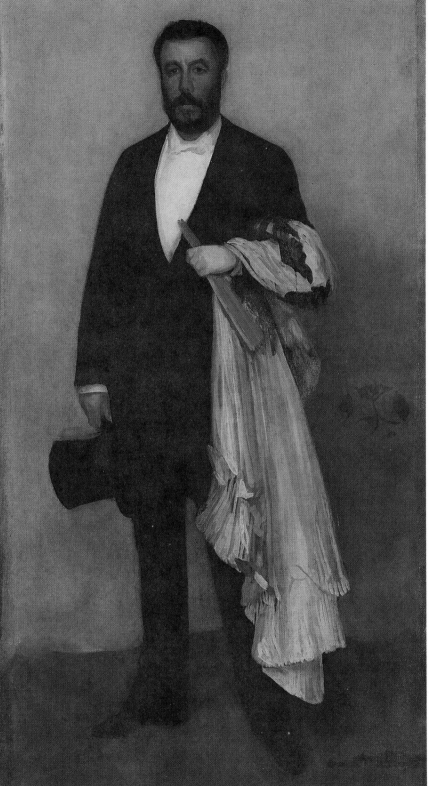

Nocturnal subjects were ideal for Whistler: the issues for which he had no patience – atmospheric and linear perspective, clarity of detail, distinctions between form and background or horizon and sky – became irrelevant. His method of painting with pigment thinned to the consistency of ink, rubbing out with a rag, and then repainting, conveys perfectly the sense of moving, layered shadows. After Frederick Leyland first proposed the designation "nocturne", the delighted Whistler wrote: "You have no idea what an irritation it proves to the critics and consequent pleasure to me – besides it is really charming and does so poetically say all I want to say and *no more* than I wish." This infamous canvas of the fireworks in Cremorne Gardens was the centerpiece of Whistler's 1878 lawsuit against the "irritated" critic John Ruskin, who had written: "I have seen, and heard, much of cockney impudence before now; but never expected to hear a coxcomb ask two hundred guineas for flinging a pot of paint in the public's face." Throughout the trial, Whistler entertained the courtroom with his wit and won his case – a Pyrrhic victory, however, since he was awarded one farthing and went bankrupt over legal expenses.

Arrangement in Flesh Color and Black: Portrait of Theodore Duret, 1883

Oil on canvas, 76⅛ × 35¾ in.
© *1984 The Metropolitan Museum of Art, New York*
Catharine Lorillard Wolfe Collection, Wolfe Fund, 1913. (13.20)

Duret was an art critic and collector whom Whistler met through Manet in 1880. Against a vaporous grey background, Duret, in evening dress, holds a domino and fan, feminine accessories introduced for their rosy color. Duret recalled that the artist began by making chalk marks indicating the top, bottom and sides of the figure. He then stepped away, grabbed a large, long brush and began painting with sweeping movements. Within an hour or two, the basic elements were in place. Then his painting spells grew briefer, his periods of scrutiny longer, his brushes smaller, and his strokes more delicate. In a three-hour session, he would touch the canvas no more than 50 times. Once the picture seemed complete, Whistler would suddenly seize a rag, rub out his work, and recommence the whole process. Correcting was out of the question – he always had to begin anew. Believing that the paint should rest on the surface as lightly as breath upon a pane of glass, Whistler used highly absorbent canvases and paint so thin he called it his "sauce."

SELECTED BIBLIOGRAPHY

General

BOOKS:

Boyle, Richard J., *American Impressionism*, New York Graphic Society, Boston, 1974

Gerdts, William H., *American Impressionism*, Abbeville Press, New York, 1984

Hoopes, Donelson F., *The American Impressionists*, Watson-Guptill, New York, 1972

Novak, Barbara, *American Painting of the Nineteenth Century: Realism, Idealism, and the American Experience*, Praeger, New York, 1969

CATALOGUES:

American Women Artists 1830-1930, exhibition catalogue, Washington, D.C.: The National Museum of Women in the Arts, 1987

The Bostonians: Painters of an Elegant Age, 1870-1930, exhibition catalogue. Boston: Museum of Fine Arts, 1986.

Burke, Doreen Bolger, *American Paintings in the Metropolitan Museum of Art, Vol. III: A Catalogue of Works by Artists Born between 1846 and 1864*, Metropolitan Museum of Art, New York, 1980

Lasting Impressions: French and American Impressionism in New England Museums, exhibition catalogue. Springfield: Museum of Fine Arts, 1988

A New World: Masterpieces of American Painting, 1760-1910, exhibition catalogue. Boston: Museum of Fine Arts, 1983

Individual Artists

Boyle, Richard J., *John Twachtman*, Watson-Guptill, New York, 1988

Burke, Doreen Bolger, *J. Alden Weir: An American Impressionist*, University of Delaware Press, Newark, 1983

Cecilia Beaux: Portrait of An Artist, exhibition catalogue. Philadelphia: Museum of the Philadelphia Civic Center, 1974

Edward Redfield: First Master of the Twentieth Century Landscape, exhibition catalogue. Allentown Art Museum, 1987

The Flag Paintings of Childe Hassam, exhibition catalogue. Los Angeles: Los Angeles County Museum of Art, 1988

Frank W. Benson: The Impressionist Years, exhibition catalogue. New York: Spanierman Gallery, 1988

Helen M. Turner (1858-1958): A Retrospective Exhibition, exhibition catalogue. Cragsmoor: Cragsmoor Free Library, 1983

Hoopes, Donelson F., *Childe Hassam*. Watson-Guptill, New York, 1988

Holden, Donald, *Whistler: Landscapes and Seascapes*, Watson-Guptill, 1976

Mary Cassatt and Philadelphia exhibition catalogue. Philadelphia: Philadelphia Museum of Art, 1985.

Mathews, Nancy Mowll, *Mary Cassatt*, Harry N. Abrams, New York, 1987

Philip Leslie Hale, A.N.A., 1865-1931, exhibition catalogue. Boston: Vose Galleries of Boston, Inc., 1988

Pisano, Ronald G., *William Merritt Chase*, Watson-Guptill, New York, 1986

Ratcliff, Carter, *John Singer Sargent*, Abbeville Press, New York, 1982

Twachtman in Gloucester: His Last Years, 1900-1902, exhibition catalogue. New York: Spanierman Gallery, 1987

Walker, John, *James McNeill Whistler*, Harry N. Abrams, New York, 1987

Werner, Alfred, *Inness Landscapes*, Watson-Guptill, New York, 1973

William Merritt Chase: Summers at Shinnecock 1891-1902, exhibition catalogue. Washington, D.C.: National Gallery of Art, 1987

Winslow Homer, exhibition catalogue. New York: Whitney Museum of American Art, 1973

Winslow Homer: The Croquet Game, exhibition catalogue. New Haven: Yale University Art Gallery, 1984

Young, Andrew McLaren, Margaret MacDonald, and Robin Spencer, *The Paintings of James McNeill Whistler*, Yale University Press, New Haven, 1980

PICTURE CREDITS